Sexed

Universals

In Contemporary Art

PENNY FLORENCE

ALLWORTH
PRESS
NEW Y

© 2004 Penny Florence

07 06 05 04 03 5 4 3 2 1

Published by Allworth Press
An imprint of Allworth Communications, Inc.
10 East 23rd Street, New York, NY 10010

Cover design by Derek Bacchus
Cover photo: Detail from Marsyas 2002, by Anish Kapoor. Courtesy
 Tate Modern and the artist. © Tate London 2003.
Interior design and page layout by SR Desktop Services, Ridge, NY

Library of Congress Cataloging-in-Publication Data
Florence, Penny.
 Sexed universals in contemporary art / Penny Florence.
 p. cm.—(Aesthetics today)
 Includes bibliographical references and index.
 ISBN 1-58115-313-9 (pbk.)
 1. Identity (Psychology) in art. 2. Gender identity in art.
3. Sex role in art. 4. Arts, Modern—20th century. 5. Arts,
Modern—21st century. I. Title. II. Series.

NX650.I35F57 2004
700'.453—dc22
 2004004426

Printed in Canada

IN MEMORY OF

Wilhelmina Barns-Graham, Painter

1912–2004

contents

acknowledgments

This book could not have been written without the support of many more than I can name here. The ways in which colleagues and students contribute to scholarly research are very hard to define, but I have been in the situation where I have had to write without them. That former absence makes me appreciate them all the more.

The research students on the PhD programme at Falmouth College of Arts, U.K. were an enabling and stimulating presence throughout the development of the ideas that inform the book, and they have kept me on my toes. I want to thank them for their commitment and integrity. I have engaged in some wonderful discussions with the staff and students on the MFA program at Art Center College of Design, Pasadena, California, where I have been privileged to be a Visiting Speaker on many occasions for some years. Joanna Hodge and Jeremy Gilbert-Rolfe read the manuscript and it is much improved as a result. Of course they bear no responsibility for its imperfections. With them, Norman Bryson has been a highly valued interlocutor, as have Linda Anderson, Margaret Whitford, Petra Kuppers and Nicola Foster, and the members of the Women's Philosophy Review.

A research leave grant from the Arts and Humanities Research Board allowed me to complete the writing, while the British Academy supported my conference activities. Falmouth College of Arts research fund contributed to the development of this work from inception to completion, and I am extremely grateful for this sustained support. I regret to say that recent political decisions in the United Kingdom will mean the withdrawal of such opportunities from all but a few universities, and I wish to register a strong protest at this money-led approach to education and research. Finally, thanks to the Slade University School of Fine Art and University College London for their contributions towards later changes.

Particular sections of this book draw on material that I have published elsewhere. The discussion of cross-dressing in chapter four, part one, derives from my essay in Lund, Lagerroth, and Hedling, *Interart Poetics*, Amsterdam:

Rodopi, 1997. The idea of the "cybiog" has appeared in "Cybiog and Sexed Digitalia" in a special issue of *Digital Creativity*, Autumn 2003, though here it is rather a question of the article drawing on this book than the other way around. The fundamentals of chapter five, part two, were worked out in the lecture given at the Los Angeles Museum of Contemporary Art on the occasion of Liz Larner's mid-career retrospective in 2001. I want to thank them for their invitation and their considerable assistance; and finally, chapter seven draws closely on my essay in the final volume of the *Disciplines, Fields, Changes* series, Article Press, 2002, edited by John and Jacquie Swift. My warm thanks to them.

foreword

I am a Hittite in love with a horse. I don't know what blood's
in me I feel like an African prince I am a girl walking downstairs
in a red pleated dress with heels I am a champion taking a fall
I am a jockey with a sprained ass-hole I am the light mist
 in which a face appears
and it is another face of blond I am a baboon eating a banana
I am a dictator looking at his wife I am a doctor eating a child
and the child's mother smiling I am a Chinaman climbing a mountain
I am a child smelling his father's underwear I am an Indian
sleeping on a scalp
 and my pony is stamping in the birches,
and I've just caught sight of the *Nina*, the *Pinta* and the *Santa Maria*.
 What is this land, so free?
 —Frank O'Hara, from "In Memory of My Feelings"

"Within the Humanities in the 'West', there have been decades of decon-
struction and opposition. The time has come to evolve new values."
 —Penny Florence

I may be truly free in the last moments of my life, but until then I can at least
aspire to go beyond my present limitations.

 And with that aspiration I sat at a little round table in a hotel room, first
in Badenweiler and now in Le Muy, reading Penny Florence's manuscript,
Sexed Universals.

Florence's book is the thirteenth book in my series "Aesthetics Today," copublished by Allworth Press and The School of Visual Arts. The series has touched often on the contemporary questioning of universals, of the positive aspects of doubt, and on the debate between universalists—those that would believe in absolutes within a human commonality—and the relativists' approach to art and aesthetics.

The series, in fact, began with John Ruskin's *The Laws of Fésole*, a book that I chose to bring back simply because it seemed so odd now in its argument for absolutes. For Ruskin, all and everything emanated from the meridian whereupon the hill of Fésole lies overlooking the city of Florence, cradle of the Renaissance. (Of course, around 1610 Galileo fixed his telescope there and got into a lot of trouble concerning the whereabouts of the earth, the sun, and truth.)

Further on in the series, Thomas McEvilley picked up this weave of certainty and doubt in *Sculpture in the Age of Doubt*. He addresses it also in his earlier essay "Doctor Lawyer Indian Chief: *'Primativism' in Twentieth Century Art*, at the Museum of Modern Art in 1984," concerning an exhibition curated by William Rubin and Kirk Varnedoe. McEvilley's essay first appeared in the pages of *Artforum* in February 1985. In successive months, both Rubin and Varnedoe responded, and the debate finished with Varnedoe's piece in the May issue of *Art in America* (though I can assure you, none of the parties involved believe the discussion is over). It is published in its entirety in *Uncontrollable Beauty*. This exchange is an eloquent and bitter contest, a milestone in contemporary discourse that set the stage for art criticism in the decades that followed.

Jeremy Gilbert-Rolfe's *Beauty and the Contemporary Sublime* is in part a response to Kant's observances on beauty and the sublime. Kant argued that there is no certainty with respect to the ultimate nature of reality, only a commonality of experience through the means of human faculties—thus a concurrence through beauty. Gilbert-Rolfe speaks to Kant's categorizations: beauty's femininity, and the masculinity of the sublime (Jeremy describes it as androgynous). Because his book addresses the genders of aesthetic concepts, and simply because it is refreshing, *Beauty and the Contemporary Sublime* and *Sexed Universals* make excellent companions.

———————

Sexed Universals evolved from notes that originally focused on the work of Barbara Hepworth. Florence expanded it to include other artists as examples to support her predominant theme: "There do *seem* to be structures that are universal, and certain forms appear to stand in an indexical relation to the signified. These issues must be open to discussion, not blocked or refused." Her book is a

step out of the conundrum of what has become, at least in Western academe, an assumed universal: that everything is relative to cultural context and circumstance. Therefore, universals are merely the dictates of those presently in power. It is ironic that now, those in power within the limitations of Western academe have come to pose, even to enforce, the universality of non-universality.

This book touches the heart of contemporary disquiet; it addresses the postmodern argument that all meaning is relative to cultural context and circumstance, as well as the contemporary need for some deep, unchanging, inclusive commonality.

The argument of the relativist's viewpoint goes something like this: We have a message, "She follows Marx," for example. Without changing a single word it can have a number of different meanings. At the McCarthy hearings in 1953, it might mean "Blacklist her," at dinner with Jean Paul Sartre and Simone de Beauvoir it might mean "We adore her," and behind camera in the early days of TV it might mean "She's on after Groucho." Significant connotative meanings spring from the context and circumstance in which the message is uttered. But if everything is relative, subject to change as soon as context and circumstance change, how could we ever dream of knowing what "everything is relative" means? Some kind of constant has to be in place for there to be any understanding at all.

Through a more open attitude with respect to questions of race and sex, the past thirty years or so have seen social progress made though the rejection of previously proclaimed universals. Whereas Descartes employed doubt as a means to certainty, essayists from Montaigne to McEvilley argue the importance of sustaining doubt. This fluidity seems crucial nowadays, and is reflective of the ordinary lightness of being that was a hallmark of the late twentieth century. But for these past thirty years or so we have also been embroiled in cultural wars, and especially a notion of identity politics, that ultimately limit an individual's possibilities of expression. Notions of race and sex are so fetishized that they often entomb rather than liberate.

Bruce Benderson writes in *Toward the New Degeneracy*:

Today, identity politics is one of many facets of the middle class mentality that has absorbed some marginals and worked to sever the old fertile connections between bohemia, the culture of poverty, and the avant-garde. Such politics spends a lot of time fearfully discussing the uncontrollability of libidinal behavior and deconstructing aestheticism while it continues to neglect the embarrassing subject of class. Concurrently, it has become the voice of one ruling class—the homogenized suburban bourgeoisie. For the liberal, there are many ironies in the new politics; among them is the following: about those we liberals have been taught not to vilify—the poor— there is now no language to speak about at all.

In describing the work of artists, female and male, Florence develops the concept of sexed universals though a unique and varied discourse. Substance is the gender of the work, more so than the sex of the artist. Her aesthetics seep into present day politics as well, from the faux politics of art criticism to real political issues.

For as long as postmodernism was postmodernism, aesthetic choices were treated as political. But it is also possible, even in the choice of the current American president—whom many of my students thought cute, despite the fact that he was of the same party as Tom Delay, Donald Rumsfeld, and John Ashcroft—that political choices can be made on the basis of aesthetics. With the advent of TV, looks must have had something to do with the choice of Kennedy over Nixon. Aesthetic choices often are responsible for electing people who change politics.

Florence's real subject is the politicization of art through the language of criticism. She enters the debate surrounding perhaps the most politicized painting in the Western history, Manet's *Un bar aux Folies Bergères* (1881–82). She observes in a section called "The Artist as Cosmic Barmaid":

> Who among art lovers has not looked up in a gallery to catch a look on the face of a stranger, perhaps someone quite unlike oneself, to be united with them in momentary recognition? Just for the moment, you both know what you have seen and understood. It is part of Baudelaire's love of the universal life. This alone means that "universalizing" does not have to return to a pre-modern exclusivity.

She looks at the work of contemporary artists such as Sam Taylor Wood, Anish Kapoor, Liz Larner as well as modernists such as Brancusi and Gauguin, Hesse, and finds them volatile and alive.

But what is the need for imperishable bliss? A bottle of wine on first encounter is either good, or it isn't, and if it is, it is only for that brief moment of time. Fleeting experiences, pleasurable or not, are much of what life is about. Of course, consensus from across the table may help in the success of a particular evening, a commonality that may have something to do with such writers as Noam Chomsky, who believe in an underlying grammar for all languages. If it is so for formal language, why not for iconic languages, and wine as well?

Somehow, consensus ultimately winds up dictating rules, power, canons, and given, and so we question "universals" as markers or standard-bearers of what is outmoded. Why prove that a particular work or idea is relevant in every case and for every society? What would an obsession with that proof mean, and what would it lead to? Certainly not aesthetic experience. One could ask as well, what is the motivation to prove that everything is relative? (And what irony to any conclusion of that proof!)

Arthur Danto has posed death, common to all cultures, as a route to the universal, and an inspiration to beauty through elegy. "Elegies," in Danto's words, "are artistic responses to events the natural emotional response to which is *sorrow*, which *Webster's* defines as 'deep distress and regret (as over the loss of something loved).'" Danto cites Maya Lin's *Vietnam War Memorial* and Motherwell's *Elegies* to the Spanish Civil War. Interestingly, both examples are feminine—Lin's dark slice in the earth, and Motherwell's black pregnant forms. And both are responses to war. I believe Florence would take issue with Danto. She relates in her concluding chapter that "it is the capacity for mourning, not mourning itself, it is the passing through of this psychic state, not the sustaining of it, that constitutes the subject. . . . This book has tried to examine contemporary art, not as constituted by mourning, but as transitional, not locked within prohibition and blockage." She cites John Donne's beautifully titled *A Valediction: Forbidding Mourning*, reproduced here in part. The title is also echoed in the title for the last chapter, "A Valediction: Nationalism and Melancholia; Sex, War, and Modernism."

> As virtuous men pass mildly away,
> And whisper to their souls to go,
> Whilst some of their sad friends do say,
> "Now his breath goes," and some say, "No."
>
> So let us melt, and make no noise,
> No tear-floods, nor sigh-tempests move;
> 'Twere profanation of our joys
> To tell the laity our love.
>
> Moving of th' earth brings harms and fears;
> Men reckon what it did, and meant;
> But trepidation of the spheres,
> Though greater far, is innocent.

But I can't help myself! Certainly this summer, many sad Spanish songs have played through the thin CD slot in my car's radio; Alber Pla's "Qualsevol nit pot sortir el sol," Ana D's "Me quedo contigo," and Caetano Veloso's "Cururrucucu' Paloma," to name but a few.[1] I don't know what it means if anyone else finds or does not find these songs beautiful in their sadness, a sadness almost unbearable, a sadness that transcends the language of their lyrics. I think that Florence would not be satisfied with motivations of sorrow or at death, particularly in death's association with war. We can also look at birth, common to all cultures, as well as to laughter.

When music or art affects the listener, I believe what occurs is the relationship Martin Buber called "I You." The "I It" is a relationship of categories. The "I You" obliterates them and is wholly present in the experience of the death of love, the death of a loved one, and the life and death of a friendship.

> When I confront a human being as my You and speak the basic word I-You to him, then he is no thing, nor does he consist of things.
>
> He is no longer He or She, limited by other Hes and Shes, a dot in the world of space and time, nor a condition that can be experienced and described, a loose bundle of name qualities. Neighborless and seamless, his You fills the firmament. Not as if there were nothing but he; but everything else lives in his light.
>
> Even as a melody is not composed of tones, nor a verse of words, nor a statue of lines—one must pull and tear to turn a unity into a multiplicity—so it is with the human being to whom I say You. I can abstract from him the color of his hair or the color of his speech or the color of his graciousness; I have to do this again and again; but immediately he is no longer You.
>
> —*I and Thou*, Martin Buber, translated by Walter Kaufmann, Simon and Schuster, New York 1970

The experience of "I-You" that Buber describes accounts for much of art, literature, and music, and hopefully, in an era that collates, not coincidentally, logowhores with identity politics where most everything is experienced as "it," we can return, at least fleetingly, to the possibility of "You."

After decades of postmodernism, there may be a shift away from the era of after, into an era of ever after—Après Post. My students have matured in an environment of identity politics and the assumption that somehow they create through an assumed identity, an identity that has the ironic pretense of being inherently fixed, not shifting or forgetting. On an island where striped lizards, striped fish, striped snakes, and zebras live, one of the things artists and poets would probably ignore are stripes. Stripes would be a given in that particular cultural environment and difference would be more likely determined not by stripe, but by profile. (In contemporary art, the stripe—Stella—made its début as a response to the dominance of drips—Pollock.) The very rationale of

relativism, the belief that all is culturally determined, undermines the deduction that differences such as sex, race, and sexual orientation inherently give life meaning.

This courageous book addresses the prescient issues of our time. Penny Florence looks for ways out of the fixation with identity without giving up on the progress that has been made and the equality that is possible. Thinking of yourself as an adjective coupled to a noun is one way of defining yourself and the work you create. Though this way of categorizing the world seems to have unlimited indexical possibilities it is couched in the language of Western academe. To be truly inclusive, it is not only through our eyes that we may compare, but through language as spoken, which has as many possibilities for variance and transcendence as anything I can think of. People in the music business have intuited this for millennia.

----•----

K.A. (a Puerto Rican from the South Bronx draped salaciously over a chair): Sh*t, I don't know, they might say chocolate ass or somethin. F**k, there's so many . . .

B.B. (with a faux sigh of exhaustion): I only asked for a couple of examples— no big deal. Anyway, you know what I'm talking about. All you have to say is "white" and it's disparaging. Add "male"—forget it.

K.A. (consolingly): No, not really, it all has to do with the tone—blanquita, Taina, negra—all shades of Puerto Ricans. Blanquita obviously being the highest because it's the lightest. (This last line rings hollow.)

B.B.: So what, ghetto princess?

K.A.: Listen Old Man, the ghetto has been using that word for f**king years. I don't. Princess is so f**king corny. I've got others but I'm not going to f**king tell you. You'll just use it for that f**king paper of yours and not give me any f**king credit. Just like you used f**king "faux",[2] "logowhore",[3] and "wifebeater".[4] Those are my f**king words.

B.B. (starting to spaz out—her terminology—thus reverting to the hypothetical): I have not used logowhore, but maybe I will someday. What about a black

person who comes from Africa with a little Louis Vuitton bag to carry her or his passport, and his or her cell phone and cigarettes? What if he or she is sitting in class? How would we know not to call her or him an African American without him or her producing her or his passport from out of this Louis Vuitton pouch?

K.A.: I don't give a f**king shit about his or her or her or his f**king passport! Louis Vuitton, maybe . . . F**k, I think I forgot to brush my teeth, I hate when that happens.

B.B. (grasping at straws): Dominicans?

K.A.: What about those f**kin Dominicans? F**k them! There's that rivalry between us you know, they copy our food, our dance, and then come to our island for their f**king freedom. And they use the same f**king beat too, that sh*t is so whiny.

B.B. (floundering, whispering): WASPs?

K.A.: F**k those f**kin pointy-faced, cyan-looking sons of . . . But it wasn't a wasp that we saw sucking on those bright red flowers in the sunlight that late afternoon. It was the smallest hummingbird in the world, with its black and white speckled bottom, and its delicate . . . I don't know . . .

B.B.: There was a tiny little straw on his face and he sucked the nectar as he hovered next to the bloom. Wasn't he beautiful?

K.A.: Yes, and such a good boy. He did look like a bee, he was so small. This world is too big, too cruel for him. Breaks my heart to look at something so soft and feathery and innocent. Where do you think he sleeps at night?

I am an adjective noun? I am an adjective noun?
Why not a verb, a preposition, a salutation, or a conjunctive.
See what the f**k happens.
Thank You, Penny Florence.

—Bill Beckley, Le Muy, June 18, 2003

Oh, what the f**k? Why not a f**kin noun, *then* a f**kin adjective?
That's the way the f**kin frogs do it.

Notes

1. Thanks to Pedro Almodóvar for compiling a selection of these songs in "Viva La Tristeza!"
2, 3, 4. TM Katherine Aguilar.

introduction: into the thick of things

I remember always working with contradictions and contradictory forms, which is my idea also in life [. . .] my life never had anything normal or in the center [. . .]

—Eva Hesse[1]

The *point* of some contradictory positions is their contradictory status.

—Penelope Deutscher[2]

[. . .] it has become harder to separate out what Hobsbawm calls the egoism and moral blindness from valid social and material aspirations; [. . .] we are being presented with a split and coalescence of legitimate claims to national self-determination and autonomy with the absolutes of ethnic purification and hatred. How to distinguish them may be one of the most important political questions of today.

—Jacqueline Rose[3]

Women and the Universal! Very interesting; one kind of giggles because women have always been confined to the realm of the Personal. In working with a notion of difference that is not synonymous with opposition or segregation, the apartheid notion of difference, I focus on the relationship between women and living spaces [. . .] as the very site of difference on which both the Universal and the Particular (historical, cultural, political) are at play.

—Trinh T. Minh-Ha[4]

SEXED UNIVERSALS, CONTRADICTION, AND POLITICS

This book aims to engage readers who would not usually consider issues of cultural, racial, and sexual difference in art, alongside those who would. If it can contribute to developing dialogues across this divide, it will have done its work. To state what ought to be the obvious, the constitution of the universal is an issue that concerns everyone. But few are addressing it right now in relation to radical agendas, other than to say it is outmoded. While it would be absurd to claim for a book on sexual difference in contemporary art that it addresses directly the questions of politics and ethics raised by Jacqueline Rose above, such a book can work with the imaginative positioning and psychic structures through which the disastrous politics she describes might themselves become outmoded.

The idea of a sexed universal is clearly contradictory. Yet some kind of qualified or differential universal is beginning to be recognised as a necessary concept, if current arguments from what were "the margins" are to be brought—

if not to the center because the center may be part of the problem—into the thick of things. Drucilla Cornell, Rosi Braidotti, Christine Battersby, and Patricia Huntington are some of the writers whose recent work, in my view, points in this direction. It is out of Cornell in particular that my articulation of the connections between the aesthetic, the social, and the sexed have grown, leavened with the work of Peg Brand, Carolyn Korsmeyer, and Jeremy Gilbert-Rolfe from the particular direction of aesthetics. These thinkers are diverse; my aim in working with them is not to homogenize their differences, but rather to open polylogues, avoiding thereby one of the hazards of metaphysical thinking identified by Joanna Hodge: "a tendency to try to show a compatibility between hopelessly heterogeneous elements."[5]

In developing a female universal, it is important to see it as part of a differentiated subaltern universal, in which there probably has to be a male universal. Certainly this will have to be examined, possibly en route to another configuration altogether. I see no particular virtue in fixing the concept of the sexed universal. In the course of writing, I have sensed something of a male universal developing, something shifting out of the false neuter of the "old" universal, but know that it is not as conscious, or fleshed out, an idea as one might wish. The work needs a greater number of interlocutors for this to happen.

Yet in building analyses of work by women and men, with a focus on the universal and in light of the work being done on the new masculinities, something more of this silence within men's work seems to begin to speak. Women who make art perforce have had to consider the relation of their work to sex in a way that has hitherto appeared to be unnecessary for men who make art. This has been so even where, as with several modernists, sexual difference appears to run counter to everything they believe their work is about. Concepts and approaches developed through work on cultural difference is making it increasingly plain that men's distance from this necessity may indeed be only an appearance; one indication would be the increasing recognition that the speaking subject is a located and embodied subject. As soon as this is acknowledged, there is a frame that allows sexual difference.

I think that attention to these issues of location and embodiment also clarifies that the way of coming at the sexed universal in art is not going to be the same for women as it is for men, and also that "sexed universal" is a genuinely differential concept, in the sense that what emerges is not another clear binary of opposing monoliths, but rather a changing network of structured relations. What this might mean in practice should begin to emerge in the following pages.

There is an urgent need to bring political economy, interaction, and imagination together in the elaboration of this differentiated universal, not least because, as Patricia Huntington has pointed out, postmodern theories are most vulnerable to the charge of reinforcing current material relations "when they fail to theorize the need to dialectically mediate cultural change with structural transformations in political economy."[6]

This is an enormous issue, and again, like that of the male universal, it is not fully articulated in this book. But the conceptual underpinning of this

work has been thought out consistently in relation to the reconfiguration of the status quo in sexual and racial socio-economic terms, while holding open the utopian possibility that is always the seduction, and ultimately the ethical character, of art.

An ethical take on the most intractable and relevant issues of our time is a major characteristic of the feminist philosophy on which I have drawn greatly. Problematic figures who have shaped so much of postmodern thought have been revisited in the spirit of what Penelope Deutscher has called an "ethics of discussion."[7] Heidegger and Nietzsche are obvious examples, with Joanna Hodge entitling her book *Heidegger and Ethics* in order to bring a thinker who rejected ethics and even sympathized with Nazism into a relation with a new and expanded understanding of what ethical interpretation might be. Her sense of Heidegger's "*besinnendes Denken*," a kind of thought that assigns meaning rather than indulging in metaphysical calculation, leads to "a closer connection between thinking and poetry."[8]

The aim of this book, then, is similarly to try to move forward from oppositional strategies that inevitably tend to re-install normative positions: To oppose is to fix a relation, and to fix a relation is to tend to normalize. One way in which certain ideas are reinforced is through reiteration, understood both simply as straightforward repetition, and in the complex ways theorized as "performative." If the relation of female to male is to be changed, a way has to be found to move beyond attributing certain features to the established traditions of masculinized genius without also reading for the inherent contradictions. This is an argument for a specific change in radical strategy to facilitate new understandings of sexed and raced tradition.

If a moment of auto-history may be allowed, one source of my own conflicted relation with feminism over the years is that my position in relation to work by women is as contradictory as my relation to work by men. I do not identify or define myself in relation to the conventionally feminine or domestic, in life or in art, and I cannot identify this as my space. Nor do I reject it. It is just too limiting. To regard this as a "problem," to pathologize it or even to attempt to justify it, is to adopt a normative position. It just is, and if it is, it is possible! (I have no idea what the accusation that women who want to be human are trying to be men might mean.) Inhabiting contradiction may not be all that comfortable, but comfort is probably overrated, certainly as a determining condition. The conventionally feminine spaces, moreover, are breaking down, and the family paradigm that was so strained in my generation is finally being shattered. The point is to come fully into one's humanity.

All this is not to deny the value of all the necessary work of rediscovery and redefinition of women's art and thought, or the particular and necessary part feminism has played, and continues to play, in contemporary social, psychic, and intellectual life. But it has long been my position that all strategic movements must work for their own redundancy. Feminism must continue to change until it is no longer necessary, and we are not there yet. And I have always been sceptical of "-isms" wherever they occur.

3

If the sexed or racially aware individual is to be able to speak for humanity, that person can only do so from a position that is both like and unlike that of the much-reviled Enlightenment subject, with his reason, his false neutrality, and his projectile tendencies.

To begin to allow this to emerge is the underlying aim of the book—to try and make meanings that continue and sustain the democratizing moves of the last half century of change in understandings of culture, while moving out of some of the impasses that have been encountered. Contradiction is one condition of this move.

The work is directed towards the contemporary, but because modernism has been such a contested philosophy and practice, it has been necessary to establish the argument in a relation to modernism. Very briefly, it is aligned with those like Lyotard, who find what is now called postmodernism in early modernism. But in line with the dislike of -isms referred to just now, I have not foregrounded any consideration of either modernism of postmodernism or used it explicitly to shape the inquiry.

The mode of the book is applied. Not only have I drawn widely on the recent work of feminist philosophers, which I have found exciting and revelatory, but I have also drawn on cultural theory from several fields within the humanities, which cast light on the issues from many directions, thereby clarifying those which have the widest application. Drucilla Cornell's concepts of "reiterative universalism" and "constitutive instability" have been vital in her work, and in Huntington and Deutscher's elaborations of it, and while I do not discuss these in detail, I have brought them to bear on the interpretation of art in various manifestations.[9]

This is Huntington's position:

Reiterative universalism strives to occupy a middle position between nostalgia for the past and an imaginary futuristic pluralism that coexists with segregation and colonial fragmentation. But reiterative universalism can hold this middle position only on two conditions. One condition entails abandoning the assumption that the signifier Woman or the feminine-universal revolves univocally around masculinity or the phallus. Another condition requires compensation for the abstraction of reiterative universalism through a paradigm of communicative interaction.[10]

My aim is to contribute to this by using the sexed universal as a critical mechanism within signification, working towards bringing the terms of metaphor, fiction, and art closer to the actualities of contemporary social relations, for the sake of future relations. The drive is utopian, not in the sense of seeking otherworldly or escapist ideals, but in the poetic elaboration of the conditions necessary for the realisation of postconventional forms of collectivity or perhaps community (though neither word is exactly right).

- The universal as a concept does not depend on transcendence for its utility.
- The sexed universal as a concept applies to all sexes and does not depend on the female-male dyad.
- Sexual difference is not foundational, nor is it privileged over any other kind of difference. It may, however, be a limit case.
- The female universal is no more privileged than the male; it does not map onto an Irigarayan understanding of the feminine as imaginative universal.
- Sexual difference can mask other differentials, not least because it is highly significant and always present.
- The same basic pattern applies, for example, to race, class, and ability.

In light of these aphorisms, the idea of the sexed universal is intended to facilitate exploring how a located universal, as a perspectival concept, might operate from a multiplicity of positions, by opening an extended discussion of the sexed perspective. Crucially, though, it is not intended as the model. It cannot be simply solved and applied to other views of the universal. Irigaray's claim, in *An Ethics of Sexual Difference*, that sexual difference "is probably that issue in our own time which could be our 'salvation' if we thought it through," now seems to me highly problematic, if interpreted to privilege sexual difference to the exclusion of all other forms.

There are several reasons why sexual difference cannot be the privileged differential, but the prime factor among these is that of the falsity of a hierarchy of differentials. Sexing universals aims to disperse fixed hierarchies, though it may admit of specific priorities. My perspective is weighted by my experience and location, but I have aimed to elaborate the arguments that are inevitably inflected by my subjectivity and location, so that they are not fully determined by such factors and do not become exclusionary. If it does not sound overblown, truth-telling requires it: Reconceptualizing exclusion is an ethical responsibility imposed by truth.

I have made no attempt to define the contemporary in art, though if pressed I might say it emerges out of a combination of the aleatory and the imposed. This would do as well as anything as a description of the principle of selection of works, which I decided to structure by taking recent exhibitions as well as academic and artistic debates as elements in determining which artists to discuss. Certain artists were selected because their work appears to require consideration of some idea of the universal—Edouard Manet, Barbara Hepworth, and Liz Larner, for example, each in significantly different ways. Paul Gauguin, Lubaina Himid, and Lyne Lapointe appeared productive in bringing the concept of the sexed universal into relation with issues of race and ethnicity, at least as a beginning.

Some selected artists are American, some French, one Canadian, one Finnish, one Romanian, one Spanish, some white British and some black, Asian, or Palestinian British. There are even a few poets. No attempt has been made to consider them in relation to the nation-state; rather, an implicit critique of this runs through the reasoning, surfacing occasionally, especially at the end. It has been said of woman and of artists that they have no country. Critics, unfortunately, do.

Other artists appear because they are canonical and because they have been the subjects of significant recent exhibitions—Henri Matisse and Pablo Picasso, for example. A certain logic then flows out of this, leading to other artists. Hepworth, for example, is usually thought to lead to certain artists, such as Henry Moore or especially Ben Nicholson, but because of the issues raised through the logic of the differential universal, I selected Constantin Brancusi and Anish Kapoor, the former predictable, but the latter less prominently so. To these I have added a number of artists I admire, either because they seemed to clarify particular issues, or because I wanted to see whether the principle of sexing universals had general application. The same applies to the balance of work by female or male artists. It has been recognized for at least thirty years, and possibly more, that taking full account of women's cultural contribution and artistic production will fundamentally change the history of art. That change is evident more in contemporary art than it is in mainstream history. But history has a determining part to play in "differencing the canon," in Griselda Pollock's phrase. It is therefore important that it be addressed, so that the traces of women's art are not effaced from, or diminished in, the record of what is now contemporary.

One initial aim of considering universals as sexed was to see whether this could cast light on why, up to the present historical moment, there has always come a point when the dominant histories have been unable to deal with art by women.

There are two artists who have particular positions in the genesis of this book. They are the French poet Stéphane Mallarmé and the British sculptor Barbara Hepworth. I have never quite been able to shake Mallarmé off, since first discovering his poetry when I was an undergraduate. It has been an inconvenient obsession, and my thought is too strongly marked by it for me to be able to objectify how it impacts this book. But since I am not alone in finding in Mallarmé a necessary ghost, both of the contemporary and of rethinking sexual difference, I think his presence here may not be simply the product of my personal preoccupations.

This introduction constitutes the first chapter, since it is longer and more substantive than some introductions. Chapter two is entitled "On Universals, Myth, and Morphogenesis," and it goes further into some of the philosophical issues raised by sexing universals, with the aim of setting out reference points for an inclusive understanding of art. It suggests that the differential understanding of universals might offer a way of exploring some kind of link between the materiality of form and the instability of meaning that does not reinstall the "form and content" opposition.

The third chapter, "Playing Balls with Matisse, Picasso, and Himid," takes recent exhibitions as a major point of reference. It opens the game suggested by Matisse through close analysis of paintings by the artists in the title, all of which have been recently exhibited. Meanings implicit in their curation are incorporated into the analysis. Several of the main issues around the sexed universal are set into play through trying to follow the "Plan B" of a lesser-known woman

artist as she negotiates being a painter in the shadow of the recently invented Matisse-Picasso giant. Something of the kind faces all contemporary artists— Richter, who has been suggested as perhaps a Master for today, deals with it through photography. This version of a universal condition is particularized through Himid.

Chapter four, "Sexing the Modern with Manet, Morimura, and Sam Taylor-Wood," moves more firmly into historical territory, taking two figures from Manet as the anchor, the barmaid from *A Bar at the Folies Bergeres*, and Victorine Meurent as she appears in *Mlle V . . . Dressed as an Espada*. The position Manet occupies at the beginning of radical modernism is problematized and sexed, while claims made for the universality of his art are re-examined in light of the sexed universal. Issues of sexuality, celebrity, and self-portraiture are further examined as the argument is taken forward into the contemporary through Sam Taylor-Wood and Morimura.

The fifth chapter, "Myth, Utopia, and the Non-Narratable Self," as the title suggests, foregrounds the question of myth in relation to history, first raised in chapter two but running through the book as a whole. Paul Gauguin's Tahitian odyssey is neither championed nor attacked, in an attempt to open the door to a two-way interpretation of cultural miscegenation, at least in principle. The sexed universal is used to suggest a postcolonial universal with which it is not coterminous. Color and beauty play around the discussion, extending the idea of "tone" into one of structure, not according to structuralism, but rather in attending to the blind spots or groundlessness. Lyne Lapointe and Jeremy Gilbert-Rolfe are the contemporaries through whose work some absences are activated.

Chapter six, "The Devil's Interval: Barbara Hepworth, Anish Kapoor, and Liz Larner," is slightly different in structure, in that after leading in through Brancusi, the artists Hepworth, Kapoor, and Larner—all sculptors—are treated as an intertext; the analysis moves back and forth between them. (The part of this introduction that immediately follows this summary of chapters refers directly to Hepworth's topology, and this is taken further through detailed analysis of artworks. I continue to seek a way of articulating the sexed universal through art that associates it with the located voice of a putative diasporic subject.)

Finally chapter seven tries to foreground the fundamentals of the argument in tension with political actuality. "A Valediction: Nationalism and Melancholia; Sex, War, and Modernism" takes as its starting point the destruction of the Bamyu Buddhas by the Taliban. A place for aesthetics in the world disorder of terrorism may be reaffirmed by understanding it as necessary not only to artistic, but also to social, meaning.

THROWING EGGS AT THE GLASS CEILING: THE CASE OF BARBARA HEPWORTH

As just indicated, I would like to say a little more about Hepworth here, since her story may serve as a kind of case study to illustrate a significant element in the historical problematic of bringing women and men artists into a structure

that does justice to both—perhaps the historical necessity of the sexed universal. Also, the year of writing this book coincided with the centenary of her birth, and a centenary is an opportunity, and perhaps a kind of reason, for reassessment. Hepworth lived from 1903 to 1975, moving from Yorkshire via London to Cornwall, now my home. I began studying her work because there was to be a fairly large conference on *Imagining Cornwall* and nobody was giving a paper about her. This was probably the starting point of *Sexed Universals in Contemporary Art.*

Somehow Hepworth's modernism does not look especially contemporary to many commentators, especially in Britain, and this at a time when modernism itself has been under considerable scrutiny. Indeed, it has been observed that her aspiration to a universal outlook in, through, and for art is thoroughly outmoded, so that her apparent lack of relevance has been associated precisely with her aspiration to a modern form of universality. This clarified for me a feeling that the absence of a concept of the sexed universal strengthens the "glass ceiling" in the critical evaluation of art by women. Women are seen as relevant primarily to women, and this association of the female with particularity works in a conceptual alliance with understanding universals as male—or even as neutral in sex terms—to maintain not only a sex hierarchy, but also a formal hierarchy. It is the cultural version of self-fulfilling fear in which the presence of those of lower status in a neighborhood brings the value of the real estate down.

Hepworth is undervalued for a whole nexus of reasons of different kinds, all associated at varying levels with her being a woman. This in itself is not the focus of my inquiry, though it clearly is part of it. The logic of the sexed universal does not lead to the argument that any particular work is essentially female. Even though the idea of the sexed universal incorporates sexual difference, and is even in one sense defined by it, it is not sexually divided at the macro level—it is only differentiated.

Objections have been raised to my claim that Hepworth is undervalued, which I have made at various times over the last few years.[11] She is both visible and invisible. Her name is internationally known, and it is frequently asserted that she is one of the major artists of her generation. But if you consult the bibliographies, look at the citations, read the histories of the period, and examine the records of international exhibitions and retrospectives, this claim is not borne out in convincing detail. The Hepworth retrospective of 1994, for example, toured the Yale Center for British Art, New Haven, the Art Gallery of Ontario, Toronto, and the Tate Gallery, Liverpool, U.K.[12] With all due respect to these institutions, this omits the major capitals in and through which the great reputations of European and Eurocentric art are sustained. Similarly, the Centenary Exhibition (17 May–14 September 2003) organised by the Tate and Yorkshire Sculpture Park will not be held in London. It will take place in St Ives and Yorkshire. These are neither inappropriate nor insignificant as venues, but again, Tate St Ives is not Tate Britain—or even Tate Modern.

The Tate Gallery in Britain has a very large collection of Hepworth's works, over seventy sculptures, and many drawings and other material. The ret-

rospective of 1994–5 was the first since 1968, a gap of over a quarter of a century, and it was not shown in London. This appears to indicate that there is international significance—and international significance. The recent book by Matthew Gale and Chris Stephens goes some way towards remedying the situation I am describing, and it makes available a sense of the development of her oeuvre over time that is long overdue. *Barbara Hepworth. Works in the Tate Gallery Collection and the Barbara Hepworth Museum, St Ives* (1998) is a detailed and thorough reassessment in light of new research on the artist. It is, however, more of a catalogue than a theorized interpretation, and the kind of conceptual undertaking for which I am arguing is outside its brief.

This lack of mainstream exposure is particularly deleterious for a maker of large sculptures. The version of Hepworth that predominates in circulation is highly selective, focusing on the work of the 1930s and some of the 1940s, photographed so as to emphasise its "unity" or serenity or some such. Direct carving is promoted as the quintessential Hepworth, and it is perfectly true that without looking at this practice, any observer or critic will miss major elements. But it is not all she did, and to treat her considerable body of work in metal and plaster as nearly beneath consideration produces a falsely unitary picture.

It is as if naming her is enough—she gets a mention, so she is recognized. But like femininity itself, the name is at least part masquerade, concealing as much as it reveals. In the current critical mode of using an artist's name to signify their wider cultural meanings, "Hepworth" is not the signifier of a major cultural force. Her name often appears in lists, with Henry Moore at the head.[13] Moore's work is discussed in the literature, and there is a great deal of writing about him.

The Finnish sculptor Laila Pullinen, who first saw Hepworth's works in 1955 in London, says, "When I first encountered the work of Hepworth and Brancusi, I felt an immense kind of relief." Yet she goes on to say, "Although I revere Hepworth for being the first to pierce her sculptures (i.e., to make a hole in them, making them even somehow more three-dimensional, or possibly even a kind of *écriture féminine* in 3D), I still think Henry Moore was the greater sculptor."[14] Despite this, to me there is a comparison to be made between Pullinen's own work and Hepworth's, one that is much harder to articulate for the complex of reasons being outlined.

Whatever the criterion, Moore is in the major league. He made a great deal of money as an artist, for example. In the 1970s, Henry Moore paid £1 million pounds per annum in income tax to the British Government, an indication that he was one of the richest men in the country at that time. During his life and in his will, he made many endowments, including the Institute that bears his name, The Henry Moore Institute for the Study of Sculpture, based in his home town of Leeds, U.K. This is the prime example, and it is not without irony that the HMI is headed by a Hepworth specialist and supports research into Hepworth. Moore's sculptures of family groups in particular are familiar to anyone even slightly interested in twentieth-century European art, and there is a sense in which he has become the gold standard of British sculpture of the

period. It is not at all clear to me that this gap in estimation is justified—which is not at all to denigrate Moore, who is clearly a major artist. Some kind of institutionalized presence is the kind of measure that signifies a major artist of the previous generation, whether or not it is the kind of measure that also might be taken to signify the true value that is so unfashionable at present. Many contemporary artists are market-wise super-stars, as is clear from the careers of the so-called YBAs, the Young British Artists, of whom Sam Taylor-Wood, discussed in chapter four, is one. It will be interesting to see how their careers develop from now, and I do not know how their success compares along male-female lines, regardless of criteria. Certainly, there are more men than women represented on their Web site, and the most prominent among them is a man (Damien Hirst). But this is not the place for a full evaluation of them as a group. Suffice it to say, an argument could already be made that makes the male YBAs just that little bit more prestigious than the females. As in business, the women make good vice-principals, excellent at the level just below the real CEO.

One further illustration of why I say that Hepworth is held at this level below a glass ceiling. On 10 January 2003, the exact centenary of her birth, there was no major arts television programme in Britain devoted to her work. The BBC radio programme *Woman's Hour* did, however, broadcast a short magazine item on Hepworth. Two eminent scholars spoke about her, and both of them expressed a very mixed view of the quality of her work. One even said that there was some work they would prefer not to have seen. (A senior member of the Tate Gallery agreed with this remark when I commented on it. I find this astounding.) Both discussants on the broadcast agreed that the work of the 1940s and the small pieces were really what counted. There was no attempt to assess what the legacy of this major artist might be, what specific mark she has left on the traditions within which she worked and to which she presumably contributed. One is always left with the sense that she was a net beneficiary of, rather than contributor to, her artistic milieu.

(My non-specialist friends who listened to the broadcast later on the Internet at my instigation, when informally consulted, said they were left with the impression that she was "all right, but not really all that good.")

My point is not that the oeuvre should be above criticism. It is that the work I have seen deserves the kind of sustained attention that seeks to understand the fundamentals of what it is about, and importantly, where it might have left its mark on culture. It is in both of these that cultural meanings are to be found, from Tracy Emin's bed to the most un-ironic directly carved classicism imaginable. I do not (necessarily) think that there is conspiracy to keep Hepworth or other women artists down (I keep an open mind), and even if there were, it would not be the real point, not here at least. (I am not that much of a Foucaultian, but I do think the problem is at least part discursive.)

British writing on Hepworth concerns itself with her relation to the art of the period, British modernism, the St Ives School—all of which are of course valid and important. But most critics do not pursue her relation to wider traditions of Westerns art—such as the European modernism she admired—with any

commitment, nor do they seek to elaborate fully the Hepworth legacy that might raise the stakes for "Hepworth."

Criticism in the United States may not run the same risk of limiting the work to national British concerns, but there is nevertheless insufficient to enthuse students about her relevance to current interests, or even to ask why she might be important to understand historically.[15] The 1997 Chicago show *From Blast to Pop*, for example, treats Hepworth seriously in her own right and beyond the local concerns of her immediate circle,[16] but unfortunately its historical structure stops at the 1960s. The catalogue essay, however, does refer to work in all media in the period it covers, and rather than compare her with Moore, who is also in the show, looks briefly at Robert Adams in light of her work.[17]

This overall situation, even as briefly outlined as it is here, is symptomatic: We do not have the critical understandings that enable us adequately to evaluate any art by women such as Hepworth as part of the major traditions to which they must contribute if they are to take their deserved place in symbolizing their cultures, whenever and wherever they might be. This may hardly seem to be news to feminist-informed analysis, but I think the reason it has not been followed through in relation to the mainstream is the absence of a large enough framework to accommodate the varying levels and kinds of differential, including the present conceptual terms, but also those of power and history.[18] And feminist analysis of Hepworth is not especially forthcoming, either. She was not a feminist, but then few artists before the 1960s could accurately be called feminist, and most were rightly wary of being seen as such, precisely because it is limiting. Her strenuous efforts to be "one of the boys" seemingly rendered her illegible in feminist terms.

This brings us back to the fact that Hepworth's language is that of universals. It may be useful, but in the end it is not enough to read "Hepworth" as symbolizing the female or as working in a sculptural equivalent of *écriture féminine*. Irigarayan understandings of the sexed dialogue in culture, the between-two, only go so far in providing a framework with real explanatory power. It is all sexes that have to approach symbolizing sex, each from their partially alike, partially differentiated positionings. In this light, Hepworth's quality as a major artist may well come into view.

The contemporary art scene is diverse enough, though it is much more so than it seems from what feels like the British media fixation with Saatchi satellites. Looking at artists of the previous generations can be impeded by a desire for innovation (of an obvious kind, perhaps, "revolution") as well as the Oedipality of which an obsession with innovation and/or revolution is probably a derivative. Hepworth's time is long. Her monumental art looks as right in wilderness settings as it does in urban environments. In this, and in what I see as her topology, she is becoming increasingly relevant.

An elliptical move might show what underlies this. The underlying question is whether in Hepworth's topology the ovoid is to the egg as the hole is to the cervix.[19] I will give the game away immediately and say that it is. But this is only possible if the relation is taken out of the geometric. Making a hole

through the stone is a clue, and Nietzsche is a prime witness. The move requires conceptualizing the present as the future in embryo, which runs counter to the pessimism of the last hundred years. That nihilistic view predominantly found a universe as aleatory as it was indifferent, in effect reducing the intensity of the Buddhist present to a diffuse striving. Or to sending Aphrodite into exile, as will emerge in later chapters. Hepworth's view, as seen through her work, is neither monotheistic nor atheist.[20] I am invoking Nietzsche neither as a straw opponent, to be knocked down, nor as Casaubon's "key to all mythologies" that for a time deceived George Eliot's heroine, Dorothea, in *Middlemarch*. I refer to him here because he has a taste for metaphorical eggs as strong as Lacan's for his occasional *hommelette*.

Nietzsche is thus not the only male to enjoy the unborn female cell as metaphoric food for thought more human than avian in association, and the reader who does not find Lacan's abject joke amusing might prefer to bear in mind Brancusi's bird-related sculptures, connoting origins, flight, and transformation.[21]

The mammalian egg is a more simple biological entity than the avian or reptilian. It is exclusively and internally female. If Hepworth's equivocation about being a "woman" sculptor once seemed outmoded, it can appear that she was before her time, knowing that the exclusively single-sexed has its limits and that embodiment is not a unitary matter. With her eye on the limitless, she and her successors call on the power of the fertile non-objective egg. How much genetic material might it share with Nietzsche's?

Gary Shapiro is to play Virgil to our Dante, but I shall keep making space for Beatrice as guide rather than muse. The relation between his text and mine is dialogic. The aim is to show how the concept shifts both interpretation and what is sayable. It is also to look closely at embodiment in a topological light. Shapiro focuses on voice as tone, as music; my focus is on voice as embodied language. But I want to listen to tone, and I shall pick it up again.

Alcyone. Nietzsche on Gifts, Noise and Women[22] takes its title from the mythological woman, Alcyone, who was turned into a bird (a kingfisher or halcyon), and though versions of the story and the name vary widely,[23] what counts here is that she is one of several bird figures in Nietzsche noted by Shapiro—the phoenix is another, which Shapiro calls auto-genetic rather than partheno-genetic. Shapiro alludes to *The Birth of Tragedy*, where into the Apollonian comes the Dionysiac, understood as excess. In this way, the "psalmodizing" Apollonian artist is challenged with knowledge he cannot contain and which interrogates what he (and his song) might mean. This is, he says, part of an attack on logocentrism (insofar as words are always prior to melody). "Excess revealed itself as Truth."[24] In this, Nietzsche aligns with Wagner's attack on the discursivity of opera.

The trouble with this is that, though a certain concept of truth is overthrown, the agents of that overthrow remain "superfluous by any measure" (in Shapiro's words). Moreover, women, as part of this overthrow, remain as excess and outside language. This is the position taken up by very many feminists. The

excess and the proscribed are embraced as the bringers of discord to the exclusionary system. But for me, this is neither a desirable nor a just location. I would prefer an understanding of language that did not place me, or any other subject, outside, not only for the sake of empowerment, but also for that of the language itself. Of course I am self-interested; but I am also engaged with Wittig's political semiology[25] and with the realities of language itself, as collective. As people can be deprived, language can be debased. Ultimately, linguistic impoverishment, too, is a social issue.

A few pages earlier in *Alcyone*, things look rather more promising. Shapiro establishes how in Nietzsche, although all languages are different, rather than being derived from one *Ursprache* to which they relate as variants of different closeness, the question of "what is given" (again, in Shapiro's words) in any language remains. There follows a brief discussion of the difficulties surrounding Heidegger's "*es gibt*." Those familiar with thinking about the position of women, including the sympathetic, if I may so put it, will immediately recognize one of the binds in which they are often caught: They cannot be the givers (subject) because they are the given (object of exchange). Shades of the Phallus. While I am aware that the "*es gibt*" is not the same as the given associated with the gift, the two givens are not separable. That is the direction towards which Shapiro's understanding of a giving beyond economies of exchange in Nietzsche moves. It seems hopeful in my terms, but as shadowy as Heidegger's "given."

I thoroughly concur with where Shapiro takes this, in using Alcyone's song as necessary to understanding Zarathustra, but it is still only a "tone." This is not much through which to challenge the universal humanity we now have begun to see as male—"a gender to which women will be admitted only by surrendering their own voices. Nietzsche's objections to this duplicitous universalism are well known, but we have only recently begun to discover that his writings can be read or played in such a way as to hear some of those tones as he transgresses so many mimetic canons."[26]

There is a structurally related difficulty to be found in the comparison Nietzsche makes between the conflicts of the Apollonian and the Dionysiac (a relation characterized more by conflict than by reconciliation, even of opposites) and the conflict between the sexes. In this, Apollo is clearly male, while Dionysus is more ambiguous.[27] The problem with this is the diminishing of the female—that Dionysus, while he may be ambiguous, is either male or androgynous. Even if we push the point and take him as always androgynous, we have in the engagement with Apollo the male versus the half-female. The odds are clearly loaded in favour of the male. In a definitional fight between the clear and the ambiguous, where one element of the ambiguous is shared by the clear, the remaining element is marginal indeed. Neither clear nor fully ambiguous, it is even less than the not-male of the binary sexed relation.

If this same structure of the androgyne is rotated through, say, about forty-five degrees, however (to lend my thoughts a scientific cast through measurement), we can see it in effect from the female point of view. The idea turns on the impossibility of the pregnant male body.

The sight of the pregnant belly can only be read as female. There is almost nothing in our culture that suggests any kind of semantic relation of the gravid with the male body—apart perhaps from natural history discoveries about sea horses, where the male acts as an incubator who eventually expels the maturing fry into their liquid world, an analogy for the complexities of mammalian intra-uterine development and birth-giving as poor in factual terms as it is in cultural weight and semantic value.

This is not about the meanings derived from or related to imagination, ideas, or science. Many men claim pregnancy as metaphor and even as fact—but not in their own bodies. It is the pregnant body (rather than the capacity to give birth) that gives the lie to the androgyne as an adequate figure for a new sexed understanding of culture, because though the androgyne should in the abstract be fertile, as soon as it actually becomes so, as an embodied event, it ceases to be androgynous.[28]

This leads me speculate on Socrates' prohibition in *The Republic* of mimesis of women, especially if they are ill, in labor, or in love—part of the "mimetic canons" transgressed by Nietzsche as referred to above. The hero should not imitate women at all ideally; Achilles will not lament. Though not directly stated, it would be coherent to think of all three of these particularly abhorred states as arising from perceived aspects of pregnancy. The pregnant woman is still basically conceptualized as ill in contemporary society, as many feminist studies of childbirth provision show, and this is entirely consistent with viewing females as flawed males. Pregnancy writes the flaw large on the belly, whose richness becomes mere distortion. Love is a weakness whose consequence is there for all to see, to be punished through labor.

Yet the tone Shapiro exhorts his readers to hear in Nietzsche is the halcyon tone. It is joy and stillness.

The ghost of pregnancy may well be there in the myth of Alcyone, in the peculiar significance of the nest, which is miraculous, floats on the water, and is shaped like a gourd. A detachable womb solves the problem of the pregnant androgyne.

The historical reason all this matters—what makes this reference to myth relevant rather than an evasion—is the aspiration of so many philosophical and artistic nineteenth-century males towards pregnancy. In one of Mallarmé's most elliptical poems, a sonnet of truncated lines, the dominant metaphor is that of writing as a billowing lace curtain, a silent mandolin, autogeny. It ends:

[. . .] vers quelque fenêtre
Selon nul ventre que le sien,
Filial on aurait pu naître.

[. . .] from some window
From this own belly only
Birth might have been.[29]

There is no body and no birth. In the translation, I have resorted to "this" to avoid sexing the absent body, or bodies, the "qui" of the poem ("chez qui du rêve se dore"). They are evoked through absence. But the absent is what constitutes poetry, according to Mallarmé. The curtain floats rather than buries, "Flotte plus qu'il ensevelit." The sleeping mandolin of the previous stanza introduces a melodic tone. The issue for me is how to activate it.

The question remains, then, is it therefore always a disembodied pregnancy? "By means of a learned joke about the elephant's period of gestation, Nietzsche reinforces [. . .] his presentation of himself as fecund and female ('the secret of my existence is that I am alive as my mother [. . .]')"[30] Perhaps inevitably the misogyny surfaces in postpartum disgust—the birth of his great work causes him to become weak, and furthermore he also associates his mother and sister—the females with whom he is contiguous—with unspeakable horror and abysmal thought.[31]

The sexed ambiguities and confusion of Nietzsche's texts, and of the stories to which they relate, are symptomatic of the impossibility and desirability to the (unreconstructed) male of the androgyne as human model. Examples could be multiplied, from Balzac to any number of Symbolist painters. It is the only way he can approach the female as he desires, by incorporation, and it does not work. His rage against women is his protest. Somewhere, he knows that he cannot know. This is what marks him as both the inheritor of Socrates and the end of that tradition of metaphysics. Or, to put it less portentously, it is what is makes him more interesting.

The female body is there and not there. It disappears because it cannot sustain the cultural weight. This is an impossibility that arises because it appears only as the particular, and therefore unable to sustain a structural role. Hepworth's ovoid does not stand in the same geometric or Platonic relation to the female as the hole, because it does not relate to the human egg as the hole relates to the human cervix. The cervix is a hole in the wall of the womb (the vagina, however, is not a hole). In this geometry, it can go no further.

A highly significant moment in Hepworth's career was when she carved through a piece of stone to the other side. Why was it such a big deal to pierce the stone? There has been some dispute about who did it first, but this is hardly the point. It is the overall logic of form that turns making a hole into a revelation, a new topology, that counts. Hepworth worked with the consequences of her discovery in way that nobody else did, and it matters greatly that she did so in the context of carving. This is not to associate the geometry itself with carving as such, but rather to say that carving was the technology then available whose process would be likely to reveal this geometry. (The digital is probably the contemporary equivalent in this sense). A sexed universal immediately requires a beyond and a process or movement through, equalized with its beginning, non-teleological. Hepworth demonstrates that transcendence is expansion and contraction at the same time. This is topological in that a relation is embodied that involves shape, but is not limited to it, and that therefore also embodies change related to a starting point, that may also change.

The point about the hollow and the surround is their mutuality. There is no hole without the substance and there is no substance without its internal reflection of space. They are not the same thing. But they are. They propose their relation; they do not negate each other. If the investigations of art over the last hundred years have done anything, they have led to the moment at which you step through the mirror, beyond opposition to relatedness. This relatedness is specific and sexed.

Piercing the stone impacts on everything Hepworth did from then on, whether or not it had holes and regardless of whether the structure directly suggested them. In fact, it was the new set of three-dimensional relations that mattered rather than the hole. Piercing the stone made accessible a continuous surface that altered how surface itself is conceptualized: The surface of a stone is only that part of it currently exposed. It is not a skin. The centre of the stone is the surface when there is a hole in the stone. For all the associations of Hepworth with landscape and nature, her stones are clearly worked: West Penwith is not scattered with naturally formed stones with holes in them.[32] Those you do find are on the whole spouts, or holes in the cliffs where the sea sprays through. Presumably there are none of these on the Yorkshire Moors of her childhood, either (West Yorkshire being landlocked).

There is a view that geometric abstraction goes in a direction other than biomorphic; that abstraction and Surrealism, while they both stand in oblique relation to some idea of perceptual reality, are somehow incompatible. Thus for example in the 1930s, any work of Hepworth's that is seen to approach, or be comparable with, Surrealism becomes a little puzzling, and more liable to be read primarily in terms of the influence of artists such as Giacometti, Moore, Arp, and others[33] than in terms of her very focussed abstraction. My aim is not to deny influence, which would be pointless, since no artist is beyond it; and even if it were possible to be so, such isolationism would hardy be a virtue. The issue concerns the nature of the abstract inquiry and where it leads historically.

One way of looking at what follows is as a probe into the challenges there have been over the twentieth century to the kind of abstraction that appears not to refer to the body—the biomorphic abstraction of the 1940s on, Lippard's "Eccentric Abstraction" show—and to review what it means. The predominant way of understanding what is being done is to differentiate between movements, groups, and allegiances on the basis of form. If you shift this basis to subjectivity, you still get differences of form, but the way they interrelate changes. What is more, because you are coming at form through the subject, you can take account of many differentials, including sex.

It is in this way that I relate Hepworth to contemporary art, especially to Kapoor and to Liz Larner. Larner is interested in the signifier-signified relationship at a fundamental stage. She opens up the "something before" that concerns the derivation of the signifier. It is the source-referent of the signifier I am talking about here, not that of the work, though "source" is understood as plural and non-ideal. Simply put, it's where the work comes from as well as where it is headed. This is a contiguous economy that "brings abstract speculation back to

the interchange between the real, the sign, and subjectivity, and to the materiality that goes beyond the physical."[34] In this place, the universal is sexed.

INTRODUCTORY ENDGAME

Two seemingly unrelated facts:

BBC Radio 3 is a channel devoted to classical music and serious programs about the arts. A recent edition of their regular arts review slot, *Nightwaves*, included a panel discussion about the Royal Academy exhibition in London, *Paris, City of Culture*.[35] A distinguished panel and audience debated whether Paris really was still the city of its essentially 1890s mythology: the hub of something someone called "world art." What struck me most about this discussion was the way the speakers had to skim over the issues this raised in relation to tradition—both in its narrow sense, and in the expanded sense in which I would use the word, to mean a complex mix of the inherited and the chosen among the connotative aspects of art. They speculated in a rather unsatisfactory way about how far this Parisian tradition was French. This idea of "Frenchness" was made up of a great deal that is contentious. It glossed over the difficulty the panel had with what constituted French art and what constituted world art, and this is the first of my two seemingly unrelated facts.

The second concerns two books published by the same publisher at about the same time. One is entitled *Contemporary Art*. The other is entitled *Contemporary Women's Art*. They are both very good examples of their kind. They both contain women artists. But neither contains an explanation—as far as I noticed by looking in the obvious places like the prefaces and introductions—of why there are two books or what determined whether a woman appeared in both. A sample of those women who do appear in both indicated that the entries were identical in both books.

But some women's work is especially significant in thinking about the two general kinds of issues I have just raised—the first in relation to Paris and concerning what used to be called the "cosmopolitan," and the second in relation to the parallel universes of contemporary art and contemporary women's art. They are of course deeply related.

To reverse the perspective, the relevance of these issues is very great when looking at what international women's art is doing in its aspiration to the universal, and trying to grasp its reach.

It is a context that includes the mainstream. This is not a question of seeking to establish a women's tradition, but rather of taking a sexed view, starting from a female view, of the mainstream tradition and see what it produces. This is already consistent with the notion of the sexed universal.

One recent approach to sexing artistic tradition involves talking about "spaces between." Others involve fluidity. I hope the book will show that neither approach will do in the long view. These models basically leave the mainstream tradition unchanged.

I have wanted to demonstrate this in relation to work by men in order to stress that sexing universals is not a matter of establishing an immovable divide,

but still more in order to begin the work of reshaping tradition that the assimilation of women's art and of "world art" to one paradigm implies. It will always be mobile and often perhaps messy. There is a level at which it is not about establishing a divide at all. And of course, it is also the case that several of the men who appear in this book were explicit in their inquiry into the universal. The task now is to come to an understanding of this element without reinstalling the unitary "Subjectivity" on which their work is thought to be founded.

The same basic argument underlies my intermedia approach. Since Hepworth and Larner are the artists to whom I have just referred, I will articulate how through sculpture. Since the 1960s at least, sculpture began to be perceived as operating in what Rosalind Krauss called "the expanded field"—when it is not clearly defined as a carved or constructed object in space. That was the time a separation occurred that set minimalism against modernism, and it was a separation deriving from the understanding of the status of the sculptural object.[36] What I mean here is that no such separation is possible within the signifying relations outlined through the differentiated universal. To explore the issue of what sculpture is within and through the form of the sculptural object cannot be abolished. It is an interesting fantasy, but it is impossible to realize. Through what she calls "working formalism through," Larner has burst through it to something else. I share Larner's surprise that the unexplored possibilities of the kinds of question that used to be called Formalist are not being more explored. Because they are some of the most fundamental to art, and in the end, they are the questions of meaning and insight into subjectivity that constitute the point of art—apart from pleasure.

It is the uniqueness of a work of art that is its justification—but it is its connection with the greater that is its value. Whatever it is that constitutes sexual difference—and that is a whole vast issue—is not constant, but it always exists and it is always connected with the greater. This is as true of the masculine as it is of the feminine. I have elsewhere called this a "constant relative." It is persists as a set of relations. But it has no essence.

CONTROL, CHAOS—AND AN AGE OF ANXIETY?

> [. . .] un art consacré aux fictions, sa virtualité.
> (an art consecrated to fictions, its virtuality.)
> —*Crise de vers*, Stéphane Mallarmé 1896

Interrogation of "grand narratives" has been necessary over the past twenty years or so, but it has resulted in some quarters in throwing the baby out with the bathwater. There has been an element of anxiety in Eurocentric culture ever since the "death of god" in the nineteenth century, and I would associate this with what was the predominant form of masculinity before it began to be dissociated

from it opposition to femininity. If surfaces in the prohibition of universals.

The "sexed universals" posited in this book are intended to contribute to opening a certain class of question that was important to artists in the past and in modernism, but that has become very difficult to access within the terms of radical and progressive critique. These questions around universality and sex might enable us to address

FIG. 1 Diana Thater *Dark Matter*, 2003. Installation: Two flat screen monitors, two DVDs, lights, colored lighting gel, window film, and existing architecture. Installation view part of *Transcendence is expansion and contraction at the same time*, Haunch of Venison Gallery, London, 2003. Copyright: Diana Thater, 2003.[37]

the wider issues of art within a socius that is no longer defined by the old certainties of stable identity and subjectivity, locale, the family, and the nation-state. There is (at least) one major difference between the position of this book and that of a hundred years ago, and it is to a significant degree affective. It is as if the nineteenth century's anxious male has, in a sense, been allowed to displace elements of that which would have been the truth, allowing no place for a subjectivity that is not defined by anxiety and/or loss.

"Universal" is a particularly strong term, with a history whose connotations would seem to be, to put it mildly, out of step with my project. Why resurrect such a term, in the teeth of all the debates that have consigned it to the dustbin. There are at least two reasons. One is that the concept of the universal is not a singular one, nor is it confined to one historical period or one culture. It is, well, close to universal. The odd half-century, such as the last, however fascinating and vital it appears to the human subjects, such as myself, whose thinking life coincides with it, is not enough to abolish it altogether. Another reason for the deployment of a term as strong as "universal" is that I want to invoke a concept that goes further than crossing binary divides, even though this is basic to the work I want to do—or, more importantly, that needs to be done. The sense of the universal that I think is required in art, and implicitly often by artists, does not only suggest an overlap between areas (such as might exist between binaries), or between the sexed. It has to be able both to recognize difference and similarity, and to do so in the same terms. This is possible if the uniqueness of individual beginnings is acknowledged at the same time as the convergence towards certain abstractions. Perhaps this is too condensed, but it should clarify in the course of this book because it is an idea that underpins the analysis of all the works, regardless of media, and that illuminates its reading of

19

abstraction in art. It suggests a temporalized, embodied commonality that is not fully ideal, nor yet fully concrete. It moves freely, but crucially not fluidly or without structure or trace, between the material and the immaterial. The residue of the process or trajectory inflects the universal. It is in this sense that it can be the same and different, qualified, yet universal. It is not subject to the bind of "the logic of the same." It is also non-determinist, and open to the kinds of innovation claimed by artists such as Barnett Newman, where each work is its own emotion.

The issue of universalizability arises with some urgency when considering sexed embodiment and experience in a multicultural frame. As Drucilla Cornell observes, "The equivalent meaning of our sexuate being has to be substantively filled in, in different ways, by every culture. This can be opposed to the positive universalism which has been an endless danger when feminists from the United States, or for that matter, Great Britain, or what used to be called Western Germany, get involved in the human rights dispute."[38]

The qualified universal is not the same as the currently popular term, the "global." In his book *Globalisation. The Human Consequences*, Zygmunt Bauman gives an account of the formation of the current politico-economic situation worldwide that runs from the old "universal" to the new "global." It situates the collapse of the two-super-powers structure of Russia versus America as the moment when the uncontrollable character of international economics became visible. This has clear effects on the political capabilities of the nation-state. It is not that the earlier conceptualization was essentially different or more manageable than it is now, but rather that an "uncomfortable perception of 'things getting out of hand' had been allowed to emerge in the gap left by the binary, conflictual model of the super-powers." It is a model that is familiar within the kinds of cultural analysis that align themselves with postmodernism.

One striking feature of this analysis is clear in Bauman's unequivocal summing up: "*no-one seems now to be in control*" (italics in the original).[39]

If the issue now is the loss of the *appearance* or *ideology* of control, it is an appearance that is not constant. It looks rather different from the point of view of those not previously invested in the structures that produce this kind of power. Loss of control produces anxiety in those who subscribe to its ideology. These may be the controllers or the controlled.

But loss of control may also be an opportunity. Chaos is a risk attached to the loss of control, not a necessary consequence of it.

There is another way of understanding what is here being characterized as dissolution and unease. It is that a false perception has yielded to that which is as yet only partially understood. Bauman's analysis is significantly different from Noreena Herz's in *The Silent Takeover*. The point is not that in Herz there is a miraculous freedom from anxiety—far from it—but rather that her intellectual

framework does not depend on it. The global in Herz's sense does not maintain the "conflictual model of the super-powers," and therefore it does not situate itself in one of the currently fashionable gaps. Rather she recognises that "regaining" a control that was illusory in the first place is not the best move.

Interestingly, it was at the time of the rise of modernism in the mid to late nineteenth century that "scientific" studies of hysteria began, involving practices that now look exploitative and prurient. As opposed to the manly character of "virtu," women were seen as prone to the disturbances of the womb, named hysteria. As Tom Laqueur and some lesbian historians have shown, for example, the medical view of female sexuality in history has been variable, yet we do seem to be fixated on this attribution of hysterics to women. Many feminist critics have adopted the "hysterical" voice in a strategy of re-appropriation. I can appreciate the advantages of this, certainly at a specific historical moment. A difficulty that arises for me is one that is hardly startling in its originality, but is no less recalcitrant for that: It is not clear how the hysterical voice can address the "voice of reason" that predominates as characterising the male, nor is it clear how these voices can possibly be open to change. That is to say, it risks continuing to essentialize rationality as male and its opposite as female. It is as if while men were having "an age of anxiety," women were having private hysterics. An age of anxiety is not necessarily out of control, while a hysteric is.

Herz and Bauman, however, may be used to exemplify a change—with apologies to Bauman, who is being reduced to a rhetorical device, a textual messenger. It is the old male who is out of control, at least in the sense of no longer in control, and among some of the more extreme, exaggerated manifestations among the young urban underclasses and the religious fundamentalists, quite disastrously.

I am suggesting that this may not be fundamentally any different from the situation symptomized by Charcot, and then Freud, and later still, Lacan. What has changed is the continued emergence of the female voice, allied with the feminised "racial" voice, if I may so put it.

These differentiated voices may well find positives in the new situation, in that the realisation of the lack of control comes closer to the actuality of the impersonal forces to which humanity has always been subject, but which the modern dominating shout has projected on to its others for about half a millennium. This is not to posit a laissez-faire, pro-globalization theory, but rather to suggest that the models of summation or collectivity (totality, the global, the universal) have not been adequate. It would be easy to mis-recognize the kinds of social responsibility towards which Herz's argument moves as a return to an old Left agenda. It is not. Where it traverses that agenda, it allows for a reframing of certain of its more positive—and, yes, less controlling—values and conceptualizations. Its implicit model is one of an interdependency that recognises differentials (of location, development, social aims).

Very few radical critics of art have been able to begin or maintain the work of elaborating a credible account of the crucial nexus around representation and the social. Those that have addressed the issues remain, on the whole, the inheritors of a left-leaning analysis that strains valiantly within a systemization of class that cannot hold for much longer. Theresa de Lauretis and Teresa Brennan are inspiring exceptions to this, and so, in a different but related field, is Drucilla Cornell.

My summing-up, therefore, unlike Bauman's, would not focus on the absence of control, but rather on the need to generate an intellectual structure that can illuminate, and operate or intervene within, the new order. I am well aware of the ambitiousness of addressing such a need, and this book does not aspire to anything so grand. It is rather an attempt to view the issues from the point of view that is almost always a major—if not *the*—weak point of any analysis that takes on "the human" as a generality: the female.

If I do not map the politico-economic alluded to above directly or simply on to the cultural, no more do I map the female directly or simply on to women. The word "gender" appears rarely in the following pages, and "feminine" and "masculine" only as pertaining to an obsolescent ideology that fails to take account of the absented or disavowed female (femininity may be more about masculinity than about women). Insistence on a sex-related yet non-essentialized, non-biologically determined understanding of subjectivity is consistent with the qualified universality that is proposed. But that subjectivity may be less unstable than that dreamt in postmodern philosophy. The same applies to meaning.

Crucial to this reformulation is the role of representation and identification in the constitution of human subjectivity, together with the related structures of identification and projection in art. There are areas within these somatic functions that are common to all subjects, but that diverge according to developmental pathways. The notion of the sexed universal is intended to address these, not as a fixed, absolute, or teleological point, but as a nexus with a flexible structure—capable of a certain degree of shift, ebb, and flow and so forth, but a structure, nonetheless.

This is implicit in much of the application of psychoanalytic concepts current in cultural theory, although overwhelmingly, any thing that smacks of "universalizing" is strenuously avoided.[40] I find this difficult, in that it installs the kind of impossibility symptomized by slippage so characteristic of certain parts of Lacanian thinking and its cognates and derivatives. I owe a certain debt to Lacanian thought, but no "allegiance."

I use the word "differential" in relation to the structures involved, rather than "dissymmetry," a term deployed by Mieke Bal to express what is in many respects a closely related view to mine in this book, and I acknowledge how much I have learnt from her in thinking my ideas through. Bal is right about

the interpretation of art as related to both fantasy and the social, and in her location of sexual differences in interpretation at this juncture. Recognition of the instability of this difference, according to which aspects of psychic engagement are activated within the image or cultural artefact, is also an important convergence between us. Together with her equalizing of word and image, her deployment of a semiotic understanding of culture, and her aim of holding open the potential for positive female understandings in text hitherto regarded as misogynist, this makes for strong similarities.

I remain less sure about any pre- and post-Oedipal division in Subjectivity, and open to considering ways in which the encounter with the artwork is marked. Contrary to what appears to be Irigaray's recent position, I do not think that the psyche is a blank screen any more than the work is.[41]

This book is intended as a part of the same overall project engaged by those critics, still predominantly female, who recognize the illusions and instabilities that inhere in the sexed relation between art and the social, yet still insist on its importance. It is a relation that exists regardless of form, style, school, or genre, or any category I might prefer to avoid, but that is more resistant to understanding in some than in others: The screen of the non-representational is perhaps the most difficult. Or the most obviously difficult. The aim is not to tame or explain this away. There will always be a moment when art escapes, and I celebrate that.

In addressing the contemporary, and hopefully the future, certain issues from the past are hard to avoid, however much one might sometimes dream of starting afresh, or announce the "end" (of history, art history, sexism . . .). This is the more so, given the Oedipal fantasies of revolutionary change that dogged the last century. The work of change is actually much slower, messy in a different way, but less violent.

The character and utility of a concept of universality is one such issue. I have mentioned before that I view the pan-European movement that was "Symbolism" as continuous with the modernism of which Manet is generally regarded as having done most to inaugurate. Manet's summarizing moves through European painting were re-enacted in a much shorter time-frame by Gauguin and within many of the movements bridged by him. Picasso did something not fundamentally dissimilar, if more abridged, and there may be a sense in which many artists since the Surrealist element became sidelined have, as it were, moved through what looks like Surrealism in their early work—think of Hesse, Pollock, Newman. Artists did not do this before modernism, and criticism was much less about the self before the invention of the Freudian unconscious. (Remember Lacan's formative association with Surrealism). It was a consistent inquiry into the nature and potential of signification that involved the semiotic body itself because it was a massive re-evaluation of what had been

"universal." To allow myself a moment of wild optimism, on the pretext of needing to be brief, Engels wrote of the world-historical defeat of women. Perhaps he was seeing their world-historical return.

The early part of this book must therefore also begin with early modernism, in order to set out the ground for understanding the contemporary. It was a time of revolutions, let us say, inaugurated by 1779 as the first real chink in European aristocratic and hegemonic armour, and followed by what can look like two centuries of successive wars as the colonised inexorably fought back, at home and abroad. In this sense, the fiction of cultural beginnings is more defensible as a way of reading what happened, as a specific phenomenon, and of interpreting what it might have meant. It is also the beginning of modern feminism, whose only possible forerunner was in the medieval "querelle des femmes," ended as surely by the extraordinary upheaval of the European Renaissance as was the prosperity of the colonized world's old traditions. At a time when it is being argued that there is need of new forms of empire, cultural "stakeholders" (with an awareness of all the ambiguities and baggage of "stake") might wish to ponder the emptiness of their rooms and of the contemporary notion of art. Those like myself who know its power, not because they claim superior sensibility, but because they have been changed by it, must surely want to examine with some urgency the vacancy left for colonization by capital by the abolition of "universals," "grand narratives," "collectivities," or even society (as in British Prime Minister Margaret Thatcher's notorious claim, that society did not exist).

The new became the subject of art rather than tradition. It is now difficult to appreciate fully what this must have meant, it has become such an unchallenged assumption—and hollow claim. For some, it seems hard to conceptualize the contemporary in any other terms. Shock, overthrow, innovation, originality, challenge, affront—no matter how often the bourgeois have been "épaté" before.

The task now is perhaps how to get aspects of culture to "talk to" one another, both in the regular way and in the manner of the digital interface.

Notes to chapter 1

1. Interview with Cindy Nemser, quoted in Bill Barrette *Eva Hesse. Sculpture. A Catalogue Raisonné* New York, Timken, 1989: 11.
2. *Yielding Gender: Feminism, Deconstruction and the History of Philosophy* NY/London, Routledge, 1997: 196.
3. *Why War?* Oxford/Cambridge, Mass., Blackwells, 1993: 74
4. In response to a question about her film *Naked Spaces–Living is Round* (1985), in which the questioner, Harriet Hirshorn, said that "the soundtracks tended toward the universal: i.e. about human nature, approaches to living, and theories of creation, yet the images in the film focused on women." Trinh T. Minh-Ha *Framer Framed*, NY/London, Routledge, 1992: 185.

5. Hodge is commenting specifically on Heidegger's discussion of "transcendence." Her later remarks on a shift in Heidegger from metaphysics as reductive to metaphysics as "as a marker of a transition out of distorted thinking" is also resonant in this context. Joanna Hodge *Heidegger and Ethics* NY/London, Routledge, 1995: 73, 76.

6. Patricia Huntington *Ecstatic Subjects, Utopia and Recognition*, Albany, SUNY Press, 1998: xxix.

7. Penelope Deutscher, 36–7.

8. Joanna Hodge, 1995: 47.

9. See, for example, *Beyond Accommodation. Ethical Feminism, Deconstruction and the Law*, NY/London, Routledge, 1991: 195. Cornell acknowledges an unpublished MS by Michael Waltzer, *Two Kinds of Universalism* of 1989, which I have not seen. It is her broad approach rather than the specific term that is significant in the genesis of the sexed universal as I understand it so far.

10. Huntington 272.

11. See my article "Barbara Hepworth: the Odd Man Out" in Thistlewood (ed.) *Barbara Hepworth Reconsidered*, Liverpool, Liverpool University Press/Tate Gallery, 1995: 23–42. I have also made several conference presentations that touch on this, and they have always aroused protests that Hepworth is recognized as a world-class artist.

12. Organized by the Tate Liverpool and the AGO. Catalogue with essays by Penelope Curtis and Alan Wilkinson. Hepworth's first retrospective was in Leeds, UK, 1943; the second in 1951, in nearby Wakefield, where she was born; the third, and first in London, was in 1954; and finally, the major retrospective of 1968 at the Tate Gallery, London. The 1994 exhibition was thus the first major show for over a quarter of a century. It was a revelation and the beginning of my own deeper interest in the artist. A new catalogue of her work in the Tate's substantial collection finally appeared in 1998 (London, Tate Gallery. Details on page 9).

13. See the above article.

14. Written response to written questions from myself, February 2003. Translated by Jean Ramsay. Thanks also to him for coordinating our correspondence. I did not mention Moore in my list of questions. I asked "Do you know the work of the following artists well, and if so, what would you say about it? Constantin Brancusi, Barbara Hepworth, Anish Kapoor, Liz Larner."

15. See for example Emma E. Roberts "Hepworth Speculatively Perceived in an International Context" in David Thistlewood (ed.) *Barbara Hepworth Reconsidered*, Liverpool, Liverpool University Press/Tate Gallery, 1995: 185–200. Roberts experimentally relates Hepworth to Rothko. This could perhaps be followed through by relating both to Hesse's work, given her early career as a painter, and her relation to Pollock and Abstract Expressionism.

16. It may be that Stokes, Read, and the rest also deserve consideration in a wider artistic frame of reference, but that would be another book.

17. Chicago University Press, 1997: 72–77.

18. I am not calling feminism narrow, very far from it. Feminism has had to work with the tools available, and they decrease in appropriateness as scale increases.

19. One hope here is to exorcise the literality and unproductiveness of a common association of Hepworth with eggs. This began with Sven Berlin's satirical "roman à clef" *The Dark Monarch*, in which the Gabo figure accuses the Hepworth figure of stealing "ze egg" and persists to the present. For example, in the 1998 Hayward show, Anish

Kapoor included several works that referred formally to Barbara Hepworth. This element of the show passed with very little critical comment and no analysis, other than the usual reference to eggs—that is, the only way in which reference to Hepworth was marked related to the ovoid. See chapter 6 for a discussion of Kapoor and Hepworth.

20. She was actually a Christian Scientist, though I have not gone into this in any detail, beginning as I do with the work. How relevant it is may emerge when her papers are fully in the public domain, which they are not yet. When they are, they will require very careful interpretation; what is currently available bears the marks of careful strategy. Not for her the luxury of Richter's dismissal of strategy: "It goes without knowledge. One day I'm ready and that's that." (Speaking to camera in the *South Bank Show*, ITV Channel 3 in 2003, a programme devoted to his 2002 retrospective at MOMA, *40 Years of Painting.*)

21. See also chapter 6.

22. Gary Shapiro *Alcyone. Nietzsche on Gifts, Noise and Women*, Albany, SUNY Press, 1991.

23. Robert E. Bell, for example, notes that "there are many versions of the Alcyone/Ceyx story, and it is easy enough to get confused." *Women of Classical Mythology*, Oxford, Oxford University Press, 1991: 24. Bell lists four different figures, sources ranging through Ovid, Plutarch, Homer, Apollodorus, etc. Graves has still more in his *The Greek Myths* (Penguin 1955) Folio Society 1996.

24. *The Birth of Tragedy*, 4;1, 40–41.

25. See chapter 2.

26. Shapiro 10.

27. See Shapiro "On Presents and Presence," esp. 32.

28. In effect, it has to refer back to the fairly common mythological stories of "origins," in which the primordial human was both male and female, split for in what seems to me to be no good reason in particular. The earliest versions of the story tell of a split into three, but since Aristotle, those in circulation only allow two; so, the one half becomes fated for ever more to seek its other. So desire is always already based on lack.

29. *Une dentelle s'abolit* c.1887 (my translation).

30. Shapiro 127.

31. Shapiro 136 and 139.

32. There is in Penwith a Neolithic site called the Men an Tol which consists of three stones, one upright and one with a large hole in it. It is about six miles from St Ives. Hepworth certainly knew it because it appears in the 1953 film by Dudley Shaw Ashton, *Figures in a Landscape: Cornwall and the Sculpture of Barbara Hepworth*.

33. See Curtis and Wilkinson, 54ff. One of the strengths of Briony Fer's *On Abstract Art* (New Haven/London: Yale University Press, 1997) is its move beyond this division. It is all the more regrettable that Hepworth does not appear in her book.

34. Which is what I said in an article "Touching Gender: The Word, the Image and the Tactile. Barbara Hepworth's Stereognostic Sculpture," in Heusser, Hannoosh, Schoell-Glass, and Scott (eds.) *Text and Visuality*, Amsterdam/Atlanta GA, Rodopi, 1999: 281

35. BBC Radio 3 *Nightwaves* 24 Jan 2002 9.30–10.15

36. For a useful outline, see, for example, Williams *After Modern Sculpture*, Manchester, Manchester University Press, 2000.

37. See above, page 15 on Hepworth and the catalogue to Thater's show (London, Haunch of Venison, 2003). The words "Transcendence is expansion and contraction at the same time" are from one of my lectures, as she says, and Thater's transposition of them is both exact and an amplification; she makes the idea her own, as she does an architectural space. The way in which her installations relate to architectural space resonates with Kapoor—see chapter 6, especially page 151. Thater, Kapoor, and Hepworth evoke the material intimacy of this "void-ness" through varying processes and media—light, PVC, and stone.
38. "Toward the Domain of Freedom. Interview with Penny Florence" in Cynthia Willett (ed.) *Theorizing Multiculturalism*, Malden, Mass/Oxford, Blackwells, 1998: 221.
39. Bauman, 59.
40. Alison Assiter's *Enlightened Women*, NY/London, Routledge, 1996 is a clear defence of the modernism that much postmodernism denies, and a critique of aspects of the work of major figures such as Butler, Irigaray, Derrida. See especially chapters 1 and 7 on "universalism."
41. As articulated, for example, in her address at the International Association for Philosophy and Literature in Rotterdam, 2002.

on universals, myth, and morphogenesis

The question underlying this chapter is this: Can we reformulate understandings of the universality of art on a principle of inclusivity? There is a kind of absurdity in the notion that the universal should not be inclusive—that which is universal must surely be all-embracing. But this is not so in practice. Only a select group is thought to be able to access it. Furthermore, it might seem that the universal must be fixed. The universal must be eternal. But why? It would only be eternal if the universe were static. Few would now claim this to be the case. If a concept is to be applicable to everyone, and if it exists within a dynamic, then it must be subject to change. The question that now arises is this: Is the universal an invariant?

PART I: UNIVERSALS AND INVARIANCE
Monique Wittig seemed to think that universality and invariance were linked in her (in)famous attack *The Straight Mind*.[1]

I am going to suggest that the universal is not an invariant. But universals might well be *sui generis*.[2] This is interesting because it affords a way out of the disembodiment generally taken to characterize "the universal" as a singular.

Wittig's essay is an attack on structuralism and Lacanian psychoanalysis. Let me be very plain. This chapter is not a defence of either—or indeed of anything else, including Wittig. "An anthropologist might say that we have to wait for fifty years," she said, about twenty-five years ago. Allowing for the acceleration of change of which computers are an indispensable part, perhaps the time has come. Wait fifty years for what? To be able to discern the "invariants" of the new? Wittig recognizes the historical location of what she has to say, for between the main lines of her principal argument is the sense that we have to live our way into the new. Her position seems to be sufficiently open to suggest that it is not necessarily that there is no such thing as a universal, or that this term, even if notional only, has no utility. It is rather the appropriation of the idea of universality to one view. It is the rendering exclusive of universality, whereas it must surely be, by definition, inclusive.

There is another reason for starting this part with Wittig. It is that *The Straight Mind* is a polemic calling for the breaking of "the heterosexual contract." Let me be plain again. This book, unlike Wittig's short article, is not a polemic, nor does it call for, or suggest, a turning away from any kind of sexuality, individual or collective. The reason for looking to her words is that she was right in locating sex as a necessary site for intervention, especially into ways of thinking that lay claim to universality. In this, she is unusual.

It may seem in some light that the idea of a sexed universal heralds a debased and uncertain understanding of the universal, but this is not so. It restores to the universal its universality. It is only the contingent that can arrogate to itself the right to closure on such a concept. How can the concept of the universal have a limit? Only by its misapplication to the specific without return to the universal from whence it came. If you begin at the universal in thinking about a phenomenon, but then stay with the specific manifestation of the universal in that phenomenon, you will cease to think about the universal.

Wittig urges that "[W]e must produce a political transformation of the key concepts, that is of the concepts that are strategic for us." The universal and its relation to the political Subject is one such concept.

My understanding of Wittig's argument in 1978 is that she accepted that there was work to be done, there were lives to be lived, before we could begin to think directly about universals once again. My present gamble is that enough of that work has now been done for us at least to begin to do so. More, the political economy of globalism makes it urgent that the "political semiology" she calls for is used to present genuinely different economies, not the oppositional scenarios that produce the "economy of the same" in Irigaray's terms.

To think the universal may be without limits, but it also installs the humbling fact that final answers are out of the question. Any "proofs" are provisional. Definitions are equally out of reach. As Adriana Cavarero says, "[. . .] philosophers quickly and peacefully determine what it is about universal Man that should be questioned regarding 'reality', and they then proceed to the answer by means of a definition."[3] This definition, she goes on to say, is not the problem, but rather a game.

Readers of Cavarero might be asking themselves at this point why a book about universals, sexed or otherwise, should be adducing as support a thinker who concentrates on the uniqueness of the self. If the definition of Man is not the problem, then what is? Cavarero's answer is that it is in the concept of Man him/itself. "'Man' is a universal that applies to everyone precisely because it is no one. It disincarnates itself from the living singularity of each one, while claiming to substantiate it. It is at once masculine and neuter, a hybrid creature generated by a thought, a fantastic universal produced by the mind. It is invisible and intangible, while nevertheless declaring itself to be the only thing 'sayable' in true discourse. It lives on its noetic status,[4] even though it never leaves behind any life-story, and impedes language with the many philosophic progeny of its abstract conception."[5] Perhaps most succinctly, she says, "In the sentence, 'I, Man,' it is the reality of the 'I' that dies."[6] In this book, an equivalent aphorism might be something like, "In the phrase, 'I, Man,' it has been the story of Woman that died." But I hesitate, both before the notion of "the reality of the I" and that of "the story of Woman."

At the same time, the opposite to Cavarero's assertion about the "I" could not apply—in the phrase, 'I, Woman,' it could not have been the story, or putting into discourse, of Man that died. This asymmetry underlies many of the pathways tracked in the pages that follow. Their aim is not primarily to analyze how stories have died, though some of this is inevitable. It is rather to contribute to outlining structures whereby no other narration would be sentenced to death.

The task of this book is to move towards understandings where universals might be recognized in and through their specific applications, defined not by exclusion and purity, but rather by breadth of relevance. The movement of abstraction is from the bottom up, if you like, rather than top-down. Or even more, the conceptualization is non-objective, pertaining not to representation at all (which still hovers around the notion of abstraction, or its process). This matters more than it may seem. You may have noticed that "story" was substituted for "reality" in my rewriting of Caveraro's words. The universals under discussion here do not presuppose higher reality, Platonic ideals, or detachment from lived experience. Like Cavarero, I want to work towards an ending of the "deadly alternative between abstract Man and concrete uniqueness."[7]

The problem I want to address is not how to define the universal, nor how to "know" it in its perfection, drained of embodiment, life and—I would add—sex. The universals of this book are embodied, imperfect, and not without their relation to the unique. The universal Cavarero opposes is like Gradgrind's horse in Dickens's *Hard Times*—a string of abstract nouns. Heaven help the child who tried to ride it.

But then also, the child without a sense of horse-ness (I am tempted to say, horse sense) is in trouble. In saying this, I hope I am duly attuned to the issues about discursiveness that are implied in this elementary example of psycho-linguistics. I want therefore to pay close attention to the following two sentences from *Relating Narratives*, in order to introduce a number of interventions that the sexed universal allows.

> The discourse on the universal, with its love of the abstract and its definitory logic, is always a matter for men only. The scission between universality and uniqueness, between philosophy and narration, signals from the beginning a masculine tragedy.[8]

Yes—and no. There is clearly a sense in which this is true. It might seem to do very well as a description of my starting point in writing this book. But there are (at least) two problems that arise.[9] The first is that without establishing some relation to this discourse on the universal, women as exemplars of the subaltern will always be confined to the particular. Cavarero takes this forward precisely into an *identification* with the particular, with the "delightfully feminine," and associated with "the fragile, the little and the vulnerable," a particular that "[. . .]

enjoys being such, and does not aspire to transcend itself." Here I would not go. This is limited and dangerous ground.

And yet. Among the qualities or gifts of Aphrodite, the goddess invoked as the mythological figure of the feminine, there used to be an intensity of the immediate and every-day that effected something close to a transformation of the everyday, an effect that now tends to be understood as a kind of "transcendence." But the investment of the here and now with what used to be the "beyond" leads to the kind of secular expansion of ethical understanding that is consistent with the structure of the sexed universal in relation to the particular.

Mallarmé's poetry effects this kind of transformation. In many of his late sonnets, he starts from some banal object or event—a vase, a drop of water, a lace curtain—and seamlessly leads the reader into the universal, often symbolized by the stars.

> Elle, défunte nue en le miroir, encor
> Que, dans l'oubli fermé par le cadre, se fixe
> De scintillations sitôt le septuor
>
> She, naked, dead in the mirror, yet
> There, closed in oblivion by the frame, forms
> The seven starred glitter of the Great Bear[10]

The trouble is that the poem is deadly. Mallarmé's feminine is hardly a fate to which one might aspire, particularly as the poem hints at a deadly rape. But there is a challenge for the reinvention of the female in his vertiginous and telescopic moves from the details of an empty room to the details of the actual universe, a constellation. The focus on the material world is intense, and if it takes the reader on to another plane in and through materiality, this is not the same as the transcendence of either the sublime or the religious. The rhythm of the poem, like that of *L'après-midi d'un faune*, is that of breathing, expansion, and contraction.

The second of the problems that arise out of the passage from Caveraro concerns the particular through which she articulates her understanding of the universal as male. It is the story of Oedipus. His tragedy is located as that of one who cannot know himself as an "existent." Apart from the fact that Oedipus's inability to know himself arises out of his not knowing his *mother*, which is surely a universal in the present time, it seems to me precisely to locate a universal problem for the female in discourse; it is the disjunction between the experiential and the discursive that is problematic for many living women. Thus this aspect of Oedipus's tragedy is, in the present, overwhelmingly *female*. The unfortunate blurring of the linguistic juncture between materiality and the lived self does not have to degenerate into an issue about the sex of the tragedy, how-

ever, and this is an important point about how any idea of sexing universals must be deployed to be of any use. The issue does not concern assigning to one sex or the other definitional attributes.

I mentioned at the beginning of this chapter that the universal might be *sui generis*. This is an idea borrowed from the British philosopher Bertrand Russell. Russell's idea seems to have concerned facts in relation to atomism,[11] and this raises a number of issues I want to signal, even if they are beyond the scope or intention of the present study. If Wittgenstein gave up on atomism because the problems around the independence of the atomic fact were insuperable, the difference between him and Russell turns on the status of the general. Wittgenstein's sense of the atomic fact could not account either for contradiction or for the fact of inclusivity (that the enumeration of all facts is a fact, but not a basic atomic fact).

Atomism has a fascinating history, but far too large to tackle here. For now, I want simply to note its relation to other philosophical traces. Epicurus is perhaps its most influential exponent, and it was through his works that the Renaissance rediscovered it and passed down into seventeenth century "corpuscular philosophy." It relates to the molar philosophy of Deleuze and Guattari so influential at this present time, perhaps through the currency of a certain reading of Spinoza, if I may speculate in this way.[12] If I avoid Deleuzian terms, it is because I find them highly problematic in precisely my two principal areas of inquiry: sex and the universal.[13]

It seems to me that if the universe is both a mental and physical totality (as in Spinoza) then it is both inclusive and sexed. What would the sexes be, other than aspects of the same physicality, both of each other, but in their particularity not necessarily sufficiently definable in relation to each other—and certainly not in opposition to each other? But this idea must be taken further if it is to be productive, because it seems to me that in the social and historical field, there most certainly *is* a relation. It is not simply "fluid."

If the variety of current styles of postmodernism is inimical to the idea of universals, this is countered somewhat by the phenomenological turn. Both currents run through feminism, although I think perhaps what feminists particularly seek in phenomenology is a perceptual epistemology. "Eidetic intuition," by which the perception of something is also knowledge of its universal, has the attraction of directness, as does the phenomenological account of consciousness. This is appealing when one is trying to break down barriers. But the trouble is its idealism. The sexed universals under discussion do not lead back to here.

When, later in this book, I come to discuss Anish Kapoor, the philosophy of India comes into the picture, and it would be easy enough to bring in the Kabbala and Taoism through the artists of the nineteenth century.

If I have picked out various problems with the thinking to which I owe so much, and if I have begun to refer to an alarming array of philosophical traditions,

it is because there still remains the one overriding problem. They are always inadequate on sex, partly because even the most egalitarian of the philosophies of the past that have come down to us in writing and in images that re-import hierarchies in relation to women—if they bother with "the sex" at all. It seems that sex and universals, which must surely stand in some relationship, are oil and water in contemporary thought.

Kapoor's latest work installed at Tate Modern in London invokes the myth of Marsyas. I shall look into this more closely later in the book. Cavarero, too, has recourse to myth, and so do several of the artists in this study. There is nothing unusual in that. But myth is generally understood as a discourse of "the universal." As such, it is suspect in the current critical climate. This necessitates some thought in the context of my argument here.

PART II: MYTH AND MORPHOGENESIS

As Mieke Bal points out in *Reading Rembrandt*, discussion of myth leads immediately to the universal, as "the eternal, the true, the similar, the imitative." She rightly asks, "What does it mean for a culture to assume that stories are always available—permanent essences—ready to be taken up again and again?" She interrogates the kind of interest in myth that derives from a "persistence of romanticism and conservatism occasioned by the fear of history."[14] Bauman's spectre of anxiety is conjured.

I thoroughly agree with her in that the inquiry into myth in this book does not define it as a source of stories with different versions, or essentially a stable repertoire of fixed and "universal" meanings. It is rather Wittig's "political transformation of the key concepts" as part of the wider transformation to which Bal is a major contributor. It seeks to explore artistic engagement with myth as critical in Cornell's terms, and, with reservations, in those of Irigaray, rather than as either naïve or conservative.[15]

> [. . .] the "universals" expressed in myth are not and cannot be just the mere repetition of the same. Indeed, the "universal," the symbol of the "killing mother" cannot be known except as it is told in context. The "universal" in myth, in other words, is much closer to what Michael Walzer has called "reiterative universalism." The "universal" is only as it is told in difference.
>
> —Drucilla Cornell[16]

> "[. . .] the relation between a mythical unit and its so-called versions is not simply a relation of interpretation, but a relation of transference."
>
> —Mieke Bal[17]

In an article entitled *The Daughter's Patricide*, I asked what meanings might cluster around a structural absence in myth. I was thinking about sexed asymmetry: the fact that "reversal fictions" usually cannot work (unless through humor) because sex roles are not reversible. Making the hero a woman is unconvincing without other significant changes to a narrative. Indeed, the role of hero has developed as structurally male. This is not to say it must remain so, but rather to note that it is our historical starting point. It is not possible to change tradition by an act of will. As in the old British joke about asking someone for directions to a certain place, my thought turned into the obstructionist reply: "Well, now, if I wanted to go there, I wouldn't start from here."

Like many other scholars, the "here" of my starting point was the ubiquity of the Oedipus myth. It quickly faded into a secondary position in the analysis, and indeed I found myself somewhere else. I realized very soon that daughters almost never kill fathers,[18] certainly not in the myths whose currency is sustained through reiteration. The transformations within myth, and the internecine violence that characterizes them, moves through all other relations, but violence in one *relationship* is confined to a one-way traffic from a clear dominant (fathers/kings) to a clear subordinate (daughters/subjects), who can never win: Daughters are the most passive and empty signifiers. This seemed to signify a sexually specific gap in the structure of relations. Not only that, but it is a gap that occurs at a crucial point in two important respects: one concerning power (the male as father-king), and the other concerning the social (the point where myth and the social group are closest).

The role of the father and daughter is both biological actuality and social construct. Even as biology, it is not fixed, however. The father can be anything from the distant provider of the contents of a turkey-baster to the passionately involved, long-term provider, or, indeed, dependent. It is my contention that these differences have bodily impact. One considerable strength of Drucilla Cornell's analysis and method is her attunement to the law as transition point between representation and social actuality.

The basic question of narrative power and social power is taken up again here, and pushed further. At issue is not some supposed inherent meaning of any given myth, but rather the ways myth is deployed in culture and the power invested in whoever has the agency of a Subject. Agency is not assumed to be unproblematic.

At issue is the contentious notion of an overall structure and its susceptibility to diachronic change. The structure impacts on the pattern of its change. The structure is what determines the specific details of the myth, and to some extent, its form. The specific details are not necessarily insignificant—not at all—but their potential in signification depends on the structure.

In opening these questions again, it should be very clear that I do not aim to reintroduce what Bal calls "formalist-structuralist narratology."[19] Bal's insight, quoted above, precludes any return to this. Rather I seek to build on the work of art as the locus between elements in meaning generation of various kinds and level, yet at the same time, as always already marked.

In this way it may be possible to address some questions that are currently impossible. There do *seem* to be structures that are universal, and certain forms *appear* to stand in an indexical relation to the signified. These issues must be open to discussion, not blocked or refused. At the very least, the manner in which the appearance of universality is produced should be examined, and a framework for renewing analytical discourses around it–in the sense of regenerating, not of repeating–should be explored. At bottom, in a philosophy rooted in contiguity rather than in splitting, these concepts become more open and inclusive.

One of the issues on which many important questions turn is that of any possible "outside" to discourse. The kinds of issue traditionally associated with universals and with myth assume that there is—often, there is just no reference to discursivity, and any relation to "reality" is taken to be unproblematic, a non-issue. It just is. On the other hand, analysis that follows Lacan and Foucault asserts that there can be no outside to discourse. The present approach derives much from the latter, though it follows neither. I think this is possible in light of recent revisions of materiality and Subjectivity, though I also think there is a great deal more work to be done before the case is established.

There has always been greater difficulty in feminist and postcolonial analysis over the relation of signification to social and material reality than there has in what I might call the non-aligned. Recent feminist positions have reasserted the importance of the Subject, but not as central. It is no longer the "fons et origo."

I recognize that some of the objections—and objectors—to this way of proceeding are truly formidable, and I am duly sobered. But equally, the reasons why something of the kind is currently necessary are compelling: Too much power attaches to the issues to leave them out of court. That is why I re-pose the questions. It is more in trepidation than out of hubris.

While the aim of this book is to move forwards rather than to analyse the past, I am indeed in the position of the adventurer in my opening joke, the one who asked the way and was told not to start from here: There is a certain territory that I have to cross to begin my desired journey. Myth is an indispensable part of this on various levels: It is a deeply entrenched part of the semiotics of art; it is supposed to be universal; it is deployed to considerable effect in psychoanalysis, which has marked both recent cultural criticism and feminism; and finally, it concerns both power and its impossibility (in that the arbitrary action of the gods always cancels [what appear to be the relations of] human power).

Though the gods translate readily into the dominant of any social or political situation, their continued secularization may offer ways through the constrictions of hierarchization into a more humane world. In this, the gods are more like chance than masters.

Reinterpretation of dominant meanings cannot deal with meaning as separate from form. A semiotic approach clearly has a great deal to offer here, and it informs the analyses that follow. My sense of this is that the debates vary significantly between different fields within the Humanities, with, for example, Peircean semiotics occupying a far more significant place in visual culture than in verbal.[20] The reasons may be on one level not hard to find: Peirce's sign is less specifically language based than Saussure's, rendering its deployment in relation to the image less problematic. It is within a diachronic semiotic framework that I suggest the term "morphogenesis" as part of re-examining myth in art, a word intended to draw on the advantages of iconology in art historical usage, while extending the term to found it more clearly in the materiality of a work. Similarly, the arbitrariness of the signifier-signified relation is re-problematized to become an element in the generation of meaning, not a condition.

"Morphogenesis," then, stresses structure in meaning as transformational, not as fixed.

The current online Oxford English Dictionary gives two definitions for *morphogenesis*. Its etymology leads to the Greek μορφή (*form*) and μορφή (*origin*), and my introduction of it here is intended to put both into question. Can they be reformulated in such a way as to allow a different approach that expands the potential of radical critique?

The first OED definition (a) is from biology and the second (b) from geology. They are as follows:

a. The origination of morphological characters; morphogeny.
b. *Geomorphol.* The formation of landscapes or land forms.

These two contemporary usages of the word are serendipitous for this study, since, taken together, they suggest both embodiment and continuity of matter, while avoiding the contamination of any received position in cultural theory or art discourse, and most particularly the idea of their being inherently meaningful. "Origination," used in the first definition from biology, is also appropriate as a term, in that it is less fixed, more dynamic, than "origin." The emphasis is on origination as a temporal process, not a fixed point at the start of a deterministic trajectory, or telos, and on the structure on which the form depends as capable of generating meaning, but without inherent meaning.

The possibility explored here of an interface between morphogenesis and how meaning is created opens on to the potential for sexing meaning without recourse to essentialism. The meanings are generated and carried in the process

of formation, not in an ideal origin, and not in a fixed understanding of the body. Reinserting the sexed Subject and the sexed body from which it is inseparable into understanding meaning in art is not a matter of identifying forms or structures as sexed in themselves.

I do not say "content" because this suggests something inherent and stable, if not static. Form and content are an old pairing, as an opposition or as inseparable parts of a whole. Roughly speaking, the breakdown of certainty about them ghosts many of the divisions in the art and art discourses of the last century. To talk about form or structure is to fall into a regressive series, to set off a chain of connotations that imprison you in anti-radicalism. But not to address some of the issues they have been used to articulate is to render certain questions impossible. Semiotic impossibility signifies.

The historical occurrence that was Formalism is a good example: Why is it so difficult to discuss form without being taken for a Formalist? Do we really have to keep going back to Greenberg or the Russian Formalists of a century ago to talk about form, especially in relation to abstraction or non-objective art? This example has considerable reach because it is very difficult to say anything much about either without touching on those intractable questions about art that cannot be answered without coming up against the possibility of the universal. Indeed, they are often the class of question that oppositional movements in art since the 1960s have explicitly countered. Aesthetics, or "the aesthetic," is another prime example. It is not that the artists or thinkers who intervened against the exclusivity to which the "universal" had been misappropriated were somehow "wrong" to oppose. Rather it is that they have cleared the way so that we no longer have to.

The problem of Formalism links to that of sex because of the position of the Subject, and because of the narrative roles traditionally available to the sexed Subject. These are changing, and if this is not as rapidly as some of us might wish, the interesting point is how they change. One way of analysing this is through the interrogation of structural patterns in narrative—but several traditional ideas stand in the way of this. One of these is the separation of non-objective art from art supposed to be "representational," a symptom of the fragmented approaches to form and media that still hold back historicized understandings of art, and especially of modernism.

Mieke Bal has raised some very serious objections to "myth criticism," both in the discourses of art and of psychoanalysis. She has also taken analysis significantly "beyond the word-image opposition," as the subtitle of her book *Reading Rembrandt* indicates. What I have to say about the materiality of a work, and a difference in relation to language, is in agreement with her position and is not intended to reinstall this opposition. It is rather to allow for a variation in relation, a differential between forms that neither refers everything to language nor separates anything from it. It holds open the issue of whether there is an out-

side to language, which from a material point of view it must, while recognizing that in representation, the constitution of the subject may be linguistic.

Bal points out the fallacies of assuming that what myths are taken to mean can be passed from one text to another, especially as in painting, and history painting in particular. She questions the different ways narrative is treated in the discourses around verbal and visual art, and analyses especially "the social issue of representations of women." I am thoroughly in agreement with what she says about this.

One of Bal's insights is extremely significant here. It is the one quoted at the start of this chapter, that "the relation between a mythical unit and its so-called versions is not simply a relation of interpretation, but a relation of transference." What the myth may mean for any reader is not primarily a matter of content, then, but rather of structure. The myth is like a screen, or like the analyst when transference occurs, a sign "mistaken for another. Such a relation is mutual, dynamic, historically specific, and discursive. Consequently, a mythical unit is not a discrete unit of meaning, but a signifying structure." She goes on to put this in Peircean terms, thus: "[. . .] an indexical relation between the screen and the myth is obscured by the *illusion* of an iconic relation. [. . .] Myth criticism and psychoanalytic criticism both try to obscure that indexical relation under cover of the universalistic fallacy."[21]

In revisiting that "universalistic fallacy" in relation to myth, I have to maintain the possibility that the mythic structure is not an empty signifier and, in any case, I am not convinced that there is such thing as an empty signifier once you are in the cultural or linguistic field. It is an idea only. Nor am I convinced that the screen is fully sufficient as a figure for this structure. By this I mean that I do not know, and I do not know how to know whether it is empty. It is therefore necessary to hold open the question so that it allows that the screen might not be empty. Bal's framework allows that the screen itself may vary in structure, and this is important. But it is nevertheless a screen, implying opacity, blankness, and concealment.

The notion of morphogenesis is intended to hold this possibility in tension with another—that the materiality of art is both screen and another kind of structure altogether, one which I am tempted to call "virtuality" in the full and contemporary resonance of the word. It bears a relation to a screen, it is material, yet not present; like the digital, it resituates the material relations of representation without abolishing them, and it is related to an ethical and practical structure that takes the ontological subject outside itself.[22]

I have argued before that the eruption of that which was designated feminine, the blankness of the screen here, into high culture reactivated the problem with perspective that has remained since its emergence in the Renaissance.[23] In this restricted sense, those commentators who noted the "effeminacy" of Impressionism were right. Drawing on Bonnefoy's outline of "the impossible

synthesis," the attempt of the scholastics to think of Man simultaneously in terms of the singular and the universal, I tried to argue that the ontological problem of which perspective is a symptom, its indissoluble link with the split between timelessness and lived time, is integral to a fundamental part of the obsession with women, or rather with imaging the feminine, in nineteenth century art-production, especially perhaps its high art. Some of the best contemporary feminist philosophy is taking this problem on again, though this move should not be thought of as a return; neither time nor the timeless is absolute in the cultural imaginary, even if that imaginary figures them as such. Women's historical presence in culture has been "postmodern" for a very long time.[24]

Notes to chapter 2

1. First given to the MLA in 1978 and published in 1980 in *Feminist Issues* 1: 106–11. Monique Wittig was one of the first to formulate what would come to be known as "compulsory heterosexuality." She drew significantly on anthropological racial "othering" to theorize her understanding of the exclusion of lesbianism from theory and culture. Her visionary novel *Les Guérillères* articulated the battle of the sexes as mythic struggle—won by women.
2. Bertrand Russell argues that it was. See for example the *Oxford Companion to Philosophy*, 64.
3. Adriana Cavarero *Relating Narratives. Storytelling and Selfhood* (Trans. Paul A. Kotman) NY/London, Routledge, 2000: 9.
4. noetic = abstract or purely intellectual existence; only in the mind, etc.
5. Ibid.
6. Cavarero 2000: 10.
7. Cavarero 2000: 9–10.
8. Cavarero 2000: 53.
9. I take issue in this way as a mark of admiration and an acknowledgement of indebtedness.
10. Not the least of the challenges of this poem, the famous French sonnet "en '–ix'," is its impossible rhyme-scheme "ix" and "or," which verges on a kind of hysterical heavy breathing. A Mallarmé can stay on the right side of the ridiculous with it. It would take a better translator than I to come anywhere near it in English. Mallarmé actually wrote about the poem to his friend, Henri Cazalis (18 July 1868); most unusual for this recondite writer.
11. See, for example, the *Oxford Companion to Philosophy*, 64, logical atomism. Entry by Prof Mark Sainsbury of King's College London. See also below, chapter 3, and the related discussion of color and universals.
12. I make raids on philosophy when I need to push certain problems further than the terms in which I encounter them allow me to go. I would happily defend this as a method. But tracing the history of philosophical ideas from this position is much riskier. My criterion is whether or not the speculation appears likely to be productive. What I mean by "a certain reading" of Spinoza is simply that there appear to be a huge number of interpretations of his work, not all of which would by any means understand it as compatible with my brush with atomism. My greatest problem with Spinoza derives from his determinism.

13. Besides, there is much very good writing on Deleuze. Grosz is an excellent starting point, especially for anyone sympathetic to the views underlying this study. See, for example, *Volatile Bodies* Bloomington, Indiana, 1994.

14. Bal, *Reading Rembrandt* Cambridge, Cambridge University Press,1991: 95–6

15. See Huntington xxvi and chapter 4.

16. *Beyond Accommodation* London/NY, Routledge 1991:195

17. Bal 127

18. The few exceptions tend to prove the rule, as I demonstrate through Shelley's *The Cenci*, in which Beatrice's patricide is erased as soon at it is posited.

19. Bal 97

20. See Bal's essay with Norman Bryson, "Semiotics and Art History" in *Visual Theory: Painting and Interpretation,* Icon: 1991. Bal takes the artifact as a blank screen in *Reading Rembrandt,* but has since revisited her position. For a more current assessment of her invaluable work, see *Quoting Caravaggio: Contemporary Art, Preposterous History,* Chicago/London: Chicago University Press, 1999. See also Norman Bryson's presentation and assessment of Bal's work in their contribution to the *Critical Voices* series (edited by Saul Ostrow), *Looking In: The Art of Viewing,* G&B Arts International, Amsterdam, 2002.

21. Bal 127–8

22. For an expanded notion of "virtue," on which I have drawn, see for example James F. Keenan "Moral Theology out of Western Europe" *Theological Studies* Jan. 1998.

23. "Remembrance of space-time: time and perspective in nineteenth century poetry and painting" *Journal of the Institute of Romance Studies* vol. 1, 1992: 425–38. See especially pages 433–4.

24. This paragraph comes from my unpublished 1997 paper, "Sex, Blankness and Signification: Anamorphic reflections on an essay by Jeremy Gilbert-Rolfe," a response to Jeremy Gilbert-Rolfe's essay "Blankness as a Signifier" *Critical Inquiry* vol. 24 no. 1, Autumn 1997: 159–75, a version of which also appears in his *Beauty and the Contemporary Sublime* New York, Allworth Press, 1999: 109–23. See also chapter 5 in the present volume.

playing balls with matisse, picasso, and himid

> A ball is not an ordinary object, for it is what it is only if a subject holds it. Over there, on the ground, it is nothing; it is stupid; it has no meaning, no function, and no value. Ball isn't played alone.[. . .] The ball is the quasi-object and quasi-subject by which I am a subject, that is to say, submitted.
>
> —Michel Serres[1]

> Isn't [. . .] postcontradictory psychic mobility what is desired psychoanalytically, and what Freud sought to circumscribe through reference to the bisexedness of the psyche? Is this mobility not a sign that a rigorously instituted logic of repudiation is not, after all, necessary for psychic survival?
>
> —Judith Butler, *The Psychic Life of Power*[2]

MORPHOGENESIS AND TRANSFORMATION

The idea of morphogenesis introduced in the preceding chapter is intended to reopen the possibility of the transformative power of art at the same time as recognizing material continuities. As Joanna Hodge has said in relation to authenticity and historicality, they require to be thought together, across the "broken middle" located by Gillian Rose,[3] so that they are no longer understood "as displacing the concerns of aesthetics, with affectivity and receptivity on the one side, and politics, as concerned with collectively constituted constraints on human understanding, on the other [. . .]."[4]

Rather, we have "to think instead in terms of trajectories of collective transformation."

Such trajectories do not just occur. They require intervention. The idea of morphogenesis is intended to allow the kind of intervention that crosses the "broken middles" between political semiology and artistic form. That is to say, it allows both mobility and connection, the arbitrary and the necessary. Aesthetic structures carry meaning, but not in a denotative sense. They do not refer back to a single originary meaning. Their meaning is connotative and cumulative, and therefore historical. It is also transformative. A morphogenetic understanding of art may not be a whole new ball game, but is a game whose rules are subject to change. These balls are not static or ideal—they are in motion, they have a trajectory.

One of the prime determinants of who is able to pick up the artistic ball in the contemporary scene is still a relation to the giants of modernism. This is reinforced by lucrative international exhibitions in which the towering status of a select band of genius-men is celebrated. If this sounds an exaggeration, try to imagine art discourse without Matisse and Picasso. It is therefore with these two

giants that I begin. It is also why this chapter takes recent exhibitions as a major point of reference. Works referred to have all been recently exhibited, and meanings implicit in their curation are incorporated into the analysis.

OPENING GAMBIT: MATISSE

At the beginning of the last century, someone now known to be a great artist made a painting about a game—with balls. His subject was a very traditional preserve of the ageless men all over rural France, males who still occupy the dusty space in the middle of the village. They now often share that space with cars, tourists, and a war memorial; but of course, then, the space was empty of them, most especially free of the stone bearing its melancholy litany of fallen brothers, their surnames repeating. Then, the flattened surface surrounded by houses would have been a blank on which the locals would play and parade.

The blank of the background to the painting is of different kind, though of course neither painting nor village ground is actually blank. Aside from its ostensible subject matter, there is very little that is traditional about the painting. There is no detail whatsoever to define the game. There is no flat surface or track, no sign of habitation. The players are three naked boys, barely distinguishable from each other. The figures are as summary as Minoan acrobats at Knossos (whose sexes were distinguished through color, not physique). Their placement on the canvas is both convincing and impossible; the boy on the right could not possibly sit where he appears to sit, yet this matters so little that one does not notice, certainly at first. There is another kind of rightness about it.

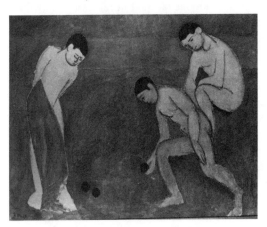

The work is deceptive in its simplification. The three boys are playing with three green-black balls in a landscape that is boldly but summarily indicated in broad bands of color, mainly blue and green. It is easy now to forget how radical its whole approach was in 1908. How does it signify now?

Jeu de Boules was selected to end the recent exhibition *L'invitation au voyage. French Painting from Gauguin to Matisse from the Hermitage,*[5] a show that

FIG. 2 Henri Matisse *Jeu de Boules* 1908, oil on canvas, 115 × 147 cm. The State Hermitage Museum, St. Petersburg.

affords an opportunity to see works from the great Russian museum-palace. Large-scale art exhibitions have become a feature of the cultural landscape. They are now as important a conduit to international painting and sculpture as books used to be. Whose game do I play as visitor to that exhibition? My own, neither Tsarist nor Communist, neither liberal nor conservative. There is another game,

one in which the stakes are even higher because it involves us all. There is perhaps an unconscious gesture towards this inclusivity in the design of the end of the hang. *Jeu de Boules* is certainly privileged as the grand finale, but it is awkwardly accompanied by a displaced element of itself. Besides, it is another painting from which it ought to be inseparable, if its game is to be divined.

Jeu de Boules is, in fact, a part of a design for a ceramic triptych. This is not foregrounded in the show, certainly not visually, though the information is provided. One of its companion pieces is installed on the wall to its right. This, the penultimate work in the exhibition, is in fact the design for the *centrepiece* of the ceramic: *Nymph and Satyr*. Neither the recorded commentary nor the catalogue links the two paintings.[6] *Jeu de Boules* is one of the privileged paintings that gets its own commentary. As such, it is not just inside the borders of the exhibition territory, it is part of what defines them.

The question is, why? This question is not a portmanteau for saying that it should not occupy the position it does, though substituting a side-panel for a centrepiece would seem to require some explanation. My inquiry concerns what it is possible to understand, and how. Games are not possible without some rules, preferably freely agreed. Respecting the original form of a work is usually a ground rule of art historical curation and interpretation.

The dialogue between the paintings is significant, moreover, and it goes beyond the contingencies of time of execution and a shared project. Put together with the third painting of the ceramic triptych, *Dancing Nymph*, we (should) have here paintings of males and a female flanking a painting of a heterosexual encounter.[7]

But what an encounter! No seduction here, no Arcadian romp.

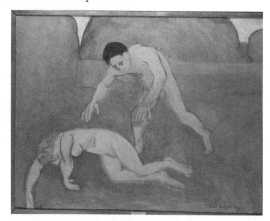

FIG. 3 Henri Matisse *Nymph and Satyr* 1908, Oil on canvas, 89 × 116.5 cm. The State Hermitage Museum, St. Petersburg.

They are not playing. And Matisse is often a great player. The satyr is a modern man, extending huge hands towards the nymph, who droops, defeated. The contrast with the Art Gallery of Ontario's *Satyr and Nymph* by Gerrit von Honthorst[8] (to take an example I saw very soon after) could hardly be greater. The seventeenth-century pair are lascivious and satisfied, obviously consensual and post-coital. Both smile, she shows her teeth (a strong signifier in painting of various forms of disreputability). He shows his tongue, as she tugs his (goat)-beard and he chucks her chin.

Not all scenes on the nymphs-and-satyrs theme are consensual, of course, and many of them concern rape. Matisse's version of this generic scene displays

little sensuality, and the animal nature of the satyr is played down—his legs are those of a man, not an animal, although in the completed ceramic, he has a satyr's hairy limbs. Notwithstanding this, the catalogue commentary is not entirely wrong to say that "its expressionist hues and overt sensuality are unique in Matisse's work,"⁹ though it is not its sensuality as such that is unique, but rather the tone. (The idea that Matisse is not usually sensual seems very strange.) There is undoubtedly a charge to it, but it is suppressed rather than overt. It does not seem convincing as a rape, despite the nymph's reluctance.

The painting was done very quickly. The ceramic triptych was to be installed in the house of a patron, and there was some urgency. Both paintings in the show still bear the evidence of repainting. *Nymph and Satyr* in particular has the marks of an inquiry. The figures have been repainted roughly—the areas under the arm of the satyr and behind the head of the nymph clearly show this, and they have been retouched only enough to maintain the flat bands of colour of the background.

Jeu de Boules may indeed be seen as part of a cycle of works linked to the Golden Age, as the catalogue suggests. It has also been seen as the masculine counterpart to *Bathers*. Its blue symbolises water, we are told, but also the "dialectical unity of life and death"; its green refers to nature, but also to Osiris, god of productive forces of nature and sovereign of the sepulchral world.

This is true in a very general sense, but it is in the details and the layering of the details that its divinatory questions gain relevance and life. If the notion of morphogenesis introduced in the previous chapter has explanatory power, these details should allow a reading to emerge that does not mask the possibility of an indexical relation between structure and its manifestation in this story.

It seems clear from the abundance of transformations in mythical narratives that it is only possible fully to separate out the masculinity of deities by selective or abstracted reading, especially according to a synchronic principle, and indeed the history of these changes overwhelmingly moves towards such a division of the sexes. As in the exhibition, the mythic structure has been universalised in a way that erases the particulars of the story and of its transformations through time. This is a process that runs strongly counter to the temporal character of mythic narrative itself, which is cyclical. Its structural temporality is thereby also obliterated, significant in itself, and possibly hiding a further thematic, if Graves's references to "calendar mysteries" are well-founded.¹⁰ The male god Osiris is virtually inseparable from the goddess Isis, not only because they are complementary,¹¹ but because in the metamorphic embodiment of the gods through time and across cultures, they merge with figures whose attributes are transferable; as Graves shows in linking the greater Eleusinian Mysteries with the Egyptian Book of the Dead, "[. . .] since Dionysus was identified with Osiris, Semele must be Isis; and we know that Osiris did not rescue Isis from the Underworld, but she, him."¹² Above all, Osiris is associated with time and with castration or the matriarchal sacrifice of kings. Graves notes that the mysteries were, according to Plutarch, named "to commemorate Theseus's defeat of the Amazons, which means his suppression of the matriarchal system. Originally, the

mysteries seem to have been the sacred king's preparation, at the Autumnal Equinox, for his approaching death at midwinter."[13]

Jeu de boules is not a falsely universalized image of the "unity of life and death," but rather something far more edgy. Despite its simplicity and surface serenity, the painting, as part of a triptych, is a question. In 1908, in Britain, women's suffrage was very much on the agenda, and it is hardly news that in artistic circles all over Europe, women were experimenting with sexed identity with a frankness that was unprecedented. If this is a game of divination as well as a game of boules, it invokes a Frenchness on the cusp of change. It is boules in the same way as the horizontal bands of colour are landscape, in the same way that the boys are male youth—but these youths are alongside female youth and a scene of potentially dark sexual maturity. This is a painting about universals at a particular artistic and historical moment in that part of Europe that is France. And its inquiry into the universal is sexed.

In connecting this painting to the boys' sex, it is noteworthy that the boys are not strongly marked as male, which is generally consistent with Matisse's style. They inhabit a transitional time. *Nymph and Satyr* is part of their question, as is *Dancing Nymph*. Did the dancing nymph escape the satyr? Is she an expression of a physicality, of a connectedness we find hard to know in this culture of mourning?

In divination, of course, the questioner inflects the outcome. I am implicated in the game and if there is only a psychic ball, as in the dancing nymph, "the quasi-object and quasi-subject by which I am a subject" plays its part undiminished.

A RACE OF MIXED DOUBLES: PICASSO

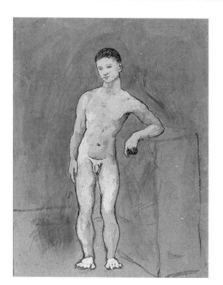 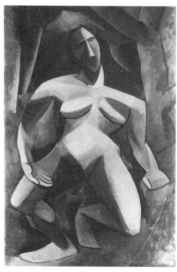

FIG. 4 Pablo Picasso *Naked Youth* 1906, gouache on card, 67.5 × 52 cm. The State Hermitage Museum, St. Petersburg.

FIG. 5 Pablo Picasso *Dryad* 1908, oil on canvas, 185 × 108 cm. The State Hermitage Museum, St. Petersburg.[14]

Earlier in the same show as the Matisse, the visitor can see several works by Picasso, including *Naked Youth* and *Dryad*, painted with about a year between them. *Dryad* was done in 1908, at the same time as Matisse's triptych. The position of these two artists as giants in the creation of twentieth-century art has recently been reinforced through the *Matisse-Picasso* show,[15] which trails them as "the two giants of modern art"—not just "giants of modern art," but *the* giants (behind whom is the Ur-giant, Cézanne).

The show bodies forth how far there still is to go before the rules of the game have changed enough fully to accommodate even the consideration of new players, let alone their admission to the game. The dominant narrative presented is that between the two giants, taken at their own assessment of each other as worthy interlocutors—especially Picasso's, who is prominently quoted as saying of his dialogue with Matisse, "We must talk to each other as much as we can. When one of us dies, there will be some things the other will never be able to talk of with anyone else."[16] This appeals to the spectator to aspire to being the rare individual who might be the exception, who might also understand. It does not invite critical engagement.

If a clash of the Titans is the main narrative, or the heroic struggle of rivals and yet brothers in the same cause, it is told through formal comparison based on the old line-versus-color dichotomy. Reference is made to the portrayal of women and the use of African art, and to war, but these have no place at all in the structure. The story of modern art is very largely untouched by the story of what is now contemporary art, or to the adventure of recent critique, which has been, and continues to be, extraordinarily rich. Indeed appeal was made on the French version of the bilingual Web site that accompanied the show to an underlying emphasis on the traditions of French art and the grounding of the idea in Apollinaire's commentary for the 1918 show, focussed on this relationship as exemplifying the two great tendencies of (then) contemporary art.[17] Even formally, the hint that the line-color dichotomy might have been superseded through Impressionism is nowhere to be seen; the shift from color as a property of bodies to color as light has immense significance in dissolving the old line-color paradigm from the inside, but it is resisted in the dominant story, despite the seriousness of the claim that can be made for such a development as innovatory both formally and philosophically.

It is a claim that is consistent with sexing universals. While a critic of my persuasion sees strong philosophical reasons connecting sex with why these tramlines are hard to escape, it is not so easy to lever the juggernaut off them. Calling one of the lines male and the other female, or one Eurocentric and the other postcolonial, will not do. Color has indeed been identified with the female, line with the male, alongside a whole series of dualisms that are now over familiar, but no less difficult or intractable for that.[18] But that is not the fundamental direction of the present argument. It is rather to atomize the rails, while maintaining the capacity to steer.

Picasso's game, in this move, is read as differently sexed from that of Matisse. He is another kind of male. He was also born a Spaniard, not a

Frenchman; bullfighting, rather than boules, was more his game. The issue is not so much how might that show have looked, had it been presented in such a way as to include a sexed dialogue between insider and outsider (though that would be fascinating),[19] as how might its most important issues be related to the specific manifestations of those universal questions of sex, insider-ness, and cultural exchange so as to alter their constitution.

These two paintings by Picasso directly parallel the artistic and psychic economy of the Matisse. They were painted at very nearly the same time, and they articulate a similar (not the same) unease about the female. There is another factor, too. They are more strongly marked by a concern with what now reads as race.

The *Naked Youth* appears to be a classical study, typical of what is known as Picasso's Rose period. Those feet are somewhat surprising, though, betraying perhaps a reference to Manet, subliminal or deliberate. But like *Dryad*, there are some fascinating details to be explored about it. It seems that it also derives from a Javanese bas-relief.[20] It is not only sex that is being explored, but also the racial universal.

Like Matisse's *Nymph and Satyr*, painted the same year, *Dryad* has been noted to be quite unlike other works in Picasso's 1908 bather cycle, which works through lessons learnt from Cézanne. Despite differences, it has also been connected with *Les Demoiselles d'Avignon*, through a perceived similarity in the position of the figure of *Woman in an Armchair*, also of 1908.

But the relationship which I want to emphasize comes about through the poet Apollinaire, who was a significant link between the worlds of painting and literature at the time. The link here is visual, though. It is with a sixteenth century image of a corpse. The pose of the wood nymph is exactly the same as that of a body hanging by the neck in Vesalius's work of 1543, *De Humani Corporis Fabrica* (*On the Construction of the Human Body*).

If a dryad's tree died, she died with it. But I do not think this is the kind of connection one ever finds in Picasso. Nor do I think that naming his misogyny is sufficient, though it is necessary.

Picasso's primary drive at this time was the invention of a new visual language. As with the Matisse above, it is the articulation of the female body that seems to fracture serenity, but in Picasso it is more pronounced. Sexuality was to remain a major theme and focus for formal inquiry for him. If what this signifies is misogyny, then in what does it consist? What is the pattern underlying the violence and projected fear that breaks through here, and the kind of disturbance in the articulation of the female that is evident in the Matisse? What are the historical meanings within the universal inquiry being made, and why is it so strongly articulated through the female body and/or the human qualities associated with it/her?

This is the kind of question this book seeks to address. It is about moving forward, equipped as we now are with nearly half a century of sustained change in sexed roles (much longer of intermittent change), in understandings of race and subjectivity, and the same time span of cultural critique. It is about

deploying such discoveries of scholarship as have explanatory power, not about rejecting approaches as outmoded or worse. Art cannot be against anything, not in its fundamentals. It cannot oppose. Neither can criticism, as the philosophy of art, again, in its true (unconscious?) impulse. Oppositional moments do not render this false as a principle. Feminist critics have long been aware that the restoration of women's art to its rightful place in the history of art overall will change that history. Something similar applies to treating world art as an equal player, although there is a great deal that is different in the race dynamic as differentiated from the sexed. The art of ancient civilizations that was treated as plunder in and by the artists and critics of the Eurocentric tradition was never the unconscious of its culture in the same way as women's culture; they were never the occasional spectators at the side of the pitch, allowed only to witness selected parts without full access to the rules or the status of players. Rather it was a competing game that was emphatically brought in, incorporated to enhance, develop, and change the tradition—but only at the cost of outlawing their "non-Western" or "exotic" version of the game and disavowing or containing its part in the regeneration.

Is it perhaps that the inside-outsider aggression of Picasso, his sublime, has prevailed over Matisse's more integrative beauty? Again, this is not simply to try and place Matisse's female to Picasso's male. It is to ask how part of their attraction is towards each other's femaleness, and what meanings it generates as it plays out. In the characterization of Matisse and Picasso as giants in dialogue, Virginia Woolf's notion of the delicious effect of women in reflecting men back at twice their natural size is repeated to infinity. Matisse and Picasso are co-opted into an exclusionary dynamic. The Oedipal parental dyad is reinstalled, and we are protected from the change they herald.

But these painters are not poles of a stable structure. They are as unalike as they are alike. Like male and female, they cannot be subsumed into a balanced structure. Let us read Matisse's runes—and also try to anticipate any assumption is that this move is 'against' Picasso. This is not about overturning them. Cultures do not have to destroy each other. The construction of history has thus far been poor in telling this story, preferring armchair battle and someone else's overthrow.

GAME PLAN B: LUBAINA HIMID. HISTORY AS PROPHECY AND LEGEND

> With these works I want to say I know your game, I know what I want to say with my medium and my tools, I want to show my truths, my illusions and my prophecies and my legends.
>
> —Lubaina Himid[21]

Lubaina Himid joins the game knowing the score. Her plan is Plan B, chosen in the absence of Plan A; the strategies involved are dialogic, a response, involving

interpretation and adjustment. It works through both race and sex. The game for Matisse and Picasso was within a paradigm of revolution and innovation, and its engagement with material history was in a limited and specific sense—even the gesture that was Picasso's *Guernica* is contested. The operation of limits, however, is stronger within the critical frames that continue to defuse the redefinitional elements of their art by containing it within a specialized area of experience, dematerialized and removed. The work was part of changing the paradigm. Resistance to it remains strong, sustained as it is within the oppositional mode, which actually becomes a conservative mode, against aim or intention. Oppositions are implicated in each other as the same structure, as recent theorizations across the Humanities have demonstrated widely and from varying points of view. Yet it is very difficult to move out of. That is the work to be done, the work to which Himid contributes.

FIG. 6 Lubaina Himid *Plan B* 1999, acrylic on canvas, 4 × 10 ft. Collection of the artist.[22]

FIG. 7 Lubaina Himid *Partition*, 1999, acrylic on canvas 4 × 10 ft. Collection of the artist.

Himid constructs a doubled history through doubled lives. Born in Zanzibar, Tanzania, her mother was born in Farnworth, Lancashire, United Kingdom. Her exhibitions are produced as signifiers, not just of "Himid" as artist, but of particular narratives. The paintings work within a narrative structure produced by the artist herself. Thus, for example, in *Double Life*, by structuring her own paintings through a female genealogy—that of her mother and aunt—into a palimpsest actually overlaid on photographs from the extraordinary experiment that was Mass Observation, social and family history are brought into the heart of representation in art.[23] Himid's double inheritance informs her work as history painting, but does not contain it. The great events of contemporary history are not heroic, as they were in the apogee of History Painting as the highest genre of oil painting.

Just after completing *Plan B*, Himid wrote:

[. . .] the Turkish earthquake, the Greek earthquake, the killing in East Timor and Taiwan earthquake flit across the mass in my head, strangely highlighting the calm of this pleasant northern town. I know there are major civil disturbances inside the domestic interiors, but no one sees them happening. [. . .] It is exactly the sinking and regretful feeling in the Plan B paintings before they were painted. The act of making the work took my painting and my thinking to a place beyond my expectations. I became dedicated to action, moving forward, communicating with the living.[24]

For Himid, material history is the motor. At the same time, she knows that the ways in which modernist art engages with history are indirect and subtle, but powerful: She is not bent on destruction. Far from being denied in her art, modernist strategies are taken up and carried forward. As Jane Beckett points out, the deployment of color throughout the works that make up the exhibition to which the painting *Plan B* gives its name makes "multiple references to a modernist play with color, the Red, Yellow and Blue of the pool paintings possibly echoing Barnett Newman's *Who's Afraid of Red Yellow and Blue* (Stedelijk Museum, Amsterdam) which itself cites Mondrian's classic abstract canvases of the inter-war years."[25] It is a major part of her artistic vocabulary, signalling not pastiche or irony, but a close engagement with the terms of the game.

The insertion of another dimension so minimally indicated through Newman's "zips," the narrow vertical bands of color that became his best-known device, is opened out by Himid, for example, in the illusionistic cubes of the vertical flat band that bisects the painting *Plan B*. The three pool paintings, Red, Yellow, and Blue, each nine feet high by only four feet wide, while operating on the vertical axis of the "zip," refer to the horizontal of *Plan B* in various ways— through windows and grids, the latter simultaneously referencing both modernism and (two of) its sources, the Kente textiles of Ghana and Kangas from Tanzania. Newman's works were each of them an event, indexical in their exact articulation of emotion. At their best, Himid's work have this quality, even as they depart radically from economy Newman made his own.

Plan B was made in Cornwall, in a lifeguard's hut. As well as being close to the Tate Gallery, St Ives, where the work was first shown, such huts are also close to the concrete bunkers put up during WWII, an actual presence still, reinforcing the lookout-tower appearance of the lifeguard stations more common in the United States. In wartime, the coast was subject to military surveillance, and civilians were not permitted to survey it for any reason at all. As Himid notes, "[. . .] the painters of St Ives could not paint the sea or the coast line. Torture to have to turn their easels inward, their backs to the world, the roar of the waves, and the wind. The threat of war something to be glanced at furtively over one shoulder until the planes came."[26] The lifeguard hut where *Plan B* was made is right on the same beach as many of the studios of the St Ives painters, still the home of Wilhelmina Barns-Graham, the greatest colorist of them all. Himid's high window-like spaces and darkened interior in *Plan B* recall the danger through which these artists lived, the dank atmosphere and dark connotations of

war or of drowning predominating over the light and relaxation of sport and summer holidays. The high horizon line, indicated with free brushwork, is disturbingly interrupted by the hard-lined chequerboard of the "zip"; what is visible in the windows behind it that we ought to see? Or is this the intervention of another dimension altogether? The painting leaves the choice of illusions open. Like *Partition*, which works in predominating reds and yellows rather than the blues of *Plan B*, abstraction and figuration work together to make and re-make impossible spaces and connections. The trick of the magician's cup is diagrammatically revealed, but it explains nothing about the cubic tiles interrupted by the pink vertical or the curved wall with the half-chair, which might be a mirror were it not for the seeming horizon visible through it. These re-image the trompe l'oeil that has been painting since Zeuxis; instead of Zeuxis's illusory grapes, there is a vanishing trick, the journeys of the slaves who never returned home, the differential inscriptions of this and all crimes on the psyche of their inheritors, master, slave, or escapee.

Illusion was one of the elements Himid referred to above, in the quotation at the start of this section; the others were truths, prophecies, and legends. Contemporary art is often commented upon in terms of illusion, less so in terms of truth, prophecy, or legend. Their mutual imbrication is inescapable in her morphogenetic work.

There are no figures in *Plan B*, though there are voices in the text-image sections. It is precisely in the absence of any explicit reference to sex, race, or descriptive location in time or space that I am reading this work as evidencing a new understanding of the universal in art.

Plan B, exhibited at the Tate Gallery in St Ives, a remote part of the United Kingdom, was not part of a major international touring exhibition. "Himid" is clearly not a signifier in art in the same way as "Matisse" or "Picasso"; very few names indeed are, none of them women. She has exhibited widely in the United Kingdom and Europe, in New York, Los Angeles, and Cuba, and her work is in major public collections in Britain.[27] She is Professor in Contemporary Art,[28] another sign of how artistic production has changed. Like many artists today, she supports herself not only through the sale of her work or patrons, but through art education.

It is open to question whether there still could be such figures today as Matisse and Picasso. I do not know. The conditions for the production of such super-human stars may have passed for good, even though the museums and the art market may try to promote successor-giants.

Yet Himid has history in her sights. Hers is an art that deploys both text and image in a transformative journey through time and across colonial, local, and intimate or domestic space. As her curator at Bolton, Jennifer Shaw, observes, "Lubaina Himid is an artist whose aesthetic and intellectual vision can encompass both the grand narratives of global history and a household yarn [. . .]."[29] The clash of the Titans as history obliterates the connections between private or individual and public or national in a dangerous splitting of affiliations between feminized locale and manly State. It is but a short and logical step

to universalize the latter, leaving the former routed and scattered into individual voices that are easy to discount. We are seeing the something of the consequences in the terrorism and suicide bombing of those who have nothing left to lose.

The issue here, then, is not so much the terms on which an artist such as Himid might enter the game as played by Matisse and Picasso, but the meanings her presence signifies for the game itself. She is in the game. She plays it knowingly, redeploying many of the devices of modernism, not in opposition, but rather in reflexive critique. And the works claim the right to speak for us all, not in the same dominant gesture as high modernism in the commonly accepted understanding, which it is part of complicating and patiently revising, but in a new assertion of difference within universality.

Jeu de Boules is a painting about universals, but not about certainties. It is a questioning. Matisse can be read for his participation in a wider understanding of art and its histories than he often is, far beyond the narrow confines of "pure" modernist dialogue. This opens the modernism of which he is a significant part to the criteria of those it has traditionally "othered." As Jean Fisher comments:

> For the West to frame and evaluate all cultural productions through its own criteria and stereotypes of otherness is to reduce the work to a spectacle of essentialist racial or ethnic typology and ignore its *individual insights and their universal applications*—a treatment not meted out to the work of white European artists.[30]

And what of balls, the game of which this chapter is an opening gambit (and of which the ironic tone of these closing remarks is an indicator of unresolvability)? The game they signify appears preferable to the game of/with the phallus, since they are material and subjective, body and mind, morphogenetic rather than contained within language like the phallus. In order to be able to play Serres's game, you have to pick up the ball—in this ludic economy, even while they may be continuous with the phallus, balls are intersubjective rather than disembodied or disingenuously exclusive.

If I take up my place in the game, how do I manifest my balls? Though I have in my present physical state no testicular balls, I am at least a quasi-subject in Serres' terms (which may well be enough!). I have eggs, ova. Perhaps elliptical balls will do fine, especially in a culture of rugby or American football, and there is more to a ball than roundness.

Why this play on balls and eggs? Because my psychic balls don't make me an androgyne, any more than they signify "male identification." If I am a human with balls and eggs, my eggs and balls are not equivalents, and will change with whoever else enters the game. This rather changes the meaning of "bisexed" into something less circumscribed than in Freud's version, but not totally mobile. A plurisexual female, since in many definitions, I am not a woman; a cyborg, but not a generic or undifferentiated cyborg. Which balls shall I pick up today? Which will be tossed to me? In any event, I do not plan to sit alone playing a fake game with a faux ball of a cotton reel—"fort-da," indeed![31]

The androgyne ultimately traces back to the figure of Universal Man that is the negation of the sexed universal. As an aesthetic ideal, it goes back to the double-sexed beings of ancient Greece, brought right into the modern discipline of art history through Winckelmann, who found their transcendence of sex a mark of their "purity." His *History of Ancient Art* (1764) finds the statues of hermaphrodites models of ideal beauty, that "dissolves all particularity of features into a harmonious wholeness," in the words of Kari Weill, with whose study of *Androgyny and the Denial of Difference*[32] I begin to conclude this chapter. Tracing the history of the androgyne—from Plato's *Symposium* through the Romantics (Schlegel, especially), the late nineteenth century (Balzac and Gautier, especially), to its eruptions in Barthes, Freud, and feminism—Weill demonstrates not only the androgyne's status as myth of original unity, when Zeus cut the primal androgyne in two, but also the selectivity and partiality that this version of the myth constitutes. In opening the *Three Essays* with this "beautiful" myth about how the original human beings were cut in half and so are always striving to reunite, "Freud repeats a gesture common to a tradition of readers of Plato by neglecting to mention that Aristophanes describes *three* primal beings, not only one of a male and a female joined together, but also one each of two females and two males, whose separation also instituted the beginning of homosexual love. Thus Plato's theory will not conflict with Freud's presentation of homosexuality and lesbianism as 'deviations.'"[33] Equally serious is the production of a model of difference that cannot extend to social and racial differentials within our common humanity.

If this mythic story seems too far away to connect with the contemporary world, let us bring it to bear on a current social phenomenon, supposedly an innovation. Gay marriage is thought to be an entirely new idea, and heterosexual marriage is considered to be threatened both by same-sex unions and by any more open form of sanctioned heterosexual contract than strict marriage for the procreation of children. In fact, this disregards not only the practices of many peoples other than the Europeans, but also Europeans' own history. As John Boswell has shown, there was in premodern Europe a ceremony of same-sex union that functioned as gay marriage. Marriage in general has varied widely over time in its nature and purpose, and the promotion of the male-female relation over all other relations is a historical phenomenon.

> Christianity's main innovation was to privilege and make real widespread voluntary celibacy, implicitly or explicitly suggesting that heterosexual matrimony was a mere compromise with the awful powers of sexual desire, even when it was directed exclusively to the procreation of children, the one rationale Christians found convincing. But passionate friendships, especially among paired saints and holy virgins, continued to exercise a fascination over the early Christians—still residents of the ancient world—and in time were transformed into official relationships of union, performed in churches and blessed by priests.[34]

Notes to chapter 3

1. In *The Parasite*, cited by Gary Shapiro in *Alcyone. Nietzsche on Gifts, Noise and Women*, 1991: 34. Shapiro continues his consideration of the economy of the gift, which is probably outside my use of the Serres—but not necessarily.
2. Butler 164.
3. "Aesthetics and Politics. Between Adorno and Heidegger" in *The New Aestheticism*, John J. Joghin and Simon Malpas (eds.), Manchester and New York, MUP, 2003: 218–238. In this quotation, I am bringing together elements from the beginning and end of this essay. In between, Hodge's analysis of Heidegger's "The Origin of the Artwork" is most pertinent to this study, especially her interrogation of the idea that "what is at stake in aesthetics [. . .] is the status of universalising judgement." (225). Rather, judgement is differential, especially in relation to history.
4. Ibid 232
5. Montreal Museum of Fine Arts and the Art Gallery of Ontario, Toronto, Hazan, 2002. I have been influenced in my analysis of exhibitions by the work of my former student, Dr. Nedira Yakir, whose doctoral thesis, *Wilhelmina Barns-Graham and Margaret Mellis. The Gendered Construction of 'St Ives': Display, Positioning and Displacement*, incorporates an extensive analysis of how specific elements of the dominant narrative of modernism have been drawn out of an exhibition, despite clear evidence that would complicate, if not contradict, this. There is, of course, a great deal of scholarship on curatorial issues and on museology—see, for one example, Carol Duncan, *Civilizing Rituals: Inside Public Art Museums*, London/NY, Routledge, 1999. Yakir's focus on the interface between local and national curating of strategic exhibitions, women's evidence, and art history makes an original interdisciplinary contribution to the field.
6. The catalogue gives full notes on their provenance and other such details. I refer to the absence of any discussion of the works' thematic and formal relationship.
7. The painting was not in the show and it was not available for reproduction here.
8. 1590–1656. On loan from a private collection. Correggio's *Jupiter and Antiope* and Watteau's *Nymph and Faun* (both in the Louvre) have both been identified as prototypes.
9. p. 197
10. Isis and Osiris were two of the five who were honored in the sacred Egyptian year by having days set apart for them—the others were Nephthys, Set, and Horus. Robert Graves *The Greek Myths* [Penguin, 1955] Folio Society, 1996: 429, 493, etc.
11. "[T]he bond between Isis and Osiris is one of the creative forces of life, for together they are the universal soul of growth. If he is the flooding of the Nile, then she is the earth that the Nile covers, and from this union, as Plutarch said, the Egyptians make Horus to be born." Ann Baring and Jules Cashford, *The Myth of the Goddess*, London, Viking, 1991: 237
12. Graves 472. There are many other references in the text to similar effect.
13. Ibid.
14. Also known as *Nude in the Forest*.
15. Tate Modern, London, 11 May–18 August 2002; Grand Palais, Paris, 22 Sept 2002–6 Jan 2003; MoMA QNS, New York, 13 Feb–19 May 2003.
16. *www.matisse-picasso.org*, commentary to room 14. This is a reported comment, moreover, not a clear attribution to Picasso. The site went live 17 Sept 2002.
17. "On vient d'avoir l'idée la plus rare et la plus imprévue, celle de réunir dans une même exposition les deux maîtres les plus fameux et qui représentent les deux grandes tendances opposées de l'art contemporain. On a deviné qu'il s'agit d'Henri Matisse et de

Pablo Picasso. L'œuvre éclatant du premier ouvre de nouvelles voies à l'impressionnisme et l'on sent bien que cette veine de la grande peinture française est loin d'être épuisée. L'autre au contraire, montre que cette riche perspective n'est pas la seule qui s'ouvre à l'artiste et à l'amateur et que l'art concentré qui a donné le cubisme, cette esthétique éminemment contemporaine se rattache par Degas, par Ingres aux traditions les plus hautes de l'art [. . .].' Ces lignes de Guillaume Apollinaire introduisent en janvier 1918 le communiqué de presse annonçant l'ouverture à la galerie Paul Guillaume de la première exposition conjointe jamais consacrée à Matisse et Picasso." Opening page of French version of the site, "Présentation."

18. In case anyone has forgotten, examples are: reason-emotion, good-bad, culture-nature, mind-body, etc., etc.

19. Even here, it is not so easy. Matisse was not an "insider" in any simple way; the structure will not hold against the dialogics of the conventional story.

20. See Richardson 1991: 200.

21. *Revenge: A Masque in Five Tableaux.* Catalogue Rochdale, Rochdale Art Gallery 1992:31, in Maud Sulter's essay "Without Tides, No Maps." Also cited by Griselda Pollock, *Differencing the Canon. Feminist Desire and the Writing of Art's Histories*, London and New York, 1999: 176. Pollock's section *Revenge* (169–200) in this book works around the exhibition. For another indispensable reading of this work, see Jane Beckett and Deborah Cherry, "Clues to Events" in Mieke Bal and Inge Boer (eds.) *The Point of Theory* Amsterdam, University of Amsterdam Press, 1994: 48–55. I want to acknowledge the extent to which these thoughts about history have been nourished by Pollock's work, especially as exemplified in the collection of her writing *Looking Back to the Future* on which we collaborated (G+B Arts International, 2001). Two of its five sections are explicit in their concern with histories, evidencing, as she declares that "What I am aiming at is historical knowledge" (402).

22. *Plan B*, exhibition at the Tate Gallery St Ives, 13 November 1999–7 May 2000. Catalogue essay by Jane Beckett, not paginated (third to sixth pages): "In structure *Plan B* can be related to musical composition: the ten canvases are in three distinct movements with variations, refrains, and repetitions. There are three upright, four text/image and three horizontal canvases." Also contains letters from Himid to Mike Tooby, then director.

23. See *Double Life* Bolton Museum and Art Gallery, the United Kingdom, 29 September–1 December 2001, not paginated (last page). In the catalogue, the photographs overlay the paintings on semi-opaque paper, so that they are available as separate elements and as combined image. The Mass Observation project was started in Britain in 1937 with the aim of bringing social science into ordinary lives and vice versa. Huge numbers of photographs were taken. The photographer Humphrey Spender is perhaps the best-known exponent of this approach. Contemporary artists who hand the camera over to their subjects are both its inheritors and critics.

24. Letter to Mike Tooby, then director of the Tate Gallery St Ives, 8 September 1999, published on the penultimate page of the *Plan B* catalogue (not paginated).

25. Ibid. Pollock and others have noted other thematic and structural plays in Himid's work with modernism. See works referenced in note 21 above.

26. Catalogue for exhibition *Beach Huts* Wrexham 1995, cited in *Plan B*, catalogue for exhibition at the Tate Gallery St Ives, 13 November 1999–7 May 2000, second page (not paginated).

27. These include: Tate Gallery, Arts Council of Great Britain, Victoria and Albert Museum.

28. University of Central Lancashire, United Kingdom.
29. See *Double Life* Bolton Museum and Art Gallery, UK, 29 September–1 December 2001: not paginated (last page).
30. From an essay in *Third Text* 1989, quoted in *Differencing the Canon*: 172.
31. The current frequency with which the episode about the little boy symbolizing his desire to control the disappearance and reappearance of his mother, a story begun by Freud, is repeated in some circles makes footnoting this seem prolix. But not everybody reads psychoanalytic literature. See "Beyond the Pleasure Principle" in *The Standard Edition of the Complete Psychological Works*, (ed. James Strachey), 24 vols., 1953–74 XVIII: 14–17 and any number of secondary references, some well worth reading.
32. Virginia, Virginia University Press, 1992: 67.
33. Weill 3.
34. *Same-Sex Unions in Early Modern Europe*, New York, Villard, 1994: 280.

sexing the modern with manet, morimura, and sam taylor-wood

Ainsi l'amoureux de la vie universelle entre dans la foule comme dans un immense réservoir d'électricité. On peut aussi le comparer, lui, à un miroir aussi immense que cette foule; à un kaléidoscope doué de conscience, qui, à chacun de ses mouvements, représente la vie multiple et la grace mouvante de tous les éléments de la vie.

(And so when someone who loves the universal life enters a crowd, it is like entering an immense reservoir of electricity. Such a person can be compared with a mirror as immense as the crowd itself; with a kaleidoscope endowed with consciousness, which, in each of its changes, represents the multiplicity of living and the mobile grace of every single element of life.)
—Charles Baudelaire, *Le peintre de la vie moderne*, 1859–60[1]

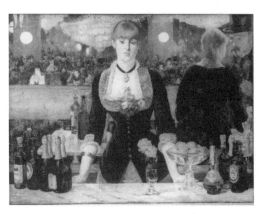

FIG. 8 Edouard Manet *Un bar aux Folies-Bergère* 1881–2, oil on canvas, 96 × 130cm. Courtauld Institute of Art Gallery, London.

PART I: COSMIC BARMAIDS, CROSS-DRESSED BULLFIGHTERS

Why should difference entail threat?

In *History after Lacan*, Teresa Brennan takes this question right into the heart of the division between understandings of subjectivity and of history, rendering them more permeable to each other. This is significant when brought to bear on Manet, an artist in whose work both subjectivity and history are clearly at issue.

Freedom as Recognition

The tendency of the dominant forms of the modern ego to regard the admission of the abject as catastrophic renders the risk of self-destruction preferable to opening to change on this level,[2] and while much has been written on this in relation to Subjectivity, much less work has been done in art-historical analysis on how this might impact in terms of history.

Might it not be what relates Cézanne's *A Modern Olympia* (1873–4) to Delacroix's *La mort de Sardanapale* (1827), whose structure it recalls? Sardanapalus, in Baudelaire's poem, is impotent, bored with everything, with the

green waters of Lethe flowing in his veins for blood. *Ennui*, the modern dandy's condition—and it is deadly to the women who in the painting are being murdered while the idle king looks massively on, a still, dead weight at the top of violent motion. Baudelaire's poem opens with a comparison of this terrible king with himself.[3]

What this chapter aims to do is to defamiliarize. It will try to indicate a way of articulating sexual difference in Manet as one who has now become a canonical artist, without reproducing the familiar categories of masculine and feminine, or naming the public as masculine against another particularized space of femininity. At the same time, it will attempt to disturb some of the orthodoxies that rest on eliding all forms of radicalism into opposition, and restricting political engagement to a certain kind of materialism. It is an analysis that seeks to contribute to the production of a framework within which it may be possible to synthesize many of the insights of my predecessors and creditors. Manet's work appears in this as imaging recognition across difference. In this he is an exemplar of one kind of freedom—as recognition. It is the fearful and unfree who find threat in difference—Sardanapalus as against the man of the crowd, Baudelaire's lover of universal life.

The position Manet occupies in the history of modernism is both an advantage and a disadvantage in elaborating this framework, and in seeking evidence in the work. Once a painter is installed, as he is, as one of the giants (like Matisse and Picasso in the previous chapter of this book), it is very difficult not to reinforce the ideology supporting Great Men. This chapter is not intended to do this, but I recognize that it inevitably does to some extent. Manet's status as origin of modern art is fascinatingly demonstrated in a long footnote in Carol Armstrong's recent book *Manet Manette*, in which she samples Greenberg's writing for references to Manet. She lists a broad range of references from writings from the 1940s to the end of the 1960s, and they are all of the same type: "since Manet," "dating back to Manet," and so forth.[4] If Greenberg promoted Cézanne as the "gateway" to contemporary art, Manet was his gateway to the gateway.

That said, there *is* something in the work that anyone seriously interested in contemporary painting has to encounter. This being the case, Manet's status can be made to work for bringing the marginal to the center. I am interested to explore this "something," following a hint from Mallarmé, in relation to a particular sense of the *democratic*. "The participation of a hitherto ignored people in the political life of France is a social fact that will honour the whole of the close of the nineteenth century. A parallel is found in artistic matters, the way being prepared by an evolution which the public with rare prescience dubbed, from its first appearance, Intransigeant, which in political language means radical and democratic."[5] Doubtless Mallarmé did not have women prominently in mind when he said this, but the work bears examination in just this light. It is a drive towards freedom rather than a constitutional democracy that it seems to embody, and it is much more specific than an overall commitment to individual or artistic freedom.

The aim is to build on the work of which Bourdieu seems to be unaware, but for which he calls in his fatherly advice to feminism: "Do not the invariants which, beyond all the visible changes in the position of women, are observed in the relations of domination between the sexes *require one to take as one's privileged object the historical mechanisms and institutions* which, in the course of history, have continuously abstracted these invariants from history."[6] But I am in agreement with the spirit of his study of masculine domination, and express in this criticism impatience for the dialogue he calls for rather than disagreement. There is a growing number of women writers who not only interrogate such institutions, but who also push forward into the unknown (though not unmarked) terrain of what might lie beyond them.[7] It is in this light that Manet is brought into the frame of "sexing the modern," in the service of what Patricia Huntington sees as perhaps the enduring significance of both Heidegger and Irigaray to postconventional ethics, the cultivation of "substantive modes of poiesis" that are grounded neither in an opposition of the individual and interdependence, nor in the desire to conquer reality:

> Perhaps their most lasting conceptual contribution stems from their formal efforts to show that a critical relation to normatively secured social conventions will never become complete without theorizing the need for a metaphorical (or poetic) mediation of ontological sensibilities and imagined telos. This practice must become part of a critical social formation.[8]

I hope to show that this is precisely the terrain of Manet, the attempt to articulate *in relation to the social formation* a mediation of "ontological sensibilities and imagined telos." Positive freedom is the reference point of this exercise rather than the analysis of domination (as in Bourdieu among others), which risks falling prey to being held in the fascinated gaze of the condemned. This is perhaps not the place to go into the full details underlying my conception of freedom, which is in any case still being worked out, but it aligns closely with Patricia Huntington's in seeking a path that "resists both the stoic logic of affect repression which leads to a truncated moral psychology and the sacrificial logic that fails to differentiate reactionary, cathartic forms of transgression from those that lead to self-transformation and ethical investment in intersubjective relations and social life."[9] This is a corrective to the "Kojèvan legacy" in which existential philosophy, phenomenology, and psychoanalytic feminism of all kinds "adopt Kojève's definition of freedom as negation of what is."[10]

In Manet, then, is to be found the drive towards an imagining of a positive freedom, one based in recognition, and (in marked contrast to the moves in some Symbolist art towards similar ends) based in the social formation, in the here and now of modern life.

Preamble to a Version of Manet's Bar

In the passage at the head of this chapter from *Le peintre de la vie moderne*, Baudelaire weaves his way between philosophical positions just as he does between

the people of the crowd. He is poised between the old "general in the particular" and the differentiated universal with which we are concerned. The particular may start as the macrocosm in microcosm, the same as the collectivity, but very soon, he/it undergoes a series of transformations. Unafraid of the banal or everyday, Baudelaire offers the reader an experience of phantasmagoria with the simplest metaphors. First of all, he is subsumed by the crowd, an undifferentiated part of it, dissolved into a single reservoir of invisible human energy, electric! Then he becomes visible in a kind of reflection of all the other people, but with a subtle difference: The crowd as a collectivity is mirrored in him, which doesn't exactly mean that they reflect each other or that he is a simple reflection of the crowd. No, he is the mirror. Both tain (or reflective surface) and light, medium and message, the dandy as lover of the universal life is a vast and receptive effect of human light. No longer part of the crowd, because he is its mirror, he becomes greater than himself because of it, the crowd lending him a massive and impersonal identity. The crowd makes him disappear into non-identity to re-emerge limitless and dazzling.

Finally, as if this were not enough, that single identity breaks down, and the mirror turns into a self-aware kaleidoscope, hundreds of re-arrangeable particles that always make a new, yet similar pattern. The crowd and the dandy are again indistinguishable, but no longer singular. The metaphors are cheap as the fairground, and as strong as theatre.[11]

Something of their trickery remains directly available today, potent as Noel Coward's cheap music.

There is in Paris a little nineteenth-century cabinet of curiosities still open to the public. You enter a small, plain room crammed with people. There is nothing but dark panels and a bare, dim light bulb. You wait, a little self-consciously, perhaps, wondering if you've been had. You try to get past the nervous clever comments of everybody else and into the frame of mind of the audience of over a century ago, excited about the newest technology: electric light. They say it is much brighter and more like sunlight than the greenish, hissing gaslight and yellow flickering candlelight of your home. You imagine being in a crowd in just the same way as Baudelaire did—like entering a great pool of electricity.

The dingy light fades into complete blackness. Strange sounds obscurely thud somewhere as the mechanisms begin to work. Panels in the walls swish as they are reversed, and you control your disorientation by trying to work out what is happening. The occasional glint in the near-dark hints at exciting revelation. Suddenly the place is ablaze with light. In spite of your collective and digitized nonchalance, the mahogany and crystal hall of mirrors sends a shiver down your spine, and, as one, you all gasp.

After ten dazzling minutes of clunking wheels and clicking switches, during which the room is transformed in an infinite recession of mirrors, electric chandeliers, and light bulbs, you return to the grey streets bewitched. The brazen theatre of a mechanized wonderland has sharpened your senses and you imagine a visionary laser across the Paris skyline—until you catch yourself in absurdity and return to the ordinary street. Despite its obviousness, the whole

thing seemed to shift materiality, to make you actually see how the surface world is part of a vast and shimmering continuity, crossing the breach between the tain of the mirror, the crowd, your eye and what is behind all of them.[12] Instead of one skyline, you have many, your horizons enriched. But you have not left the street. It is still there, but changed. The knowledge of the theater is crucial to its effect. You have not been mystified, just reminded of the existence of manifold views, all related, and all opening on to possibility. The here and now has been brought into an enriched relation with your own imagination through common experience and contact with the expanded imagination that is collective experience.

The Artist as Cosmic Barmaid

Manet's late painting *Un bar aux Folies Bergères* of 1881–82 has become an iconic image of modernism, the spectacle of the society of spectacle, commodified consumerism in all its seduction and illusion. It is all this. It has also been recognized as fractured, refractory, indicative of a new social imaginary, all significant. The barmaid, her mirrored setting behind the barrier of the bar, and her customer have been the object of critical writing ever since the painting was first seen a century and a quarter ago. A glance at one of the most recent publications on Manet, *12 Views of Manet's Bar*,[13] a volume that offers itself as an indicator of the variety and complexity of art-historical methodologies, shows how fruitful a ground it has been for all kinds of art-related analysis and theorizing. The debating chamber is indeed crowded. The painting would seem to have something to say to everybody, but at the same time, nobody knows quite what that might be. While the individual who sought to explain a work of art would be likely to die as disappointed as Balzac's Frenhofer was deluded, there is a particular character to this unknowing. Indeed, nobody seems to want to know, because agreement appears to be equated with boredom, with the absence of anything further to say. Conversation, in this company, is much inferior to debate.

One approach, however, is discounted. The door of the chamber is closed against the universal. In the introduction to *12 Views of Manet's Bar*, Richard Shiff outlines the state of criticism as encouraging subjectivism and the autobiographical voice. This applies even to an archival method, because the selection of documents must inevitably reflect bias. "Art historians' increasingly explicit recognition of their contextual limitations—the author's own situation in discourse and inability to assume a universalising stance—might be linked to a postmodernist carnival of language and denial of authorial control."[14]

Recognizing one's own bias in selection of research material is a long way from full-blown subjectivism or the denial of authorial control. Of course I, as critic, suffer the limitations of my time and situation. Of course I am interested in speaking to an audience who share my values and with whom I have a ready dialogue. But I do not want to write in a subjectivist monotone. Nor do I want to speak only to a predetermined section of the possible audience for the painting. This is not out of hubris, but because I do not think I will understand this or any other painting of wide and enduring appeal without looking into

how it can seem to effect the kinds of shift Baudelaire described in the experience of the "lover of the universal life," both reflecting on one's individuality in the crowd and at the same time making one part of the crowd as a collectivity, and further, as part of humanity. I must aim at (perhaps I have *de facto* assumed) a universalizing stance, however provisional and unstable, of a kind that holds the particular (myself, or some part of myself, or indeed part of someone I recognize, since I am not entirely locked within my subjectivity) in view, while at the same time remaining alive to the ways in which the painting resists. Who among art lovers has not looked up in a gallery to catch a look on the face of a stranger, perhaps someone quite unlike oneself, to be united with them in a momentary recognition? Just for that moment, you both know what you have seen and understood. It is part of Baudelaire's love of universal life. This alone means that "universalizing" does not have to be a return to a pre-modern exclusivity. It is also a stance that the painting seems to confirm, and it will take most of the rest of this chapter to say how.

The barmaid herself dominates the painting, but not its commentary. In accordance with the contemporary habit of fracturing and dispersal, her centrality as the pivotal symbol is disallowed. To put it another way, in the postmodern dynamic of free association and limitless play, she is deprived of her role as the semiotic lynchpin, the conduit to its take on reality. The barmaid herself, however, as a central portrait figure, is part of an inquiry into sexed subjectivity conducted by Manet throughout his mature life, conducted as it was more freely than our contemporary, post-Lacanian language often allows.

The *Bar* was the work of a secular visionary investing the immediate moment with time immemorial, while yet remaining with actuality. To bring the "beyond" into the material is not necessarily to recuperate the depiction of modern life to transcendent religiosity or the ethics of deferral, but potentially the action of one living in a great capital city and thoroughly aware of his cultural history.

The investment of the everyday with significance was Aphrodite's gift, and in the nineteenth century, full of invention and seeming-progress, she would have seemed apt. (I am not saying Manet makes a deliberate reference to her. I don't know, and it does not matter fundamentally, in the sense that the point does not rest on this.) Aphrodite was of course one embodiment of the goddess of love, and there is the *possibility* of love in the painting, suspended, but not erased. Prostitution is the discourse that our contemporary worldly criticism emphasises, and I would not sentimentalize it out of the work. But it does not account for it, not if understood solely as a social phenomenon, only as a collectivised fact of urban life. What is the individual take on this supposedly universal form of commodified sex? Why is the barmaid so inaccessible if she is a prostitute? Is she a prostitute-priestess? Is she an innocent, there for the first time, a modern Thel?[15] Or is it that a moment of recognition has occurred, like that of Chantal Akerman's suburban housewife-prostitute in her 1975 film *Jeanne Dielman, 23 Quai du Commerce, 1080 (Bruxelles)*, where the possibility of love will destroy everything she has? The film is shot in real time, depicting the

precise daily routine of a seemingly respectable middle-class woman who makes the same meal on each day of the week—and entertains the same clients, one for each weekday afternoon. What breaks this controlled existence is pleasure. One day, against her will, she climaxes with a client. Her world is changed.

Or is the barmaid another of Manet's costumed identifications, an exploration of the female at least in part in his own subjectivity? In this it would be radical indeed, but not singular. Many works were made by men at the end of the nineteenth century that evidence a strong relation with the female and/or with specific women, and Manet is no exception. His close friend Mallarmé, furthermore, must be one of the prime examples, and, to speak personally for a moment, it is this that has made both of them a significant element in much of my own work. It does not appear to me always to be simply identification or projection, or some other form of voyeurism, though in both of them it may sometimes be this. It is interrogative, and it is in the form of the question that the structure is to be found. A question is dialogic, whereas projection or identification are not; and if universality is at issue—which I think it must be in some sense if a concept of art is deployed rather than one of cultural product—blankness and silence are revelatory.

How might the *Bar* look, not only as structured on discontinuity and silences, but also as the last major work of a radical artist whose universalizing desire extends beyond that of his immediate history? Radicalism tends not to be thought in terms of the long view or the mainstream. Yet when Jonathan Dollimore calls for "a longer perspective on the history of thought," he is right to point out that there is a particular risk to would-be radicalism that comes from short-termism—that of complicity with the conservative. His point is especially trenchant in relation to desire, where it is the radicals who appear to inherit a sense of desire as daemonic and necessarily disruptive, thereby landing themselves with a formulation that inherently gives rise to the need to control. What he calls "radical continuity"[16] brings back into view not only the impossibility of a radical break with the past, but perhaps also its undesirability. It is appropriate as a view of history that shapes and appears in Manet's work, as will emerge below.

But in the end Dollimore stubs his toe on misogyny in the course of the very move I have referred to, which is toward acknowledging the daemonic and the persistence of myth. He supports Camille Paglia's revival of the Apollonian and the Dionysiac as the underlying struggle in culture. The effect of this move is to pit the masculine as reason in Apollo against the mostly masculine as desire in Dionysus, and the female is (yet again, and still) nowhere to be seen. The immediate and ordinary, in the expanded sense once symbolized by Aphrodite, and the conduit to marvellous through the senses, remains the repressed. The barmaid's cosmic connection continues to be displaced on to everything in the painting except what I see as an aspect of what is, so far, in European culture the female universal—"so far" in that it does not have to remain sexed as female. Perhaps it is because this conduit to the marvellous is a gift of passivity that it is attributed to the female, and until Western culture frees itself of that myth of the absence of autonomous desire in women, so it will remain.

Dollimore is right in saying that "older ways of thinking can emerge precisely from within the discourses which we thought has superseded them [. . .],"[17] but this emergence is only the beginning. The whole issue of cultural repetition is invoked, including the reasons why these ghosts are brought back, and the meanings that attach to the forms they assume in order to become visible. If the revenant is simply a projection of the old structure, then modern life is sucked back from its technologized glitter to chthonian slime, as if this opposition were truly the only model for the conflicting energies of a culture on the brink of becoming the first ever world culture, whatever that is going to mean. The way to lay a ghost, say the old wives, is to understand its question. Unlike the sphynx's question to Oedipus, it does not require an answer. Whatever the cosmic barmaid's question may be, I suspect it may not be addressed to Oedipus.

If radicalism, then, can come in many guises, including elements of the seeming-conservative, it was a complex issue for Manet, in his lifetime and ever since. He is a painter who has almost always been recognized as both radical and major, at least by radicals, ever since Zola first took up his cause in print on the first day of 1867. It was the time of Manet's mid-career retrospective, already conceived on the interventionist model of Courbet's independent pavilion, in response to the official system. All this is well known and widely documented. Yet he always seemed to prefer to maintain a relation to the mainstream and to the Salons. His was not a straightforwardly oppositional radicalism.

His position as radical now, however, is at the same time more equivocal and much the same, since within criticism, the adoption of a supposed radical stance, especially an oppositional voice, has been an orthodoxy for many years. Manet is ensconced as the founder/precursor of that certain modernism deriving from Greenberg, whose demise has been claimed by postmodernists. He stands as the first in a series, like Baudelaire's beacons in *Les Phares*, but with only a flickering gleam, since lighthouses are no longer really necessary; they stand as a nostalgic reminder of a redundant system.

A place for Manet has, as I say, convincingly been claimed within a number of very different critical frameworks, including perhaps three of the most significant of the last century: Marxism, psychoanalysis, and feminism. The latest of these is feminism, and the case for Manet as painter of sexual difference has been powerfully set out, notably by Carol Armstrong in her very recent book, *Manet Manette*.[18]

Indeed, the above is indicative of a spate of fascinating new writing on Manet, which appears to confirm that his work remains live. "Manet," artist and historical phenomenon, continues to come under scrutiny in such a way as to challenge and complement the more conventional art-historical approaches, deploying some of the powerful interpretative tools that have been developed over the last quarter century or more.

One reason for this is precisely his relation to the female universal, the risks he repeatedly took with the values that made him. This is why there is still more to be said about him, despite the risk of seeming to reconfirm the kind of Greenbergian history that I have suggested is, or should be, extinguished. The

work lies partly in finding a structure capable of allowing some of the opposing voices to talk to each other, not in synthesising them. Feminism is no stranger to strange bedfellows.

The critic who has most broadly and most recently discussed Manet as "universalizing" is Michael Fried in *Manet's Modernism*.[19] Carol Armstrong counters the universalizing argument in Fried, and I would not disagree with what she says. More, I have been enabled through her argument to develop my view of the female in Manet considerably, yet the differential and sexed universal I am proposing clearly leads somewhere else. Fried's argument is useful in getting us there because he examines both realism and the universals it implicitly references.

If Armstrong and Fried enable me to clarify and amplify what I am saying about sex on the one hand and the universal on the other, I do not mean to turn them into representatives of different kinds of Manet scholarship, despite selecting significant elements of where their arguments diverge in the service of mine. It is intended as a way of mobilizing what I am saying within current discourses both of Manet and his broader field, and of art and cultural criticism. Armstrong conducts an extensive analysis of Manet's relation to females and the feminine, discovering the "Manette" in "Manet." Fried insists on Manet's "universalizing." Armstrong's is a timely and important contribution to feminist readings of the period, and to Manet studies, and this book stands in a complementary relation to it. There are significant differences however between what they have done and what I intend. Indeed, it is precisely on the issue of the universal that Armstrong parts company with Fried, and this is also where I would dialogue with them both. Yet she is the more radical critic, and my arguments share her ground. I hope my discussion brings them into relation with each other's questions and issues.

The subtitle of Fried's book is "or The Face of Painting in the 1860s," printed above a detail, a close-up of Victorine Meurent as she appears in the celebrated and notorious *Luncheon on the Grass* of 1862–3. But despite imaging the painting of an era with a woman's face, still he does not make the connection between what Manet was investigating as "universal" and "the sex": like more and more of the painters who were to follow, Manet's new art operates to a significant degree around and through contemporary women, as demonstrated in detail by Armstrong. This is not to say straightforwardly that it is "about" women. The question is, as ever, why.

Fried's arguments relate Manet's to Michelet and to a certain canon of French painting, thereby linking his work to the major issues of the day. Well made though they are, they are framed so as to marginalize the dimensions of subjectivity and sex. My sense is that Manet's response to history painting, and to history in painting, is far more fractured than Fried asserts, and it comes much closer to Armstrong, who emphasises the discontinuities of Manet's work on many levels, what she calls his "inconsistency," but what I would call his sustained inquiry into limits. Fried glosses his claim thus: "Manet's use of sources in older art has as its deepest purpose the achievement of universality with respect to national schools," a programmatic approach paralleled in his working through

of genre, which took in everything apart from landscape. Fried believes that Manet looks back and unifies; I would say rather that he selects a new basis out of the old and looks forward. This novel kind of unification does not homogenize. It is rather a forward-looking reconstitution, desconstruction *avant la lettre*.[20]

In his extended and detailed examination of Manet, Fried goes in to the matter of genre at some length, though he does not problematize it. Genre, however, appears always as marked by the impossibility of completion in the generic, its definitional imperfection that evidences a lesser version of the tension inherent in the sexed universal (in that in genre the question of inclusion is at a secondary level), though one that enables consideration of the normative (in that once a genre is named, the question of the hybrid and/or the monstrous arises).[21] Thus Manet's work appears as non-genre in established terms: it not as a *fête champêtre* that *Luncheon on the Grass* is most interesting, nor as a "study of a female nude," but rather as a transgression of both, with portraiture thrown in.

It is a very new portraiture, however, and it was rare to portray a model in the same way as famous persons, lovers, or family, as Manet did. Fried finds Victorine's face in *Luncheon on the Grass* and *Olympia* equivalent to the "upright distance marker topped with an open circle" in the watercolor of 1864 of *Races at Longchamps*.[22] This marker seems to Fried to stare back, operating as an unintelligible and obdurate refusal. Clearly I think this symptomatic. A blank face, any blank face, is a very different signifier from a blank disc. When the face is that of a woman it sets up an entirely different nexus of meanings than it does for a man; try to imagine an argument based on a male equivalence to Barthes on Garbo, in his famous reference to the final shot of *Queen Christina*.[23]

Illegibility is not blankness, nor is it singular. The illegibility of portraits of Victorine is drawing attention to her face as that of a modern woman, an unknown quantity in the painting of modern life. It is often said that one of the necessary tasks in addressing sexual difference is the reinsertion of the male body into "disembodied" Enlightenment thought. Perhaps so, although I would qualify this to say that it is the displacement of it to accommodate the female that has to be done, since I think the male body is all too pervasive. The dehumanizing of a woman's face into the equivalent of a blank disc is one consequence of the evacuation of the human from the concept of women. It does not have to be deliberate. It just has to be possible—and invisible/illegible.

Genre does not map easily on to the artistic movements of the later nineteenth and twentieth century, whose self-declarations, oppositions, and posturing have held far too great sway over criticism. I have always held that they cannot be understood in isolation. A greater deconstructive awareness in the analytic history of all movements at a given moment—synchrony in the service of diachrony—would reveal more exactly how they are related more than they can ever oppose, but it is more than that, and much more specific.

This is not what Fried means, however, when he goes as far as to say "[. . .] Manet's priority as the first formalist-modernist painter should be shared with the Impressionists [. . .]." Clearly I disagree with the basis of a comparison that both projects a reverse teleology and erases the differences between a large

group of artists, Manet included. But the general idea that there is no conflict between Manet's work and Impressionism is both right and significant. The feminization of Impressionism is a complex matter, and it is a factor in its lack of status relative to abstraction; it was not until he was recently claimed as a forerunner of abstraction that Claude Monet, for example, could be fêted by the big boys. Fried does not mean what I would mean even if I agreed with his words above ("Manet's priority as the first formalist-modernist painter should be shared with the Impressionists"), and the difference is extremely important in differentiating what I am saying about the sexed universal from what Fried (and many others) mean by "universal." His account of Impressionism will not do. He summarizes it as having been, with "extreme rapidity [. . .] correctly grasped by its commentators," and he does so in the simplest realist terms.[24] The sentence just quoted goes on to include Courbet's Realism, on grounds of its flatness. More genre trouble! We can see where this is going, the track to Greenberg's door.

If I do not follow here, it is partly also out of scepticism over the primacy of this idea of flatness as well as my remarks on realism below. I take the generally accepted point about flatness, a commonplace of modernist critique, but do not find its explanatory power as great as seems to be supposed. I certainly wonder at its elevation into a credo, given the range of factors it can be used to homogenize. Or perhaps that is the point. You can talk about surface without calling it flatness, and in Manet, given his spatial ambiguity, the effect is, well, levelling. I am not being literal about this, or not only, since the basis of the idea is indeed literal, but I am considering the imaginative frame/imaginary this concept installs.

If this possibility is to make any sense, it must be approached through the material, in which Manet is deeply engaged. Paradoxically, this is one quality in particular in Manet that has perhaps tended to mask the aspects of his work I am emphasizing, since it is approached through what is called his realism. It comes to the fore in analyses engaged in exploring his relation to tradition, especially to French tradition through Courbet and the Spanish tradition through Velásquez. A view of the quality in his work that is named realism may be projected forwards, however, as well as deployed in recognition of its pathway out of Courbet or Spain.

The recent exhibition *Manet/Velásquez. The Spanish Manner in the 19th Century*[25] at the Musée d'Orsay in Paris affords a way further into this. The show includes many other French and Spanish painters, and does not stage a confrontation between Manet and Velásquez. The British critic Waldemar Januszczak sexes the result by characterizing France, the colonizer of Spanish gloom, as the Empress Eugénie, an interesting manoeuvre, since Eugénie, as Januszczak himself points out, was Spanish. "What we are actually watching is a one-sided colonization of the French imagination by the altogether darker, more intense, more virile, more psychologically charged Spanish imagination."[26] He even goes as far as to describe Manet's absorption of the art of Spain as a "virus."[27] Eugénie is a kind of Mata Hari, a dangerous undercover agent of feminine unreality on the one hand and foreign gloom on the other.

Januszczak reproduces the well-known pairing of Manet's *The Dead Torero* with its clear "source," *The Dead Soldier*, attributed in Manet's day to Velásquez. He finds Manet's realism lacking when compared to what he calls the "stripped-down reality" of the Spanish. Instead, Manet "leaves you feeling you are observing a costume re-creation rather than the real thing. It's a common shortcoming of Manet's overtly Spanish subjects. The costumes feel imported." Strangely, Januszczak also says, "pinks and blues have been banned," when it is the pink in Manet's *Dead Torero*, as I shall show, that bears the weight of its meaning.

FIG. 9 Edouard Manet *The Dead Toreador* 1864–5, oil on canvas, 75.9 × 153.3 cm. © 2003 Board of Trustees, National Gallery of Art, Washington, D.C. Widener Collection.

It is the Manet that is stripped down, and the costume is essential to the point. Gone are all the trappings of the traditional *memento mori*—the skull, the extinguished lamp, the bursting bubbles. The body is pivoted very slightly to afford a three-quarters view rather than a profile, and the gap between the left arm and the body and the angle of the drooped head both emphasise this closer, more intimate view. The Spanish painting is more than half way to imaging a figure on a sarcophagus, probably a deliberate device to dignify the soldier, since only the great are so memorialized; Manet's bullfighter is poignantly in the moment of death, his ring visible and hinting at a life, the tiny splashes of blood on the white shirt investing the

FIG. 10 Unknown seventeenth century master *A Dead Soldier* (formerly aka *Orlando Muerto*) National Gallery, London. Copyright: National Gallery Picture Library.

pink cloak with all the uncanny foreboding of red blood displaced on to the charm of pink satin. It is a detail that relays to many of his bullfighting paintings, in which he effects in colored cloaks the same marvel of the oranges in the *Bar*. Manet can convince you a scene is full of color when the palette is actually very restricted. The *Bar* is predominantly blues, with accents here and there, and the one intense moment of complementary, shiny orange. It is about paint and it is about life and death.

This is indeed an inquiry into realism, as was Manet's lesson from Courbet, but the result looks like an element of quite another kind of painting. We can approach it through color.

Color is a phenomenon whose existence and effect on the edge of materiality situates it on the cusp between art and philosophy. Its status in defining universals is matched by its explanatory power when considering realism. The "real" is a term which has always been contested, but especially so since the Lacan's opening out of the Real as indefinable further element rendering the Imaginary and the Symbolic binary into a sort of trinity (I am tempted to say, "triumvirate").

How does color—say, pink—relate to the kind of universal under discussion? Isn't it all connotation? Pink seems to carry meaning because it has linguistic and social applications, which can change. The notorious classification by the Nazis of gays with a pink triangle has been changed through gay liberation embracing the color as its emblem. But in practice, pink in painting is not quite the same. I am not advocating the Platonic notion of color, which would necessitate positing pinkness as the referent of pink. This kind of universal pink is quite distinct from any specific example, such as the cloak. It is supposedly common to all and only those particulars that are pink. At the same time, realism also finds this kind of universal necessary to explain what is correctly pink. But crucially, one version holds that this pinkness would exist even if there were no pink things, whereas the other, the Aristotelian, would maintain that the universal subsists in particulars. There is pinkness because there are pink things. There is no need for the universal to be real for it to be true, in the sense of bearing some relation *other than the arbitrary* to the signified. This is especially important if the universal in question is not restricted to the single, unqualifiable material object or, indeed, term.[28]

The traditional idea, deriving from Plato, that the concept of the universal is necessary to explain why all and only a certain class of particulars may be describable in a certain way appears to posit realism because it rests on referents. You need a universal chair to understand what is correctly a particular chair, from which it is distinct. The referent "chair" has something in common with all other chairs. The difficulty here for me is clearly the ideal abstraction of the universal; its corrective, though perhaps not its solution begins from something closer to the Aristotelian, approximately that universals are inseparable from the particulars on whose existence they depend. This view is not realist in the same way, since from a contemporary standpoint, it introduces a different kind of real, one not rooted in a distinction between the real of the here and now and that of the absolute.

No mention is made at the point in Fried's argument under discussion of the phenomenological reading of Impressionism that came later and that must surely be worth a mention or a footnote. It is most influentially traceable to Merleau-Ponty, and implicitly and explicitly posits a completely different subjectivity from that of realism. Ontology does not make the work of the historian easy. And in a fascinating footnote that Fried attaches in support of his claim that there exist "fundamental differences that have never fully been given their due" between Manet and Impressionism, he cites a female critic—a rarity indeed in 1874—whose words do not necessarily support his case here, which is rather

unsubstantiated and ambiguous. Fried takes the sex of the critic, who uses a male *nom de plume*, at face value.

Marie-Amélie Chatroule de Montifaud[29] (Marc de Montifaud) clearly prefers Monet, and with light irony contrasts Manet and Monet to judge the latter endowed with a grace the former will never attain. But she says nothing in the passage quoted that necessarily refers to fundamental differences. Indeed, her rhetorical style depends rather on the similarities.[30] What she says is entirely compatible with establishing a direct lineage from the elder to the younger painter, whereas Fried's aim is to conform to the general separation of "schools" in early modernism. Montifaud observes, "Whether or not the one worries about plagiarism, or couldn't care less about composition, the other knows how to melt disparate elements into each other, to find the secret of joining them in a kind of harmonious relation."[31] Here she hints at the point I would make: that the ontological implication works towards the same/non-same, a differentiated commonality. The individualism of earlier painting is dissolving into a mode that does not depend on a highly developed painterly style—disregard for plagiarism on the one hand, the discovery of a harmonious link on the other—and a painting that is not personal. It will lead to the extreme eradication of the signature style in some (beginning with the Impressionists, but also, for example, in color field painting), and to the variation of refusing stylistic consistency in others.[32]

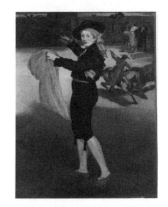

FIG. 11 Edouard Manet *Mlle V. . . . in the costume of an Espada* 1862, oil on canvas, 165.1 × 127.6 cm. The Metropolitan Museum of Art, New York, H.O. Havemeyer Collection, Bequest of Mrs H.O. Havemeyer, 1929.

Manet's use of sources is indeed a kind of summarizing gesture, and its character is not universalizing in the sense that contemporary critics wish to avoid, that of an exclusive appropriation of the right to "speak for" humanity. At bottom, it is a gesture that looks very different, not only according to the kind of subjectivity brought by the viewer, but also according to that interpreted in the painter. I would not claim, as some might, that this is always only a projection. It is a *responsive* subjectivity, unafraid of passivity in the way that Impressionism is; in that it is what has hitherto been named as feminine.

It also implies a particular kind of history, and here, too, Impressionism and Manet signify related responses to the same change, as in my view they would have to as contemporaneous serious art. Time in Impressionism is speeded up (Futurism did not invent this idea) and brought closer to the immediate moment; time in Manet began that process, and the importation of elements from the past is another strategy towards (in part at least) an ontological inquiry into time. I am not seeking to render them identical; I am trying to understand the pattern, and to do so in historical, sexed terms. Manet's starting point may seem to be with the public, Impressionism's with the private (in the sense of individual perception and family orientation; clearly they depicted a

kind of sociality, public in that sense, but strictly not institutional), but the point is not to freeze them into this sexed binary. It is much more complex than that. Both were working towards the reconfiguration of collectivity and the Subject. The objection may easily be raised that Impressionism was all about the new, public life of the moderns, and indeed, this subject matter is important, rendering more complex the initial subject positions: Manet's trajectory moves towards the more Subjective as distinct from the private or individual, perhaps;

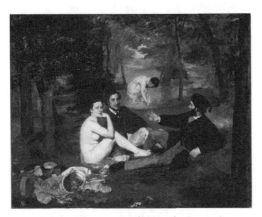

FIG. 12 Edouard Manet *Luncheon on the Grass* 1863, oil on canvas, 208 × 264.5 cm., Musée d'Orsay, Paris. © Photo RMN–Hervé Lewandowski.

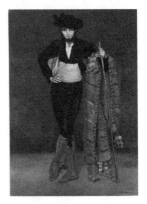

FIG. 13 Edouard Manet *Young Man in the Costume of a Majo* 1863, oil on canvas, 188 × 124.8 cm. The Metropolitan Museum of Art, New York, H.O. Havemeyer Collection, Bequest of Mrs H.O. Havemeyer, 1929.

and Impressionism's towards the more expansive and collective, objectivized. Manet appears to suspend time, while the Impressionists sought its evanescence. They are not identical, but they open on to differentiation of the same.

Manet's realism is of this order, moving between generalizable qualities and effects that nevertheless do not necessarily share distinct features with the specifics to which they may attach. It becomes a component of a more complex inquiry, whose aims may be related, in their analytic and phantasmatic structure, to Cubism, in the sense that the real is undergoing a change in its relation to the sign, as it is in relation to the sexed Subject. Later, I shall also link it to the work of Sam Taylor-Wood, not in any sense of suggesting influence or even straight-forward equivalence, but as a productive intertext on the sexed universal. Like Manet, Taylor-Wood takes as her models the celebrities of her time, mingled with friends and family, and her work involves fragmentation and the recognition of discontinuity; but it does not have to end there. It reaches towards a coherence that is not available to an art that does not problematize its own grounding in its own time and its own means. Manet's art is visionary as much as it is realist. What does it mean for a visionary to take as his subject matter contemporary mores, including sex? Critically speaking, this is an inquiry that demands the very long view. It is of course vital that Manet is understood in

relation to his time, as all his most prominent critics have done in various ways. But it is also necessary that his continued relevance is understood in greater detail, and at the same time with greater distance.

Dead Torero is one of a large number of paintings directly related to bull-fighting, and of an even larger range of Spanish "costume" works. One of these, *Mlle V . . . in the costume of an Espada*, draws particular attention to the costume, not only because it is in the title, but also because its subject is *en travestie*, or cross-dressed. It therefore takes up the Baudelairean theme of clothing as artifice, and as construction of "femininity." In contemporary terms, it also connotes sexed subjectivity, as it did then, though perhaps not as immediately as it does now. As students of Manet will know, its model, Victorine Meurent, figured in many paintings, and was perhaps the most favored of a painter whose models were rarely just models—family, writers, fellow painters, or individuals like Berthe Morisot, who was both painter and family (in that she married Manet's brother).

Unusually, too, he did a portrait of Victorine, in the same year, 1862 (unusually because she was not one of his social circle, nor was she a celebrity—she was, at least at first, just a model). Apart from this, *Mlle V. . . .* is the only work depicting Victorine that names her, or at least alludes to her name. It is a kind of portrait, but oblique; it is not called "Portrait of," it only alludes to her name through the initial of her first name, and it depicts a French woman in the costume of a Spanish man.

Dress and the body are clearly mobilized in relation to space, staged in a certain sense, in many paintings and etchings, including *Olympia* and *Luncheon on the Grass*, both among the most notorious of Manet's work, and both depicting Victorine. This last was shown at the Salon des Refusés in 1863, with *Mlle V. . . .* on one side and *Young Man in the Costume of a Majo* on the other. They are a pair among many pairings, both within paintings and in actual linked works. The model for this work was Gustave Manet—and it is also he who holds out his arm in the strange gesture at the centre of *Luncheon on the Grass*. Or at least, it is both he and Manet's other brother, Eugène, who may have posed; scholars are divided on this point.

There were no roles for women within the bullring, just as there have been none until very recently indeed in Western culture as a whole within scenarios of ritualized violence. The name of Victorine's *espada* derives from the "espadon" or double-edged sword; his is a lethal role. Nancy Locke has convincingly associated swords in Manet's iconology with Léon Leenhof, son of Suzanne Leenhof, whom he married when Léon was about eight.[33] The boy's paternity is unclear; he went under the guise of being Suzanne's youngest brother. As Locke has recently shown, he may well have been his brother's child by Suzanne, well before she became the painter's own wife.

Manet's family relationships were therefore complicated, and he explored both his personal and his social identities by mobilizing them, costumed, in works that are structured in whole or in part on previous masterworks. It is a semiotic investigation that brings sexed subjectivity and sign into a kind of per-

formative collision. Still more tellingly for the present argument, Locke suggests that an unconscious element in Manet's fascination with Victorine is indicated through her resemblance to Mme Manet in his portrait of her in mourning for her husband, his father.

The argument does not depend on an actual physical resemblance between the two women, but rather on a psychic configuration. Locke reads this in terms of the Freudian primal scene. Taking my cue from her, I would follow Victorine and Léon as outsider-protagonists in a psychic drama that pushes at the limits of the family and its sexed cast of players in the Freudian scenario. The nuclearity of the family Manet was already extended into a wider sociality, one that becomes inseparable from his identity as a painter. The public-private distinction is extremely tenuous, an interpretation strengthened by Manet's exhibiting practices, which ranged across the spectrum from studio shows, through his own independent pavilion (after Courbet), to the official spaces of the Salons.

Assigning sex roles to the pair of paintings *Mlle V. . . .* and *Young Man* along conventional lines is already disrupted by the fact that one is cross-dressed. Apart from this, it is a reversal. Gustave Manet leans on an obvious prop, in both senses (the stick is a staging device and a support for the pose), with an ornamental drape over his arm that would clearly be of no use in the ring. His right arm is on his hip, while his left leg points across his right with balletic delicacy. Indeed, the body overall is graceful and slight. His hat is impractical, with bobbles and a heavy brim that shades his modestly lowered eyes. The setting is neutral and could be indoors or out, in line with many of Manet's portraits, including those of the in-outsider, Léon. There is no sign of the bullring or any of its trappings other than on the body.

Victorine, on the other hand, is all activity, the central figure in a public display of violence. Her suspended gesture with the sword is repeated in the strange scene of the *coup de grâce* behind her and to the right, the red cloak an allusion to bloodshed, as the pink one is in the *Dead Torero*. Her yellow scarf draws the eye to follow the diagonal that makes two parallel lines extend from her arms to enclose the backlit scene in a backwards embrace: Her sword is at exactly the same angle as that of the man behind her, and her left arm lines up with the body of the bull as it merges into the front leg of the horse, the whole emphasised by the odd shadows under the scarf and the horse, and the lower edge of the cloak. Through an exact and emphatic construction of space, Victorine is implicated in the deathly scene behind her, mediating the viewer's access. She dominates.

This spatial disposition relays to *Luncheon on the Grass* with which *Mlle V. . . .* was exhibited. This, too, shows a striking scene in the foreground, with a strangely placed secondary event, in a background that is not exactly a background, because of the non-naturalist lighting, which we would now call backlit and spotlit, and because of distortions of scale. In both paintings, this scene dislocates the overall picture plane. There are at least two other significant similarities between them.

Victorine's pose in *Mlle V. . . .* is like that of Gustave/Eugène in the *Luncheon on the Grass*, and the composite brother holds a stick. His raised thumb aligns precisely with the woman's arm in the "other scene" behind the foreground trio, while her spread hand recalls the positioning and pose of that of *Olympia*: in holding her thin chemise, she also covers her crotch. (This spread hand appears in Courbet's *Portrait of Baudelaire* of c1847, on which Manet based his *Portrait of Mallarmé* of 1876, and again in his illustrations for Mallarmé's translation of Poe's poem *The Raven* of the previous year, 1875). The paintings are related as an intertext, going beyond the confines of frame or the self-contained, unified work.

The other similarity is that of subject matter, again accessible if the already mysterious manifest subject is extended. The first title for the *Luncheon on the Grass* was *Le Bain*, or the bath/bather. This would emphasise the importance of the female figure in the water whose position is so awkward if the figures are viewed as a group. Her position is not awkward if read as a dynamic indication, leading outwards from it. Underneath the figure of *Mlle V. . . .* is a nude, visible through X-ray photography, which may be of Suzanne, and which links to the theme of the bather with which she was associated in the period 1860–61.[34]

The paintings in this light do not appear as non-narrative modernist structures, and although discontinuous in temporality, spatiality, and address, they do not aim to erase these. They exhibit the structures of the dream-work, in their condensation of event and figures, their displacement, their repetition, and their relays. The merging of identities, however, and the transferability of the referent between signifiers, makes them difficult to contain with the Freudian/Oedipal story. Rather they disturb it. This is demonstrable through the mobility of the narrative I/eye and the sex of the protagonists.

The gaze of the textual "Victorine" cannot be fully accounted for as appropriating a putative male gaze, though she may indeed do this. The first person in the narrative is transferable, and so is the addressee. They are blurred in relation to each other. Such a loosening of the carriers of meaning in the semiotic event reduces the clarity of specific meaning, but it also opens the potential for new meaning, because it admits different configurations. The connotative, the detail, contiguity, and the syntagmatically marginal are promoted in importance, de-differentiating the structures that generate meaning.

The task is to complicate and refine any attempt to link specific forms or structures with sex. This is not to rule them out altogether, but rather to attend primarily to patterns of change and from a dynamic understanding to read the mutually productive. Given the asymmetry between the socialization of the sexes, certain forms are likely to predominate in either, which is not per se especially interesting. So-called *écriture feminine* shares most of its common features with texts by male predecessors; Cixous indeed claims some of them as feminine, including Mallarmé.

The common factor is not primarily sex. It is the sexual ambivalence of the transformative. The transformative was, according to Baudelaire, the defining characteristic of the dandy, who appears at times of historical change

and uncertainty ("aux époques transitoires").[35] But Baudelaire played down the dandy's "femininity," differentiating him from women in *Le peintre de la vie moderne*. He became *the* secular guide in a world of artifice to what had been the spiritual. It was as artifice, the power of the individual to make his (explicitly not her) subjectivity, and as a visible sign of transformation that the dandy's attention to his attire and manners, and to social ritual, carried meaning.

Psychoanalytic terms, however, can be read outside the Oedipal frame to indicate that dandyism brings both male and female sexed bodies into play in the formation of the male ego. It is a general psychic configuration that aligns with contemporary gay "clones," the fetishized gay attire and body presentation that articulates identity through the physical and material.

Clothes for the dandy *are* the body. In its extreme form, dandyism involves denial of the existence of nakedness under the clothes. Freud's notion in *The Ego and the Id* of the ego as bodily projection,[36] as not just surface, but the projection of a surface, is here replicated at one remove—the ego becomes the projection of a projection. In this way, the dandy is enabled to "make up" (invent, use cosmetic means) a living fetish. In his elevation of the *toilette*, Baudelaire puts the exclamatory questions: What poet would separate a beauty from her costume? What appreciative man has not enjoyed the complete unity ("l'indivisible totalité") a woman makes with her clothes?[37]

This process is compatible with the underlying idea of the ego in Freud, but it changes the fixed sexed configuration of identity of the Oedipal formation. The dandy clothes the maternal emptiness or absence in totemic paternal fragments of superficial décor, to paraphrase Chervet.[38] But the emptiness is not just the fear of castration; it is the socio-symbolic castration that is the loss of the mother. In Lacanian terms, if clothing and the body are regarded as interchangeable, the dandy is making of his own body the phallus; both the father's (the lack in terms of possession; the penis he has not got) and the mother's (the lack in terms of psycho-corporeal existence; the penis that does not exist).[39] In the present terms, the dandy appears to overlay fetishization with hystericization, the former supposedly male and the latter, female. In other words, he crosses the sex boundary in terms of psychoanalysis and the body at the same time as he dons the transforming garments or make-up. An exclusively male phenomenon, dandyism, is by definition formed through the female body.

A similar interchange appears to happen in Baudelaire's treatment of women in *Le peintre de la vie moderne*. In the section in praise of the cosmetic ("L'éloge du maquillage"), he is keen to differentiate the cosmetic from the imitation or embellishment of nature. It is artifice, even cheap effects ("le rien embellit de qui est"), that frees the dandy from the constraints of a nature depicted as animal, deprived of the supernatural that is art. It is but a short step from nature to the female, and Baudelaire tries bravely to exclude it.[40]

In what sense, then, is dandyism exclusively male? If the phallus really is properly regarded as separable from the penis, female psychic structures can be understood as analogous to the dandy as the concomitant formation within the

social body. De Lauretis points out with regard to the supposedly exclusively female phenomenon of lesbian perverse desire that "[. . .] the fantasmatic object is the female body itself, whose original loss in a female subject corresponds [. . .] to the narcissistic wound that the loss of the penis represents for the male subject." I am suggesting something slightly different from this, while drawing on her insight, because, deploying the idea of a sexed universal would suggest that any correspondence between the female and the male subject turns on a differential view of the same phenomenon. Both sexed subjects have suffered the loss of the female body, at birth and because the female is inadequately symbolized, and this impacts on phallic power, such the psychic loss of the penis. These losses are not identical, and do not make all subjects into the androgynous and similar. Rather they indicate a generalizable pattern of relations within which change may occur.

If the Lacanian "phallus" as a concept were truly neutral, and the elaboration of female sexuality as full as that of male within psychoanalysis, then nothing here would necessarily be impossible to encompass in its terms. But these provisos are too great for it to be possible to say that the phallus is appropriate as a term.

My point, then, elaborates on the hypothesis that either sexed body implicates the other in its own corporeal and psychic formation, or psychic corporeality. There is no exclusivity, there is nothing that is solely male or female. Wherever there is a phenomenon that is seemingly exclusive to one sex, its analogue will exist in the other, and though it may be displaced or otherwise differentially formed, it will stand in some relation.

Castration is of course critical in current formulations of desire as lack. In its reference to the subject's apprehension of a self as separate from the mother, narcissism relates to the female body. Since the female subject relates more directly to the mother, there is a greater degree of enclosure in this reflection, and a correspondingly lesser degree of the drive to cross an unbridgeable gap. Lacan's text bears interpretation in this way when he contrasts the "naturalness" with which butch dykes "appeal to their quality of being male" with what he called "the delirious style of the transsexual male."[41] These kinds of sexuality are particularly relevant because of the fetishized elements shared with dandyism.

Appealing to a quality is very different from transsexuality, however, no matter how naturally it may be done, and in setting the dyke alongside the male tranny, Lacan appears to do as the dandy by equating the body with clothing. This amounts to a revealing elision, because the transsexual male undergoes voluntary castration in order that s/he might recover the female body, and as a physical event this seems to bring closer the fear that produces Lacan's refusal of signification to the female body. In order for desire to be satisfied, the male returns to the female body, and in so doing forfeits his primacy. Inevitably perhaps, through all the sophistication and pyrotechnics, Lacan sometimes reflects the stereotypical understanding of his time of women as closer to the natural. It is not a matter of the natural, nor is it a matter or being male, as the experience

of the dildo-wearing dyke testifies: She makes no appeal to the natural, nor does she differentiate the prosthesis from her body. She is more cyborg than male-identified. Yet her sexuality manifests considerable differences from that of the butch, who may be historically, perhaps, her predecessor; though there can be no certainty about this before explicit "scientific" writings on sexual practices. Forfeiting primacy is not the same as disempowerment or castration. The dandy's subjectivity is, in Baudelaire's words "un culte de soi-même,"[42] a cult of himself. He has not achieved identification with the father, but rather an extreme form of identification with the mother that goes beyond many forms of female subjectivity, certainly heterosexual forms. His narcissism is complete and he desires nothing beyond himself. This is only necessarily the absence of desire if desire is never autonomous and, perhaps more importantly, never contiguous, but always a trajectory across a gap and towards some absolute "other."

If we consider the *Luncheon on the Grass*, in which clothing and the body are clearly and explicitly at play, as the centre piece of a displaced triptych, with *Mlle V. . . .* as one side panel (especially if the existence of the nude that was painted over is borne in mind, as mentioned above) and *Young Man in the Costume of a Majo* on the other, they form a mocking and bravura exploration of the sexuality of the dandy. A pile of clothes by the naked Victorine, the fashion-able toilette of her companions, the theatrical presentation hinting at a cross-dressing that moves beyond costume towards the performativity of prosthetic clothing: What might Baudelaire have written, had he taken Manet, not Guys, as his painter of modern life? Manet's problematization of the sexual economy clearly goes beyond that of the "gaze," which is in these paintings a specific part of the story, but far from the story itself. Clearly the look, especially in the eyes of Victorine, is highly significant; but how and why they are so lead back not only to the body, but to the female body in relation to which the others enact their masquerade. In *Mlle V. . . .* she is a circus ringmaster, who yet looks over her shoulder like Manet's image of Zola's *Nana*. The emotional register is com-plex; detached, knowing, one of self-enclosed suspension—the flâneur cannot be moved, any more than the cool cross-dresser of the 1960s—but not the aristo-cratic condescension Baudelaire sometimes attributes to his dandy. Rather, it is the complicity of his address to the reader of *Les fleurs du mal*: hypocrite reader, my likeness, my brother.

PART II: DEMOTIC SPEECH, UNIVERSAL SUBJECT: TAYLOR-WOOD AND MORIMURA

Morimura and Taylor-Wood both make explicit reference to Manet. This alone would not be sufficient reason for connecting Manet to the contemporary, since references to him are so many. It is as portraitists that I want to examine their work, as working the genre through to the limit in the construction of embodied Subjectivity.

Still more pertinent to the present argument than Manet's use of portrai-ture, as discussed above, is self-portraiture, and I think it might relate to the simultaneous tendency towards narrative and suspension of narrative in Manet,

a kind of poise between economies. His portraits are not separable from an inquiry into the self. If the separated ego is visual and melancholic in predisposition, then perhaps the more contiguous ego developed in recent feminist theory since Irigaray is oral and manic in predisposition. Let us suppose that these are indeed in the current economy sexed predispositions, as it would appear, in which case the potential for an art that works beyond such boundaries would also move towards a changed sexual configuration.

Contemporary digital art offers the potential for kind of self-portrait that works beyond such boundaries, because hypermedia is more than the sum of its constituent media, and constitutes a connective structure that links all art forms. It comes somewhere between the traditional fine-art self-portrait and the literary genre of the autobiography, a form which feminist literary scholars have illuminatingly theorized in terms of interrogating the selfhood it appears to posit.[43] The innovatory potential of digital art for the self-portrait is its capacity simultaneously to bring all these elements together and to open them on to something greater. With due awareness of the monstrosity of so doing, I have called this hybrid "cybiog."[44]

The Japanese artist Morimura exemplifies a move in this direction, though he often works, like Cindy Sherman, to whom he has paid tribute, through photography.[45] Sherman's implicit narratives rely on film, already a hybrid in terms of the pre-modernist visual-verbal divide, and interestingly a form in which the genre of the self-portrait as such does not exist, as far as I know. The trick of the self-portrait photograph was to introduce a series of splits or dissociations in identity around the light of a single moment. The light bounced off the physical self at the moment of image-capture could be changed and reproduced, but it always retained the fascination of that indexical link with the body, a kind of imaginary aura.

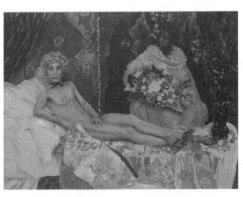

FIG. 14 Yasumasa Morimura *Portrait* (*Futago*), 1988, color photograph , 82¾ in. × 118 in. (210.9 cm × 299.72 cm.), San Francisco Museum of Modern Art. 97.788. Collection of Vicki and Kent Logan; fractional and promised gift to the SF MOMA.

Morimura's *Art History* and *Actress* series implicitly bring the iconicity of film into collision/collusion with the quite different iconicities of both the painting and the photograph, and all of them with reference to his own image as female. The earlier *Art History* images feature Manet prominently, with *Portrait Futago* (1988) closely based on *Olympia*, asserting a blonde Olympia with Morimura's Asian features, which are shared by the black woman to the right of the painting, the bringer of flowers. It is a double self-portrait, trans-gendered and trans-raced: Olympia's body has male

breasts, but her/his genitals are as invisible under that notorious hand as Freudians seem to think female genitals are by definition. Such self-portraiture cannot be understood in traditional terms.

The trick of the digital self-portrait is to offer a surface which breaks the indexical link to remake the object every time it is brought up on screen. In this sense at least it has no frame.[46] That is not necessarily as radical a break with the body as some would have us believe, but it is a vast distancing (and Morimura appears as anything from goddess to fruit, opening on to another materiality that might erase the distance). What it can do that is new is to counter the splitting from the body surface by making possible new connections: with the machine and with other "selves." If, as Barthes said, "the Photograph is the advent of myself as other," then the digital is the advent of others as "myselves." The little death that Barthes locates in the photograph has in the digital an afterlife, though perhaps it cannot escape the epitaphic that autobiography always contains.[47]

Morimura relates to Manet through his cybiog as progenitor of his mutating subjectivities. A strong relation to the contemporary feminine is implicit, furthermore, because the change in material-mental relations in cybiog releases new intersubjective and transgendered energies.[48] This relation also exists with "minority" cultures, not only in the Western context, but whenever individuals are displaced: Both the displaced and the feminine are, in a sense, mutational and nomadic. They are no longer necessarily confined within the master-slave or exploitative relation.

Morimura, then, takes the step that Manet did not take—I do not think it was available to him, even if he had desired it—of portraying himself as Olympia. What Morimura's art enables is the retrospective view of Manet's implicit direction. In his identification with Victorine, he sought his own reflection. But he finds a kind of blankness. Not the dehumanized disc of Fried's equation, but rather Heidegger's "nondominating attitude to what French feminists call the excluded feminine dimensions of language, e.g., nonmeaning, nonbeing, absence"—in Patricia Huntington's words, the "protoethical possibility of taking pleasure or finding *jouissance* in groundlessness."[49] Such arguments facilitate laying the groundwork for a positive, nonmelancholic theory, partly because there has to be something other than elation with which "jouissance" may be tainted. Elation relates to the same mental economy as melancholia.[50] The price of displacing the economy of melancholia may be the myth of feminine jouissance.

These questions about signification in new media have a particular bearing on the philosophy of being—specifically, for example, on the relation between the ontic and the ontological. If indeed cyberspace shifts "being" away from presence towards something like "Being" in the abstract, or as constituted through the collective as dispersed relationality, how cybiog performs (its) being will reformulate such issues, and how they are sexed. Manet through Morimura (and, as we shall see, Sam Taylor-Wood) is one indication of how it can be understood historically, or how it might begin to be historicized. Cybiog in

Manet as precursor to this new form or genre (in Derrida's sense) foregrounds elements that develop the contiguity between the embodied subject and the possibly prosthetic, possibly somehow "collectivized,"[51] but not external, thought-space that is the virtual. From here, a useful comparison appears with abstract visual art, which is productive in resituating language in subject formation as process. If my sense of virtual iconicity is correct, a shift occurs on the same model as that pertaining to the sexed digital/ized body.

At the extremes, artforms, like lifeforms, cease to be primarily about their own specificity, though they do not transcend it. In this way, abstract painting ceases to be "about" the visual. It moves towards the fictive space of the virtual, a feature which was in pre-virtual times frequently described in terms of music, and on which claims of universality are based. The cybiog shares with abstraction a topological relation to the referent (in this case the "self"), in the sense that it does not describe physical externality, but rather a qualitative set of relations between the surface and "something else." To put this another way, it extends the physical, including appearance, towards an abstract or patterning of the material. Materiality in this sense is not distinct from selfhood, or indeed from thought, but rather recognized to be continuous with it. In the place of the fantasy of absence of self and body beyond the screen is a far more challenging re-figured and potentially re-sexed body. It is potentially newly sexed because its biological sex is only its starting point in the cyber-social, and thus "presence" is not definitional; if, for example, an avatar is transvestite or transsexual, then these identity choices are in terms of presence on the same level as each other and as any other. This is not so in the actual-social. It is more than pointless to deny that biological sex relates to the actual-social in a much closer way, even though it is not necessarily its determinant. Arguing this does not reduce to biologism. To take this further, I now turn to the work of the British artist, Sam Taylor-Wood.

> If there was a strength to British art in the 1990s it was a gutter confidence, a demotic speech that tackled universal subject matter.
> —Jonathan Jones.[52]

Jones excludes Sam Taylor-Wood from this judgement, finding that apart from her recent photographs, which are "simply emotional," her work consists of "chill, flatly ironic film installations [. . .]. It is the lack of any reason for these works to exist, the sense that their only value is anecdotal, the cumulative fatuousness—why should anyone care that she knows Robert Downey Jr?—that makes it bad art. Only the editor of the anti-Britart newsletter *Jackdaw* will be satisfied, because it lends credence to his vision of a corrupt art world with an unseemly desire to be in on the hype."

What he is objecting to is an emotional register on which many critics have commented; Michael O'Sullivan, for example, calls it empty "post-postmodern nose-thumbing."[53] Their reactions echo many of those of early critics of Manet, and indeed what I might call the "screen-effect" of her work bears strong

comparison with that of the Manet, and for many of the same reasons. By this I mean that both artists present the viewer with images suggestive of meaning, while at the same time denying access to it, a structure related to that of the screen memory, in which the accessible memory both alludes to, and shields from consciousness, a deeper mnemonic deposit (if it is unconscious, it is not strictly a memory). There are many ways of approaching this: constructing a narrative out of the manifest content, looking for displaced connections between the elements of the work, treating it as an abstract work where you accept there is no referent, but rather an arrangement or structure which simply is, to suggest but three. All of these may be relevant, and may contribute to a multivalent analysis of the works as interrogative. They are seeking the right questions, partly through a process of suggestion-refutation.

If this structure seems more closely allied to the female than to the male, it may be that "femininity" demands such a great deal of denial, both in subject formation and in its continuation (since being feminine is a high-maintenance activity). This is where the dandy differs from the formally dressed man and is more feminized, since he, too, seeks to symbolize the absent female principle, including, but more than, his mother.

The issue of celebrity that exercises Jones in the review just quoted cannot simply be dismissed purely as bad faith as a feature of contemporary art, though indeed it may sometimes be this. It was certainly a significant element of Manet's art, most clearly in *Music in the Tuileries*, in which Baudelaire appears along with the glitterati and many recognizable celebrities of the day. What is the fascination with the rich and famous (as typified in the mass media by the *O.K.* or *Hello* magazine phenomena) but a desire for an Olympian world, the old gods costumed by Chloë or Versace? There is in the contemporary scene one difference, however, from what such an elevated sphere used to mean, and it is access. Once the gods were all-powerful, their despotic privilege transferred to royalty and its attendant aristocracy through the Divine Right of Kings. Now the ticket to Mount Olympus can be bought with a popular song, and membership in the "artistocracy" gets better press than that of the upper classes. (After all, it takes a cataclysm or revolution to bring royalty and aristocrats down, whereas celebs can easily fall at the whim of journalists). The view of one who has become an insider is as valid as any other, and indeed it is precisely this that may be new. It is one that was not available before, despite the exceptional parvenu who gained limited entry through beauty or some great achievement, because any such persons were never allowed to define or to speak for the gods. Even Zeus has bowed to demos, and Mercury works for Warner Brothers.

Manet's own celebrity was not inconsiderable in the Paris of his day, as indicated for example by the impressive committee brought together to buy *Olympia* for the Nation. It brought out the A List. Eric Darragon opens his biography with the fact of Manet's fame. Carol Armstrong hints that some of Manet's seeming-identification with the greats arises from a nostalgia for the society of the Court (such as the one Velàsquez inhabited).[54] But I think rather that this is part of his exploration both of the construction of sexed identity and

of its social effect; the Ur-King and Queen are the Oedipal parents. Dislodge this, and the Court is open to the people—perhaps. Clearly it is not simple.

Although Manet cast himself in many costumes and roles in his paintings, he was never identifiably cross-dressed. Perhaps this is displaced, either into elusive structures such as those suggested, only to be withdrawn, as in the "triptych" formed by the *Luncheon on the Grass* with its side panels of *Mlle V. . . . in the Costume of an Espada* and *Young Man in the Costume of a Majo,* or in the elaborate costume of, say, his self-portrait as Rubens in *Fishing* of 1861–3 (not illustrated). This last also incorporates a portrait of Léon Leenhof and of Manet's wife, Suzanne Leenhof (as Hélène Fourment, Rubens' wife). This work is linked to *Luncheon on the Grass* by date (both around 1863), by the general structure of the landscape, and by the stooped figure that occupies the physical, but not the apparent or manifest psychological, centre of the work: In *Fishing,* the figure is a boy in a boat, and he faces towards the left, whereas the figure in the water in *Luncheon on the Grass* is a woman who faces right. But it is the same pose.

Sam Taylor-Wood can afford to be much more explicit in her *Self Portrait In A Single Breasted Suit With Hare* (2001), in which she appears in a man's suit. So much has changed since Manet's day that it is sufficiently unremarkable to see a woman in man's clothes for it barely to read as such. Here she uses a man's suit as synecdoche for her post-operative, single-breasted female body. Her facial expression recalls that of Victorine in *Luncheon on the Grass.*

In suggesting common ground between Manet and Sam Taylor-Wood, I am constructing an intertext around sexual difference that does not necessarily seek to make direct links, and certainly not the kind based on equating them. My emphasis is on the differentials that make comparisons really productive when considered within an overall imaginary, if I may so put it, the articulation of a sexed imaginary, poesis in relation to the social formation. In this, she is perhaps darker. If Manet's barmaid is detached, many of Taylor-Wood's figures are isolated to the extent that even the negative relation that is detachment is lost. She does not appear to refer directly to Manet, either in her works or in what she says, although, like Manet, she adapts extensively from the repertoire of great European painting. Her work includes references to (at least, and for example) Botticelli, Gainsborough, Velásquez (*The Rokeby Venus* in her photographic work *Soliloquies*).[55] Michaelangelo (*Pietà,* in her film loop of the same name), Leonardo da Vinci (*The Last Supper* in the photograph *Wrecked* 1996), and numerous mythological and religious themes. Perhaps it is in the treatment of religious themes that she is furthest from Manet. In Manet, they are subsidiary, and his *Dead Christ* is hardly one of his major achievements. Her Christ lives, precariously: *Noli me tangere* suggests that to be touched would threaten Jesus' transitional state. The artist is reported to have told curator Olga M. Viso that she wanted to achieve the threat: "[. . .] of having the man standing there in a vulnerable state, so that touching him might totally shatter him."[56] Of course, "noli me tangere" were the words spoken by Jesus to Mary Magdalene in the garden in that strangely transitional time before resurrection was consummated at the Ascension; the god-man rendered vulnerable to the sexual woman.

Manet did not attempt to portray the Virgin Mary—unless you agree with those who see her in the barmaid.[57] His omission is as interesting as this possible displacement, since women occupy such an important position, not only in his overall oeuvre, but in what are recognized to be his major works. Taylor-Wood has not only referred to the figure of the Virgin Mary, but has cast herself in the role. *Pietà* shows her not enthroned, but sitting on a flight of steps, trying to hold a man's body in the familiar position of the Virgin holding the dead Christ in her lap, his body open and vulnerable. Michaelangelo's *Pietà* at St Peter's in Rome—the iconic work damaged in an attack a few years ago—is invoked despite the relative humility of this image. Inevitably, she cannot hold a body like this for long, and as he begins to slip out of her grasp, the film loop returns to the beginning. The viewer is deprived of seeing the moment when he falls, just as s/he is also shown the scene only after the protagonists have taken up their positions. The moment is thus extended and truncated, temporal but never-ending.

The body of Christ is that of the actor Robert Downey Jr, and the film was made with leftover stock from the making of a video of the actor lip-synching the musician's latest song at singer-songwriter Elton John's home. Given the iconicity of film, this ostension opens out in identity terms the question of the referent: that is, the relation of the actor to the persona is redoubled; a known actor mimics a known person while playing the role of another known person. Moreover, that known person, Christ, is of mythic or divine status. It thus plays from the self-portrait to the mythic figure through role: Taylor-Wood; Virgin; Taylor-Wood as Virgin; Taylor-Wood as painter as Virgin; Taylor-Wood as actress as painter as Virgin; or not Taylor-Wood at all, but contemporary white woman as actress as Virgin.

Looking past commercial or self-promotional motives that may or may not be involved in portraying celebrities[58]—Manet's included famous actors such as Faure (in his role as Hamlet)—they are powerful signifiers as figures in the contemporary imaginary. They are, and are not, portraits; as Victorine is, and is not, "herself" in the several paintings in which her features are clearly recognizable; and as the drag queen is and is not the Judy Garland or other female singer to whose song s/he mimes. The public image as an element in the constitution of the self, qualifying the family and depriving it of its unique status as the conduit to the collective, is perhaps a consequence of the development of secular painting. The transitional psyche of the dandy is not far away.

Further still than this, however, is Taylor-Wood's particular invocation of time and space, a dynamic topology that works as strongly with Manet's secularism as it does with her tendencies towards religiosity, and it echoes the strange suspension of time experienced through the surface imperturbability of his best work, such as the *Bar*. Taylor-Wood's movements between time-based media and the still image take up this inquiry, and it recurs in different ways through her exploitation of technology, such as that enabling her to pan through 360 degrees, previously a feature of art film alone—*Five Revolutionary Seconds* also deploys displaced sound, effectively anchoring this strange visual experience in the real.

In *Pietà*, read now in terms of the social and of time rather than as above, the fact that although the woman (Taylor-Wood as woman as Virgin) cannot bear the weight of the man's (Downey as man as Christ) body for long, there is no consequence, the return of the start of the loop just as the fall becomes inevitable suspends the narrative against the story of the eternal made temporal; the son of God as mortal man stretches his mother to the limit of fleshly endurance, to be returned to the strength of her embrace at the moment that would have been the end. It is as relevant to the current social formation as it is to theology, especially when related to Taylor-Wood's broader explorations of time and space, and of narrative. Theirs is a questioning interdependence in time, not human mourning in impotent contemplation of divine mystery.

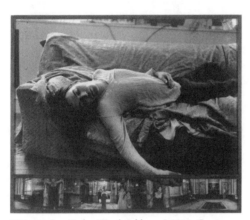

FIG. 15 Sam Taylor-Wood *Soliloquy I*, 1998, C-type color print, 6 ft. 10¾ in. × 8 ft. 5 in. (210.19 × 256.54 cm).

The two *Soliloquy* series are perhaps most explicit in articulating these abstractions in concrete terms of the individual-social problematic, underpinned with a covert religious question. Both soliloquies consist of portraits positioned above a panoramic photo series, which has been linked to the predella, an element common to Italian Renaissance altar paintings in which a narrative is depicted below a central image that relates both aesthetically and thematically to the figure seen above, perhaps representing the inner reality of the person portrayed. The multiple levels of *Soliloquy I* and *Soliloquy V*, however, take the viewer through the individual's self-address (or soliloquy, which in any case is a dramatic convention, not a matter of "inner reality") to recall Manet's internal referencing and the implicit serializing that occurs when these are followed through.[59] The predella could be thought of as a variation of the triptych structure that I have suggested can usefully illuminate the *Déjeuner*. The Manet, like Taylor-Wood's phantasmatic scenes, suggests an internal-external relation that is worlds away from the didactic narratives of altar painting in substantive and formal terms. This is much more the interrogation of the spiritual than its interpretation.

Time is explicitly at play in Taylor-Wood's *Killing Time*, a work which consists of four screens showing contemporary ordinary people in everyday, anonymous settings, singing roles from Richard Strauss's *Elektra* (of 1909, libretto by Hugo von Hofmannsthal). Richard Dorment commented that the theme of the work is "simple, indeed commonplace—that if you scratch the surface of normal people, you discover a cauldron of implacable hatred, envy, and desire. It is the visual expression of this idea that is so original."[60] This would

only be tenable if you were to drain the work of manifest content to the point where the selection of opera became arbitrary, and seems still more perverse, given the themes. Electra is the dominant figure of the Orestes cycle of plays, and the figure selected by Freud for his misguided attempt to balance the Oedipus complex with a feminine equivalent. As Philip Slater put it in his study of Greek mythology in relation to the Greek family, in the Orestes cycle, a "[. . .] simple tale of war and politics [. . .] was later transformed into one in which matricidal revenge was the central theme. Paradoxically (but not really surprisingly), it was the gynophobic Athenians who filled the story with women and made it a tale of family conflict."[61]

Putting matricide in terms of temporality is a bold and serious move towards understanding it in universal terms. Time and space are as distorted in Taylor-Wood's work as they are in Manet—expanded, condensed, and held in suspension around the non-classical narratives inhabited rather than enacted by her protagonists.

Reviews of Taylor-Wood's work in general tend to worry about its supposed emptiness, and yet at the same time appear to avoid tackling either its manifest content or its feminist antecedents. *Slut*, an earlier work of 1993, shows the artist wearing make-up, and with a bruised neck, holding a balance between descriptive and the analytic characteristic of recent feminist-inspired work, while *Wrecked* (1996) and *Fuck, Suck, Spank, Wank* (1993, referencing Boticelli's *Birth of Venus*) reference work by artists such as Mary Beth Edelson, whose *Some Living American Women Artists/Last Supper* (1971, offset poster) is based on Leonardo's work, as *Wrecked* is, and also counterpoints the central image with a series of others, this time arranged as a frame. The gestures of the Apostles are rearranged, and the design ironically asserts women's place in the history of art, commemorating them in the manner of paintings such as Fantin-Latour's *Hommage à Delacroix* of 1864 (in which Manet is prominent, with Baudelaire seated at his side), or the photographs in which many movements of the twentieth century declared their allegiances. These are always dominated by men.[62] Thirteen women artists are named: Lynda Benglis, Helen Frankenthalet, June Wayne, Alma Thomas, Lee Krasner, Nancy Graves, Georgia O'Keeffe (in the Christ figure), Elaine de Kooning, Louise Nevelson, M.C. Richards, Louise Bourgeois, Lila Katzen, Yoko Ono. Sixty-seven others are arranged around the border.

It is a strategy of appropriation and intervention with many variations. Taylor-Wood's handling of it takes it forward from the explicit to the imaginary, negotiating morphogenetic form and antecedent with subtlety.

The effect is not to equalize or homogenize all these kinds of painting, nor is it to dehistoricize. Rather it is to recognize a dynamic between them other than one of opposition. A differential relation exists between the works of contemporaries, especially at times of rapid socio-political change. Categorization into schools can mask this, as indeed can a nationalistic focus since the nineteenth century at least, and to an extent before—since communications really began their international free-flow in the Renaissance, a process accelerated exponentially in the nineteenth century, enabling the artistic phenomenon that was to be "Paris."

It is a specific post-Romantic, forward-projected universal aspiration, and while it may have grown out of colonialism, the colonizing ego is not the only possible model. It would not fully account for the theory and practice of Mallarmé, for example, who was right at the center of these worlds of nineteenth-century painting, and whose thought has continued to engage contemporary critical theory, not least through writers such as Derrida or Cixous. The universal aspiration in Mallarmé, as in Manet and many others, was to a significant degree symbolized through women and through the feminine, yet his art was not "about" women in any clear or direct sense, again, as in the painting. This can be read as a cancelling gesture: patriarchal art that obliterates women, transferring to men such qualities as they wish to appropriate. Indeed there is misogyny in Mallarmé, and it would most certainly be possible to elaborate an argument to this effect. But the centrality of female figures, or even their presence, in an art that aspires to universality, be it through explicit inquiry, or through an address to the enduring questions faced by every generation, should restrain the critical mind from solely negative interpretation.

The effect of the use of pre-modernist art that sought to articulate the great issues of the day through religion or myth was ideological, the reinforcement of status quo. The contemporary was restricted to the ruling classes or to the minor genres. Of course there are exceptions to this (Vermeer springs to mind) but let this rough working generalization stand for now. The vocabularies at the disposal of European painters before the mid-nineteenth century accorded very much more specific and restricted space to women, regardless of how many female figures appeared, and of course women were never the intended audience of the major genres. Perhaps because their lives were further from the heroic, the goddesses were further away from them. They could not address women, femaleness, the feminine, as concepts, abstractions, or semiotic elements, directly at all. The Virgin Mary seems to be the exception, and I shall take this up in the next chapter, where I shall argue from the standpoint that she may not be about women at all, but rather the emblem of their exclusion from the universal.

Bringing sexual difference to bear on our immediate predecessors, who have remained relevant to cultural commentators ever since, is historically justifiable through the progressive works of the mid to late nineteenth century themselves. In according both a prominent place to women and/or qualities called feminine, they also refuse closure. That is, they have in common elements of what I might call structural suspension, deliberate refusals to complete meaning that go beyond the inevitable acceptance of the limits of meaning or perfection of form or expression.

The ineffable was moved center stage, as it is in the art of visionaries or mystics, but in the articulation of a new secular art that aspired to the kinds of experience and understanding that had been their horizons. The barmaid is also a child of the universe, and in the absence of the son of god, the questions she poses are never going to be simple. Manet's Christ is thoroughly corporeal and thoroughly dead.

The task then does not mean moving in the gaps, however, or even "filling them in." It means revising how the structure is understood. Various models

might have served for this: the abstract female as the male unconscious, women as the dark continent, the female as the basis of the abjected other. But these inhibit the work of opening on to a new scenario. The initial issue may still be the cancelling out of the female, female semiotic mutilation maybe, but the way through to potency, if not to wholeness, must attend to this: that the near-universality since pre-history of the "othering" of women and unknown strangers appears to be connected with the traditions of linguistic representation, whereas it appears to be less so in the visual and artefactual. This is a huge claim, but I will risk the charge of being grandiose if it makes the point. It is in language that the skein of meaning is tightest. It is also language that is the most difficult to change at this fundamental level, partly because of the impossibility of metalanguage. It is also in language that sexed Subjectivity is most probably formed and reinforced.

Mallarmé's project, though it interrogated the "I," or the Subject in language, concerned a supra-individual poetry and a "Book" that would embody the relatedness of all matter. Everything in the world existed to end in that book ("Tout, au monde, existe pour aboutir à un livre"), an ironic and multivalent observation that glints off a number of points: the possibility that there is no outside to language, for example, the supremacy of fiction, and its truth, the redundancy of teleology, the limitations of the "world." In a letter to his friend Cazalis, he wrote that he was no longer the Stephen his friend had once known, but rather an impersonal "aptitude" across which the universe could see itself. I am thought, therefore it is, perhaps. Or, in my terms, I am thought, therefore we are. This letter is almost as well-known to literary scholars as Rimbaud's "lettre du voyant," in which the younger poet announced the apparently similar idea that " 'I' is an other" ("Je est un autre"), a shift in meaning that heralds the direction I am interrogating. It was and is not the only one possible.

"I is an other" is a formulation that retains the ego whose disappearance Mallarmé both sensed and feared. (The letter to Cazalis is that of a dazzled and profoundly shaken individual, who, one might say, could not even claim Faust to help him make sense of what he had intuited). It is as if he was on the brink of the potential of Ursula Le Guin's putative *passive* art, the art of the plant in *The Author of the Acacia Seeds*—something unknown and "entirely different from the Art of the Animal." This would be, of course, fundamentally, structurally—and inadequately—"feminine." It would also be illegible. It is, if you like, a male gaze, the intensity and complexity of which was to be dissipated, perhaps for lack of its return by a female gaze.[63] Furthermore, it is consistent with one of the new audience responses that became increasingly widespread—aggression.[64] The threat to the sexed Subject who tries to cross the divide may be greater than for those who remain in their oppositional corners.

The theoretical possibilities of men's "identification" with women have not been as much analyzed as the other way around, not least because without allowing Subjecthood to women, there is nothing with which to identify. (Drastically condensed, the predominant terms since the debates on female spectatorship of the 1970s focus on whether the notion that a woman watching a film has to occupy the position of the female, without falling into the volun-

tarist fallacy, or is she really able to shift "identifications"?) The debate now has a very long history in the theorization of desire. It has recently had a considerable boost in Butler's focus on identification in the processes of Subject formation and of loss. Her analysis puts sexual difference at the heart of much wider questions in order, paradoxically, to displace it, thereby allowing a richer and more varied vocabulary of attachment and loss.

> Does it follow that if one desires a woman, one is retroactively attributed to the desiring position as a way of retaining heterosexuality as the way of understanding the separateness of alterity that conditions desire? For if that claim were true, every woman who desires another woman desires her from a masculine disposition and is "heterosexual" to that degree; oddly, though, if the other woman desires in return, the economy becomes one of male homosexuality (!).[65]

This delivers to an even more ludicrous logic any potential identification of a desiring man with a woman. Let us stay with Butler's parenthetical exclamation, and examine the evidence of just such a psychic configuration. But first, we have to say "male" and "female" embodiment, in order to preserve both the centrality and the displaceability of sexual difference. I suggest that it is all over the art of early modernism.

In terms that play across and through biology, then, one prominent argument holds that in "phallogocentric" thought, and signification, the male is disembodied, especially regarding universals. Men's interests, this argument runs, are put forward under the guise of the immaterial, universal and true. One aspect of Irigaray's work, for example, would be the reinsertion of the male body into such discourses, so that the female body might "speak" in the "gaps." While there is one sense in which I might agree with this—and I certainly owe it a great deal—it is not sufficient. The impossibility of disentangling sexed embodiment in the development of what is known as rational, coupled with the ruses of the unconscious and the material uncertainties of contemporary aleatory physics (in which the impossible and unprovable appear to be even more crucial than the empirical real), makes corporeality far too uncertain. In an equally convincing sense, the problematic revolves around the male body as the *guarantor* of reason, *at the same time* as the notion of its absence and the disembodiment of reason. The secretary in Marlene Gorris's film *A Question of Silence* sits in a board meeting, experiencing just this. In the scene, the all-male board are unable to resolve a problem. The secretary makes a statement, offering a way out of the difficulty. Her point among these men is ignored until it is picked up by one of them. When he articulates exactly the same idea, it is welcomed and praised by the others. There is no dignified way for her to retrieve it as hers. Silence is the only option within the conventions of the situation.[66] This is because the point she makes is incomprehensible outside the logic that is guaranteed by the men. They do not have to try to ignore her or to rob her of her contribution. They are blind to it. It was supposed to be women

who did not know what they know. Perhaps such men do not know what they do not know. The ways in which we are and are not present at the moment of utterance are sexed.

Notes to chapter 4

1. Charles Baudelaire *Oeuvres Complètes* Pléiade, 1961: 1160. My translation.
2. A striking anecdotal example of this is the Canadian entrepreneur who built Casa Loma in Toronto and tried to live the aristocratic life. The project was catastrophic and threatened him with utter ruin. Rather than step back and regroup, he followed through with it until it destroyed him. For a capitalist, it is strange that he did not understand the economic foundation of the aristocracy in land and history—but it makes sense in terms of his identification. The possibility that he was not of the class who seemed to embody value only left open to him the absence of his own value. See also chapter 7.
3. Baudelaire greatly admired Delacroix and published on his work at least five times. The poem was collected in *Les Fleurs du Mal* (1857/61/68), LXXVII *Spleen*: "Je suis comme le roi d'un pays pluvieux [. . .]."
4. Carol Armstrong *Manet Manette* New Haven/London, Yale UP, 2002: 318, n.3
5. *The Impressionists and Edouard Manet*, 1876. Only this translation, approved by Mallarmé, survives. *Art Monthly Review* September, 1896. It has been reprinted in several places, including my own *Mallarmé, Manet and Redon*, Cambridge University Press, 1986: 11–18.
6. Pierre Bourdieu (trans. Richard Nice) *Masculine Domination*, London, Polity, 2001: 4, my emphasis. See chapter 1 of this book for more on invariance and universals.
7. Bourdieu's over-narrow reference to feminist thought may be in part a disciplinary effect, and in part because of his restriction to the Franco-British axis of thought. International feminism has begun to engage in highly productive dialogues: Minh-Ha, Alice Walker, and Pratibha Parma, Cornell, Brennan, Grosz, Pateman, Braidotti . . . would have led him, perhaps, to reconsider his strategy of more and more objectification as the "only hope." Bourdieu 2001:5.
8. Huntington xxvii. See also Drucilla Cornell *The Imaginary Domain*.
9. Huntington xix. She is bringing Alison Weir's work in *Sacrificial Logics: Feminist Theory and the Critique of Identity*, NY/London, Routledge, 1996, together with Cynthia Willett's *Maternal Ethics and Other Slave Moralities* NY/London, Routledge, 1995. This work implicitly reflects on the position adopted by Dollimore—see chapter 3.
10. Huntington 1998: 304, n. 8.
11. Several prose-poems by both Baudelaire and Mallarmé explore this kind of effect— Mallarmé's *Un spectacle interrompu* for example, but there are significant differences too diverting to go into here.
12. The first form of electric light bulb was invented in 1854, though the first practical electric lights were not made until 1880. Electricity as a metaphor was scientifically exciting, and this is what I am drawing upon. The Folies were still lit by gas when Huysmans wrote his essay *Les Folies-Bergères en 1879*—in it he comments on the reflections of gas lamps in all the mirrors. I do not know if the bar there had been wired by 1881/2 when Manet made his painting.
13. Introduction by Richard Shiff. Bradford R. Collins (ed.), Princeton, Princeton University Press, 1996.
14. Ibid. 19.
15. As in William Blake's prophetic poem, *The Book of Thel*.

16. David Alderson and Linda Anderson (eds.) *Territories of Desire in Queer Culture* Manchester University Press, 2000: 225.

17. Ibid. 232.

18. New Haven/London, Yale University Press, 2002.

19. Michael Fried *Manet's Modernism or The Face of Painting in the 1860s* Chicago and London, Chicago University Press: 1996.

20. See Fried 1996:174. Gauguin in many ways effects a similar temporal readjustment, and though his means are not identical the resultant work is more unified in structure. This is part of his fascination with Manet, as indeed it is for Picasso—Gauguin took copies of Manet's work to Tahiti, and Picasso worked obsessively on the *Déjeuner* late in his life.

21. See Jacques Derrida "The Law of Genre" *Glyph7*, 1980: 202–29.

22. 322–3. The oil was completed in 1867, and in it the marker is bisected by the horizon. Another of these markers is the sunflower in *Le Linge*, but I find it cannot bear the interpretive weight of allegorizing sunlight, vision, and painting.

23. See "The Face of Garbov" in *Mythologies*, (trans. Annette Lavers), St. Albans, Paladin, 1972:56–7.

24. See 408, and note 4, 612–4.

25. The Hispanic in Manet is a significant and useful element in Armstrong's analysis, expressed as it is in terms that go beyond the art of Spain as such to a more diasporic understanding.

26. *Sunday Times*, 8 Dec 2002. See also *www.musee-orsay.fr*

27. "Two roomfuls of Manets, including many of his best-known paintings, supply irrefutable proof of the entry into his system of the dark and dramatic Spanish virus."

28. Cf. the reference to Wittgenstein and Atomism, chapter 2.

29. "Le Salon de 1874," *L'Artiste*, 1 May 1874: 308 (page cited for the passage quoted). It is also cited in Eric Darragon's biography, *Manet*, Paris, Fayard, 1989: 236–37.

30. "His (Monet's) contrasts may not be as striking (as Manet's), but his tone rings as true. Less dissonant than Manet, his notes sing out of light and luminous depths" (my translation). "Ses oppositions ne sont peut-être pas aussi frappantes, mais le son est plaqué avec la même justesse. Moins âpres de contact que Manet, ses notes chantent dans un fond clair et lumineux" etc. Fried's quotation is longer, but to the same effect.

31. Si l'un s'inquiète peu d'être ou non un plagiaire, s'il se moque de la composition, l'autre saura fondre entre eux des elements disparates, et trouver le secret de les rallier par une sorte de lien harmonieux (my translation).

32. See also the next chapter on Liz Larner's refusal of a "signature style."

33. Nancy Locke, *Manet and the Family Romance*, Princeton, NJ/London: Princeton University Press, 2001. The following section draws closely on my 1997 essay, in which there is a discussion of how bullfighting signifies within Manet, and also of the violent iconography of modernism. See Laggeroth, Lund, and Hedling (eds.), *Interart Poetics*, Amsterdam: Rodopi, 1997:253–266.

34. See Locke 81ff. and notes, detailing the literature on this subject.

35. *Oeuvres Complètes*, Paris: Pléiade, 1961: 1179.

36. For a discussion of this formation see Chervet 1994: 411 and Grosz 1995: 85.

37. Baudelaire: 1182.

38. Chervet, ibid.

39. Ibid. 410.

40. See especially Baudelaire: 1181–1190.

41. Cited in Bowie 1992: 148.

42. *Le peintre de la vie moderne*, 1178.

43. For a clear, feminist-inflected introduction, see Linda Anderson *Autobiography* London/NY, Routledge, 2001.

44. "Cybiog and Sexed Digitalia" in *Digital Creativity*, Vol. 14, no. 3, 2003:144–152.

45. On Morimura, see Norman Bryson "Morimura: Three Readings" *Art + Text* 52, 1995: 74–9; Japanese version in *Morimura: The Sickness Unto Beauty* Yokohama, Museum of Art, 1996: 137–41; Swedish version in *Att tolka bilder: Bildtolkningens teori och praktik med exempel pa tolkningar av bilder fran 1850 till i dag* ed. Jan-Gunnar Sjölin, Lund, Studentlitteratur, 1998: 467–77.

46. The frame is a crucial element in (and metaphor of) Derrida's interventions in *The Truth in Painting* ([1978] 1987), and he repeatedly traverses the signature, "autoproduction" and "subjectum," in relation to it. See for example 18, 109ff., 286 et passim. "Lure of writing *with oneself.* '[. . .] around the effects of the *proper name* and the *signature*, stealing, in the course of this break-in, all the rigorous criteria of a framing [. . .].'" Ibid. 18. In a further entanglement of the written self, Derrida is quoting himself from *Glas*). Derrida's thinking about self-portraiture is extended, of course, in Derrida's *Memoirs of the Blind: The Self-Portrait and Other Ruins* (trans. Brault and Naas), Chicago/London: Chicago University Press.

47. Roland Barthes, *Camera Lucida*, 1980/1993: 12. The reference to the "epitaphic" is a paraphrase of Anderson's commentary on Paul de Man, 2001: 13.

48. This general idea is now familiar in the discourses of digital media, though more prominent in work by women. It is explicitly dealt with in Kirkup et al. 2000. See also *Cybiog and Sexed Digitalia* for how this relates to fetishism, in effect a connection with the dandy.

49. Huntington xx and chapter 1. This work references particularly Jean Graybeal's work on Heidegger and Kristeva, "transposing Heideggerian ontology into Kristevan semiotic theory."

50. See the last chapter of this book.

51. See the site Lina Russell curated, with constructed (fake) identities presenting themselves on the net *www.7-11.org*. The recent *Identinet* project (screened on Channel 4 TV during week commencing 15 April 2002) is another good example. The emphasis was on identity rather than subjectivity, and three of the four artists featured incorporated interactivity and a notion of permeable identity into their work: Nick Crowe (downloadable avatars); Lucy Kimbell (her invention of the LIX index); and Erika Tan (downloadable makeovers for the screen). The work of the fourth artist, Jananne Al-Ani, is in film, and its emphasis is elsewhere. See *www.identinet.net*.

52. The *Guardian* 29 April 2002. Review of Hayward Gallery mid-career retrospective.

53. O'Collins is a *Washington Post* staff writer. "Taylor-Wood's Joke Is on Us," *Washington Post*, July 23, 1999: N54. Review of *Noli me tangere* installed at the Hirshhorn Museum and Sculpture Garden.

54. See Armstrong's "Afterword," especially 317.

55. *The Rokeby Venus* was slashed by the suffragette Mary Richardson in 1914, possibly another reference in Taylor-Wood's use of it here.

56. Carl Hartman *Artist Works in Christian Theme* AP online, 14 July 1999.

57. See for example Shiff in Collins (ed.): 17 and 24, n. 40.

58. "But if you don't happen to work in the worlds of fashion, catering, PR or advertising this is pretty thin stuff: art without a moral dimension, art that makes no demand on the intellect, offers no psychological insight, and asks no awkward questions. We could be watching a commercial for Gold Blend coffee, or out-takes from a soap opera on daytime television. If only there were a Betty Trask prize for art, as there is for romantic

fiction, Taylor-Wood would walk off with it." Richard Dorment, critic of the *Daily Telegraph,* changed his mind between this review of 11 April 1998 and that of Taylor-Wood's mid-career retrospective at the Hayward Gallery, London, 1 May 2002. Here he sees, as I do, the potential of celebrities as "modern equivalents of the gods of the Greeks and Romans, beings whose all-too-human frailties fascinate the rest of us precisely because of our irrational belief that their talent, beauty and wealth should make them invulnerable [. . .]." (To be fair, Dorment did insure himself with a proviso in the first review.)

59. One might read Manet's cutting up of paintings such as *The Execution of Maximilien* in this light, as following serial structures disallowed within the single frame, a kind of proto-Derridean "parergon."

60. Dorment 2002.

61. Philip E. Slater *The Glory of Hera: Greek Mythology and the Greek Family* Princeton, Princeton University Press, 1968: 182.

62. See for example the photograph of *The Irascibles* of 1951, which excludes any women from the Abstract Expressionist club. Norma Broude and Mary D. Garrard (eds.) *The Power of Feminist Art* New York, Abrams, 1994: 15–16. There are many others.

63. See next chapter for an extension of this idea into the intransitive, taking up Gilbert-Rolfe's notion in relation to beauty.

64. I am reminded of the anecdote concerning, I think, *Déjeuner sur l'herbe,* recounting that a man tried to attack it with his walking stick. Whether apocryphal or not, it is indicative.

65. Judith Butler, *The Psychic Life of Power:* 165.

66. Anecdotally, how many women recognize this experience? And how few men are conscious of it.

myth, utopia, and the non-narratable self

[. . .] glamour inevitably acquires a critical status if found in a work of art. The word "glamour" was originally an early Scots corruption of the word "grammar," reflecting the magical power through which it organized the writing which had recently arrived amongst them, so the glamorous is that which is magically articulated.
 —Jeremy Gilbert-Rolfe, *Beauty and the Contemporary Sublime.*[1]

Mythic vision itself is fundamentally contaminated, polluted, violated by history. The stronger the stranglehold of history, the more intense the impossible desire to escape into myth. But then myth reveals itself as chained to history rather than as history's transcendent other.
 —Andreas Huyssen, "Anselm Kiefer. The Terror of History, the Temptation of Myth," in *Twilight Memories. Marking Time in a Culture of Amnesia.*[2]

"What I cannot understand," she pursued carefully, "is your preservation of such a very ancient state of mind. This patriarchal idea you tell me is thousands of years old?"
 "Oh yes—four, five, six thousand—ever so many."
 "And you have made wonderful progress in those years—in other things?"
 "We certainly have. But religion is different. You see, our religions come from behind us, and are initiated by some great teacher who is dead. He is supposed to have known the whole thing and taught it, finally. All we have to do is believe—and obey."
 —Charlotte Perkins Gilman, *Herland*[3]

PART I: SAVAGE STORIES, GAUGUIN'S JOY

This chapter brings the sexed universal directly into tension with the raced, or cross-cultural universal, moving around what Derrida has called "[. . .] the general problematic of the relations between the mythemes and the philosophemes that lies at the origin of western logos."[4] At the back of my thinking is also some kind of seeing blindspot that focuses the issues on his association of this problematic with the graphic, something I find in Mallarmé, and which is what resurfaces in the idea of morphogenesis explored in chapter two.[5] Elsewhere, Derrida acknowledges that "resexualization" has to take place, but cautions against facileness. Yet facileness is very often what characterizes male philosophers' disclaimers about resexualization when trying to confront sexual difference—despite all his care, Derrida goes on to separate the designations of

"hymen" and "invagination" from the female body in the course of a movement that leads him to ask, "[. . .] is it not difficult to recognize in the movement of this term [invagination] a 'representation of woman.'"[6] Why, and how, should the issue of how terminologies relate to the female body lead back, or be referred, to "representation of woman" ("woman," not "women"—and of course I want to hold these together)? Yet, as Derrida goes on to say, "I would like to believe in the multiplicity of sexually marked voices." Perhaps the risk of facileness is one worth taking. My inquiry at this point begins with Gauguin's representation of women and ends with two non-representational contemporary artists and their choreography of a "double dissymmetry," in the hope of opening on to an analysis where "the code of sexual marks would no longer be discriminating."[7] Derrida nevertheless seems to erase women in the end because he does not accept that terms can be sexually specific. Somewhere at the end of the rainbow, newly conceived in materialist terms of light, I think this is a place towards which we have at least to consider moving. Otherwise women will be reduced to the spectre that is "woman." Perhaps taking one male and one female artist in relation to this issue with which "philosophemes" are haunted, as I do at the end of this chapter, is a facile idea. But it is not impossible for facileness to lead to the worthwhile. The step from facileness to facilitation may perhaps be not too long for our material stride beyond physicalism.

I hesitated to invoke Huyssen's discussion of Kiefer, as I do in the epigraph above, partly because I do not straightforwardly agree, but also because it takes him into the extraordinarily difficult issues around recent German history and identity, and I do not want to seem to invoke this lightly. Eventually it also leads him to a few remarks about the reproach that Kiefer's paintings are too beautiful—he finds beauty to be "a powerful taboo in contemporary postmodern art."[8] Huyssen challenges the influence of Lyotard in promoting the sublime (as the non-representable) over the beautiful, and sees Kiefer's "immersion in the diaspora of mythical stories and conceptual narratives as attempts to break out of the prison-house of an aesthetic that remains tied to the long-standing denigration of the 'merely beautiful.'"[9] It is this association of beauty with myth, and both with the uncontrollable in art, that I think of as "the Wagner factor," and it is this with which I begin: a few notes of Wagner move me to tears; I am complicit in his notion of purity if I deny it.

Gauguin has no current place in the radical pantheon of which Manet is a part, and the fundamental reason is inseparable from the Wagner factor. Gauguin is an artist whose voyage into myth tends to be understood as actual as well as artistic. As man and as painter, he has come in for some strong criticism from feminists, and nothing I have to say is intended to gainsay such work—this chapter stands alongside, and to an extent upon, readings made by feminists and postcolonial commentators. I do not want to shield from view any of the material and cultural exploitative practices out of which Gauguin's work may have grown.[10] It would be retrograde to promote a sanitized version of the kind of modernist narrative that has been critiqued through analyses of his work and life. Yet alongside all the dark and violating aspects in which as a man Gauguin

may be implicated, there is another relation to the female, possibly inseparable from the beautiful, and from the Tahitian people as inter-racial interlocutor. It is this relation, and its utopian aspect, that is the issue under discussion.

Edward Said in *Culture and Imperialism* is alive to the value that has accrued out of colonial exploitation, and this is to my mind one of the paradoxes built into art: It is often indelibly marked with privilege and exploitation in its production, but that does not mean that its value is thereby erased. This is the problem Huyssen is trying to negotiate in Kiefer, and it traces to the impossibility of representing the Holocaust. Without making glib claims or seeking to make easy equivalences, it seems to me to connect in significant ways with the fundamental issues of sexing universals, because it tries to face both the historical specificity of works and their excess. Myth is both facilitating and obstructive in this.

One point is to test this hypothesis: Can it be that to break out of a privileged and exploitative frame in the "consumption" of art (not a term I normally choose) may open on to the possibility of some kind of reparation? This is an equivocal way of putting something whose effects are being proposed as part of countering historical processes that are massive and sometimes terrible. I do not know whether the position is tenable in the long term, but only that it is it worth exploring. It seems that the freely appropriating mode of contemporary art and thought demands of the practice of interpretation and critique that it address such issues, because without it, the crossing of artistic and cultural boundaries falls into a kind of bad faith. Not only this, but there is such considerable historical precedent for appropriation as semantic element, as the preceding chapter has indicated—or as anyone reading Chaucer or Shakespeare, themselves in turn major "sources" very quickly discovers—that it could indeed be argued as an ineradicable element of cultural change, one without which oil painting would be bereft. Many in contemporary culture appear happy to pillage and plunder freely in the name of democratic artistic exchange. Their actions participate retrospectively in the works' semiosis. This is an opportunity as well as a potential problem, as feminist use of catachresis as textual strategy has widely shown.

What I propose is not exactly catachresis, however. Rather, it is an attempt, through the notion of the sexed universal, to implicate the sexes in each other's asymmetry. Gauguin was reaching towards something expressed primarily through women, especially in the late work produced in Tahiti. In aiming to read for the valuable in his innovations, the strategy is to cease to be contained by the oppression of which he was doubtless in part an instrument and beneficiary (to avoid simply assuming his agency). Many an oppressor has been unaware of the route to freedom he may be providing for his "victim." This can never exculpate or mitigate. But that route is part of the true, simply by being there. No artwork has in and of itself oppressed. But through its insertion into fields of meaning it can contribute to sustaining oppressive structures—or to the de/constructive. I profoundly disagree with Irigaray's statement that, as opposed to natural things such as a tree, made "objects impose on us to perceive their

forms according to a pre-given intention."[11] This should be clear from my discussion of balls in chapter three.

Gilbert-Rolfe's association of beauty with "the magically articulated" in the quotation at the head of this chapter is precise. It is not to be confused with mystification or a withdrawal from history of the kind that concerns Huyssen. It is perhaps something to do with the gift of Aphrodite, the magical articulation of the everyday. For what Gauguin found in Tahiti was everyday to the Tahitians. How it is possible to come into a non-exploitative relation with this leads straight to all the issues with which the beauty of his painting, in current terms, has nothing to do.

This kind of difficulty attendant on writing about Gauguin has perplexed me for a long time, and it seems to necessitate involving his psycho-biography to a greater extent than with some artists precisely because it is as if his aesthetic moves entail geographic moves. It obfuscates the issues to have to deal with being understood as either defending or attacking Gauguin as a man, or as a representative of a certain masculinity, or contributing to deciding "whether Gauguin was a cultural hero or a scoundrel," as was recently said of Stephen Eisenman's *Gauguin's Skirt*, with Eisenman understood as arguing "on Gauguin's behalf."[12] What artists say about their work is not privileged as the truth about it, still less what they do as individuals; it is not an irrelevance, it is a factor, not an explanation.[13] What this means in practice is that biography is to be invoked for specific reasons, and always only as an element in the feints and disjunctions that characterize the relation of any work to the real. Whether or not Gauguin was a scoundrel is impossible to determine, though I find Eisenman convincing in the detailed examples he gives of Gauguin's ambivalence in sexual and racial terms.[14]

Eisenman situates his book somewhere between ethnography and art history, and in so doing might exemplify Hal Foster's barbed claim in *The Return of the Real* that in the current climate "[. . .] of artistic-theoretical ambivalences and cultural-political impasses, anthropology is the compromise discourse of choice."[15] But Eisenman's deployment of original documentation both historical and contemporary is more than elective self-positioning. It overlaps to an extent with Pollock's in *Avant-Garde Gambits*, towards which it gestures, but whose complexity it denies in its haste to refute Pollock's emphasis on individual women on the one hand, and her polemical intention in developing her critique of the "gambit" of the avant-garde on the other—not to mention her Marxist-feminist take on the material foundations of the exotic *Erewhon* that was "The Tropics."[16] Pollock's aim is a large one. It connects Gauguin's Utopian project directly not only with "masculinist but also imperialist narratives" in order to ask, "What must I become in order to confront *both* the gender *and* the colour of art history and see their historical overlappings?"[17] In this, there is a broadly Utopian character to her project, as there is to Gauguin and to feminism in general, though it is an aspect strongly denied by some activists and materialists. Utopian feminism is perhaps most often approached these days through Irigaray, though it was a powerful element in the theory and fiction of now-unfashionable

early "second wave" feminism of the 1960s to 1980s,[18] not to mention forerunners such as Charlotte Perkins Gilman's *Herland* (1915) quoted in one of my epigraphs at the head of this chapter.

Foster's argument turns on a characterisation of "the artist as ethnographer" (this is the title of his chapter) in "advanced art of the left," which he sees as a continuing attempt to resolve the contradiction between "aesthetic quality versus political relevance, form versus content" that Benjamin had already identified as "'familiar and unfruitful'" in 1935.[19] It is structurally similar to the old author as Producer model. The problem with the ethnographic model is that it involves over-identification (with the other as victim) or serious dis-identification, which is worse. His suggested remedy for this state of subjective blockage is something he calls "parallactic work that attempts to frame the framer as he or she frames the other." This involves, in his view, critical distance.[20]

There are two factors that strike me immediately about this. The first is that framing the framer is a very familiar idea, and the second is that the whole of this page of Foster's text speaks to me of sexual difference, while this is absent from the argument.

To take the first point, "framing" is most familiar to me through feminist deconstruction and Derrida's "parergon," but also more specifically through Trinh T. Minh-Ha's book *Framer Framed,* in which Minh-Ha discusses with Constance Penley and Andrew Ross. This example takes precisely a Derridean approach to framing in an ethnographic context, as understood in documentary film such as her own *Reassemblage* (1982), itself deploying strategies that "question the anthropological knowledge of the 'other,' the way anthropologists look at and present foreign cultures through media, here film."[21] In *Reassemblage,* there is both less of an impasse and more of the new, in the sense of arguments that do not reference the issues in terms of a split between aesthetics and politics but rather begin from another place.

The point is not to catch Foster out somehow—a game of cat and mouse in which roles could be so easily reversed—but rather to pose the difficult question of how it is that the subaltern voice becomes either absorbed or closed out.[22] I think it may be related to the problem of the sexed universal, which traps the subaltern in the specific. Minh-Ha's is a highly developed theorized practice, reading Derrida through Zen and aligning itself with Cage, Artaud, and Mallarmé. She is already well versed in "parallactic" theory and practice.

The second factor is more directly about how the argument is sexed. We can come at this quite simply, while maintaining the relation with postcolonial cross-cultural and raced perspectives, through unpicking the common elision between ethnology and anthropology.

These terms tend to be used interchangeably. But the former is strictly defined as "the science which treats of races and peoples, of their relations to one another, their distinctive physical and other characteristics," while the latter is "the science of Man, of Mankind in the widest sense . . . embracing physiology and psychology and their mutual bearing."[23] The most obvious difference between these two is the comparative element, which is absent from the

definition of anthropology. This already would imply a greater proximity between practitioner and object of study than in ethnology, where the idea of the comparative already connotes containment, a border, and hence some form of exclusion. In terms of sexual difference, a sexual ethnology would regard women as distinctive from men, and vice versa, while a sexual anthropology would work from within a universal concept of humanity. The trouble here is that ubiquitous slip from Man to Mankind. I am not going to re-enter the lists on this one as a general or abstract point, but rather remain with how it manifests in the present context, as the guard at the border of consciousness, defining as male the contemporary (or any other historical period or issue). There is a separation between universal functions and universal structural roles. The subaltern may become an exemplar of a universal function, but does not occupy a universal structural role.[24]

Naming these disciplines of ethnology and anthropology as "science" is also problematic, and for related reasons. My understanding of what underpins Minh-Ha's critique of the scientific pretensions of anthropology is that science confers universality, and that the institutional legitimation on which she comments is part of this.[25]

Let us develop this through an anthropologist. Edmund Leach appears in this chapter, not because I am advocating a return to structural anthropology, but because he puts very clearly—with brilliance in a flawed collection of essays—how myth, and religious storytelling, in belonging to the metaphysical, form the relationship between the "here-now" and the "other" as one of descent. Leach's waspish writing is enlivened by a number of sideswipes at his colleagues, including a "muddle-headed theologian" (who is neither the Bishop of Woolwich nor his cleverest anthropological colleague) invented doubtless as a means of avoiding the consequences of his libellous intent:

> The problem with which this muddle-headed theologian is concerned lies at the core of speculative philosophy. What is the difference between the physical and the metaphysical? One way of viewing the matter is to equate the not-now with the other world; in that case past and future coalesce as attributes of the other in contrast to the present which is the factual experience of real life. The relationship between the "here-now" and the "other" can then be seen as one of *descent*. [. . .] social distance in time and space and generation is very frequently and very readily dovetailed in with a distinction between the living and the dead. [. . .] The relationship between the here-now and the other can also be represented in other ways, for example as one of class status and power—the gods are perfect and powerful, men are imperfect and impotent, or as one of normality and abnormality—hence the supernatural birth and immortality of divine beings.[26]

This is not about causality, but rather about where certain extremely widespread stories fit in. A by-product, following his terms through, of his argument would be that while he says nothing about the kind of sexed genealogy that is the subject of

this book, he provides an insight into how the Virgin Mary contributes to ensuring the exclusion of women from the "here-now." Because they are the other, and therefore not "here-now," living women are consigned to the realm of the dead.

It is not only a matter of how this plays out in the way that female selfhood may or may not occupy the position of narrator or protagonist, but also of how the process of narration produces female selfhood as beyond the "here-now"—this is the "narratable self" of the title of this chapter. It is a version of the difference between a universal function and a universal structural role, where women cannot occupy the latter. Because of sexual asymmetry ("disymmetry" in Bal's terms), this is a problem for all subjects, but not the same problem.

If women are excluded from the here-now of the male universal, the exclusion of men from the female specific is not as structurally implacable, in part because of the narratability of the self. But they have to sacrifice something of this structural advantage, to trade their structural role for one of function, while women have to assume greater engagement and responsibility of structural roles.

In taking this further, we leave much of Leach behind, because he is a very clear binarist. There are oppositions and monstrous mediators in his text and his world, and that is it—this is the underpinning of his classic, *Genesis as Myth*. Disconcertingly for one who has learnt so much from her writing, I find that Irigaray's between-two and her angels seem to fit this pattern. But the point here is how the structural pattern is the meaning conveyed, *regardless of variations in detail*. Recent readings against the grain of this rigidity have done much to excavate women's stories, both actual and mythological, aiming to restore the link between the two.[27] In order that the pattern itself be developed, this needs to be complemented with readings of those men's work that aims to open out to understandings of the "here-now" that are not predicated on the world of the dead, that does not pit the physical against the metaphysical. Gauguin's oeuvre is one example.

The removal of women from the here-now sets up actual and objective difficulties with what is defined as "reality" and what is experienced as "reality." It installs an economy of loss, or of melancholia, for both sexes. The latter is often theorized as masculine in contemporary culture, thereby implying a feminine opposite. The symptom that relates to melancholia as its opposite is elation, and one specific feature of melancholic masculinist analysis appears to be the attribution of hypomania in some form to women. The currency of "jouissance" as female in Lacanian thought, including feminist development out of it, is indicative, and the female mystic St Teresa appears to be the predominant symbol. Malcolm Bowie's reminder of Bernini's "complex figuration of the masculine" is all too often disregarded in a mystical "Jacques-ulation"—proof, as Bowie says, that "feminine sexuality migrates between the sexes."[28] The hypomanic ego is in denial in the face of unacceptable reality, like Freud's "purified pleasure-ego."[29] There are several features of interest that relate to the cultural production of the mother as both introjected and virginal. In the first instance, mania is understood as when "the ego fuses with its superego in an accurate intraspsychic reproduction of the fusion of baby and breast at nursing."[30] It is

before rather than beyond the pleasure principle (and in its originary giving perhaps before the postal principle according to Derrida). Childbirth is, it appears, a common precipitant of mania, and "puerperal manias are usually excited affirmations of virginity and denials of marriage and motherhood."[31]

An association of these states with the divine exists on at least two levels: mystical transport or oceanic feeling of "oneness," and the removal from present reality into another sphere experienced as a superior reality. In light of Leach's analysis, the connection with the cult of the Virgin Mary, or with "purity" as definitional of womanhood, in religions that offer nothing but protection and consolation to women in this world is plain. Resexing the symbolization of motherhood according to a full and mature, non-heterosexist understanding would be part of the refiguration of female desire, perhaps opening on to a universalizable model of productive desire, not in denial of death, but capable of moving through the death of the individual, produced as finality in secular individualism.

The maternal as a universal function can only be understood according to sexed universal model. It is universal in that no human being can begin to exist without it, but if it is only understood from the one side, that of the biological mother, and therefore of women, it is ultimately atemporal for the male and of fixed duration for the female (because frozen at birth). The customary deployment of the word "maternal" in English (and the small number of other European languages I know enough about) makes it awkward and somewhat anomalous to open it *by definition* to the male, although many would presumably accept that it is not in principle incorrect. That it is a one-way and exclusive function, and the particularity of the female, is illustrated by the way that male carers have been understood as substitutes for females, in the way that women bosses always used to be understood as inauthentic copies. In this manner, it is deprived of its universality as a role, while it is a derivative of what is ultimately definitional of sexual difference.

Laleen Jayamanne, for example, speaking of her film *A Song of Ceylon* (1985 Australia), shifts attention from taking this up in an autobiographical sense to embodying it through the ritual conjunction of two goddesses through a transvestite priest:

> [. . .] the ritual in *A Song of Ceylon* is governed by two mythical avatars of the maternal found in the South Asian religious imaginary. One is Pattini, the good mother, and the other Kali, the evil mother; both are figured very differently from the beautiful spaced-out virgins of Western Christian imagery. The film yokes these two contradictory figures, whereas in the ritual of spirit possession and cure the reigning figure is Kali. The disturbed biological familial relationships are restored at the end of the ritual under the auspices of the priest dressed in drag as Kali. The maternal as the space of primary narcissism is an atemporal, eternal concept of that dual dynamic, and if women want to bring maternal into the flux of time, then different operations are required [. . .].[32]

It would, of course, be possible to read this as recuperating the hysterical voice to the Oedipal family, but that is not how I recall it works in the film. What counts is her remark about bringing the maternal into the flux of time. As Leach remarked, "God and Jesus fit well enough into the English Public School ethos; the Virgin-Mother has no place at all"[33]—and the reason for this, though he of course could not say it, is that the Public School (confusingly, this would be private in the United States, though it reflects accurately the aim of educating a ruling élite) is profoundly homosocial. This locates the difficulty with sexing the universals of religion from a Western point of view squarely with the Virgin Mary. How do women participate in the divine, or the secular and psychic equivalent, as mothers, as sexed and as more than these at the same time? In other words, the problem begins with Mary's virginity—her intransitivity in the grammar/glamour of stories.

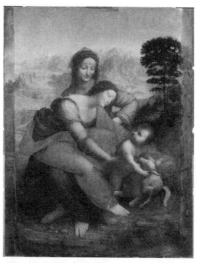

FIG. 16 Leonardo da Vinci *Virgin and Child with St Anne* c.1508–1510, Louvre, Paris. RMN.

Leonardo's painting of the Virgin and her mother brings motherhood into the picture of the divine. St Anne is a peripheral figure in Christian theology and iconography taken as a whole, but she appears often enough to be known to the faithful. In Leonardo's image she is the one on whom everything depends. The Virgin is in an almost undignified scramble with her boychild, whose proximity to the Paschal Lamb seems to emphasise his animality rather than to prefigure his divine Passion—he is almost like a faun. St Anne's smile rivals that of the Giaconda; it is she who seems to know the greater picture, to be in control, to have a sense of the beginning that understands ends as cyclical. (One might recall Walter Pater's ancestral fear of the Mona Lisa, "older than the rocks on which she sits.") Yet there is no separation between her and the Virgin: It takes time to figure out where her body

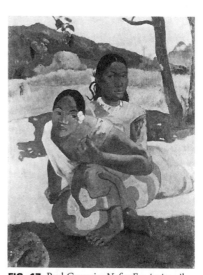

FIG. 17 Paul Gauguin *Nafea Faa ipoipo* oil on canvas *(When will you marry?)* 1892, 101.5 × 77.5 cm., Rodolphe Staechelin Collection, Basel. Loan to Kunstmuseum Basel. Photo credit: Oeffentliche Kunstsammlung Basel, Martin Bühler.

ends and the Virgin's begins; their bare feet, prominent in the foreground, look the same, an effect emphasized by the relative indistinctness of St Anne's right foot in the shadow. It appears that Catholicism accommodates the old myths of the "great" and "little" mother, "generally fused together as though they were in essence one being. This conveys the original grandeur of the Great Mother, while keeping strictly to the Mary of the Gospels, who is modest, submissive and concerned, and who is often portrayed as herself a child in relation to her mother."[34]

In light of this tradition, Gauguin's two women in *Nafea Faa ipoipo (When will you marry?)* can be understood in another frame than that of virgin and whore. A young woman sits awkwardly in the lap of an experienced woman, and their bodies commingle. But there is no Christ child in this image—though there are many examples of seemingly Marian poses of mother and child in his work. It is as if the conundrum faced by St Augustine in making the mother of God pure is bodied forth—it was Augustine who introduced the idea of the Immaculate Conception, and it was not easy to account for the birth of the virgin in the same terms as the virgin birth, for this would take the purity back through her entire maternal lineage, and that would produce a theological impossibility. In this of course it also highlights the anomalousness of the idea of virgin birth, even in Christian terms, which place such importance on the resurrection of the body. In the Gauguin, the universal of the great mother may be read as posited without the problem of an innocence tied to ignorance; sexual experience does not have to be the end of innocence, and it is corruption that constructs it as such.

There was another player in the story, without whom the structure is incomplete. It is the Holy Ghost. The intermediary between God the father-spirit and God the son-humanity is as much the Holy Ghost as it is the embodied woman, however pure. Unless supported by far greater connotative female meanings, the position of the Holy Ghost cannot be sustained as a female structural role within the Trinity, and it will be produced as exclusively male in structure. It is analogous to the problem with Apollo and Dionysus—the female aspect of Dionysus is only an aspect in an imaginative structure made up of one "masculine" male (Apollo) and another more ambivalent male (Dionysus).

The Holy Ghost was not necessarily always male, and the gradual masculinization of the Holy Spirit is a long linguistic and theological story, fixed as such in the Latin of the Apostles' Creed in the fourth century: "spiritus sanctus." Yet "[T]he imagery of the Creed still suggests [. . .] that the Holy Spirit was a Mother—'conceived by the Holy Ghost, born of the Virgin Mary.'"[35] The symbol of the dove strongly connotes the bird goddess, later the mother goddess with the dove as her "epiphany": "In the Christian tradition it is assumed without question that the dove comes *to* Mary, whereas, formerly, it would have been assumed to have come *from* her."[36] Once the dove is understood clearly as female, the trinity becomes mother, father, child; female, male, and either. But what this signifies to me here is not the sanctity of the nuclear family, but rather

"an unmanifest, a manifest aspect, and an aspect that belongs to both,"[37] or in other words, the inseparability of transcendence and immanence, the structure of the sexed universal rather than the universal egg. And Aphrodite is invoked again, as the dove is her bird.

Understood as male, the Holy Ghost substitutes for the divine conception, while Mary is reduced to the human vessel. St Anne is no longer a problem, and motherhood is further diminished. Whatever the theological implications of re-embodying the Holy Ghost as clearly sexed female, the cultural implications have some reach. If Butler's "postcontradictory psychic mobility"[38] is to manifest in the cultural imaginary, then its traces will have be rediscovered, not only as static icons, but also energetic forces. Reading Gauguin's art as moving in this direction is not to be understood as making a "positive image" for him or his work, still less as claiming him for an alternative goddess tradition, but rather as an inquiry into an oeuvre that consistently developed around a religious thematic in which the female presence is, in a sense, postconventional.

Further examination of this throughout his oeuvre from the Pont-Aven period onwards is beyond the scope of this book. The same is true of a developed analysis of the figure of the Virgin. But the advantages of pursuing through structure and form in a visionary and revisionary body of work the lexical and iconological transpositions of what is one of the very few major female figures in the contemporary pantheon, at least as manifest in European culture, are considerable. It seems to be a feature of the Virgin Mary that she merges into several figures in the stories of the Bible and before. To give the briefest indication, Bible scholars have shown that close reading of the Gospels in the originals reveals confusion between Mary Magdalene, Mary of Bethany, Lazarus's sister, and the Virgin Mother, Mary.[39] There are even early images that bear interpretation of Mary as the bride of Christ, possibly indicative of the ambiguity of the Virgin and the Magdalene. What this profusion of Marys is generally interpreted to show, it seems, is multiple aspects of the one figure, the originary goddess. But that is not what is being suggested here. The point is not to reinstall the Great Mother traditions, but rather to read the narrative structures their suppression excludes. Word-image transformations seem likely to play a strong part in this because of the significance of artefacts made in non- or partially literate cultures.

The story of the Virgin Mary is that of a mother-son relation. What the presence of St Anne in the story both symbolizes and conceals is that behind it is another story, that of a fully fleshed mother-daughter relationship, of sexed origin, one that is altogether more difficult to take from cipher to full symbol in this culture. It is part of my argument that this is a loss no Subject of any sex can sustain. It begins with a specific relation, but becomes part of the undervaluation of the universal elements within that relation, and the imbalance of values overall. The point does not just impact on daughters and sisters (52 percent of the population), but also on all sexed individuals, since the abstract or structural element of the story and its values has universal effects.

We have already seen that there are several moments in the Virgin's story that point to its own dissolution, where "the Law, fantasy, and historical men," in Kristeva's words, betray their presence. We have seen how this comes through in the psychological truth of these images. This is what we now have to pursue, rather than the fascinating transformations from goddess-worship through Gnostic Christianity to Catholicism (Islam and Judaism, too, to complete the trio of world religions to which this erasure applies). But there are a few more traces to introduce. They concern two goddesses and a child.

There is an ivory sculpture from Mycenae of about 1300 BC, apparently well known to scholars in the field. The sculpture is of two goddesses in symmetrical poses with a child. The goddesses are dressed in the same elaborate way and share the same cloak about their shoulders. The one figure is very slightly larger, and she has her arm about the shoulders of the other, who clasps the hand that rests on her. The child seems to climb from one to the other. While the sex of the goddesses is plain, that of the child is less clear. All the mythological and religious stories into which this group inserts either do not identify the sex of child at all, or identify it as a god. These include the Sumerian Inanna (cf. Anne); the "Two queens and the young god" of the Linear B tablets of Pylos; and Demeter and Persephone with the young Tripotolemos.[40] It is a family of gods whose existence is widespread and recurs in the iconography associated with St Anne.

There is no clear indication that the child is not a girl. In the absence of other evidence to the contrary, why should it not be a girl? My argument thus far can be demonstrated as convincingly as most in archaeological iconology. What follows now is pure speculation. It is a move into the unsayable, the dissolution-point. It notes that the alternatives in the case of uncertainty as regards the sex of the child are either that it is male or that it is a child, a generically young person without sex. Since Freud, we should wonder about portraying a child as without sex.

It seems that the tradition of the two goddesses maps on to the symbolization of life and death, the world above and the underworld, light and dark. The new life of the day, the year, or the grain seems usually to involve the sacrifice of a god—as perhaps most famously recounted in Frazer and transmitted through Eliot. So although it might seem a female suprematist move to suggest that this is an all-female group, if it is, it is a risky one. For the fate of the child is death. Underlying the excision of the female lineage is the death of males. Its most modern manifestation might be in the castration complex and the identification of men with the death drive. I am not denying these psychic structures exist. I am suggesting ways of showing for a specific purpose that they are not "natural": the purpose of reinserting aspects of what has become "naturalized" as female into the universal.

In the Minoan civilisation, extant artefacts appear to show that the divine figure began as unclear in its sex, and when the male principle separated off, it became subservient—virtually all the statues of the young god show his subservience to the goddess. These were images of a peaceful civilization whose

experience of violent death was primarily through natural disaster, such as earthquakes. It was only when invasion threatened and war became inevitable as part of life that the male god took over. The point is that there was already an imbalance. The female principle was dominant. This does not mean to say that war was a direct consequence of the imbalance, but rather that the response to this form of violence and the danger of domination was inflected by the internal domination already known. Perhaps this was how the new lethal trinity of war, hatred of the female principle, and of the other begins. This only matters if it contributes to the production of another dynamic; playing with the idea of origin is not the same as installing teleology. As Donna Haraway ironically reminds us, "Whatever the merits of the tale [. . .] it is always satisfying to start an important origin story with a Greek etymology."[41] In a culture that has set great store by the invention of origins as a means of securing power, myths of origin are a potent inhibitor of change. Opening them to change is one part of the strategy towards their imaginative redundancy or transmutation.

The gods and goddesses became more clearly defined by the sexing of stories as these stories became increasingly disseminated more by word than by image. Linguistic gender played its part, as has been shown, arguably more so in the translations of the Bible, in tension with which the oldest myths have come down to the present. In opting for words clearly gendered male, for example, the Holy Ghost as Spiritus Sanctus, women and the sexually ambivalent were written out of the structural roles.[42] Ambiguous figures were marginalized into commentators and seers (like Tiresias) as the heterosexual family rose in significance as a form of social organization. (The nuclear family is of course a comparatively recent invention, and even the apparent innovation of the gay marriage is not without historical precedent.[43] Eve Sedgewick has pointed out that the Greeks' homosexuality could be understood as much in terms of an ultra-maleness as of the effeminacy now widely associated in popular culture with gay males. Female homosexuality became so difficult to account for in the family romance of desire-less sleeping beauties that there were even cases in nineteenth-century Britain of professional women such as schoolteachers being acquitted of their "unnatural crimes" because it was thought to be impossible that middle-class Victorian women should desire each other—this is legal fact and enshrined in the judgement.[44]

"Yet desire, largely conceived, has been the chosen business of psychoanalytic theory from the start," as Malcolm Bowie has succinctly put it.[45] With characteristic irony, Bowie goes on to recount Lacan's position, and mode of exposition, while satirizing its limitations (for those who care to read them). Lacan on Holbein's *The Ambassadors* may be old news by now, but the force-field between death, desire, and manhood is symptomized by Lacan's analysis, which allows Holbein's display of anamorphosis to take over the entire picture.

The operation of impersonal mathematical laws has created an emblem of male potency from Europe's most popular emblem of death; the "phallic structure" of cancelled manhood has been given a grotesque new physical

form. And at the same time an impossible situation has been created for the viewer: the deathliness of the painting can be perceived only by sacrificing the rest of the painting's content.[46]

The painting reveals the Subject as annihilated, "the imaged embodiment of the *minus-phi* of castration, which for us centres the whole organization of the desires" in Lacan's words, which Bowie goes on to cite. Bowie then continues:

> And once Lacan has allegorised Holbein's detail in this fashion, everything else in the painting can be spirited away. Its conceits and enigmas, its inventive interplay of surface and edge, colour and texture, are of no particular interest once a universal key to human vision has been found. Although the painting has had its uses, and not least that of suggesting that a new Renaissance is upon us, it is no different from any other painting in the underlying structure that it reveals.[47]

It would take the argument too far away from its primary drive to try to deal with the history of desire in the twentieth century.[48] The point here is to allude to a structure in which the fear of castration and death is projected on to female desiring bodies with all the weight of hundreds, if not thousands, of years. The irony of it is that the solution to this deathly conundrum is in women's desire, both for each other and for men, and for anyone else. One of the tremendous gifts of Lacan's text here, however, is that he connects this state of affairs as he sees it to the structure of a painting.

Bowie introduces his reference to the Holbein through an allusion to Frank Stella, which he uses to alert the reader to the difficulties of "applying" Lacan, even where the painter seems to share his sense of the visual. In *Working Space*, Stella refers to the promise of great paintings as "what is not there, what we cannot quite find." He goes on to outline the anxiety of artistic vision as traceable to death. "Painters instinctively look to the mirror for reassurance, hoping to shake death, hoping to avoid the stare of persistent time, but the results are always disappointing. Still they keep checking."[49]

I want to connect this "what is not there" with Heidegger's groundlessness and the Mallarméen absence. I suggest the archaism "imaginal" as a way of doing this, partly as an alienation device, but also because it has a corporeal and beyond-human dimension. The OED defines it first as "of or pertaining to the imagination, imaginable," but there are two further hints. In one of the examples given, from H. More's 1647 *Song of Soul*, the usage implies that it is imaginable in a universal sense, not just the efforts of the modern ego to grasp an idea or image. It is altogether a larger and more humbling matter.

"That inward life's th' impresse imaginall of Nature's Art."

The nature-art conceit is conventional, and I am not suggesting a return to a seventeenth-century world view (not least because that would be impossible), but the underlying idea can be made to go further. There is not only continuity between the mind and the universe, but it is also a living relation in art.

The next point of difference of "imaginal" from "imaginable" (or, worse, "imaginary")[50] is in the second definition, but again from one of the examples, this time from Huxley in 1877, and not surprisingly, given the date, scientific. More blows to the ego are in store: not only does it concern insects, but insects in the form of maggots: "The apodal maggot, when it leaves the egg, carries in the interior of its body certain regularly arranged discoidal masses of indifferent tissue, which are termed *imaginal discs*. These imaginal discs undergo little or no change until the larva encloses itself in its hardened last-shed cuticle, and becomes a pupa."

The imaginal is thus both that which bears a transmissible imprint and an element of transformation. It is applicable to the most abstract problem and the most abject physicality. (If Deleuze's becoming-insect loses a little lustre here, it is nonetheless munches on the same leaf.)

The "something" that drives Gauguin is not death in this way, though death may well be a presence. By saying this I am not going to try to dismiss Stella, very far from it. I am trying to get at an association between the lack of the female principle within neutered male universality, the deathliness of the ego and the unproductiveness of desire. It is for this truth that I refer to Stella, and I do not limit that truth to this/his manifestation of it. In arguing towards a productive imaginal in place of an economy of lack, the pretence of eternal life is not only unnecessary, it would be anomalous. Darkness and absence were not always thought to be entropic. Death has not always been annihilation, even to the agnostic, and desire has not always been understood to be insatiable.

In the stories whose reticulation constitute what are now thought of as goddess myths, there is a fascinating intimation, barely more than a latency, that I want to associate with the current nexus I am exploring. There is a tradition that associates the capacity for abstract thought with the realization that there were four phases of the moon and not three. The fourth phase is the dark phase. Evidence is widespread in artefacts and rituals from African to Native American to European.[51] I am connecting this imaginally with a non-Aristotelian universe, that is, one not subject to his limit of the three.[52]

The moon is of course now ineradicably associated with women on many levels, from the cyclical phases of the menses to the supposed inconstancy about which so many sonnets (from the irreplaceable to the indifferent) have been written.

But what if this association is loosened from the actuality of women to a more abstract principle of m/other-ness? The issue now is how to think of these connections through a more extensive connotative complex. The worship of the goddess may have been a vital element of life in the Palaeolithic, and it may be informative now, but it will not do as an end for an inquiry such as this, in the contemporary scene. "Imaginally," this is both Kristeva's dissolution of "identity" and Heidegger's groundlessness. In her alignment of these two thinkers at this point, Jean Graybeal claims that "Heidegger's struggles to find ways of speaking after the death of God the Father bring [him] into relation with the 'mother' in language, *la mère qui jouit*."[53]

In all of this it also relates to the fourth phase of the moon, the darkness. The phases are all part of the same, yet they change. They are a visual phenomenon, but what is seen is only a part of what they symptomize. The association of abstract thought (and therefore language) with a cyclical understanding repositions the Other, that much analysed product of the modern ego. The other is not seen across a gap, or the repository for all our abjected psychic matter, but rather is the dark phase, the completion of our own individual cycle in that which we can think imaginally. The visible phases are that which we know or might know, from ourselves, what we observe or have learnt. The dark phase is the rest. The rest used to be silence.

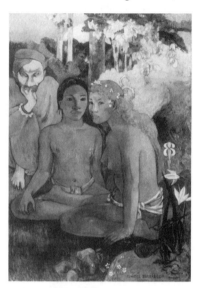

Narrative art, understood not as other to abstraction, and figurative similarly not other to non-objective, but rather as in Bal's phrase "beyond the word-image opposition" may begin to allow this structure to emerge. One of the most powerful narratives I have ever seen is Barnett Newman's *Stations of the Cross*. The story it tells is this story now under discussion, rather than that of the historical Jesus. It is a matter of what aspect of the visual is to the fore. Visual abstraction may not be identical to verbal, but it is not set against the word. One of the most abstract images I have ever seen is the constellation that images Mallarmé's poetic output in its entirety. And this image is repeatedly, obsessively—and problematically—explored in relation to the female.[54]

FIG. 18 Paul Gauguin *Contes barbares (Savage Stories)* 1902, 131.5 × 90.5 cm./ 51¾ × 35½ in.) Marquesas Islands, Museum Folkwang, Essen.

Contes barbares depicts a strange trinity. Two figures sit close to one another, so close that the honey of their skin seems to form a single focus, even though it is impossible to tell whether they actually touch.

The figure in the middle is in a half-lotus position. It is sexually ambiguous, but probably a young boy (despite some commentators). It matters no more and perhaps less than his ambiguity. He looks past you to your right with expressionless almond eyes. The girl on the right is somehow less serene, though the difference is not obvious, certainly at first. Her legs are folded back as she sits between her knees, hands balancing on the ground. She is plump, slightly more sallow than the boy, and with red hair, one of the close range of reds characteristic of the painter. It is like Mallarmé's "chevelure vol d'un flamme," and perhaps also those other "chevelures"—of Baudelaire or of Rimbaud's *Chercheuses de poux*. Her right nipple breaks the line of the boy's arm.

Around her fabulous hair is the first of several strange elements that suggest balance only to disturb it. There is an inexplicable mist or smoke seeming to emanate from it—is this mystical or symbolic, or something mundane like a camp fire? The fire would have to be somewhere near the exact middle of the pair of figures, and if it exists, it casts no light. The scene is in fact strangely lit, mostly from the middle right but with odd highlights. But most disturbing of all is the presence of a third figure behind, and crowding, the boy.

The man recalls the fox in *La perte du pucelage* (The Loss of Virginity). He has pointed ears, red moustache, and hair the colour of the girl's. He looks malevolent with his milky eyes and hunched pose at the edge of the scene.

The fox is an Indian symbol of perversity, as Gauguin himself recounts,[55] and indeed commentators have noted references (some very obvious) in this and many of Gauguin's paintings to stories from World religions, to Buddhism, to Christianity, and to Occult signs, as well as to what he was able to pick up of the remnants of Oceanic mythology.

Perversity as a Baudelairean concept with its origins in Poe—it was one of the principles of the *Les fleurs du mal*—relates closely to Gauguin's aim in trying to be both civilised and a "savage." It includes sexual perversity, ironic in Baudelaire, with his self-conscious wickedness, but more directly social and experiential in Gauguin, as Eisenman has shown, with all the difficulties this entails. The presence of such a concept radically alters the themes for which Gauguin is known: innocence, virginity, and the great religious questions. A perverse reading of his focus on women, accepting at face value his question *D'où venons-nous, que sommes nous, où allons-nous* (so hard not to be cynical about such questions so simply put), might suggest that since Gauguin's question is a material one, and therefore concerns birth, he opens precisely on to the questions Kristeva raises in her classic essay *Giotto's Joy.*

It seems as if the narrative signified of Christian painting were upheld by an ability to point to its own dissolution; the unfolding narrative (of transcendence) must be broken in order for what is both extra- and anti-narrative to appear: *non-linear space of historical men, Law and fantasy.* [Author's italics.]

FIG. 19 Giotto (1266–1336): *Last Judgement*—detail (angel at top right). Padua, Scrovegni Chapel © 1990, Photo Scala, Florence.

Kristeva illustrates her essay with the detail from Giotto's frescos in the Arena Chapel in Padua, Italy, which shows an angel in somewhat militaristic garb holding the sky as if it were a rolled manuscript. Gauguin's model for his frieze-like structure in

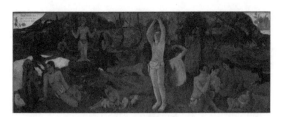

FIG. 20 Paul Gauguin, French, 1848–1903. Where Do We Come From? What Are We? Where Are We Going? *(D'où venons-nous, que sommes nous, où allons-nous?)*; oil on canvas, 139.1 × 374.6 cm (54¾ × 147½ in.); Museum of Fine Arts, Boston; Tompkins Collection; 36.270; Photograph © 2003 Museum of Fine Arts, Boston.

D'où venons-nous, que sommes nous, où allons-nous? is more likely to be Puvis de Chavannes than Giotto, yet his peeling of the corners is suggestive of a more critical stance towards his audience than anything to be found in Puvis's Golden Age paens, an edginess drawing attention to the relation of immanence and transcendence.[56]

He had too much contact with occultists—one is portrayed in *Contes barbares* and occultism is ubiquitous among the Symbolists—not to have a sense of continuity of all matter, both with itself and with "spirit," or what I might prefer to call something like energy and consciousness. Gauguin was no armchair transgressor, or theorist, and having known what it was to be a bourgeois (in his career as a banker), he gambled everything on his art. The fact that he died in poverty of a sexually transmitted disease, or that he did not find "anywhere out of this world" in Tahiti or its myths does not mean that he lost.

My poetically perverse, or imaginal, reading sketched out here, suggests that the beauty he glimpsed may be another aspect of the disruption of conventional meaning—in his case of mythic narrative—driven forward by his more clearly radical contemporaries, and that the sexual and cross-cultural politics of this attempt are not at all simple.

The probing of narrative through painting can in itself be a radical enterprise, one that is somewhat obscured by too ready an assumption that this must be "literary" and therefore in bad (modernist) painterly faith. *Savage Stories* is explicit in referencing stories, and Gauguin after Pont-Aven is always probing narratives of one sort or another. It would be a mistake to see any of these works as genre scenes or even perhaps as primarily philosophical, if that involves distracting from the painterliness of his effort to articulate what cannot be imaged through conventional means. His titling may easily be ridiculed for its bad use of the language of Tahiti, but he knew the work of Odilon Redon extremely well—the late woodcuts and sculptures abound in forms taken directly from Redon—and it was perhaps Redon's prime achievement to invent a narrative language that deployed words and images in such a way as to transpose the structures of each into the other. These were published as lithographic albums, and each title formed part of a complex narrative and imaginal structure.[57]

The most relevant such derivation here is possibly *Soyez amoureuses, vous serez heureuses*, a woodcut of 1897 that incorporates a banner with writing on it within the image, like ones found in pre-Renaissance devotional works; though

unlike these, the banner is the title. The woodcut shows a woman's profile looking over her shoulder in exactly the same distinctive pose as Redon's etching of 1891, *Perversité*.[58] Its seven figures are probably all female—one is a child—and may be a kind of life cycle, placing it more in the Buddhist tradition than in the Christian, elements of both of which are to be found in the Redon. The fox skulks towards the left, relaying to other works on the theme of perversity, and the effect of this takes the treatment of the theme in relation to the female well away from Redon's idealism. It seems most probable to me that Gauguin's title is not naïve, and that he was aware of the irony of addressing women in this way, "be in love and you will be happy," at the same time as inquiring into the great mysteries;[59] I mean by this that the tone is multivalent, as indeed are the figures, each expressive of different emotion.

If the abstract of story is narrative structure, the visual abstract is an inseparable part of Gauguin's painterly and existential (in its broadest sense) quest, and many of his works reflect this in their combination of figurative and non-representational elements, related in varying ways through color. It is perhaps as if we are looking at an embodiment of Spinozan "double aspect," in which the mental and the physical both exist and may coincide, but not in terms of one another. Or again, color as Alcyone's tone, perhaps.

PART II: THE GHOST OF A BLIND SPOT[60]: LYNE LAPOINTE, JEREMY GILBERT-ROLFE

Frank Stella's search for what is not quite there may connect with Heidegger's groundlessness and the Mallarméen (female) absence, as I have been suggesting, while at the same time suggesting Gauguin's drive through what Stella calls "the something within his always limited field of vision, something in the dark spot that makes up his view of the back of his head."[61] It is within this frame that I understand the theme of Lyne Lapointe's recent exhibition *La tache aveugle*[62] (*Blind Spot*). Gilbert-Rolfe's Heideggerian aesthetic is articulated in both his painting and his writing, and it is as a productive intertext that both are explored here in relation to Lapointe. Gilbert-Rolfe's painting may be seen in the light of Heidegger's attempt to theorize a formal delimitation of universalism, possibly avoiding the difficulty Huntington points out in Irigaray, where "the use of the feminine as imaginative universal risks reinforcing entrenched ideas about women, not to mention essentializing womanhood in ways that fortify heterosexist biases."[63]

Rather than being juxtaposed in a comparative exercise, they are being engaged as spurs to one another, contemporary artists, man and woman, working through the sexed matrix I began constructing with Matisse, or perhaps with Mallarmé. As previously, my interventions begin with exhibitions,[64] aiming to allow the appearance of style and the female without the erasure of "woman." Another starting point is Gilbert-Rolfe's essay *Blankness as a Signifier*, to which I wrote a riposte that was not published, as it was perceived to be insufficiently critical, and therefore implicitly dependent with nothing really new to add; feminine, perhaps.[65] It is one of the ghostly blind spots of this section.

Lapointe is the Canadian artist best known perhaps for her collaborative work with Martha Fleming from 1982 to 1995. She has in the space of a very short time produced a collection of remarkable, crafted artworks, the result of Lapointe's return to solo working. The show is an astounding achievement, twenty-eight large-scale works produced since 1996, half of them since 1999/2000. Not only this, but the variety of highest craft skill entailed is extraordinary. The works are precision made, exact in construction as they appear to be in meaning.

At first glance, it might seem that Lapointe might be the perfect example of Foster's artist as ethnographer. But this would be to mistake it entirely. Lapointe's self-portrait (*Autoportrait* 1999, oil on paper on board, wax, glass, mica, turquoises, shells, starfish, cement, straw, and wood frame, 167 × 117 × 5 cm., not illustrated) is telling in these terms, since it takes the self-portrait away from its limit in locating humanity in the body, or more especially in the face—barely discernible in the dark background—and away from any kind of incident. The glamour of the outer frame, with turquoises, starfish, and mosaic, and the straw under the inner frame are startling in bringing the insignificant into relation with the dark phase of the work's core. This is not a complete self that can be known, a face that mirrors the soul, or a memento mori or a resemblance, but rather a selfhood in tension with the universal (and the spectator reflected in its surface), groundless but non-abstract.

My response to first seeing this piece and its monumental inquiry into the self was slightly hysterical, veering from sensuous pleasure to ironic laughter. This is a conceptualization of the self that pulls right back from the local obsessions of individual histories and approaches (through stars and straw) to produce a Shakespearean (or Mallarméen) juxtaposition of the cosmic with the transient, risking the absurd, but in knowing it, stopping short of it. It is a grand leap more often attempted in contemporary art (and theory) through the technologized self and within the technologized discourse of the cyborg.

If Gauguin really was at the beginning of attempting to cross the gap between colonizer and colonized, Lapointe has taken an "elliptical traverse" across the intervening century to forge a North American art that does not pit the Native Americans against the technologized Subjectivity of their contemporaries. Her historical references span the entire history of art, and in this she does what every contemporary painter has to do: come to terms with the weight of tradition in painting. (So does every commentator on the contemporary). It is inevitably a particularization. Gauguin is not one of these references, as far as I can tell, and he is far from an obvious choice from which to work, in comparison to Rauschenberg or Bridget Riley, with whose work there is a clear dialogue–but precisely this pairing alerts the spectator to the inadequacy of the obvious here. There cannot be much of a critical literature on Riley in relation to Rauschenberg.

Lapointe works as Gauguin does in myth as magical articulation, and therefore in the realm of the beautiful, in Gilbert-Rolfe's terms. Visually engaging immediately, it requires time to explore on all levels—the marks, the

disparate elements, the textures, and the connotative skein. Her play on recondite meanings, ritual or talismanic investment of the object with material power, and the decorative plant forms of Symbolism and Art Nouveau, engages knowingly with the fragments of modernism's separatist aesthetic, to oppose none of it, constructing instead a rebus, working through illusion, palimpsest, and latency to make the visual engage with language as equally sensuous and equally indispensable to thought. Language manifests in these works as hieratic script, non-propositional, as semiotic potential rather than instrumental in meaning.

FIG. 21 Lyne Lapointe *Abracadabra* oil on paper on board, stamped lettering, wood, wallpaper, cut and painted, coloured wood frame, 85 × 247.5 × 15.6 cm.

Lapointe's assemblage of 1999 *Abracadabra* images this in the present. The summary painting that wittily turns the circular, carefully constructed three-dimensional assemblage into a bird is the merest few lines of black and white, thinly applied. The word "abracadabra" is printed round the circle that alludes to the bird's body, stamped with individual letters, recalling the earliest printing. The spell that is "abracadabra" is somehow redoubled by the doubling of the *a* in the circle—the word is printed continuously, and since it begins and ends with an *a*, it doubles: abracadabraabracadabraabracadabraabracadabra. . . . The size of the circle must have been determined mathematically in relation to the size of the letters, the physical manifestation of the word mapped on to the image. This may be more of a kind of semiotic intermediality than it is concretism, placing it as much in the line of Mallarmé's *Un coup de dés* as virtual prototype of the digital as in that of visual poetry.[66] One of the earliest works in the show is entitled *Constellation* (1996, inks and graphite on paper, 224.6 × 222.2 cm.), a kind of centrifugal assemblage of letters derived from nineteenth century lexicons in which the letters are made up of human forms, combined with constellations, the most prominent of which is Gemini, apposite in an oeuvre characterised by doubling. The (would-be) ruling constellation of *Un coup de dés* is the Great Bear.

Underlying the economy of these works is a synaesthetic impulse, that may be related to an extent to Irigaray's, of which I have said elsewhere that the "interwoven structures of sensate thought [. . .] are becoming more widely

understood through critics like Plant who see in Irigaray's search for 'a different alphabet, a different language' the contiguous structures of the World Wide Web."[67] It is in this frame that I read her allusions to Bridget Riley, perhaps paradoxically, since Riley's work is extreme in its opticality. *Screen* (2002), like three Rileys, though with targets and eyes, stages her location of the scene of painting between the surface of the work and the eye, while *Éclipse* (2001) and *Quinte* (2001) play perceptual games with celestial imagery.[68]

FIG. 22 Lyne Lapointe *Le double portrait de Madame Bee* 1999, oil on paper on board, painted wood frame, 222 × 103.8 × 2.5 cm.

Le double portrait de Madame Bee launches these games into myth, as Mallarmé does, not as flight from history, but as the absence, the blind spot that nevertheless shapes the artist's relation to the present as topological.[69] The modernist vision is entangled like the insect in a decorative swirl of wing-like plant—the veins of the transparent insect wings like the lianas of the orchidaceous flower whose grinning death's head gapes below petals that return to wings, rigid in their imitation of the transverse of a cross. The curlicues bring to mind the Copperplate or other archaic scripts of other recent works of Lapointe: *L'éperon* (2001) or *Perchoirs* (2002).

L'éperon is also based on the circle, repeating it in various ways about fifteen times. "At the centre, spun around by ninety degrees and barely decipherable beneath the delicate human hand is an ermine painted by da Vinci."[70] Baker's words betray the effect—of course, nothing in the work is painted by da Vinci, but the illusion it creates is that you are looking at "something real," looking right into the pupil of an eye in which you can glimpse in an antique hand a secret. The words (in French) tantalize—"ayant"? "coup"? "1445"? "lui"? "devoir"? Their silence is defended by a joke defence, an old spur, lead stars, and a few failed trophy antlers. If Actaeon had spurs, this would be one of his.

FIG. 23 Lyne Lapointe *L'Éperon* 2001, oil on paper, collage, used spur, lead stars, metal amulet, stag antlers, painted wood frame.

The association with Derrida is irresistible. *Éperons: Les styles de Nietzsche*, Derrida's text of 1978[71] takes the spur as defensive and offensive means—per-

haps his pen is mightier than the spur. Not only does Derrida bracket his invagi-
nation of Nietzsche and feminized truth with a proposition and a refutation—
that women will be, and will not be, his subject, presumably in the three main
senses of "subject" (topic, subordinate/subaltern, and Subject/ivity)—but he also
interweaves these possibilities through and across a text concerning myth,
Nietzsche's "How the 'Real World' at last became a Myth: History of an Error."
In the shifts of meaning in Derrida's text, woman as castrated, in the absence of
the real world, may seem to become subsumed into style. Yet style in the
Derrida is associated with historical and semantic necessity, something related in
Lapointe perhaps to her open morphogenesis.

Lapointe's bee, like the moon, is associated with the symbolization of the
biggest of questions, those of life and death. Clearly there is hardly a myth in the
world that does not touch on such questions, since they are its stuff. It is in their
morphogenesis, perhaps, that the non-castrated woman—and the real world—
may re-emerge. The bee[72] symbolizes the belief in regeneration, in the life that
comes from death. In the Minoan versions, like the moon, the bee morphs with
a male principle in the shape-related presence of the bull. As far back as the
fourth millennium BC, bees were associated with bulls, and both with the moon,
partly perhaps through the similarity of the horns with the crescent moon,
repeated in the goddess's gesture of arms raised in salutation.[73] Bees were sup-
posed to materialize out of the bull's carcass, and the "souls that pass to the earth
are bull-begotten."[74] Renewal, life out of death, the trinity, the hesitation
between the male and the female principles are all there. Unlike the Christian
versions, however, neither the female nor the natural, or rather, chthonic, is sup-
pressed ("chthonic" being a sense of the earth that is somewhat lost now, the
idea of blessings coming *up* to us from below the earth). This is an idea of the
dark, the blind phase of the moon, that post-Pagan religion (in its general circu-
lation; I cannot speak for theology) seems to have entirely suppressed.

(Perhaps not entirely, since Leonora Carrington invokes the bees in her
Surrealist novel *The Hearing Trumpet*: "Then it seemed that the cloud formed
itself into an enormous bumble bee as big as a sheep. She wore a tall iron crown
studded with rock crystals, the stars of the underworld").[75]

"Bi" in French would be pronounced "bee." The double of the portrait
brings to the fore the sexual ambiguity of the myth. (At least one of the bee-
goddesses of antiquity looks to me to be equally male: the insect body hangs
between the human legs like a phallus—I think of the third leg of the riddle of
the Sphinx and wonder yet again about Oedipus.) In the stories of Isis and
Osiris that we saw in relation to the Matisse, which one of them is the earth
does not seem to matter; he is green or black, earth or water, they are both in
the crops, and if Osiris is the life-force of the corn, then Isis brings about his
rebirth from the dark, both at dawn and into the eternity of the after life. But
if we are to maintain the connection with the present and with historical time,
it is what happens between that counts. In the background of the exhibition,
Tempo sounds, its vibrations varying in length, though the timing of the strike
is the same.[76]

(Meanwhile, in the Montréal Musée de Beaux Arts, Rebecca Horn's *Lenny Silver's Dream*[77] keeps time in a tiny darkened ante-room, Swiss-made motor humming as its twenty spindly arms rise and fall in an endless (wing) beat, 2/2 time, its drive arm attached to one end of a bar, so that its movements are syncopated. That is, their symmetical effect is produced by an apparent asymmetry. Difficult to read, like the glimpsed words of *L'éperon*, the six identical sheets of music mock the boatswain's stomping and banal tenor chorus: "His cheeks should flame and his brow should furl/His bosom should heave and his heart should glow/And his fist be ever ready for a knock-down blow [. . .].")

> Tant pis! Vers le bonheur d'autres m'entraîneront/Par leur tresse
> nouée aux cornes de mon front:/Tu sais, ma passion, que, pourpre et
> déjà mûre,/Chaque grenade éclate et d'abeilles murmure;/Et notre
> sang, épris de qui va le saisir,/Coule pour tout l'essaim eternel
> du désir.—Mallarmé *l'après-midi d'un faune*

(Who cares! Others will lead me to happiness/Their hair bound to the horns on my head:/You know, my passion, that, purple and already mature,/Each pomegranate bursts and bees murmur;/And our blood, inflamed with anticipated lust,/Surges always through the eternal swarm of desire)

FIG. 24 Jeremy Gilbert-Rolfe *Ghost* 1998, oil on linen, 78½ × 147 × 2½–1½ in. Credits TK.

The connection between the painters in this chapter is clearly not one of style or formal comparison. Lapointe's traverse through illusion, decoration, narrative, emblematic, abstraction, and non-representation is perhaps held in a kind of magnetic field of illusion. What is not there, "l'absente de tous bouquets" in Mallarmé's words, is not to be mistaken for the Platonic idea, but rather reaches towards another ideality in language or signification.

Thinking about the eponymous ghost of Jeremy Gilbert-Rolfe's painting *Ghost* can help to expand on this idea, starting perhaps with the appealing question of whether a ghost can be eponymous, and if so, what that makes of a name.

This name, or title, is untypical of his work in that it does not describe what it going on in the painting. Gilbert-Rolfe talks about various ghosts in *Ghost* without differentiating them, relating them rather to his ideas of space and their substantiality in the whites of the painting. Thus he says, as if they were kinds of equivalent, that ghosts are white and corporeally active, that the ghost of Kant is the revenant the painting has to deal with, that the ghost of one of his own student paintings of a white tablecloth is there, and finally that Derrida's writing on ghosts was a great move.[78] While I think this last may be taken to refer to the generality of the spectral in Derrida, it also clearly refers to *Spectres of Marx*, which prompted Gilbert-Rolfe's essay *Kant's Ghost, Among Others*.[79] In this essay, Gilbert-Rolfe allows his spectral Kant to embody itself in many of the issues of feminist or sexed aesthetics, from the Subject, through ethics (sometimes manifest as a substitute for art), beauty to the possibility of a female sublime.

The painting *Ghosts*, then, is filled with ghosts as denied presences, where the white spaces have a substantiality that is elusive partly because it touches on these different levels—as well as because of the surface discontinuities and Gilbert-Rolfe's habitual subdivision of the marks. The mid-point of the work is "actually" just to the right of the red-brown, but the eye is drawn by the intensity of activity and color saturation in the blue as much as by its complementarity with the yellow, and deflected by the red-brown, which is like a magnification of the blue vertical axis, itself like a waterfall. What you think you are seeing does not coincide exactly with what you realize you are seeing when you analyze it. The final paradox in this spatial deception and philosophical conceit is that this work of non-form has a three-dimensional identity in a very gentle gradation in thickness from 2½" to 1½", a sly joke on objectness which, once you know it is there, you both see and do not see. All this alerts the viewer to issues about edges and surfaces and bodies in space, as well as the upfront play with color and surface. The knowledge of it hangs like an invisible afterimage, disturbing habitual ways of looking and insisting on a notional meeting or non-meeting between phenomenology and ontology. Alcyone's tone as color perhaps reaches the point of rendering ghostly the old opposition with line.

In the early 1990s, Gilbert-Rolfe made his first painting for over twenty years whose size and shape had not been carefully determined by him. He only had a scrap of canvas to hand. Wanting, however, to make a piece of work, he used the fragment to explore formlessness. He says that this was not formlessness in the sense of "l'informe," the subject of

FIG. 25 Jeremy Gilbert-Rolfe *Untitled* 1994–96, oil on gessoed paper, 36" × 59". Collection of the artist. Photo Gene Ogami.

119

a recent exhibition and its associated scholarly debate.[80] What was under consideration there was "that which is about to be formed"; it relates to form as generally understood. Gilbert-Rolfe, however, is more interested in formlessness in the sense of "form without substantiality," as in a cloud or a ghost. This is not opposed to form, nor is it incipient form. It is non-form. Like immensity.

In this there is at least a point of entry to comparison to be made with Lapointe, and there is one work in *La tache aveugle* which figures it: *Éléments et mémoire de paysage*, see chapter seven). The compass in the oblong upper part of the diptych is surrounded with a baroque decoration that dissolves in the suggestive shapes of the larger square section below. These re-collected elements hint at the ghostly stags of *Cerf albinos* and *L'éperon*, while seeming to dismember the landscape of the title by denying its painterly logic, relegating it, as it were, to the past of brass compasses.

Somehow this evokes a groundlessness that may not be exactly Heideggerian, perhaps closer to Brennan's association of Spinoza's non-subject-centred logic and the conjunction between mythos and logos with which I began. Brennan comments on how this "extremely radical" logic has been neglected "in the critique of foundationalism," connecting Derrida's more recent position on "an origin before the foundation Derrida takes apart for the narcissistic charade it is."[81]

This anecdote about the scrap of canvas illuminates in at least two ways the genesis of *Ghost (1998)*, and indeed to some extent that of all five of the most finished paintings in the show. A small sketch, *Untitled (1994–6)*, like that work from the early 1990s, also began when all that there was at hand was a scrap, this time a gessoed bit of utility paper, the corner torn by mistake. The beginnings of all of the works in this show are there. (This perhaps includes what I find is an irritant element, the particular provocation of some of them, such as *Study for Lightness [1998]*). They are indicative in other ways, too, of development from his work of the 1980s when he was "loosening the form." But they are not about chance as the abolition of logic.

Order, Uncertainty, Movement, Immediacy is about discontinuities but clearly not chance. The title would not then imply a sequence; order, uncertainty, movement, and immediacy subsist in all parts of the work. The discontinuities are philosophical and also material, as they would have to be for Gilbert-Rolfe. There are various kinds of surface in this overwhlemingly blue painting—as he points out, there is no mystery about how

the last bit of blue got there (on the right, the paint is thinly applied over a visible white canvas) and a fair bit about how the large blue area did. His idea of blue is that it is always about depth, and therefore movement. The movement implied by the structure of the color, both blues and yellow, but especially of the blue, is both lateral and, rather than vertical, into an implied-refused third dimension. This is because while the largest part of the blue surface is depth and inscrutable layers, and the other is revealed flatness, they appear as near equivalents to create the absent possibility of a gap between them. The white canvas can, from a distance, seem to masquerade as a stripe down the same blue. But its status and its handling are different from anything else in the painting, including the other pseudo-equivalence, the stripe-like light area which is the left of the work.

Gilbert-Rolfe refers to Matisse's *Luxe, calme et volupté* (1904–5) when he speaks of this title *Order, Uncertainty, Movement, Immediacy*, (but Gilbert-Rolfe had to have four abstract nouns, not three, because of his aversion to threes, reaching beyond the Aristotelian universe determined by three.) When asked whether Baudelaire's poem *L'invitation au voyage*, the source of Matisse's title, were also a presence in the work, Gilbert-Rolfe replied that he did not often think much about Baudelaire any more because of the poet's concern with the transgressive and his belief in progress, which makes possible the belief in decline. But there is one word in the poem that is easily overlooked in favor of the seduction of "luxe, calme et volupté," as indeed the organizers of the exhibition *L'invitation au voyage*[82] preferred to do—doubtless much better marketing. The disregarded/disavowed word is *traîtres*. The female addressee of the poem is compared to the land, the *là-bas* that is the destination of the journey, and her eyes are traitorous. The land is an illusion.

If a ghost is an illusion, it is one that mimics materialization. The two largest paintings in this show are around eighty square feet each, in different proportions. This scale makes the painter and the viewer consider their bodily relation to the work. Scale does not of course relate directly or literally to immensity, but works above a certain size bring the possibility of a direct relation to real space into play. A question these large works seem easily to pose is Seamus Heaney's in *The Air Station*: "[. . .] could you reconcile /What was diaphanous there with what was massive?" Like Lapointe, their beauty at first makes you think that of course you can. Unlike Lapointe, the possibility of illusion is held as one equal among many. Another potential is that of beauty here and now—the beauty that is glamour, in Gilbert-Rofe's terms.

Which gives rise in these paintings to the question of whether contemporary viewers will give themselves up to color. The recent success of women such as Sandra Blow, Gillian Ayers, and Wilhelmina Barns-Graham suggests that they will indeed. Painting, like poetry, used proudly to aspire to what is beyond legibility; without this aspiration, the justification for the whole edifice that is now institutionalized art practice falls. Art truly made for its own sake is *art engagé*.

Aspects of this point can be amplified fairly briefly, even though the full argument for it would be long. The simplicity of the title *More than One Thing*

(1998) is to my mind a deadpan joke about what follows. Gilbert-Rolfe will say that all artists make the kind of work they make because it relates to something they take seriously. In other words, it is part of the definition of art that this degree of necessity is what determines process, form, and that part of meaning that resides in the work. The work is made for the sake of its own drive. Its integrity is in that of its own drive; more, they are one and the same. If you look back over Gilbert-Rolfe's career, his necessity concerns a sustained investigation of spatiality and connection, differently qualified or manifest at any given moment, but essentially that. If you wanted a generalization for significant issues of our time, these two nouns, spatiality and connection, would do as well perhaps as any. You need both, though, their tension arising out of the alignment of factors which do not oppose, are not exact equivalents, and contain something which makes one think about opposition and equivalence, and hence pluralities of relatedness. Something like this underlies the great changes we are living through. There are those who would encourage the idea that this kind of complexity and heterogeneity can be conveyed with relevance today only through a kind of pastiche. These works show another way. I say this without rejecting any kind of artistic form—futile at the best of times. It ought to be obvious that an engagement with the same issues as "the popular" (in its variety), and thence a connection with it, does not have to be in the form or in the idiom of the currently popular. The capacity to touch elements right across the cultural spectrum is a feature of art, whether it begins in the popular, the bourgeois, the high-status, or the recondite.

This was a particular discovery of the radicals of the late nineteenth century which has tended to get lost in the desire to assert for its luminaries their canonical rights. As well as the thoroughly contemporary, Gilbert-Rolfe's paintings inhabit a world of underplayed painterly references, the whole put together in a spirit of play. They are in this and in their exploration of discontinuity both like and unlike Manet. This is another not very obvious comparison among several in this chapter, and Gilbert-Rolfe is much more likely to talk about Matisse in relation to his own work. But think of this conjunction as distinct approaches to the similar—or, more concretely, as covering the same terrain but from different directions and following paths that sometimes cross, sometimes run together, and sometimes diverge. Manet is unlike Gilbert-Rolfe in that he can be inaccessible at first, almost repelling the viewer; he is figurative and it is only sometimes that color is the first point of entry. But when it is, as in *Boating* (1874),[83] the comparison is much more obvious, particularly as scale is similarly mobilized. Both painters, furthermore, are about non-representation and their own histories in that of art. Both seek to intervene in a particularly participative way. Looking at both involves moments of blankness, of non-communication, as well as those of excitement and insight. This tells you a great deal about the nature of the encounter here, as it does about what was happening in late twentieth century art. Looking back, was abstraction as such really the main issue for the century, as has been thought at times? Is the same terrain differently inhabited actually the same?

The relation between reader and text has changed considerably over the century just ended. So have understandings of it. It is now understood to be complex and various and proto-interactive. If I make a comparison between this and looking at painting, I do not at all wish to elide the difference in medium and form. What I want to do is emphasize a moment, which can be extended and repeated. I want to focus on the implicit interaction between two people at the cultural interface that is a work of art. This strangely exact and indefinable event is the delicate pivot on which is balanced a great cultural edifice, and on which can be poised a life. This is not necessarily an exaggeration. The institutions of culture are a major material, economic, and political element in contemporary world interchange, the scale concealing that moment, *which they lack,* when the viewer sees the work. But they recognize it in the status awarded to exhibitions and the expensive promotion internationally of the opportunity to see *original* works. Individual destinies can be indelibly marked by that moment. Seeing original works by Barnet Newman was crucial in making Jeremy Gilbert-Rolfe leave England for the United States thirty years ago.

It may be projection on my part, but the last of his works I want to mention, *Space in the Forest (1997),* seems inflected with a re-emergent European sensibility, while marked with its distance from its own origins. (This is the reason why my plain metaphor of a terrain above is apposite. It concerns the impact of America on a European, especially, perhaps on one from England). *Space in the Forest* is unsentimental, liminal, its concern with edges internal and temporal. Artists of color have promoted excellent and important shows about cross-cultural effects. While there have of course been shows about mutual "influence" between Europe and America, it might also be interesting to see a show about space curated on an open and mobile sense of what diaspora might mean. It has, fundamentally, no color.

FIG. 27 Jeremy Gilbert-Rolfe *Space in the Forest* 1997, oil on canvas, 70½ × 77 × 2 in. Collection of the artist. Photo Gene Ogami.

The sense of diaspora might be perhaps like Isaac Julien's in his film *Vagabondia* (2000), which is set in the Sir John Soam Museum, London, a building that articulates the liminal space of the colonial collector—part house, part cabinet of curiosities. London has many such extraordinary places, and their ubiquity in the rest of the country, and perhaps of Europe, testifies to a widespread social phenomenon. Soam was not an isolated eccentric. From the eighteenth century on, gentlemen travellers would return to their homes laden with artefacts. They began to modify their houses to accommodate what they had found. Few of them, if any, built the new house in such a way as to articulate what they had discovered.

Julien's film probes this house as a Pandora's Box. Images are doubled, turning in on each other to form patterns like that of a kaleidoscope. There is a voice-over in Creole, spoken by the artist's mother, and as we pass through a recession of doors, we become aware that there is no single architecture here, no surface knowledge, or knowledge-object to be packaged and taken home. Rather there is an ever-changing view of a set of relationships, each partially secret, none fully accessible. Nevertheless, there is a set of relationships. There were white colonists and black colonized, male colonizers. Without installing a separation between viewer and viewed, I want tentatively to maintain a differential between the view that changes and what it is in the object or the observed that endures. Julien does not critique the Soam museum as an instrument of oppression. He does something far more difficult, though it appears to come readily to him. He inhabits it through his mother's voice.

This is a kind of structural persistence within change that is very difficult to articulate in specific terms, through the particular. While recognizing the mobility of relationships, it accepts that movement leaves its trace. It does not assume a fluid economy. Nor does it equate to assuming there are secrets that can be revealed. Or that ghosts do ~~not~~ exist.

Notes to chapter 5

1. NY, Allworth Press, 1999: 77–8.
2. NY/London, Routledge, 1995, 209–47: 228.
3. 1979 [1915] London, The Women's Press.
4. Jacques Derrida, (trans. Barbara Johnson), *Dissemination* Chicago, University of Chicago Press, 1981: 86. (*La dissemination* first published 1972).
5. I freely admit that it is not developed in this text, yet it insists on being here. The reader is equally free to ignore it.
6. "Choreographies" (written interview with Christie V. McDonald) in Peggy Kamuf (ed.) *A Derrida Reader. Between the Blinds*, NY/London, Harvester, 1991: 453–4.
7. All these quoted fragments are from "Choregraphies": 454–5.
8. Huyssen 246.
9. Huyssen 246–7.
10. Griselda Pollock's evidence in *Avant-Garde Gambits 1888–1893. Gender And The Colour of Art History* London, Thames and Hudson, 1992, cannot easily be set aside, and her insistence on the presence of actual Tahitian women is essential.
11. *Being two, how many eyes have we?* Gottert Verlag, 2000: 9E (text published in four languages. English marked with *E*. Irigaray co-translated.) There is much in this small book I read with dismay (considering her earlier work), including the seeming fixity of her view of a world "peculiar to each gender." (14E). The same applies to her recent lectures and other publications.
12. The words are Richard Shiff's, on the jacket of *Gauguin's Skirt*, Stephen F. Eisenman, London, Thames and Hudson, 1997.
13. Linda Goddard, currently finishing her Ph.D. research at the Courtauld Institute in London, is demonstrating how Gauguin developed his skill as a writer, and the extent to which *Noa Noa*, the diaries, and letters evidence rhetorical self-positioning.
14. The records of the artist's anti-colonial resistance are scrutinized alongside his letters and writings to powerful effect. See especially 153–201.

15. Cambridge, Mass., MIT Press, 1996: 183.
16. Her critique of the avant-garde may be fruitfully read alongside the view of the film-maker Leslie Thornton, who sees it at "the outer edge of narrative" (Interviewed in Minh-Ha 1992: 244). Eisenman acknowledges that both Pollock's and Abigail Solomon-Godeau's (1989) "polemical assaults upon art historical complacency are brilliant," though they appear as a "pair" whose work is homogenized. The second reference to Pollock's text is brief and skims her position: See 18–19, 91
17. Pollock 1995: 8–9.
18. See Florence "The Liberation of Utopia" in Linda Anderson (ed.) *Plotting Change. Contemporary Women's Fiction*, London, Edward Arnold, 1990: 65–84.
19. Foster 1996: 172.
20. Ibid. 203.
21. Minh-Ha 1992: 228. The whole of this chapter "When I Project" is highly relevant.
22. I also hope I am playing fair by using his work as an example of what I think is a widespread phenomenon not exclusive to men, since Foster has edited a collection with an article by Minh-Ha, so he knows of her work. "On the Politics of Contemporary Representations" in Hal Foster (ed.) *Dia-Art Discussions*, Port Townsend, Washington, Bay Press, 1987.
23. Oxford English Dictionary.
24. I am indebted for this distinction to Andrew Ross, from whose question based on Geertz's work I have extracted it, though I disagree with his conclusion about what follows from it. This is the whole of his question/statement to Minh-Ha: "Nonetheless, the interpretation of this whole question of repetition with respect to the analysis of ethnic cultural events has been an important element of recent critiques of structural anthropology. Much of Clifford Geertz's work, for example, has been concerned with demonstrating that rituals are not expressions of universal functions, or rather that they do not conform to universal structural roles. Each ritual, inasmuch as it is repeated, attends to different, or specific, local circumstances each time. As a result, one can only construct 'local' interpretations of any culture's social meanings, rather than an authoritative, structural breakdown of its workings." Minh-Ha 1992: 229. The next note is an extract from the reply.
25. "If there is one thing that would always invalidate anthropology, it is precisely its claim to scientific knowledge. This claim can be conscious or unconscious [. . .]. People like Geertz who criticize the claim to the universality of such discourse would be the first to declare that if anthropologists' interpretations differ from any one else's interpretation, it is because they are 'part of a developing system of scientific analysis' [. . .]. This implies the accumulation of specialized and institutionally legitimized knowledge." Minh-Ha 1992: 229.
26. Leach 108–9.
27. Bal, Pollock, on figures from the Bible, such as Ruth, for example, among many feminist writers.
28. *Lacan* London, Fontana, 1992: 151. Bowie is here at his subtle best—scathing, fair— and Lacan's essay has had wide currency, but a clinical case-study of the 1940s, in which the analyst also cited St Teresa and other mystics is equally relevant here. See D. Bertram *The Psychoanalysis of Elation*, London The Hogarth Press, 1951: 146–50. There is much of interest in this non-feminist, non-Lacanian study, not least its simplicity and unselfconsciousness about interpreting a woman's ecstasy with her lover as part of her sense of fusion with God.
29. Bertram 1951: 57.
30. Ibid.

31. Ibid. 63.
32. Dialogue with Minh-Ha, interwoven with another dialogue with Leslie Thornton, forming the chapter "Political Cinema": 246–7.
33. "Genesis as Myth" first published 1962; this collection "Virgin Birth" in *Genesis as Myth and Other Essays*, Cape Editions, 1969: 100.
34. Anne Baring and Jules Cashford *The Myth of the Goddess* London, Viking 1991: 593. I am much indebted to this study for its scholarly account of these myths. Freud interprets this painting in terms of psycho-biography and the genesis of Leonardo's homosexuality, making reference to the mythical goddess Mut's association with a vulture in support of his case. See "Leonardo da Vinci and a Memory of His Childhood" (1910) in the New Penguin Freud *The Uncanny*, (intro Hugh Haughton, trans McLintock), 2003: 45–120.
35. Baring and Cashford: 597.
36. Ibid. 596.
37. I am deeply indebted to Baring and Cashford for this insight, though I am removing it steadily from their vocabulary of sacred marriages and holy children. Archetypal complementarity is not the model I am elaborating.
38. Butler: 164, also cited as an epigraph to chapter 3 above.
39. See Baring and Cashford, esp. 588ff. I am much indebted to this book for its account of the story of the Virgin and how it maps on to that of the Great Mother.
40. Baring and Cashford 130–1.
41. *Private Visions: Gender, Race and Nature in the World of Modern Science* London/NY: Routledge, 1989: 156. Quoted in Assiter 116.
42. There is a great deal of scholarship tracing this story, and for the open-minded, the evidence is weighty indeed. See for example Pamela Berger *The Goddess Obscured*, Boston, Mass.: The Beacon Press, 1985. In Baring and Cashford, even where they are citing a passage to demonstrate the persistence of the mother goddess, they reveal the awkwardness of female lineage in the stories (from the Emperor Julian in 363 A.D., a Neoplatonist, so perhaps it is not surprising). Julian lauds Cybele in fulsome terms— but says as part of this praise, "She is the motherless maiden [. . .]." (403)
43. See John Boswell *Same-Sex Unions in Premodern Europe* NY, Villard Books, 1994.
44. See Lilian Faderman *Surpassing the Love of Men* London: The Women's Press, 1985.
45. *Lacan*: 171.
46. Bowie: 173.
47. Ibid.
48. Scholarly obligations are near collapse in an argument of this breadth, especially in relation to a concept as widely debated as desire. I will acknowledge the writer who first convinced me of the possibilities for a productive model of desire: Elizabeth Grosz. See, for example, her *Volatile Bodies* Bloomington, Indiana, 1994.
49. Bowie: 169.
50. "Imaginary" trails clouds of Romantic Imagination and the Lacanian pre-Symbolic. It will not serve here.
51. There was a land bridge that once joined Siberia and Alaska, by which the people of the Stone Age most probably reached the Americas. It leads to a tradition that scholars of the period have traced to be so widespread that it must go back to the Palaeolithic. See Baring and Cashford: 20.
52. See chapter 6 for more on the sexing of number.
53. Huntington: 4. Huntington develops this in relation to Heidegger's methodology, concluding that his "[. . .] truncated praxis leads to stoic consciousness and paves the way for Heidegger's reactionary politics of the thirties" (16–17).

54. Dee Reynolds, in an argument with which I have much sympathy, and through which the relation with abstraction alluded to here could be further developed, explores the politics and problematics of Utopian thought of the period in her sixth chapter, "Universal Exceptions." "The male creative consciousness would find its apotheosis in fusing with the self-generating structure of an art work whose 'universality' is conceived of as androgynous, and where the feminine principle is 'aufgehoben' in the masculine." *Symbolist Aesthetics and Abstract Art. Sites of Imaginary Space* Cambridge, Cambridge University Press, 1995: 223.

55. In a letter to the painter Émile Bernard in 1889 (*Lettres*: 87).

56. The face behind the sky in the Giotto is echoed in more than one of Odilon Redon's lithographs, and these Gauguin certainly knew.

57. See my *Mallarmé Manet and Redon*, 1986.

58. M 20 in Mellerio *Redon: Oeuvre Graphique Complet* The Hague, Artz and Du Bois n.d. (1913), reissued New York, Da Capo, 1968. For another example, the figure of death from the album *À Gustave Flaubert* (1889) (M 97), is exactly replicated in Gauguin's *Ghostly Figure* (1890), his statue in wood *Lewdness* (1890–91), and in his *Caribbean Sunflowers* (1889–90), which also repeats the thick serpentine line and pendant flower with a human face of Redon's charcoal *Marsh Flower* of 1885. The reverse of this pose, which shows the figure with arm raised, elbow bent, and hand across the face, appears in the central figure of *Passage d'une âme* (M 21, frontispiece to the 1891 novel *La Passante* by André Remacle); and both this and the wave-like division of space appear in *Soyez Mystérieuses*, a painted wood relief of 1890, which also shows the fox and a seated figure with head in hands like that of *D'où venons-nous*, in which this figure also appears. The dating of this example is a little uncertain, but the figure is sufficiently characteristic of Redon to allow of little doubt. Another of Gauguin's wood reliefs of 1889, also entitled *Soyez Mystérieuses*, shows some of the same figures. More examples could be adduced. Redon in his turn acknowledged Gauguin in, for example, *Portrait Imaginaire de Paul Gauguin* (pastel, c.1900), which incorporates some of Gauguin's forms and colors, and *Hommage à Gauguin* (pastel 1894).

59. See note 8 above for reference to research on Gauguin as a writer.

60. I want to record an allusion to Gauguin's grandmother, the socialist Flora Tristan, about whom I recall an independent film entitled *Blind Spot*. I think I saw it in the 1980s, but have not retraced it or verified that this is correct . . . (one of) my own blind spot(s), perhaps.

61. Frank Stella *Working Space* (1986), cited in Bowie: 169.

62. Musée d'art contemporain de Montréal, 25 May–13 October 2003. This is not a review of the exhibition, however, and the reader is referred to the catalogue "La tache aveugle," Gilles Godmer with Steve Baker and Christine Ross, Montréal, 2003.

63. Huntington *Ecstatic Subjects*: xxviii. See also chapter 5.

64. *Jeremy Gilbert-Rolfe: Recent Paintings*. Shoshana Wayne Gallery, Bergamot Station, Los Angeles, Autumn 1998.

65. "Sex, Blankness and Signification: Anamorphic reflections on an essay by Jeremy Gilbert-Rolfe," unpublished 1997 response to Jeremy Gilbert-Rolfe's essay "Blankness as a Signifier" *Critical Inquiry* v. 24 no. 1, autumn 1997: 159–175, a version of which also appears in his *Beauty and the Contemporary Sublime* NY, Allworth Press, 1999: 109–23.

66. See my essay "The Virtual and the Visual: the Sex of Visual, 'Intersign' and digital Poetry" Oxford, Legenda, 2000: 43. This is one of five short essays published together with interactive versions of the poem *Un coup de dés jamais n'abolira le hazard* in French and English on CD-Rom (conception and design by Florence, programming and design by Jason Whittaker).

Ce doit être
Le Septentrion aussi Nord

UNE CONSTELLATION

Froide d'oubli et de désuétude

(It must be/the North, the Great Bear/A CONSTELLATION/Frozen in oblivion and neglect)

67. Ibid. 48. The reference is to Sadie Plant in *Zeros and Ones* London, Fourth Estate, 1998: 140–1.
68. For details of the allusions in these works, especially to Richard Gregory and Paul Bonnet, see Christine Ross's essay "How to see?" in bilingual catalogue of *Lyne Lapointe. La tache aveugle*, Gilles Godmer with Steve Baker and Christine Ross, Musée d'art contemporain de Montréal, 25 May–13 October 2003: 79–80. There is important work to be done on British women artists working in relation to abstract or non-objective art—Riley, Ayers, Blow, Barns-Graham, to name a few.
69. I have in mind, for example, *Mes bouquins refermés. . . .* See the end of this section.
70. Steve Baker, "Tyger, Tyger" *La tache aveugle*: 71.
71. First delivered as a lecture in 1972, *La question du style.*
72. The butterfly is also associated with images of regeneration, and Lapointe uses them several works, which may be associated with the "butterfly effect" of Chaos theory. See *La tache aveugle*: 11 n. 17.
73. Baring and Cashford: 74, fig. 35, "Bull-horned goddess in the shape of a bee picked out in dots on a stylized bull's head of bone." It is not clear to me as a non-specialist of the Late Cucuteni in Poland why this is a bull's head rather than that of a cow—other than as a backwards projection of the later Greek understanding.
74. Ibid. 118.
75. 148. The novel was written in Mexico in English and not published until 1974. This version produced by Boston, Exact Exchange, 1996, with an introduction by Helen Byatt and illustrations by Pablo Weisz Carrington. Thanks to Liz Larner for introducing me to this book.
76. Not illustrated (2002, Latex, pyrogravure, collage on paper on board, modified clock mechanism, oil painted glass, batteries, metal hinges 81.7 × 122.5 × 64 cm.).
77. Not illustrated (1991, sheet music, brass, electric motor).
78. This final section of the chapter draws on conversations with the artist at the time the paintings were exhibited in 1998.
79. In Penny Florence and Nicola Foster (eds.) *Differential Aesthetics* Aldershot/Burlington VT, Ashgate, 2000: 99–117.
80. See for example Rosalind Krauss "*Informe* without conclusion" *October*, fall 1996: 89–105
81. *History after Lacan*: 88.
82. This exhibition is the both basis of chapter 2 and part of what prompted the current chapter. It began with Gauguin.
83. Or, rather differently, Manet's *Un bar aux folies bergères* (1882) in which simplified color works (among other things) to structure illusion.

the devil's interval: barbara hepworth, anish kapoor, and liz larner

I will abandon restrictions and curbs imposed upon myself. Not physical ones, but those restrictive tabs on my inner being.

—Eva Hesse[1]

PLACE AUX MYSTÈRES OBJECTIFS! [. . .]
Fini l'assassinat massif du present et du future à coup redoublé du passé. (Up with objective mysteries! Down with the wholesale slaughter of the present and the future by the past.)

—*Refus Global*[2]

In the *Timaeus* Plato idealises these numbers [Pythagorean Dyad and Triad]. The Father, the immutable One, is the source and the Mother, the Dyad, is the recipient. They produce the Offspring, i.e., the prime number 3, the Triad. But he also says that she, the Mother, [is . . .] "all receptive" and not as anything specific such as earth, air, fire or water. This means she is the principle of no-thing. It is the offspring, the Triad or triangle, which [. . .] is the principle of the potential for solid objects.

—Barbara Underwood[3]

A sculpture is always the result of thousands of years of polishing and storytelling.

—Laila Pullinen[4]

The devil's interval, *diabolus in musica,* is the sound in music that often produces a shiver. It is the augmented fourth in the Lydian mode, a tritone that does not appear in the overtone series. The Roman Church in the twelfth century condemned it, and church musicians were banned from playing any music that contained it.[5]

If myth is taken to be one kind of universal language, music is another. The association with mathematics and number linked it in the medieval university with philosophy and mathematical science through the discipline of the "quadrivium,"[6] and in the nineteenth century, music was held to be the highest art. This lends to it an appearance of objectivity and neutrality.

Underwood's argument alluded to above goes on to show how the octave space between one and two is filled through the number three. In this scheme of things, three is a male number, and in Plato's *double entendres* over his aim "to leave no gap in my test of pleasure and knowledge," the association of the triad or the three with the phallus as the key to unifying Pythagorian dualism is visible.[7]

The gap or space between has been a much-favored critical metaphor over recent years. In this chapter, the aim of the analysis is to move out of this seeming-neutral geometry and into a topology that posits structures that articulate another spatiality than this understanding of the musical structured on intervals. Laila Pullinen's sculpture incorporating bronze and stone, both polished to a high degree, is in this way understood through the particularities of her materials as the energetic and temporal in mutually operative registers.

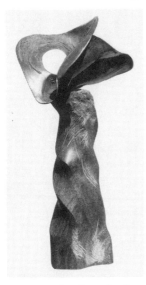

The devil's interval, then, is invoked as a discordance, not tied to its strict musicological meanings—I can make no specialist judgements about music or its history. It plays through the material, social, and aesthetic movements in what follows as a tone. Of course, there is no such thing as a devil's interval in the quartertones and microtones of Indian music, for example, and in Western music the predominance of the major scale is a post-Renaissance phenomenon. My sense of the devil's interval is one of uncertainty and un/familiarity, the slippage of the uncanny. Like Blake's poet (Milton), I may be of the devil's party. Perhaps. This is the point, the uncertain and potential meaning I want to attach, perhaps temporarily, to this tone. "L'espace à pour jouet le cri: 'je ne sais pas'"—"Space toys with the cry 'I don't know'."[8]

The gap in which this tone sounds is especially that within the split subject and between the self and the other. The possibility is utopian, a move through the fiction of separation.

FIG. 28 Laila Pullinen *Carelia* 2000, Mäntsälä red and black aurora and bronze, 295 cm.

Carelia refers to the isthmus between what is now the border of Finland and St. Petersburg in post-Soviet Russia. It is Pullinen's homeland. Finland is on the borders of Europe in a very different sense than Britain, and Carelia is its oldest part. In her words:

> The people of Carelia, now lost or incorporated into the Finnish population, were poets and artists as well as fishermen and hunters. I have sometimes likened them to the Etruscans; their relevance to Finnish culture is similar to the Etruscan influence on Rome. The Finnish national epic *Kalevala* is based on the oral poetry of the Carelian people, and it was sung by women at weddings and funerals, and passed on from mother to daughter, but it was also part of daily speech in the form of proverbs and poetic similes. Carelia was conquered and destroyed [. . .] by the Russians in the Second World War. My father, an officer by trade, died fighting in this war.[9]

My hope is to continue to seek a way of articulating the sexed universal through art that associates it with the located voice of a putative diasporic subject, such

as Isaac Julien's in his film *Vagabondia*. The aim is not to assimilate either to the other, or to accord primacy or priority to either.

The ethics of this move may be questioned by some, since it involves an exploration of how the diasporic subject may be part of the constitution of the dominant, and I can see that there could be negative and conservative appropriations of what I am trying to say. It takes considerable negotiation to get beyond seeming to suggest little more than that we are all nomadic subjects now. But this is precisely why the concept of the sexed universal, as part of Cornell's version of reiterative universalism, appears necessary.

Christine Battersby has pointed out the greater affinity of "nomadism" in Deleuze and Guattari to Kerouac's beatnik than to "the more material modes of becoming that characterize American Indians, gypsies, migrants, aboriginal Australians, or Bedouin." In *On the Road* (1957), there are no children and the only women are "chicks."[10] It is an articulation of the structure of production rather than reproduction, the primal horde as (b)ratpack.

The artists through whom the main thread of the argument is taken up are Barbara Hepworth, Constantin Brancusi, Anish Kapoor, and Liz Larner.[11] The strategy is more like taking different readings of a landscape from a variety of points than going through it "on the road." It is going to be partial, but while it may show the partiality of the more familiar, and therefore more obvious, view, it will also suggest another, topological model. This is not Peter's projection of the world map versus Mercator's. It is, at least in aim, a model that can accommodate the logic of both, with accountability, if not arithmetical accuracy, of scale and navigation. The chapter implicitly takes up the problematic in relation to which Hepworth was discussed in the introduction, the ways in which the "subaltern" might break through the glass ceiling into participating fully in the invention of a culture in which there is no dominant, and in which there is immensity rather than limits.

Homi Bhaba, for example, effortlessly moves from reading Kapoor's *When I am pregnant* (1992) (dimensions variable—a deliberate joke, presumably) in terms of time and empty space to a notion of the self-born.[12] This is a familiar erasure of the female, as we have seen in the introduction, and entirely within the logic of Bhaba's focus. But it is not straightforward. Bhaba goes on to discuss the void. Gender would be very much to the fore in analyzing his work, were Kapoor female. The problem is not the philosophical pairing (in and of itself) of the void with matter. The problem is one of connotation: in the Western tradition, this locates the male with the void and the female with matter. Again, within non-alienated conceptions of the void and of matter (which seem now largely to mean obliteration and the sub-human respectively, and both without "spirit"), the question might arise of whether Kapoor is working in the cultural feminine at present. Is there an historical imperative here? If there is a sexed structure to the universal, can Kapoor be read as articulating that relation— topologically. But I anticipate.

It is well known, and much quoted, that Hepworth visited and admired Brancusi, and it is this affinity I want to follow now. Brancusi has posed a

problem for critics for the best part of a century, in that there is no clear "source" for his art, either in terms of the forms he deploys or his technical approach. A Romanian émigré in Paris, his Eastern European peasant origins ensured that he always had to negotiate across social categories of most kinds. His focus on the female subject in his work made that negotiation apply to all kinds of division: cultural, linguisitic, racial, and sexual. He was already multicultural in outlook and self-constitution, and it has been suggested that he derived his inspiration from cultures as wide as the European, African, Chinese, or Indian.[13]

How far this is exact is beyond the scope of this discussion. What it signifies, however, is an artist who reached through difference. Anna Chave has observed, "Brancusi's homelessness, as manifest in the ethnographic eclecticism and aesthetic diversity of his work, is the very sign of its modernity."[14]

European culture over the last century was on the move, especially at the time of some of the great developments in European modernism from the first years of the twentieth century towards about the 1930s. It followed the upheavals following on more than two centuries of colonialism, the revolution, and wars in France, and encompassed the Russian revolution and the First World War, to select a few of the most major. It is not enough to view this in terms of style (to say, for example, that certain artists derived from, say, Constructivism, or the folk art of their country of birth—itself sometimes a catch-all that fails to examine commonalities across "folk art" internationally) or to adopt the evasive formalism of what I might call mid-modernism. Building on the immense volume of scholarship on all phases of modernism that has been published over many years, the broad questions can be posed in sexed terms, not only why artists across Europe were exploring form in particular ways at the specific historical moment when migration, war, and state-directed ideologies were tearing the old certainties apart, but also how these events impacted on the deepest levels of sexed subjectivity. Hepworth's understanding of art was committed to precisely this class of question, if not these actual ones.[15]

Chave goes on to outline Brancusi's "counterorthodox images of sexual positioning" through which, together with the cultural diversity just mentioned, he articulated "an imaginary restructuring of power relations." Finally at this point in her discussion, she adds that his idea of beauty was "not the white, the pure, or the universal, but 'as absolute equity': perfect justice."[16]

What I think Chave is describing here translates readily, if not obviously in all ways, into the frame of the sexed universal. Though it seems that he discounts the universal, Brancusi would not aim for the universal in the terms available to him, because he did not share the same model of unity and coherence that defines the thinking characteristic of self-referential universalizing. His understanding of subjectivity was not simply that of the dominant, but rather a complex that included the subjectivity of the subaltern, and as such, the "self-other" construction of centrist thought was alien to him. I wonder if this might be part of what gives European modernism its edge over British modernism, and, furthermore, that which connects Hepworth more closely with certain ele-

ments of European art than with the British, in terms of which she is usually discussed. At the same time, Brancusi was clearly able to incorporate the other sex, and sometimes to appropriate the female voice, in his art in a way that remained beyond reach for females.

The crucial difference is that Brancusi could work with the entire conceptualization of the universal at his disposal, and, like considerable numbers of modernists, forged his art in relation to a female phantasm he either invented, projected, appropriated, evaded, or at best questioned. Brancusi, like Picasso, went so far as to appropriate the female body, fragmenting and abstracting it, as in his sexually dimorphic sculptures like *Princesse X* (a pun on "prince's sex"). It would not be until much later that Louise Bourgeois would be able to approach anything like so explicit a gesture, as in *Fille*, the huge phallus that-is-not-one famously photographed tucked under her arm by Robert Mapplethorpe in 1982, or again that Eva Hesse would bring together male and female forms as she did most explicitly in her work of the early 1960s, such as *Ringaround Rosie* (1965), which she described as looking like "a breast and a penis."[17]

A work by Brancusi was the subject of a famous trial in the United States. When Edward Steichen, a friend of the sculptor, took *The Bird in Space* to New York, it was assessed by customs as attracting import duty, because they did not accept that it was a work of art. It was officially seen as some kind of miscellaneous implement, and therefore subject to duty. Brancusi had some extremely eminent supporters in the ensuing legal debacle, including Duchamp, Epstein, and Gertrude Vanderbilt Whitney, and in the end Brancusi won.

What is interesting here is a certain element in his defence of the work. Despite that fact that he later used both assistants and mechanical tools in his work, Brancusi insisted that *The Bird in Space* was art for two main reasons: First of all it was his original conception, and second, that none of the many versions of this work was a reproduction—"I never make reproductions." Changes to each version could be very small indeed, but such was the precision with which he viewed them that he could say, "There is no similarity whatever between them. [. . .] if I change one dimension an inch all the other proportions have to be changed, and it is the devil's job to do it."[18] It was the handmade quality, as opposed to mass reproduction, that was a necessary part of the work's status as art. It was an approach that was clearly under interrogation at the time (not least by Duchamp, one of his supporters) and that has still more clearly been displaced since.

This is a relation to the sculptural object closely shared by Barbara Hepworth. The terms in which it was often expressed were those of direct carving. But in both cases, the underlying conception has to be understood more broadly if this example is not to become limiting. In Brancusi, it seems to run counter to his later use of assistants and motorized tools; and in Hepworth, direct carving, strictly interpreted, seems less relevant to her bronzes and some later works in metal. As I see it, the underlying reason for this shared insistence on process is relational. It is because the sculptor is not separable from the work, not because the work includes the artist in the Romantic sense, but rather

because it is part of a philosophy of the material that is based on contiguity. Brancusi's attention to his studio-home bears this out. It was well known that he incorporated technological and other objects into his living and work space, which were one and the same,[19] an investment of the immediate that I have associated with Aphrodite.

This brings us back to the mythologizing tendency in his work and the element that has made critics see it as both primitive and futuristic at once. The tendency is to refer back to the mythological unity of the sexes, however, rather than forward to the differentiated contiguity posited by the notion of the sexed universal. This arises at least in part because the languages of these two faces of the universal are so unbalanced, and the topology unknown. If matriarchy was indeed succeeded by patriarchy, and only the latter recorded its history, there never has been a balance. The idealized projections on to the various gods of mythology have available to them only the models of androgyny or sexlessness, and neither will suffice. Pregnancy is androgyny's nemesis. Only by assuming the unfertilized body can the androgyne appear to be both male and female. As suggested above, perhaps this is the attraction for such myths, including their articulation in Brancusi, of eggs—they remove the foetus from the female body.

The difficulty that arises in abstract or non-objective art thus concerns what determines the spatial to a significant degree. Classical geometry cannot account for the ways in which the sexed human mind and its sexed embodiment both is and is not alike within, across, and between the sexes. (For the sake of simplicity I write as if there were only two, but my aim is to think in such a way as to allow for more).[20]

The question of spatiality has been opened right out since the later twentieth century.[21] Eva Hesse's blurring of chaos, structure, process, and ephemerality are indicative of the new paradigm. It is a development equalled by the elaboration of theories of Subjectivity. The trail is not an obvious one, and it crosses and recrosses familiar territory, which makes it easy to lose. But it can be followed, as for example in the work of the contemporary American sculptor, Liz Larner. In Brancusi (and Gabo, see below), space is perhaps what defines the work; in Larner, as prefigured in Hepworth, it is topology, a studied movement from Hesse's "anti-form." In making her case for a positive reading of the sexual ambivalence of Brancusi's figures, Chave refers to Jardine's "genderization beyond opposition," which is intrinsic to modernity.[22] But all her examples are male writers. Women have to express that desire, too, of the bisexuality of the Subject in classical psychoanalysis is shot through with problems for the female subject, which ultimately must mean for the male subject, too.

An analogous difficulty arises in relating this back to creation myths which have a tendency to be taken, even among sceptics, as absolute. They also refer back to an ideal unitary source that condemns the Subject to seek its completion.

Larner's work is, generally speaking, as heterogeneous as Brancusi's is consistent. She avoids a "signature style," which, while it is not sufficient alone, is an indicator of a subjectivity less fixed on the consolidated ego, and her *Bird in Space* appears at a glance not to be closely related to much of her work. There are some series to be found in her oeuvre, but because there is such a variety in general, the occurrence of these series signifies in different ways (see below). Nor is her work thematic; there is no equivalent in Larner to "flight" or "origin" in Brancusi ("flight" and "origin" an interesting combination). What primarily has determined her oeuvre to date is the structure of space rather than space itself—"making visible that on which visibility depends," as Gilbert-Rolfe has put it.[23] This is a step further than the broader nineteenth-century inquiry into the invisible, though it is possible with hindsight to see its beginnings in the likes of Mallarmé.

FIG. 29 Liz Larner *Bird in Space* 1989, nylon cord sewn with silk, weighted with stainless steel blocks, dimensions variable. Installation at Los Angeles Municipal Art Gallery 1989. Courtesy 303 Gallery, New York, and Regen Projects, Los Angeles.

Brancusi made several versions of *Bird in Space* that are so alike that they are barely distinguishable.[24] They form part of a series on the theme of the bird and of flight on which the artist worked for over forty years. It began with a clearly figurative *Maïastra*, a Romanian myth about a bird-princess, which Chave associates both with the phallic mother and with Brancusi's biological mother.[25] This version itself went through seven versions before the version illustrated above, the one that for most people must be the quintessential Brancusi. The variation in the bases is far greater than in the works.

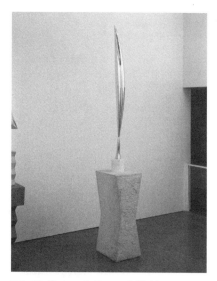

FIG. 30 Constantin Brancusi *Bird in Space*/circa 1932. Centre Pompidou-MNAM-CCI, Paris. RMN=ADAGP. © Photo CNAC/MNAM Dist. RMN.

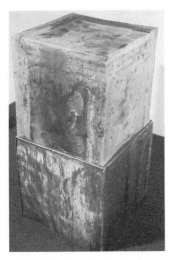

FIG. 31 Liz Larner *Used to do the Job* 1987, steel, aluminium, coal, copper, iron, zinc, copper carbonate, brass, bronze, saltpetre, bursera, gummfera, glass, iron oxide, santalum album, bluestone, sulphur, tar, rubber, volcanic ash, lodestones, TNT, ammonium nitrate, and other natural and artificial ingredients suspended in microcrystalline wax and paraffin on sheet metal base, 48½ × 25¾ × 24¾" Collection of Alan Dinsfriend, Boston. Photo courtesy 303 Gallery, New York, and Regen Projects, Los Angeles.

The base, a crucial issue for Brancusi, has a rather different role to play in Larner, for whom it is also significant, but as a locus of redefinition and and interrogation.[26] *Used to Do the Job,* for example, consists of a cuboid of sheet metal as a base with an almost identical cuboid made up of a variety of materials suspended in paraffin wax. The base is grey, with the appearance of lead, and the top is a warm honey, punctuated with irregularities. Its references within modern sculpture are many in addition to Brancusi; from, for example, Serra or Judd, and towards Rachel Whiteread's *Plinth* (2000 Trafalgar Square).[27] Through Larner's own work, *Copper Cube, Woven* (1988) and *Grid Cube* (1989), they also reference Eva Hesse's *Accession* series of 1968. The use of weaving and binding in these works connects them directly with other pieces from the 1980s, such as *Out of Touch* (1987, four-cubic-foot sphere, composed of sixteen miles of surgical gauze) and *Head, Torso, Foot* (1989), which use soft materials in a feminist-inspired deployment of fabrics, thus bringing in an explicitly female element of the overall frame, through an ideological and connotative connection. Referencing also Duchamp's "mile of string," it is an Ariadne's thread of far greater ingenuity than escaping the Minotaur. Would even the Fates dare to cut it? (It runs through the *Corridor* pieces, *Head, Bird in Space,* and back again to the bendiness of *Two or three etc.*)

The materials solidified into the wax in *Used to Do the Job,* however, go further than the connotative femininity of weaving and soft fabric; they are indexical. It is important to read the list of what is in there, to confront an imaginative reconstruction of these explosive or inert elements: steel, aluminium, coal, copper, iron, zinc, copper carbonate, brass, bronze, saltpetre, bursera, gummfera, glass, iron oxide, santalum album, bluestone, sulphur, tar, rubber, volcanic ash, lodestones, TNT, ammonium nitrate, and other natural and artificial ingredients suspended in microcrystalline wax and paraffin on a sheet metal base.

An investigation of some relation to the real seems to be currently a feature of work produced by women, non-representational, non-objective though it may be, and it may be here that some of the defining factors in the contemporary sexed universal are to be found. In this example it consists of fragments from bronze casting on the one hand and bomb making on the other.

NATO, a potato and the Republic of Plato is similarly subversive and seemingpassive. It strikes the viewer as Minimalist-related at first, only to make one shift one's ground and think again. Inside the work is a petri dish in which organic change has taken place. If Hesse is here, it is in her process-oriented trend, away from Minimalist geometry. Not only this, but the material inside that reacted is paint. And not only is paint understood as an artistic medium, but it is paint from the NATO building, thereby establishing a connection with actuality in the form of a real place and a real political institution. Science is there in the background, too, the science of the laboratory and the molecular model. Plato would of course have kept artists out of his republic. It is a great joke and a great title, and it turns on pigment.

NATO, a potato and the Republic of Plato (1988) may look like a Minimalist

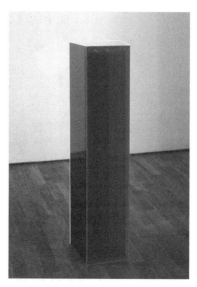

FIG. 32 Liz Larner *NATO, a potato and the Republic of Plato* 1988, bacteria, glass, Plexiglas, 37¾ × 25¾ × 24¾ in. Private collection. Courtesy 303 Gallery, New York, and Regen Projects, Los Angeles.

piece both in form and in material, and at first sight, one might easily begin to respond to it as one might to a Judd. But then one very quickly realizes that this is not at all the kind of "literalist" work (to borrow Fried's term) that excludes the imagination in favour of real relations in real space. Moreover, Minimal art (if I can use that term—Judd rejected it) opposes illusion. Larner's work exploits it. What we have here is a piece that straddles separated traditions and that does not oppose. Art cannot simply oppose, in the end. It can be other than that with which the artist disagrees. But it cannot oppose. It is too much allied to the senses, to pleasure, and to the indeterminate to oppose. It can of course be inserted into a discourse of opposition, but then the nature of the work within signification is immediately altered, and it is not the work itself that opposes. If Minimalism opposes illusion, that is its limitation.

The incorporation of a real organic process is a device used in several other works of the 1980s, such as *Orchid, Buttermilk, Penny* of 1986. It consists, like some but not all of the others, of a petri dish containing the ingredients of the title and photographed fresh and at three weeks—a kind of grim gestation gesture, full of dark humor and existential insight. Metaphorically, indexically, and in its embodiment, these works are sexed. But they are not confined to the "feminine" in any way, neither in themselves nor in their frame of reference.

Larner's *Bird in Space* compares as readily with the Hepworth of *Orpheus* as it does with Brancusi, and the comparison emphasises her contemporaneity in relation to Gabo, with whom Hepworth is often discussed.[28]

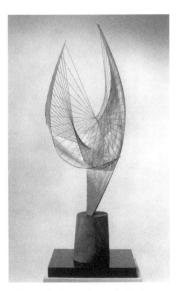

FIG. 33 Barbara Hepworth *Orpheus* 1956, © Bowness, Hepworth Estate.

Indeed, if you look at Gabo in light of Hepworth, rather than the other way round, instead of seeing them as doing the same, as I have argued before, you realize that they approach the problems of space from opposite ends. As abstracting movement they are indeed indicative of compatible conceptualizations of space; but because Hepworth sought the relations between planar, linear, and mass elements of form, where Gabo sets them in opposition, her understanding is potentially broader and more radical in application than what appears to be Gabo's dualism.[29]

It is this kind of non-dualist re-viewing that is essential to the sexing of tradition—"both-and," to point out both the similarities and the differences between Hepworth and Gabo, and in the same way with Brancusi.

Without this kind of change in the underlying critical framework, we cannot account for the kind of Subjectivity I am arguing we see in and through Larner. Even those few critics whose work moves substantially towards rendering the issue of gender more relevant to the major questions of tradition tend to remain within the paradigm of a self formed in the mirror stage. Although much has been done to put the body back into the discourse around abstraction—and indeed that body is sexed—there has been little room for a Hepworth. There are signs that this is changing, but unless the frameworks can reformulate universals as sexed, there will be a similarly partial view of artists such as Larner.[30]

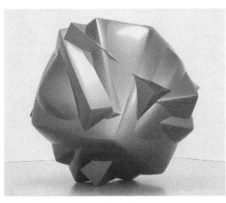

FIG. 34 Liz Larner *Untitled* 2001, fiberglass, steel, and urethane paint, 12' cubic. Courtesy 303 Gallery, New York, and Regen Projects, Los Angeles.

If one of the things art does is to look into the way sensuate knowledge is organized, to coin a word analogous to Irigaray's "sexuate," it is not confined to epistemology. A love sonnet will be about how the lovers love, and how they know they love, but it will also be about poesis. That's where art for its own sake is not decadent, but necessary. The delightful thing about this is that it means that pleasure is necessary. Not all art *foregrounds* this inquiry into how knowledge is produced, but I suggest that

Larner's does. What really motivates her work is a sensuate inquiry into the organization of knowledge. In so doing, it illuminates the changes necessary within the broader critical framework.

Contemporary knowledge has behind it a tradition of splitting the senses from each other and from the intellect. This has been said often enough. This division maps on to a number of ways of organizing knowledge, most notably here, sexual difference.

FIG. 35 Liz Larner *Untitled* 2001, *detail of Fig. 34.*

Familiar ground, probably, even if not favourite ground. Women are supposed to be more on the side of the body, men on the side of the mind. Nature, nurture, raw, cooked, etc., etc. The trouble with this is no longer that it is hard to see, it is that it is generally hard to follow through.

Larner requires it, however. It is plain that her work does not thematize sexual difference as such, yet there are particularities that are inaccessible without considering sexual difference as a philosophical and formal issue. This is so even when, or especially when, her eye is on the universal. If sexual difference is not taken account of, a whole dimension is lacking that limits its reach—historical, formal, and contemporary. Nowhere is this more difficult than in the mathematics of science, although women working in cybernetics are beginning to make real headway, and what follows draws on this work.

Untitled echoes molecular structure as in scientific models, which may be one reason for its strangeness; this twelve-foot proximate cuboid seems to represent the microscopic. If that were all it did, it would be just an alteration of scale in the manner of Koons. But it goes further, to evoke an *appearance* of the microscopic. Seen in close up, the shift in scale seems to continue and to modulate. The microscopic is not solid like this, however. This digitally designed elemental form seems now to be morphing, now to be some strange residue, fallen out of an unknown space: "Calme bloc, ici-bas, chu d'un désastre obscur"; stony silence, fallen on earth from some obscure disaster.[31]

Like *Out of Touch*, it sets a mathematical form on a large scale into real space. That the works are unalike in their materials and their approach to construction is part of the point. Softness and hardness are not opposed. If you look beyond these differences, further likenesses emerge. Both works relate to the sphere: *Untitled* evolved out of a number of drawings, forming not so much a series as a number of possible starting points and directions, including the spherical, which subsists in the finished work through evocation;[32] *Out of Touch* seems more securely related to the sphere, but its direct formal reference dissolves when its materials come into the account. Sixteen miles of thin, ribbon-like material unravel the "purity" of Platonic ideals. Both pieces appear to be an interrogation

FIG. 36 Liz Larner *Chain Perspective Reflected* 1990. Installation at 303 Gallery, New York. Steel chain, mirrors, and hardware. Dimensions variable. Courtesy of the artist; 303 Gallery, New York, and Regen Projects, Los Angeles.

FIG. 37 Liz Larner *Forced Perspective (reflected, reversed, extended)* 1992. Installation at the Museum of Contemporary Art, Los Angeles. Steel chain, mirrors, and hardware. Dimensions variable. Courtesy of the artist; 303 Gallery, New York, and Regen Projects, Los Angeles. Photo: Joshua White.

not only of physica
you see it out there
its internal structur
underpins what yo
sphere and the cub
classical fundamen
form (the third bei
are intimately relat
one fits into the ot
at exact points, ass
patibility of scale. (
look closer at *Unti
seem to disappear :
under the microsc(
unlike the sphere ii
Touch, giving way
altogether far less certain and more fluid or unknowable.

What you can actually see keeps changing; it therefore both refuses the singular and insists that you stay aware of how you are looking. You cannot detach how you are looking from what it is. The impossibility of detaching how you are looking from what the work is clearly has implications for visuality. To put it in other, parallel terms, it interrogates the nature of looking through the form of the object of the gaze as much as through the construction of the subject. This matters a great deal in the context of the sexed universal, because it maintains its external anchorage. The performative, as recently theorized most famously by Judith Butler, is brought more firmly into a dialogical relation because iteration and re-iteration are not entirely freefloating. In one sense anchored in the real, the absence of a fixed or denoted relation might abolish one kind of authenticity, but it does not remove authenticity as an idea founded in reality.

Larner does not limit her reconceptualization of received thought in the visual arts to the three-dimensional, however, as the sly presence of the linear in those sixteen miles of gauze indicates, along with the strung-out works to which I have related them. Her companion pieces *Chain Perspective Reflected* and *Forced Perspective (reflected, reversed, extended)* show this clearly.

The second, more recent, one of these, *Forced Perspective (reflected, reversed, extended)*, was installed in two adjacent galleries, one with black walls and one with white. Natural light came in from a skylight. The white-walled room had mirrors on the wall, but in the black, there were no mirrors and fewer chains, such chains as there were only running horizontally, not vertically. These were actual continuations of the horizontal chains from the white gallery,

FIG. 38 Liz Larner plan of installation. *Forced Perspective (reflected, reversed, extended).* Installation at the Museum of Contemporary Art, Los Angeles. Courtesy 303 Gallery, New York, and Regen Projects, Los Angeles.

taken right through the wall between the spaces, which were not visible the one from the other.

The lines in the black room create an illusion of irregularity when viewed along the chains rather than across, constituting a rich provocation concerning looking and knowing that plays on the relations between two and three dimensions. If linear perspective attempts to copy three dimensions into two, this installation repays the compliment, and some. Not only does it copy two dimensions back into three, but it also copies back the conventions for representing three dimensions in two dimensions back into three. In so doing, it creates a space for the mind to play between dimensions and their representation, both unsettling the conventions and suggesting ways of sustaining them within the new perception. The trace of their kind of knowledge is not denied.

FIG. 39 Liz Larner detail of *Forced Perspective (reflected, reversed, extended).* Black-walled gallery, installation at the Museum of Contemporary Art, Los Angeles. Steel chain, mirrors, and hardware. Dimensions variable. Courtesy of the artist; 303 Gallery, New York, and Regen Projects, Los Angeles.

These works are full of linear intersections as the chains cross and re-cross. This network of linear intersections meets a plane as the chains pass through the wall, halfway to becoming a 3-D intersection between planes. A 3-D intersection between planes is a corner, and I shall return to this presently. For now, I want to stay with the illusion of linearity.

FIG. 40 Liz Larner *Corridor Orange/Blue, Corridor Yellow/Purple, Corridor Red/Green* 1991, lead, metal, car paint, fabric, stainless steel, wood, leather, rock. Installation at Stuart Regen Gallery, Los Angeles. Courtesy 303 Gallery, New York, and Regen Projects, Los Angeles.

The orthogonals of mathematical perspective form a kind of corridor, and it has been convincingly argued that they may in part derive from the real space of Renaissance cities. Be that as it may, it forms a connection with a work of Larner's about which there appears to be relatively little commentary.

While the preceding discussion has been implicitly about Subjectivity, the focus has been rather more on the object. Informed by this, I now want to bring sexed Subjectivity to the fore, and to use it to retrace a few steps in order that the nature of Larner's historical intervention might become more fully appreciable. *Corridor* refers to very different kinds of sculpture at one and the same time. I want to relate it to something a critic said in the 1970s, and it was a very influential observation. The critic is Rosalind Krauss, and the observation leads towards her concluding remarks of her much referenced work, *Passages in Modern Sculpture*.

> Contemporary sculpture is indeed obsessed with this idea of passage. We find it in Nauman's *Corridor*, in Morris's *Labyrinth*, in Serra's *Shift*, in Smithson's [*Spiral*] *Jetty*. And with these images of passage, the transformation of sculpture—from a static, idealized medium to a temporal and material one—that had begun with Rodin is fully achieved.[33]

This is the conclusion of a long and subtle argument that is now widely known. I just want to take a step back in it. Krauss has established her view of Minimalism, its refusal of illusion and its repetitious impersonality, as deeper than then thought. She has moved the source of meaning from the core to the surface of the work—so far so good—and she locates the beginning of the move in Rodin and Brancusi.[34] There are significant ways in which I find in Larner a means of qualifying Krauss's reading of narrative in Rodin, and though that is not the main point for now, it ultimately relates to it. The main point is that Krauss reads this move to the surface as one of decentering, and she sees it as a break with the dominant styles that immediately preceded Minimalism. She illustrates the point with Heizer's *Double Negative* of 1969.

In this, viewers must look across from one designated spot to another. They cannot be in the center, they can only look across it from one point or another. Nor can they form a sense of where they stand without crossing to the other designated spot. It can indeed be read as an image of decentering.

The sense of vision in relation to the body is across a gap. The artistic and viewing self is split and accords with that of classical psychoanalysis, and with the modifications of it in French theory that led to literary moves involving, among other innovations, the notion of the death of the author. What I think Larner does constitutes a different move than this one of decentering. It may well be in accord with the move to the surface—but it is where we go from there that is different. I also question whether this is such a complete break from the work that immediately preceded it. Larner's corridors are not Naumann's. They do not constitute an "adversarial space," as work of the period was dubbed, and while both Larner and Naumann involve the Subjectivity of the spectator, that Subjectivity is quite differently constituted. Even Mona Hatoum's corridor piece is more like Larner's, despite the apparent adversarial space—*Light at the End* (1989, 65⅜ × 64 × 2 in., iron frame, six heating elements) involves crackling electricity and running water, creating an immediate and actual sense of danger.[35]

FIG. 41 Liz Larner *Chained form on the Diagonal, interrupted* 1990, steel and stainless steel, 84" × 66" × 42". Private collection. Photo courtesy of Regen Projects, Los Angeles. Photo: Joshua White.

Taking up the reference to the corner that I mentioned before, corners are about contiguity. The same is true of the arrangement of the black and white galleries in *Forced Perspective (reflected, reversed, extended).*

Putting these corner works alongside the perspective pieces is a fascinatingly productive exercise. Kirby Gookin's observation in her *Artforum* review of the earlier work *Chain Perspective Reflected* draws attention to the experience of entering this Through-the-Looking-Glass world:

The first openings are wide enough to accommodate the viewer and invite one to enter the described volume. Because the perspectival recession is constructed rather than

FIG. 42 Liz Larner *Wrapped Corner* 1991, Stainless-steel chain and hardware. 49" × 90". Collection of Norah and Norman Stone, San Francisco. Courtesy Thea Westrei Chapter Art Advisory Services.

illusionistic, however, one's progress is soon thwarted, and a feeling of bodily entanglement and constriction becomes palpable as one proceeds.[36]

Bearing this more radical spatiality in mind, works by Hepworth begin to look rather different. *Pastorale* (1953, marble) is generally taken to be a calm and straightforward exercise on the pastoral theme. Figure 43 begins with an approximation to the received view of it, followed by five different angles.

Unless the first view is understood only as an initial entry point, what happens when you move around the work is a radical change and almost inexplicable. Because these are large works, they are often primarily known through photographs, and these rarely attempt to deal with the complexity of a spatiality that shifts from the planar to the topological. Even looking at this work from a slightly lower angle than the one of the photograph in general circulation emphasises contour and planar shift over linearity and surface.

From "behind" the work it is clear that the swirls seen from the "front" are actually holes, both now rounded—the one on the left appears as a slit in the initial view, which it echoes, but more fluidly.

In between, from the "side" (moving leftwards), the work appears very simple, though its dimensions are illegible in that it is impossible to see how far it extends away from the spectator. Without knowledge of other views, one would be as likely to predict a largely rounded shape as an elongated one.

With only a slight rotation, there is another dramatic shift, and the impression is one of extreme mass to the foreground, with surface swirls counterpointing the biplanar wedge. Unlike the previous views, this angle has a forward impulsion.

Following this walk around the piece, you arrive at the back already described, passing on the way a view surprising in its torsion—nothing before it prepares you for it. But it is the last view, at the right of the full frontal, that is a visceral shock. Most of the principal elements already described are visible to some degree. Taken together with them, it constitutes a work that goes far beyond the high modernist detachment Hepworth herself was complicit in promoting. The tone is far more complex than that of a single major chord.

Nor is this work an exception. *Oval Form (Trezion)* varies considerably in its implied relation to the viewer and in its complexity and internal structure, so that it appears as a set of contiguities in three dimensions. One effect is that the oval form is displaced from a position as the dominant and is set in relation to the multiplicity of forms described or made by the interlaced bands of bronze and the gaps between them.

This is nothing like the formal structure, subject positioning, or the viewing experience of Heizer's *Double Negative* described above, especially if understood as decentering. But nor is it a return to the kind of private self on the destruction of which Krauss tells us the Minimalists staked their all.[37] The argument runs on a notion of symbolism that I think Larner allows us to question. The kind of illusionism against which the Minimalists reacted was seen as one "that withdraws the sculptural object from literal space and places it in a

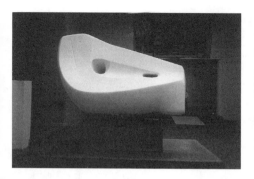
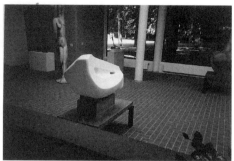

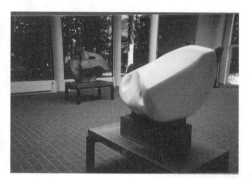
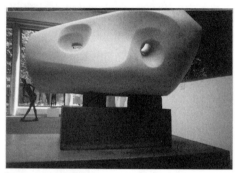

FIG. 43 Barbara Hepworth, *Pastorale* 1953, Serravezza marble, 114.3 × 45 cm. Rijksmuseum Kröller-Müller, Holland.

145

metaphorical one." The result is to endow "the object with a kind of intentional or private center."

What if the Heizer is not about decentering or centering at all, but rather the corporeality of the void?

Similarly, we might suggest a way of deploying illusionism that does not withdraw from materiality (or posit a "literal" space in opposition to a "metaphorical"),[38] that goes to another place, as demonstrated in chapter four, in relation to Lyne Lapointe and her tribute to Bridget Riley. It is also visible in a work such as Alison Wilding's *Blue* (1998, PVC, patinated brass. Not illustrated). Its principle may be closer to metonym than metaphor, since it plays not on making the work stand for something else, nor on its externality as suggesting some underlying principle of cohesion or order or tension. It plays on surface itself. (It can also comment on physcial space—a recent study of Riley's work has shown just how much the discussion of Op Art in the 1960s related to science.[39]) Larner wittily entangles her audience in the intricacies of this kind of illusion with *I thought I saw a pussycat* (1998).

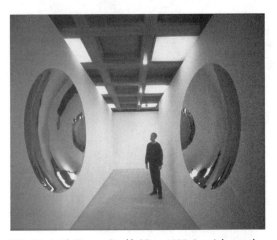

FIG. 44 Anish Kapoor *Double Mirror* 1997–8, stainless steel, two parts, 200 cm diameter each. Courtesy Lisson Gallery and the artist.

Looking at Heizer through these artists and through Kapoor would seem to point towards this topological reading.

Kapoor's material play on the varieties of illusion and spatial disposition practically necessitated the rebuilding of the inside of the Hayward Gallery on London's South Bank for this show in 1998—it was full of large pieces set into walls, floors, and ceilings; prefiguring, or even mirroring, perhaps, the activation of architectural space of *Marsyas* examined above (see also cover image). *Double Mirror* is much more dynamic (in one sense) than this. The mirrors are concave and, I think, slightly undulating and reflect your image in a variety of sizes at surprising moments as you move between them. But as I recall they don't primarily distort like a fairground hall of mirrors. There is another effect, which is the sound. Your voice bounces round to come at you from unexpected places. This is not a double negative. It's a doubled and redoubled series of echoes and reflections, and it is about a mutuality of material and space as contiguous, not about decentering. *Marsyas* achieves the same through its sketches and relocations of forms and of viewing points.

Untitled's revisionary evocation of a Minimalist object has a crucial difference from the tradition to which it alludes. It is the dark indeterminacy of pigment that hangs in or on it. Kapoor has made a great deal of work exploiting the effects of thoroughly saturated pigment. Even when you are right up close to such work, you cannot tell whether there is a cavity and, if so, how deep it is. You have an illusion of depth that you cannot resolve visually. There is a wicked, though chance, sting in the tail of your frustration in that you are advised not to touch the work even surreptitiously to resolve whether or not there is a cavity, as the pigment is poisonous. You just have to believe that the surface is flat. If color is in a sense illusion, it appears here as the kind of illusion that

FIG. 45 Anish Kapoor *Untitled* 1992, wood, fiberglass, pigment, 208.5 × 109 × 143 cm. Courtesy Lisson Gallery and the artist.

perspective is. Rather than illusion as delusion, this is illusion as interrogation of the visible, exploration of space. It is moving towards a structural role, rather than merely a structural function.

Color in sculpture is not recognized in this way, as a rule. The old "designe-colore" opposition that is embedded in conventional European understandings of primacy of line, as in colorless drawing in and over painting, resurfaces in three-dimensional guise. Such traditional approaches to color in sculpture associate its "lack of structure" with the feminine,[40] and connote the anxieties and prohibitions that I am tempted to call the feminine syndrome. Many of these anxieties attaching to the "feminine" also attach to the exotic, as Edward Said's elaboration of "orientalism" has shown. Not only does Kapoor work with illusion in a variety of structural ways, he works with color in such a way as to raise these issues of surface, vision, and the real—coating rocks in intense blue, for example. These works reorient the particular history of pigment in Western modernism, opening on to the structural female.

It is impossible to see color in this work as a purely surface phenomenon, connoting lack of depth and therefore of seriousness—as trivial, concealing,

FIG. 46 Anish Kapoor *Mother as a mountain* 1985, mixed media 140 × 275 × 105 cm. Courtesy Lisson Gallery and the artist.

147

misleading, cosmetic. In noting how color is falsely associated with the illusory (not the same as illusion) and the contingent, Gilbert-Rolfe observes that "there is nothing conceptually certain about immediacy, except that it's our fundamental connection to the truth of the real."[41] Kapoor's use of color does not distrust it, but rather embraces that it is immediate, pleasurable, beyond control, and beyond full comprehension, and, in both senses, subject to change. It does not read as the particular to the universal of form or structure. Almost all of these associations also attach to the feminine: trivial, concealing, misleading, cosmetic, incomprehensible, mutable, seductive. Anxiety over this particular set of associations constitutes a masculine anxiety, but not a male condition. A tendency towards distrust of uncertainty, especially when allied to pleasure (which pretty well summarizes all the above), may be universal; this particular form or manifestation of distrust at this historical moment and in this culture is also sexed. But you cannot have art without indeterminacy, just as you cannot have Subjectivity or the socius without the feminine, or indeed without women (which is not the same thing—fortunately in some ways, inconveniently in others).

Revisiting Hepworth's deployment of color in this light reveals that while it does not go as far as either Kapoor or Larner, it is not secondary: for example in *Portrait of Lisa in Blue and Red* (1949, pencil and paint on hardboard, 382 × 255 mm.), *Red in Tension* (1941, pencil and gouache on paper) and *Sculpture with color (Deep blue and red)* (1940, plaster and strings, 105 × 149 × 105 mm.),[42] each of which shows different aspects of her typically structural use of color, where there is no decorative aim at all, but a simplicity of effect that is easy to underestimate. Thus, in the *Portrait*, the blue brushmarks on the head and the red on the skirt draw attention to the sitter's eyes and right hand, while defining the forms; the red triangle in *Red in Tension* is absolutely pivotal, providing a plane that is as dynamic as the network of lines around it. *Sculpture with color* actualises the same kind of rhythmic gearing of line and color to the same structural purpose, in three dimensions.

An experimental exploration of *Red and Grey* might take this further, relating it to the complexity seen above in *Pastorale* or *Oval Form*. Hepworth made a number of drawings when she was unable to make sculpture. But they appear to go much further than sketches for sculptures, reaching towards sculptural ideas that push beyond what was then materially possible. Color is integral to this.

The following illustrations show a straightforward scan of the work, followed by a series of interpretations of it rotated in digital space. They pose questions about the planar, the linear, and color that take the viewer into a spatiality not normally associated with Hepworth.

Larner says of Bridget Riley, "She makes paintings you can't see. [. . .] It [a BR painting] exists as a phenomenon of how it makes you see. [This] can happen in three dimensions"[43]—as we saw in chapter 5 in Lapointe. Much of what I am saying about color applies to Larner's early culture pieces deploying the action of chemicals: you see results, or effects. Color is there and not there. This is a further dimension to color as skin because it is active, originary, and in

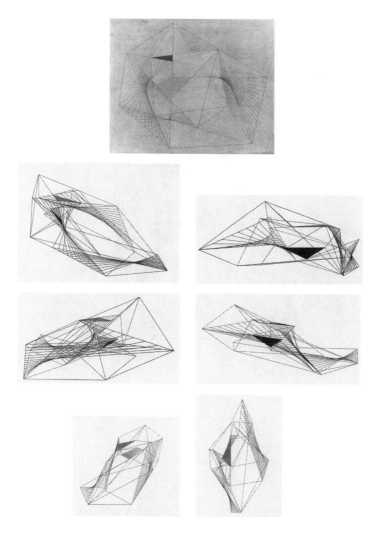

FIG. 47 Barbara Hepworth *Red and Grey* (1941, gouache and pencil, 9¼ × 11¾ in. © Bowness, Hepworth Estate. With six images transposed into 3-D by Drummond Masterton.

some ways internal. It is not a layer of any kind. It is still mutable, but in a different way from the changes wrought in color by light because it foregrounds organic change within the color-as-constituent. While all paint changes over time, presenting particular issues of conservation and restoration, this is a contingent and unfortunate effect of physical ageing. Larner's work does several things by foregrounding this otherwise hidden and chance element: It changes "what color is" in sculpture, thereby challenging many long-held beliefs about this; it introduces color as a concept and as the real and, crucially, as illusion, all at the same time; and it brings together kinds of work traditionally quite separate.

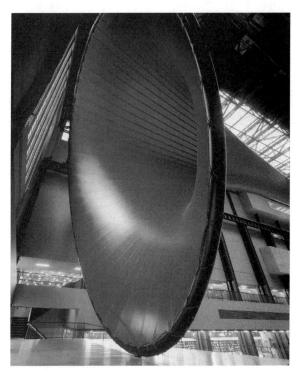

Nowhere is this elevation of color and surface to a structural role more evident than in Kapoor's most recent work, *Marsyas* (2002). It was designed using a computer for the Turbine Hall at Tate Modern in London, and Kapoor has taken the notion of the site-specific to new levels. The hall is inseparable from the structure of the work. The huge rings at either end push against the walls, and the dome of the central "mouth," like some kind of mythical trial conjuring the appearance of a great chimera wherever you turn, looms over you no matter which way you try to enter the building. Irigaray famously wrote of "two lips" as defining women's corporeality—the lips of the mouth and the

FIG. 48 Anish Kapoor *Marsyas* 2002, steel rings, single-span PVC membrane, 115 × 75 × 550 ft. Courtesy Tate Modern and the artist. © Tate London 2003.

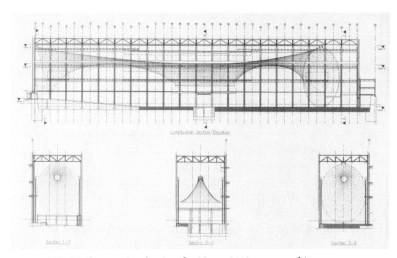

FIG. 49 Construction drawings for *Marsyas* 2002, courtesy of Arup.

genital labia. Here there are three mouths, but their lips are wide open, Eliot's mountainous "oval O," cropped out with invisible teeth. This is a topological development from *At the Edge of the World II* (1998), in which the suspended dome constituted a single element whose limits were visible from outside, and I would relate it to Hepworth's piercing of the stone.

Tate Modern is disorienting to enter, anyway, and the visitor can come in on different levels from which access to the escalators may vary. There is a staircase to a mezzanine not quite in the middle of the lower section of the hall, over which the "mouth" in the middle of the work gapes.

Marsyas is ungraspable, in the sense that it has been placed so that its form is not only impossible to take in from one view (you can say the same of many works), but that its form is dependant on a radically different one: that of the Turbine Hall itself. The question of spectator control is shifted into the mnemonic, as, in another way, in Shirely Tse's recent work, *Shelf Life* (2002 polystyrene): The only way to see this work is to walk on it, risking permanent change in the form of damage. What kind of "forms" are these?

In a broadcast conversation about *Marsyas*, Kapoor responded to the interviewer's observation—that the work was "material curved round the void"—with the following: "I think that we as beings have a deep need to have contact and intimacy. Dark spaces pull the viewer into a specific relationship with the object that I believe is intimate." He adds that it is "very manipulative."

This is clearly not the response of one preoccupied with emptiness. This is not to say an exploration of "void-ness," the quality of what this non-objective work might be in material terms, has nothing to do with it, however. Kapoor himself appears in the above conversation to be quite at ease with it, in the sense that he has a strategy. Not for him the agonized cry of one at the edge of the abyss. This is the attitude of one who is not alienated, who has looked into the pit and returned. In his interest in the ultimately immaterial (the void), Kapoor is surely taking the approach that moves in the material world.

Many commentators remark on the void in Kapoor, and it is indeed significantly different from emptiness or the horror of the abyss. Homi Bhaba associates it with Heidegger's parable of the jug, and the shaping of the void.[44]

Equally, I would align this in the contemporary scene with the groundlessness of the "feminine." The story of Marsyas turns on a female curse, in the context of an Apollonian contest. Marsyas was a satyr who had the misfortune to come across a flute made of stag's bones, cursed by Athena. She had not realized that playing the music made her look ridiculous, until Aphrodite's and Hera's laughter made her go and look at her reflection in a stream to see what was so funny. Seeing her distorted features as she played, she threw the flute away, cursing whoever should pick it up.

When Marsyas found it, it played by itself, such beautiful sounds that the people compared him with Apollo. It is never a good idea to be compared with the gods, and Marsyas ought to have denied that he was in any way like them. His fate was sealed when he did not. Apollo challenged him to an impossible competition—to play his instrument upside down and sing at the same time,

possible for a lyre-player like Apollo, but not a flautist—and when he lost, Apollo had him tied to a tree and flayed alive.[45]

Athena was supposedly born out of the head of Zeus. According to Hesiod, knowing that the child's power would mean the loss of his, Zeus deceived Athena's mother, Metis ("wisest of all, of gods and men"), through language ("with clever words") just as Athena was about to be born, and, "forestalling danger, put her (Athena) down/Into his belly, so that the goddess could/Counsel him in both good and evil plans [. . .] But Zeus himself produced, from his own head,/Grey-eyed Athene, fearsome queen who brings/The noise of war."[46]

It is, of course, the case that this take-over of birth is like the story of Eve's birth out of Adam's rib, and both myths probably allude "to that moment in history when what the German philosopher of history Johann Bachofen calls 'father-right' was established over the older order of 'mother-right.'" In the Greek version, the intervention is more clearly into the matrilineal because the father explicitly intervenes between mother and daughter, incorporating the child when the mother is almost to term, whereas the Biblical version omits the mother altogether. In the *Eumenides*, the second play of Aeschylus's *Oresteia* trilogy, Apollo reappears to promote an exclusive patrilineage: Athena is "the living witness" that "There can be a father without any mother."[47]

The earliest images of Athena trace back to the Minoan snake-goddess, who held both life and death in her hands, though it seems she can be associated with the archaic image of the bird goddess. Once again, the detachable womb, in the form of Alcyone's nest, floats into view. Rather than make of this an argument for the primacy of one sex or another, the stories bear interpretation as concerning the dangers of hierarchy and the loss of relatedness. The older bird goddess has no association with war, and the move from belly to head as origin readily maps on to the division between mind and body. Sexed language and representation are all implicated in the transformations of the story, with Zeus appropriating the female power of birth through speech ("with clever words") and the figure of what is now understood as the Apollonian, the male in art and culture, finally removing her altogether.

Kapoor's revisiting of this mythological nexus in *Marsyas* can be understood as symbolizing a movement of these sexed universals into another relation. His sense of the void derives from these mythopoeic levels where the continuity of the material posits, not emptiness, but the "shape of the void." The detachment of the female from this level is associated with conflict, which has been in turn understood in terms of history: "Athena, as a direct descendant of the Minoan palace goddess and as the distant heir of Old Europe, became Indo-Europeanized and Orientalized during the course of two millennia of Indo-European and Oriental influence in Greece. The protectress of a city naturally became engaged in war."[48] Perhaps the fear of being flayed, being turned inside out, is an articulation of death as transformation. Titian turned to this subject at the end of his life, and his great painting merges the elements into a textural continuity. Athena's archaic predecessor was both life and death.

Reading this in terms of morphogenesis brings the way that *Marsyas* is constructed into the frame. The continuity between the architecture of the Turbine Hall and the structure of the work and surface and skin makes greater sense in terms of the philosophy of contiguity in parts of Irigaray that I have elsewhere related to Hepworth. I would now want to maintain a certain distance from its most recent expression, because it appears to assume the fixity of the sexual divide in "the between-two." I do not find this in either Kapoor or Hepworth, any more than in Larner, as outlined above. This can be demonstrated in the Hepworth by revisiting a comparison between works of the 1930s, the decade often taken to characterize her work. The works are Giacometti's *Suspended Ball* (1930, metal and plaster) with Hepworth's *Two Segments and Sphere* (1935–36).

The comparison reveals as much in the differences between them as it does in the similarities. To stay with the overt sexual significance of Surrealist work would be to obscure that of the Hepworth. The latter is sexuate, not sexual. The term may not have been available in the 1930s, but Hepworth herself is clear on what she is doing. As she says in her essay published in *Circle: International Survey of Constructive Art* on the occasion of the *Constructive Art* exhibition at the London Gallery in 1937, her work has no "particular interest," but rather concerns "the whole of the artist's experience and vision [. . .] the universal relationship of constructive ideas."[49] In the example of *Two Segments and Sphere*, it requires a notion of the sexed universal to be able to see this as going beyond the sexual significance to the universal signification without denying the former. The jokiness of Giacometti's "cage" sculpture is quite unlike the tone of the Hepworth, and the same is true of the figurative suggestion on which some of the effect of the Giacometti depends. The Hepworth is non-representative, in that does not start from representation of visual reality, and one could say the same of many of her works from this period that have affinities with Surrealism. *Pierced Form* (1931 Alabaster) heralded the end of any association between the body as seen and the hole, even if that end was not immediate.[50] Hepworth learns from Surrealism, but is not Surrealist. The work is much closer to Kapoor and Larner than it is to the Surrealists. In this it presents a challenge to any claim of Surrealism, or of the psychoanalysis to which it relates, to universality. Equally, on the geometric abstraction, while Hepworth's work clearly has drawn on Nicholson's, there is always that further element in Hepworth that manifests in asymmetry, the balance of dissimilarity; in short, the mathematics of dynamic form.

Commentators have rightly pointed out that the Giacometti articulates the possibility of arousal, but not of gratification. (The viewer can swing the ball over the crescent, but it does not touch). There is no focus on unfulfilled desire, or indeed on desire at all in the Hepworth. That does not mean that desire is not relevant, nor does it indicate denial. In a contiguous economy, or in a universal topology, desire is reformulated as productive.[51] The endless trails of possibility chasing after the "objet petit a" and so forth have become sterile. What they say about desire is important; but it is not the whole story. There is such a thing as satisfaction. There is also such a thing as homosexual desire, in both

sexes. Unfortunately the diverting idea of reading Hepworth in terms of homo-sexual desire would not clarify the abstract movement under discussion. But nor would it be rendered impossible. It is a model of desire that does not separate the male and female version, that also does not merge them into an originary whole. It is not androgynous. The sexed differential is maintained.

The direction of the argument is an indication that you can work back to find a Subjectivity in art, possibly also as in Cubism, that sustains a connection with the real while exploring surface. The object is intensely individual, but it is not exploring interiority, either of subject or object. Larner's *NATO, a potato and the Republic of Plato* has an actual, though suspended process inside, but the culture is not assimilated to the case-which-may-be-a-plinth. It is not straightfor-wardly the inside of any of the work's components. Since it is not about interi-ority, it is not about decentering. In Kapoor's treatment of *Marsyas* a universal form—literally reminiscent of a galaxy—is explicitly related to the human body.

The predominant arena for exploration by contemporary women is over-whelmingly, though not exclusively, the body. Feminist artists from the 1970s initiated this work, and although a great deal of it focused directly on sexual dif-ference understood as "the feminine" for the (then) very obvious reasons that it was associated with liberation movements concerned with excavating suppressed traditions and voices.

This work signifies beyond the limits of the female body, however, and it as soon as it is read without limits, especially without this sexual limit, its origi-nality and impact begins to emerge. There is no equivalent exploration of the male body, for example; and while an expectation that there should be equiva-lence is not one I would hold, the nature of any imbalance, and the reasons for it, seem worth pondering. The male body was the primary subject of Classical art, after all, but the legacy of the eighteenth-century reinvention of Classicism, bolstered by the rediscoveries of archaeology, does not appear to follow this direction.[52] Recent studies of artists such as Thomas Eakins, for example, show how artists at the time of early modernism began to explore the male body as contemporary signifier, but this hardly places him at the helm in driving innova-tion in the subject matter or manifest content of art. I would expect, further-more, that the fact of his being American, and therefore already in a new place in relation to the European tradition is a significant factor.

Differentials of this kind might usefully be further explored, especially if the fetishisation of origin/originality could be reduced to more proportionate criterion. By this I mean that because an obsession with who got there first is a prime agent in installing a hierarchy of greatness, the time differential in the spread of modernist art tends to obscure other differentials, including the sexual. This is not to say that being the one to make the breakthrough is irrelevant, but rather than emergence of innovatory ideas is much more subtle than their being the property of individual genius. Time for women is a very different leaven in the cultural mix than it is for men. It is not meaningless that there was no woman Cubist, and while I might hesitate to try and summarize what kind of signifier this might be, I would say plainly that it does not concern inferiority.[53]

Interestingly, perhaps the one area in modernist art in which women might have a claim to have taken the lead was dance, extended and sustained into more recent work both through dance itself (more strictly interpreted within a disciplinary discourse) and through aspects of performance art, through to the technologized body in video and cyber art. From Loie Fuller, Isadora Duncan, through to the continuing inventiveness and daring of Pina Bausch, there is a remarkable female tradition in dance. Taking up the thought relating to the subaltern voices in early modernism ("early" understood not simply as a chronological term) there were seven women signatories and nine men to the Canadian *Refus Global* manifesto of 1948,[54] a document full of utopian fervour, despite its discourse of artistic purity on the one hand and rebuttal on the other. It was illustrated with a silver print of the dancer Françoise Sullivan's *Black and Tan*, which she choreographed to Duke Ellington's 1927 *Black and Tan Fantasy.*[55]

There is a sense in which this "body work" is a signifier of particular importance to understanding what I would call the trauma of modernism (it was many things more than this, and other than this, too). The semiotic and the somatic bodies are inseparable.[56] Together with the exploration of signification modernism entailed (the language/symbolic body) goes an associated dynamic of the corporeal. But the masculine is the disembodied male in a way that the feminine is not the disembodied female. Male artists could not access the body *at the same time* as they sought increasingly to distance themselves from the female. This is one reason why theories of "performativity" are fundamentally linked with the analysis of the sexed body (or "gender studies" as well as queer theory). The feminization of the subaltern male similarly contributes to what appears to be the deeper understanding of performativity within postcolonial theory.

This is a very broad generalization, and I am not saying that this is in some sense racially determined—as bell hooks's notion of "black macho" would confirm. But from Fanon's writing, much quoted in postcolonial theory, to Homi Bhaba or Edward Said, there is a greater sense of the embodied self than in mainstream white male theory. Together with the major contribution to this body of work by women such as Gayatri Spivak and Trinh Minh-Ha, this builds to a strong feature.[57]

The installation *Corps Étranger* (*foreign body*, 1994, not illustrated) by the Palestinian British artist Mona Hatoum, to whose corridor piece I referred above, is a good contemporary example. The viewer enters a booth to find a video screen installed horizontally on a plinth as if part of a tabletop. The video shows the artist's body, photographed by miniature camera inserted into her bodily orifices—endoscopy. The personal-political message of the body made strange visually and through its insertion into another culture is in a clear tradition of radical, content-led art. It tends to be seen as a kind of self-portrait. If such it is, it is surely a radical idea of the self as corporeal and immediate—that is to say, not formed across the gap of reflected vision.

Hatoum's work refers us to another example from two years earlier, Louise Bourgeois *Precious Liquids* (1992), a similar construction of a circular and

contained space into which the audience is drawn to inhabit a real place that is clearly symbolic of the body.

It is not sufficiently routine to analyze work of this kind in the same framework as abstraction or non-objective art. A division exists, generally speaking, even if it is not total, in critical discourse, as it does in art practice: body theory sticks on the whole to the body; thinking about form, especially "abstract," is constrained by the legacy of at least two strong traditions of formalism. It is one of the strengths of Briony Fer's approach in *On Abstract Art* that it allows an escape from this constraint, while semiotic approaches enable the similarities of reference to the overall codes of sculpture to emerge.

It is relatively easy to read work of this kind, the corporeal strand in contemporary art by women, in psychoanalytic terms; or, to put it another way, in terms of a psychoanalytic inquiry; or again, in terms of an inquiry analogous to that of psychoanalysis. It is less easy to do the same in relation to abstraction, and though the best critique does this, it rarely if ever squares the circle to read abstract space in terms of the sexed body as psychic, as well as corporeal, entity.[58] This, notoriously, cannot account satisfactorily for sexual difference.

Equally importantly, it also encounters real difficulties with the collective, which will be taken up in the next chapter. Suffice it to say here that this aspect of sexing universals is exemplified in Rachel Whiteread, whose *House* (1993), a cast of the inside of a nineteenth-century house typical of many ordinary homes in the United Kingdom, was scandalously demolished. This work concerns cultural memory and the shadowing of present time by the future and the past.

It deploys the displacement of vernacular architecture into a discourse of modern art, to re-insert the domestic and private back into the institutional and public, from which it can only be separated with violence. It moves into another psychic economy than that of lack and alienation that characterizes classical psychoanalysis, and another materiality than that divorced from consciousness.

Louise Bourgeois may appear to read most clearly in relation to the corporeal/Surrealist[59] strand in current discourse, which typically lends itself to psychoanalytic readings. Yet throughout her long career she has produced work that interrogates the self in space in a number of ways. This may be well enough known, but the argument is not often made through form. Her abstract piece *The Blind Leading the Blind* (1949, painted wood, 67" × 64" × 16"), which refers to Pieter Breughel's *The Blind Leading the Blind* (1525–69–late sixteenth century) is a play on the blind spots of this way of thinking (by which I do not mean a direct critique). Its radical condensation of unstable forward motion is a dark joke in the mode of her *Fillette*. Bourgeois' work of the 1940s to 1950s, such as *Pillar* (1949–50 painted wood, 64⅜" or the painted wood *Figures* from 1945 to the mid-1950s (each 66") are carried forward in recent work such as *Arched Figure no 3* (1997, mixed media). Brancusi as part of this tradition (rather than the other way around) reads as more radical in his interrogation of space as abstract and as bodily, because the formal is not the privileged determinant.

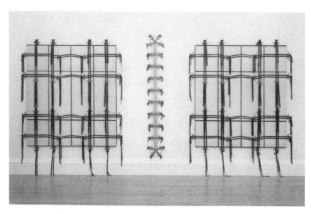

In this way it is possible to explore commonalities in work of widely differing styles and approach; the inquiry surfaces in the work of Cathy de Monchaux, a 1998 Turner prize nomination, for example, whose *Wandering about in the Future, Looking forward in the Past* baffles and divides

FIG. 50 Cathy de Monchaux *Wandering about in the Future, Looking forward in the Past* 1994, purchased by Tate Gallery, London, 1995. © Tate, London, 2003.

viewers, often along sexed lines. It provokes strong reactions, especially but not exclusively among male viewers and critics, many of whom abandon all pretence of critique or balanced judgement and resort to a visceral or abject vocabulary. It seems that Adolf Loos's pronouncements against the decorative have lasted a century, and that the decorative here is a portmanteau word for aspects of the female. De Monchaux's ironic redeployment of the modernist grid and knowing use of sensuous materials are rendered invisible in a sexed revulsion against the work, as if it were everything that the mind cannot rationalize. This is a reaction, not a response, an overdetermined resistance, driven by denial—the evasion of even the possibility of a proscribed female desire, coexistent with the male and in all subjects, arising not out of the impossible drive towards recovery of the lost object, but on repletion. Why this should be experienced as suffocation brings us close to core issues about female desire and spatiality. If desire is positive and is not necessarily structured on lack, why should it be feared? It is because it constitutes the withdrawal of the mirror, and in that withdrawal is death. If the fragile ego cannot contemplate the fictive nature of its own completion, the split subject sees only annihilation, the nineteenth-century *gouffre* or pit, rather than the fullness of the dark.

It is the age-old conjunction of sex and death, the fear of birth over an open grave, or indeed of the womb as grave. If the mind can convince itself of its separability from the body, then it does not have to die. The fantasy of the technologized body as desiring machine is the secular soul in postmodern guise. But this is a formation that belongs to the hierarchized mental economy with god-the-father at the apex, even if God is dead and the name of the father has to do instead. It is also a mental economy that has invented the grotesque that is the notion of the Phallic Mother. Larner is interested in moving out of this bind.

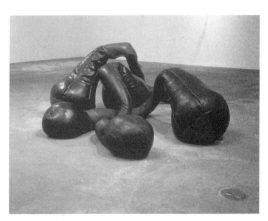

FIG. 51 Liz Larner *No M, No D, Only S&B,* 1990, leather, sand, brass zipper, and cotton thread, 36 × 48 × 60". Private collection. Photo courtesy 303 Gallery, New York and Regen Projects, Los Angeles.

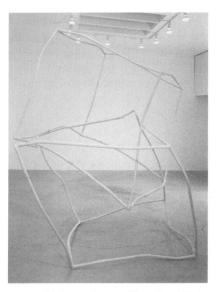

FIG. 52 Liz Larner *2 as 3 and Some Too* 1997–8, watercolor, paper, and steel 112 × 137 × 95". Photo courtesy Regen Projects, Los Angeles.

This move is most explicit in *No M, No D, Only S&B,* and its relation to *2 as 3 and Some Too* enables the viewer to track it into works that deploy a more abstract language. These works operate in different visual codes from those of de Monchaux and from each other, yet like the de Monchaux pieces they are about those codes. Larner's titles are typically oblique and they bring language—or number and language, in the case of *2 as 3 and Some Too*—into the sculptural arena. In *No M, No D, Only S&B* the allusion is both to a signified for each of the letters, and to the letters as signifiers— no letters *m* or *d,* only *s ampersand b.* If only these last remain, that means *m* or *d* stand for everything else; language is breaking down. This alarming prospect is suggested in the collapsing form of the leather bags. Filled with sand, their dark wit pits sandbags against the collapse of language. The bags also suggest conflict. They are punch bags. The whole is far stronger and more brilliantly sinister for being inexplicit; "no mom or dad, only sister and brother" brings siblings to the fore, but apparently not in rivalry, as this is sister *and* brother. If this is collapse it is also amicable entanglement.

Leather is sensuous; that tangle looks a bodily tangle, either of like forms or even of the viscera of one body. I am put in mind of the British sculptor, Peter Randall-Page, and a study for his *Fruiting Bodies* (1990, charcoal on paper). The visceral fruits are bums (top layer) and guts (below), six segments of an open box, the upper storey rounded and complete, the lower, intricate intestinal knots. Or parasitic worms? The wholeness of the bodies is deliquescent, or perhaps it is just visible in the constant mobility of matter. The fruits are whole, but if the bodies are, they are strange.

An early influence on Randall-Page was Eva Hesse, a lineage that was much clearer when he worked in mixed media rather than predominantly in stone and drawing, and he has speculated on why this has not been picked up by his commentators.[60] Randall-Page's current work would be much more likely to recall Hepworth than Hesse. He found her work "visceral and, for me at least, contains a great deal of sexual imagery. Much of the

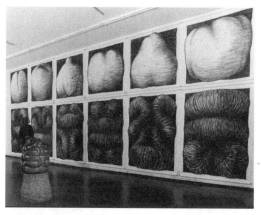

FIG. 53 Peter Randall-Page, *Fruiting Bodies* 1990, charcoal on paper, twelve drawings; six measuring 182.9 × 152.4 cm and six measuring 152.9 × 152.4 cm. Collection of Leeds City Art Galleries.

sculpture is modular and cumulative in its emotional impact (*Unfinished, Untitled or Not Yet* 1966 and *Several* 1965, for example)." It is an influence that has become invisible, not least because "it is more the underlying attitude to making sculpture that I relate to: engagement with visceral and sensual experience and direct subjective expression through the manipulation of dumb matter."

Larner commented that she was "disturbing conceptual structures by putting some signifiers together."[61] Crucially, these signifiers were shared by different things, she pointed out. Signifieds whose material existence would at first seem irreconcilable are brought together in a number of contiguous relationships that make it impossible to sustain their separateness as total.

The tone of this work is indicative. There is a dry wit in Larner's work overall, as there is in de Monchaux and Randall-Page, and to miss this would be to miss a great pleasure. But that is not all. Here, it would be to miss also much of the precision of meaning. Larner puts into play, undogmatically and perfectly embodied, the whole basis of sexual difference. This includes its conflicts, its convolutions, and its earthy corporeality. It is such a massive and fundamental undertaking that it seems absurd when articulated like this. What can you do but shrug it off with a laugh? The wit is classic psychoanalytic symptom, just as it is an artistic device, for dealing with psychic freight and prohibition. The joke hits home. Larner's aim was "to displace the structural hierarchy of parents and children." But it was also about "a more plant like reproductive process and also something very microscopic made in large if not human scale."

Randall-Page's most recent piece, a thirty-five-ton Scottish granite boulder unfinished at the time of writing, is being carved with bumps that bring it into relation with his flesh-fruit works like Fruiting Bodies, especially Red Fruit (1987). But these intumescences are different, too, and they are further indicators of how he has developed since then. The work draws on pollen morphology (as the drawings he is also working on show), and far from altering the existing

contours of the boulder, the convex segmentations stretch and distort, not only to follow them, but also the changing action of the light.[62] In a series of moves, the signifiers shift in their relation to several signifieds, and to their connotative fields. They maintain a degree of referentiality while bringing specific modes of signification under scrutiny as they move into each other's gravitational pull.

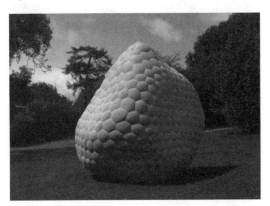

2 as 3 and Some Too (1997–8) was made seven or eight years later than *No M, No D, Only S&B*. But you could read it as of the same logic at a deep level. It is a tangle of elongated elements; it could be caught at the moment of collapse or of rise; it looks different from each viewpoint. Its title starts from a binary and moves to a different kind of relation. At a certain level of abstraction, the works are close. What differentiates them is the

FIG. 54 Peter Randall-Page *Give and Take* 2003, granite glacial boulder, 345 × 295 × 261 cm, enabled by sculpture at Goodwood. Courtesy of the artist.

formal language, and therefore the tradition within which they work. Larner is equally at home in either language of form, and the work is accomplished in both: in the exploration of, not the visible, but "that on which visibility depends" in Jeremy Gilbert-Rolfe's words (which are equally applicable to his own painting). The earlier piece may seem to be doing it corporeally, and the later piece more conceptually, but they are in fact two sides of the same coin—or rather on different façades of the Moebius strip. They do not become the same—the point is to set them into comprehensible relation, not to assimilate them to each other.

Barnett Newman's idea of each work being its own event and a new emotion in itself gives us the hint as to how a tremendous charge is brought into works that appear sometimes serene, sometimes simple, and even where complex, hold their energy concealed in involution or restraint. "Inside the sentence we are currently reading earlier sentences continue to sound." Writing of Proust, Malcolm Bowie's observation about the narrative drive in *À la recherche du temps perdu* brings into view how the sense of futurity can come out of recapitulation.[63] These works know their antecedents. The deadpan emotional surface of a Manet is a skin inside which earlier paintings and traditions continue to sound. But the metaphor of the skin has to operate temporally, as if it were the surface of a time-warp; this is not just a layer or the Freudian unconscious. The emotive tone of a Larner, while it is often immediately accessible, is not always immediately knowable. "An ambiguity in sexual identity refashions earlier ambiguous relations—say between light that shines and light that dances [. . .] the text carries along, from the before of unknowing into the afterwards of knowledge."[64] Bowie's allusion to the first sexual identity crisis is apt.

The implications of a psychic economy structured on contiguity do not obliterate the discoveries of psychoanalysis. A British critic responded to something I wrote about contiguity in another context with the remark that it might be sentimental. So I want to anticipate any such response and make it clear that it is not a matter of claiming we all exist in happy union, touching fingers across the globe and singing about The Real Thing. Contiguity entails an implication in another's existence, ethical implications, and the strength to move and bend in response to one's own imperatives as well as to be able to receive the impression of another.

In more exact psychoanalytic terms, it destabilizes the construction of the gaze as primary, both in the formation of Subjectivity and in the constitution of the visible—related in any way.

Even *Corner Basher* is consistent with this, since it is an articulation of the potential energy of the meeting point between two planes. I actually do not think this piece is violent. I guess the energy is destructive, but I would still maintain a distinction between destructive energy and violence. It is the difference between the volcano and the bomb. Larner has said: "[. . .] where two walls meet should not be a dead space; it should be one of the most powerful spaces. I like moving things into the corners

FIG. 55 Liz Larner *Corner Basher* 1988, steel, stainless steel, electric motor, and speed control, 10 ft. high. Installation at Louisiana Museum of Modern Art, Humlebaek, Denmark. Photo courtesy Louisiana Museum of Modern Art, Humlebaek, Denmark.

and sometimes trying to change the shape of the corner."[65] In that seemingly simple statement, she articulates that which succeeds the interval or space between, leaving the devil out of it. A given structure, like a corner, is modified by moving something into it, because the "space between" the walls is inseparable from them. In the energetic process of redefinition, the strenuous and complex interrelation of materiality can reveal itself. And, perhaps, the Subject can laugh at the fearfulness of the huge questions and the smallness of the self, since *Corner Basher* is very funny. On the question of whether or not laughter is demonic, I demur.

Notes to chapter 6

1. Diary entry in 1960s, quoted in Bill Barrette *Eva Hesse. Sculpture. A Catalogue Raisonné*, New York, Timken, 1989: 11.

2. *Refus Global* Manifesto, 1948 10, 11. Capitals in original.

3. Barbara Underwood "Beautiful Music—A fixed Pitch? Plato, Music and Gender" in Florence and Foster (eds.) *Differential Aesthetics*, Ashgate 2000: 83.

4. Written response to written questions from myself, February 2003. Translated by Jean Ramsay.
5. Thanks to the musician Sarha Moore for explaining this to me.
6. See Underwood 75.
7. Ibid 84.
8. Mallarmé, *Toast Funèbre*. To Gautier, 1873.
9. Pullinen interview, as above.
10. *The Phenomenal Woman* Cambridge, Polity, 1998: 194–5.
11. Exhibitions on which this chapter based are: Liz Larner, Museum of Contemporary Art, Los Angeles, 2 December 2001–10 March 2002, catalogue by Russell Ferguson, LA MOCA, 2001; *Anish Kapoor* catalogue, Hayward Gallery and University of California Press, Hayward Gallery, London, April–June 1998; *Barbara Hepworth: A Retrospective*, Tate Gallery, Liverpool, Yale Center for British Art and AGO Ontario, September 1994–August 1995. Catalogue by Penelope Curtis and Alan G. Wilkinson, Tate Gallery Publications, 1994.
12. "Anish Kapoor: Making Emptiness" in *Anish Kapoor* catalogue, Hayward Gallery and University of California Press, Hayward Gallery, London, April–June 1998: 12, 20.
13. See Anna Chave *Constantin Brancusi. Shifting the Bases of Art*, New Haven/London, Yale University Press: 1993, esp. 197. The present discussion of Brancusi is much indebted to this work, though I take responsibility for the way I have developed and built on Chave's more detailed argument.
14. Ibid.
15. Many of the not very many books on Hepworth confirm this. For an extensive bibliography see David Thistlewood (ed.) *Barbara Hepworth Reconsidered* Liverpool, Liverpool University Press, 1996: 209–58.
16. Ibid.
17. See Barrette: 20 for this quotation and for details of the work.
18. From the *Brooklyn Times*, 12 March 1927, cited in Chave 202.
19. The studio was left to the French nation and can be visited in the Plaza outside the Pompidou Centre in Paris.
20. Again, see the work of Elizabeth Grosz, especially *Volatile Bodies*, cited above.
21. For broader histories, see for example Briony Fer *On Abstract Art*, New Haven/London: Yale University Press, 1997; Thomas McEvilley *Sculpture in the Age of Doubt*, NY, Allworth Press, 1999; and Richard J. Williams, *After Modern Sculpture. Art in the United States and Europe 1965–70*, Manchester/NY, Manchester University Press, 2000.
22. See Chave: 301 n.112.
23. "Visible Space, Elusive Object," cited in Ferguson 2001: 114.
24. See *L'oiseau dans l'espace*, Centre Pompidou, Paris 2001. This book is one of *Les carnets de l'Atelier Brancusi. (La série et l'oeuvre unique)* and includes essays by Marielle Tabart, Sanda Miller, Athena Tacha Spear, Thierry de Duve, and Ileana Parvu. The entire series is illustrated by Spear in diagrammatic form on pp. 26–9.
25. Chave 117–9 et passim.
26. See Ferguson 36.
27. This piece mimicked its massive stone base, but in Perspex.
28. They knew each other during the period Gabo was in Carbis Bay, near St Ives, and there is indeed a relation between their work yet to be fully understood.
29. This is a close paraphrase of what I said in Heusser et al. 275
30. Of course Fer's study, like this, is necessarily selective, and I am not saying she "should have" studied Hepworth or anyone else. This is a comment on the critical paradigm

which produces artists in certain groups. Hepworth's biomorphic abstraction would seem to support Fer's argument, and it is of the right period for some of it. Yet this major artist has appeared to be dispensable.

31. Mallarmé *Le tombeau d'Edgar Poe* 1876. "Silent block fallen down here" is more literal than my chosen words here.

32. The preparatory drawings are illustrated on pages 116–7 in Ferguson.

33. Krauss 1977/94: 282–3. Like *Labyrinth*, a shape current in the women's movement, the sexual politics is evacuated in favour of an argument about lack of content.

34. Krauss 1977/94: 279.

35. This sense of danger is brought into the body-as-clothes by Jana Sterbak's 1984–5 work *I want you to feel the way I do (The Dress)*, live, uninsulated wire-on-wire mesh, slide-projected text. National Gallery of Canada, Ottawa.

36. Quoted by Ferguson: 68.

37. Krauss 1977/94: 266.

38. On illusion, see Louis Marin in N. Bryson (ed.), *Calligram*, Cambridge: Cambridge University Press, 1988.

39. Unpublished PhD thesis on Riley by Frances Follin, Birkbeck College, University of London.

40. This topic is dealt with in Helen Andrew's 2003 doctoral thesis *Philosophies of Colour: Gender and Acculturation*, University of Plymouth, United Kingdom.

41. In a short essay on Larner's *I thought I saw a pussycat*, exhibition catalogue, Vienna, MAK-Galerie, 1998.

42. Illustrated in Curtis and Wilkinson 1995: 67, 73, and 93.

43. MAK-Galerie, 1998. Pages are unnumbered, but citation is for the fifth page.

44. "Making Emptiness" *Anish Kapoor* catalogue 1998: 19.

45. It is doubtless coincidence that Brancusi's first sculpture was *Flayed Man*.

46. Baring and Cashford: 335.

47. For a fuller account of the transformations of Athena's stories, see Baring and Cashford: 332–45. Quotations from Bachofen are on page 335, and from Aeschylus on 336.

48. Gimbutas, cited in Baring and Cashford: 337.

49. Quoted in *Circle* 61–2,

50. *Two Forms* (1933) is sexual, and it postdates her discovery of the abstract significance of piercing the stone with *Pierced Form* (1931). This kind of explicitness was steadily to decrease as the artist discovered where the new abstraction led.

51. My understanding of the possibility of desire as productive owes a great deal to Elizabeth Grosz, for example in *Volatile Bodies* Bloomington, Indiana, 1994.

52. As far as I know at present, I have not made a systematic study of this.

53. The example is not arbitrary: The differential time and the relation to the real articulated in Cubism seem relevant to elaborating a sexed theory. I just have not yet worked it out.

54. 400 hand-numbered copies published by Mithra-Mythe. The manifesto, and its mock-up, may be seen at the Museum of Contemporary Art, Montréal.

55. Performed Ross House, Montréal, 3 April 1948. There are four silver prints in the Museum of Contemporary Art, Montréal, by Maurice Perron, costumes by Jean-Paul Mousseau.

56. This was part of my analysis of Symbolist artists such as Odilon Redon—Florence 1986. Redon is a good example because the fragmentation of the semiotic body is articulated explicitly through the somatic body: floating eyes, caricatural distortion of bodily proportions, detached heads, and so forth. Brancusi is an example closer to the present argument, whose torsos and ambivalent partial bodies may be interpreted according to the same principle.

57. Further examples can readily be found by reviewing articles published in *Third Text*.

58. Briony Fer is an honourable exception, though she conforms to the general point that where this divide is crossed, it tends to be in terms of Surrealism. Such terms do not reach far enough out of normative psychoanalysis.

59. Work produced by Surrealist women could perhaps also benefit from analysis in terms of morphogenesis. It appears distinct from the men's, especially in terms of spatiality, though this generalization is at present only a suggestion.

60. E-mail to the author, 27 Jan 2003. He also associates this with working with Barry Flanagan in the early 1980s, of whom he said "his early work (canvas, sand, rope, resin, and other mixed media) must, I think, have been greatly influenced by Hesse."

61. E-mail to the author, 10 Feb 2002.

62. The solution to this formidable technical and mathematical problem was simple and practical: Randall-Page stretched an elasticated mesh over the boulder, using it to mark up the lines which form the indentations. This paragraph draws closely on my short entry on Randall-Page in *Sculpture in 20th Century Britain*, published by Henry Moore Institute and Leeds City Art Galleries, whose collection includes *Red Fruit* and *Fruiting Bodies* 2003, Vol. 2: 291–292.

63. Bowie, *Proust Among the Stars* London, HarperCollins 1998: 52.

64. Ibid.

65. Quoted by Ferguson in *Liz Larner*: 92.

a valediction: nationalism and melancholia; sex, war, and modernism

Analysts believe in mourning; [. . .] It is as though the capacity for mourning, with all that it implies, constitutes the human community.
—Adam Phillips[1]

Moving of the earth brings harms and fears,
Men reckon what it did and meant,
But trepidation of the spheres, though greater far,
Is innocent.

—John Donne *A Valediction: Forbidding Mourning*

It is the capacity for mourning, not mourning itself, it is the passing through of this psychic state, not the sustaining of it, that constitutes the Subject. Psychoanalysis is a theory of the symptom. It is most powerful as diagnostic of dysfunction. This book has tried to examine contemporary art, not as constituted by mourning, but as transitional, not locked within prohibition and blockage.

FIG. 56 Lyne Lapointe *Éléments et mémoire de paysage* 2000, graphite, oil on paper on contre-plaqué, painted wood frames, antique compass, and tiger's eye stone. Courtesy of the artist.

Donne's lovers are likened to a pair of compasses, with the woman as the fixed foot around which the departing man revolves, leaning towards her. It is a conceit that brings within its range erotic love, divine love, death, the globe, and the universe. I would not wish to invoke Donne's god or his cosmology. I would probably prefer to avoid aspects of his sexual politics. But I would choose his valediction and forbid mourning insofar as it becomes a defining characteristic of culture. If I understand anything about seventeenth-century corpuscular philosophy at all, it would not lead to the deathliness of certain ideas of contemporary masculine culture.

The twentieth century was a bloody and conflicted time. Until the

"war on terror," unilaterally declared by George Bush in the fall of 2002 and supported, astoundingly, by the British Labour Prime Minister, the politicians used to tell us that "we" in "the West" have had peace since what is known as World War II. This is despite conflict all over the majority of the world. Modernism was born in the awful crucible of World War I, and it is disturbingly difficult to be clear about its relation to some of the worst horrors of European brutality and self-harm. There are no easy causal links here, nobody is simply or exclusively to blame. But wars are in the international psyche; the power assumed by "globalism" is predicated on violent conflict, while in supposed democracies, most of the general population is against any such aggression.

Meanwhile, a great deal of the most publicized art continues to play out the declining legacy of the century before.

In moving towards a kind of closing of this book that is not closure, the case for sexing universals must at least offer some preliminary pointers about the contemporary political situation, not because it holds the potential to be sufficient as either corrective or critique, but because it aims to contribute to a more developed understanding of artistic engagement with the great issues of our time. There are many ironies in this, not least because it sounds so solemn and straight, especially in the current climate favoring one particular kind of irony (the advocates of which can seem unaware that their plurivocalism is limited in this way). As I have argued above, it is the absence of joy that allows confusion to arise between responsibility in art and piety, a state of affairs in which audiences may come to think political correctness is the only reason why anyone might argue for higher values of any kind in art, fiddling while religious fundamentalism burns. The complicity of churches of most colors—and certainly any established church—with secular politics used to be enacted by the British aristocracy, by putting their elder sons into the army and their younger sons into the church. It is a dark irony indeed that the social and political scenario should be so thinly and patchily approached by so many prominent contemporary artists and cultural commentators, if not ignored altogether. (And this is not to say that such connections have to be explicit; one defining factor in art is that it cannot be restricted to explicitness). The risk is that of throwing out the only real justification for art in the public arena in the mistaken assumption that the rejection of the old categories leaves no choice; that advocates of the independent and satisfying values to which art stands in an indexical relation—that is, art *is* those values—are stuffy and joyless. Here the irony is especially sharp. It was not always like this, and in line with the forward direction of this book, informed but not determined by the past, it is understood as a symptom. It requires interpretation. Why is shock valued more highly than pleasure? The preparatory answer must be shaped in the field of sexual difference.

The rift that can be sexual difference is never so clear than at times of war. Modern warfare has shifted its arena from the battlefield to civilian populations. Since armies are very largely male, those who are left behind as the strange category "civilian" are disproportionately female. (It is tempting to say that the sexual division is so overwhelming that military and civilian are sexed categories,

and those in them sharply differentiated. The confusion of political power with military force would then derive from the desire of politicians not to be feminized.)[2] Though there are signs that this is changing, it still applies to conflict between large groups such as nations, as well as between the terrorist or resistance factions (according to your sympathies) and their antagonists. This would tend to confirm Teresa Brennan's theory in *History After Lacan*,[3] a book that ought to have far wider currency than it appears to have.

Brennan argues that the belief that we are contained in our psychic energies may be culturally and historically specific to the modern era, and she sets out the case for psychical interaction as partaking of an "interactive economy of energy,"[4] an idea that is impossible to the modernist separated ego, which fears annihilation by it. It implies the individual's permeability, to its others, to an economy comprising of the natural and technological. What she calls the "ego's era," the contemporary psychosis, is based on a fantasy world of objects, and this subject-object structure is implicated in the process of conceiving oneself as contained. The mother/other as object marks this indelibly according to sexual difference.

Her original analysis shows the connection between the social order and the psyche, and in so doing, sets out the ground for establishing that the hardening of subject-object thinking accompanied shifts in attitudes to women and to nature. Brennan musters considerable support along the way for her overall analysis: that contained individualism, interiority, and subject-object thinking change over time, both historically and in contemporary thought.[5] In so doing, she locates the considerable drawbacks of Deleuze and his followers, despite the energetic economy of his thought, as arising out of equating logic with "an oppressive subject-object distinction." In this, both order and history become impossible. Both are necessary to thinking through the sexed universal.

It is possible, in light of Brennan's argument, to read the alteration in modern warfare as likely to move against women, not necessarily as a deliberate, sexist move, but as a manifestation of the historical psychosis. And if art is aligned with this version of ego-maleness, as if there could be no other without annihilation, there is a terrible consistency between certain elements of violence in the contemporary artistic economy and the extremity of the suppression of women in certain modern conflicts, going beyond even the old violation of rape in warfare.

AESTHETICS, THE TALIBAN, AND A KIND OF MASCULINITY[6]

On Tuesday, 13 March 2001, the unelected, illegal Taliban régime in Afghanistan blew up the Bamiyu statues of the Buddha. They had been there, carved into a cliff face in a valley in central Afghanistan, for 1,500 years. CNN declared a world exclusive on smuggled pictures of the destruction. The Taliban had forbidden photography of the event. The Taliban are nothing if not consistent: they are against representation.

I associate this final chapter with such grave matters, now indelibly marked by the events of what has become known as "September 11" and their

aftermath, not as an attempt to add portent to the theory of sexing universals, but because as a cultural critic must offer a contribution to understanding what is a stake in the current disturbing situation. And while it is not easy to pit art against the horrors of war, contemporary warfare arises, even more than its historical precedents, out of collapsing of international relations in which culture (and education) are very directly implicated. And trying constantly to understand as a dynamic the place of art in the socio-political fabric is therefore also necessary to its avoidance.

The emphasis of my concluding remarks, therefore, is on the relationship between terror and aesthetics, and the relations possible to present-day sexed subjects who are driven by what passes for a naturalized "masculinity." The sublime is much associated with masculinity and with terror, but that is not my focus here. Clearly, however, it plays in the background. For the purposes of this argument, terror is related to the inability to play, understood as a kind of anti-aesthetics.

One of the first things the Taliban did on taking power was to burn schools and to exclude women from universities.[7] Art education and/or aesthetics will not have been foremost in their minds in doing this, but Islamist scholars (on whom the Taliban appear to have relied for advice) have a developed sense of the power of the aesthetic and the symbol, and this act is consistent with the destruction of the Buddhas.

Naming this sense "aesthetic" may perhaps seem problematic, because, with their orientation to the divine, Taliban "aesthetics" already shifts away from the notion of play with which the aesthetic is inseparable. (One might suggest a not dissimilar shift in Enlightenment aesthetics). It takes on a more solemn and directly politicized color. Of course the aesthetic is political in implication, but once politics becomes the driver, the aesthetic is limited.[8] Nelofer Pazira, the Afghan woman on whose story the film *Kandahar* is based,[9] and who collaborated in its making, commented on how "in a country that allows almost no kind of relaxation, games and menace intertwine."[10]

The sense in which I intend a constructive and engaged aesthetics is clearly put by David Black in an essay on Goethe,[11] and it is a reading which associates the growth of the poet's art with the maturing of his male identity. In this sense, it is deeply social. Black's definition, offered in passing, is explicitly read as prefiguring psychoanalysis. He comments on Goethe's innovations in taking "one's own subjective emotional experience," rather than myth or history, presenting it "as objectively as possible, shaped for the maximum of contemplation by aesthetic form and without measuring it by any extraneous moral or ideal yardstick [. . .]."[12] It is the last phrase, "without measuring it by any extraneous moral or ideal yardstick," that counts here.

So I put the Taliban's "aesthetics" in quotes, not because I wish to disparage something I know only a very little of, but because what I do know would exclude it from the realm of the aesthetic. It is an anti-aesthetics, because it is about control. This is a direct parallel with their idea of relating to women.

THE BUDDHA, THE REFORMATION, AND THE CONTROL OF WOMEN

When the Taliban destroyed the Buddhas, it was not only an act that concerns religion. They knew that such artefacts have power. But they themselves were unable, or chose not, to meet that power, to know it for themselves. ("Choice" is significant here, as I shall clarify later.) The Taliban are (hopefully, were) profoundly serious. As is evidenced in many other terrible acts and prohibitions, the Taliban opposed both play and pleasure. The destruction of the Buddhas is an awful example of why aesthetics concerns politics, but cannot *be* politics without loss. That is not to say that art cannot be appropriated to oppression and destruction, or to death. Of course it can, and history is full of examples of this.[13]

English people may, in looking at the results of this contemporary act of vandalism,[14] be reminded of what was done to its cathedrals and abbeys in the Reformation, also in the name of religion, and also for reasons altogether other than those declared on the surface.[15] While it would be straining the point to draw too close a parallel, both events hide an element that is very rarely given the kind of prominence it should have. It is the control of women in the building of a sacralised Nation.[16]

The lack of comment on the position of women in Afghanistan in the Western news was extraordinary. As Polly Toynbee observed at the time of the Afghan war, "Women are missing from the story so far when they should be up at the front—literally and metaphorically: this war between reason and unreason is ultimately about them." Toynbee's voice was almost lone until far too late in the British press;[17] not even either the leftist journalist John Pilger or the popularizing intellectual Umberto Eco mentioned women in their characteristically different indictments of Western hypocrisy in the Middle East.

Toynbee was clear that the Taliban and their fellow Islamists were masculinists:

> All extreme fundamentalism plunges back into the dark ages by using the oppression of women (sometimes called "family values") as its talisman. Religions that thrive are pliable, morphing to suit changing needs: most Christianity has had to moderate to modernize. Islamic fundamentalism flourishes because it too suits modern needs very well in a developing world seeking an identity to defy the all-engulfing west. And the burka and chador are its battle flags.[18]

Like other commentators, furthermore, Toynbee and Eco both point out how vague are the parameters and targets of this war on either side. That vagueness may be associated with many factors other than the supposed elusiveness of the terrorists: these must include the concealment of motive, the protection of alliances, vote-losing actions. Denial, in the psychoanalytic sense, is another.

WHAT HAS NATIONALISM TO DO WITH THE DEATH DRIVE?

Violent suppression of the other is fairly readily connected with nationalism. The violence to the self this entails is less so. I pose this question about

nationalism and the death drive as a way of beginning to develop as sexed the issues inherent in contemporary conflict, exemplified by Afghanistan, that most commentators deny or suppress. Not only is this the control of women, but it is also the reinforcement of a particular notion of masculinity among men. In that sense it is the control of all subjects, in both the political and the psychoanalytic senses. Those elements that the Taliban shares with received ideas of Western masculinity are especially worthy of comment in these Neo-Darwinist days of "evolutionary psychology." The calamitous implications of what they say in characterizing the essential nature of men as violent and anti-social should not be downplayed.

A first step is to refuse to separate the two parts of the "master-slave" dyad. Among some theorists, including most feminists and postcolonial thinkers, this is an idea that is common. But this is only so in selected areas of thought: The division still pervades dominant thinking in Britain, despite the fact that the number of commentators insisting on change is growing. More and more believe that the modes of analysis of the mainstream and the whole gamut of alternative, marginal, subaltern, or oppressed must be read together, not as oppositions, nor even as mirror images. Actually following this through, however, is not so easy. Thinking in terms of "economies" or complex and dynamic energetic structures impacts on the "alternative" self-positionings as it does on the dominant, and this is relatively under-theorized. They are differential manifestations within the same economy. I intend the word "economy" to be understood both broadly and specifically: It is both a psychic economy and a socio-financial economy, the whole being understood as political. The economic is personal.

Within the Humanities in the West, there have now been decades of deconstruction and opposition. The time has come to evolve new values. The current propensity of capitalism towards war does not allow the luxury of the form of liberalism that assumes an easy reconciliation of conflicting interests. But it must also not lead to an abandonment of the middle ground, as is so often the case in war. If I propose a bringing together within the same dynamic, I must also propose mutual responsibility.

The historical direction of this responsibility is forward. The point is not to assign blame, although it is vital that the abuse of power is not denied. Taking South Africa's remarkable Truth and Reconciliation Commission as an example, what I am proposing would be analogous to the next stage. What went wrong was exposed, wrongdoers have had to face the wronged; the stories of both have been, and must continue to be, told. Theory has at least to some extent exposed what is wrong. But what now? I do not equate theory with the brave and original social process of the Truth and Reconciliation Commission. But I do point out a relationship at the level of understanding. This is why art and art education remain significant. Modern wars are fought across the disadvantaged, not between more straightforward adversaries. The psychological and cultural implications of these forms of warfare are different, and they impact in terms of sexed identities on both sexes. The rebuilding of people's lives after the far too numerous conflicts of which Afghanistan is an extreme example requires atten-

tion to the loss of "masculine" ideals and the conditions under which the re-formation of sexed identity can be facilitated. But it is vital that this is not done in such a way as to reinforce the traditional associations of men with violence and control, and women with the institutionalized powerlessness that is "femininity." This is all too often what underlies "family values," as is clear from Saira Shah's second extraordinary *Dispatches* film in which she rediscovers three girls whom she had met six months before in her previous report from Afghanistan.[19] She offers to pay for them to attend school not far away from their destroyed village, but their pitiable father will not allow it, rambling about his inability to function without his wife. The girls are in effect prisoners of his inadequacy and loss, knowing full well that education is vital for their futures. Meanwhile, we also see boys with rifles, and these exhibit not only the screaming, belligerent swagger of such male victims, but also the clearly traumatized eyes and faces of those confronted by intolerable realities. Bring these representatives of the same generation together, and what family values are they going to have to work with? What kind of choice will they have unless redemptive and therapeutic avenues are opened up to them? Art as an element of social reconstruction is one such. Despite arguments to the contrary, there is considerable experience and evidence that it is effective.[20]

ART AS AN ELEMENT OF SOCIAL CHOICE

If these children in Shah's film are deprived of choice, is the same true of the Taliban? Shah did not fudge the impossibility of choice for anyone in the situation just described of the girls deprived of their future by their father's emasculation, including herself as would-be benefactor. The availability of choice is one of the myths of capitalism. While it sells itself as the ideology of choice, it builds itself on exclusion. Choice is for the chosen.

In the light of capitalism's use of Afghanistan over the last decades, what kind of choice did the Taliban have? To relate this more specifically to my symbolic example, in what sense did they choose to destroy the statues of the Bhamiyan Buddhas?

The question of agency, understood as *an empowered capacity to act meaningfully and to determine meaning*, has emerged as crucial in many areas of critical theory. It is one of the defining factors that separates differing schools of thought, the most prominent separation being, perhaps, that between postmodern readings of identity and notions of rational mastery. Yet the closer these are examined, the more alike they appear. Both of them are too easy about choice: The postmoderns tend to assume choice, and the conservatives tend to assume selectivity of choice. But if agency is restricted to this dualistic frame, both parts of which are based on a kind of voluntaristic idea of self-determination, there is no means by which to differentiate between the progressive and the reactionary.

There is clearly a great deal here that lies beyond the scope of the present book. But it is important to pursue this line of reasoning about choice and agency because it connects directly with the potential of art. Art can be a

structured way of generating meaning, bridging as it does the individual and society at a highly subjective level—to put it impersonally, the intrapersonal, the interpersonal, and the transpersonal understood as a force field whose meanings relate to and affect each other, but do not straightforwardly determine one another. In so doing, it addresses important questions about what structures feeling, rather than leaving such elusive matters out of the equation. The idea that anyone can creatively assign meaning is very attractive. It is embedded in a great deal of "alternative" or oppositional thinking in cultural theory. But it is all too easy to conflate opposition with a form of denial. That is to say, by attacking someone else, one may in fact be trying to escape one's own unacceptable realities. Meaning in this case is parasitic on that which it seems to oppose, and it constitutes a breakdown in the capacity to engage with the processes of meaning-making.

There are two ways at least of moving on from the idea that individuals cannot all creatively assign meaning in a manner that has some basis outside the ego, either in fact or in the social.[21] One is indeed towards the reactionary one that assigns to certain classes of person the capacity to know, and therefore to determine meaning. The West, and perhaps especially Britain, the United States, and their current heads of state, has a pronounced tendency to do this. The other way forward is to try to reason from the assumption that anyone can *lose* the capacity to assign meaning creatively. In this case, then what are the conditions that deprive some body—individual or collective—of this capacity? There is a substantial body of work to demonstrate that the capacity to determine meaning is to a very great degree a social function.[22]

Understood in this way, as a process of meaning-making that is inseparable from the capacity to act, the link between social change and art is a strong one. I would go further, to say that creative expression is at the heart of my argument about the social. In this sense, the Taliban regime was utterly antisocial. But I would not in any simple way exonerate the West from this charge. Following Drucilla Cornell and to an extent Theresa Brennan as thinkers from the social standpoint, and feminist aestheticians and philosophers such as Peg Brand, Carolyn Korsmeyer, and others, the aesthetic can be located right within the institutions that make up society.[23] And that means that art education is a social issue at the same time as it is one of aesthetics, and *in the same terms*. There is no opposition between art as aesthetic and art as social.

NATIONHOOD AND MALE MELANCHOLY:
"A VISION ARTICULATED AT THE 'EDGE' OF THE NOT"

I now want to connect the loss of the capacity to assign meaning with the specific form of masculinity evidenced by the Taliban. At the same time, I want to keep in mind that it is an extreme form of the same notion of masculinity that tends to erupt within the Western nations especially at times of crisis. Such pressure can be personal or social.

Some years ago, in 1989, Homi Bhaba wrote a resonant piece entitled "A Question of Survival: Nations and Psychic States."[24] In it, he asks whether there

can be culture without melancholia, and goes on to weave between ideas of nationhood, history, and the colonial, all associated in some way with death, loss, and melancholia. It is in this sense a very masculine analysis; it focuses on the notion of death at the very moment of declaring the need for birth. Even the death of the author is the birth of the text; while I am not saying there is an equivalence, the idea of the death of the author is not necessarily only about death. It is not only the transformation of immediacy into distance, experience into symbolization, but rather a moment in their continuum. "The author" does not necessarily leave a vacuum, but can become a more collective understanding agency within cultural production. Reinserting the lofty genius into the culture out of which s/he comes may mean the death of an idea of genius, but it is not a deathly idea or social process. Indeed, the etymology of the word shows that it has shifted between the individual and the national in connotation, and that the modern sense dates only from the eighteenth century.[25]

Many feminists have argued against this notion of the death of the author.[26] It is a sexed understanding. Bhaba is theoretically aligned with plural subject positioning, since he argues against "unisonance." But his focus is to stay with the patriarchal *nom/non* of which the deathly authorial view is a part.[27] The final sentence (a word on which I am tempted to pun) of his essay is a doubled negative: "It is a vision articulated at the 'edge' of the *not* that will not allow any national or cultural 'unisonance' in the imagined community of the future."[28]

Yet in the fragmented body ("corps morcelé") of the colonized to which Bhaba refers, there are many unifiers. Behind the parts is the shape of the body. Like the many commentators this book hopes to persuade, Bhaba seems to fear that the commonality that must characterize any community, imagined or otherwise, is also a totalizing narrative, despite his explicit critique of binarism. He would thus seem likely to reject the sexing of universals, although I hope to have indicated how such a concept need not be the Trojan Horse that admits the colonizing Subject. Indeed, the simultaneous "incommensurable inscriptions of social reality" and "mental constellation of revolt" that he finds in Fanon reinscribes the dynamic in the language of violence. With it goes the reading of social reality as paralysis ("don't dare to budge") and psychic reality as attack ("get ready to attack"). Bhaba has located a crucial question about contemporary theories of representation and the social. Interestingly, his metaphor is also that of the statue,[29] the "statuesque, exhibitionistic Master; the tense, muscled native."[30] Bhaba is right. But he is not thinking about women, or indeed about the kind of statues that were the Bamiyan Buddhas. For Bhaba to speculate about women here, a clear difficulty lies in the fact that his thinking about melancholic culture is not in fact plurivocal. Thinking about women would seem to rewrite his scenario. But would it? Is the link between his understanding of the political subject with a certain kind of deathly masculinity legible without reference to women? The identifications of that form of masculinity are symptomatic of an inability to empathize and form a closed circuit that entraps colonizer and colonized. Without empathy, there can be no creative ability to assign meaning.

What is required is a discourse that can recognize dialectical relations between enemies—hitherto the ultimate, perhaps, in oppositional relation—without inscribing their mutual implication as a mirroring. All sides in contemporary conflict, as perhaps in all political conflicts, claim moral superiority. The United States is dangerously close to representing itself as *innately* superior, just as inflexible régimes and masculinity have before. But there is plenty of evidence that its/our culture is in a phase of difficulty with the capacity creatively to assign meaning. There is a great deal of formulaic reference in the conduct of public life, and of the present conflict, to "family values." This is not unconnected with the fact that such values are in crisis, a state of affairs so strongly linked with sex that its marriage to it is tragic-comically invisible; sex is what is written out of the "family values" family. When Bush or Blair say "family values," the sexed implications are hidden, not revealed, especially when they tie them to religion and the state. The idea of Nationhood is uneasily linked both with sex and with the family; the Motherland exists at the same time as the Fatherland.[31] At times of war, it is the latter which dominates in the national consciousness. War is a serious, masculine business that simplifies and subordinates everything outside its economy.

In this light, Bhaba's question as to whether there can be culture without melancholia becomes all the more disturbing. One might be surprised that such a question could arise at all. But in a culture that associates masculinity with melancholia, and which is at the same time predominantly masculinist, even now, the link is at least in one aspect visible.[32]

SUICIDE ATTACKERS, MOURNING, AND MELANCHOLIA

[. . .] for Freud the construction of a persuasive new theory of the human mind brought with it, as more than incidental benefit, a whole new sense of opportunity for the cultural critic: an empire was falling into brutal disarray, the European monarchies were preparing themselves for their war to end wars, civilization itself was in peril . . . and psychoanalysis was ready armed with a vision of the human psyche that could make a desperate kind of sense out of this discouraging public spectacle.[33]

If I now move to a fairly close use of Freud, it is not in the spirit of making reference to an authority. To do so would be to fall into the trap that I am trying to outline and make sense of, and thereby escape. Rather it is intended, with due humility and self-irony, in the same manner as Bowie lightly but scathingly implies in alluding to the opportunistic benefits of Freud's thinking at another time of European crisis.

Freud wrote "Mourning and Melancholia" in the years from 1915 to 1917, that is to say, during the First World War.[34] The term "World War" locates a further disquieting parallel between that time and this, since it has recently been bandied around, not least by President George Bush II. It evidences the

capacity of the "masters" simply to leave out their thinking vast numbers and categories of people. For the masters, they do not exist. Between Bhaba's "don't dare to budge" and "get ready to attack," nothing moves.

Near the beginning of his paper, Freud says: "Mourning is regularly the reaction to the loss of a loved person [. . .]"—so far, this is not remarkable. But he then says, "[. . .] or to the loss of some abstraction which has taken the place of one, such as one's country, liberty, an ideal, and so on."[35] This is remarkable, that the loss of an ideal can have an impact as great as that of a loved person. Freud's choice of examples, moreover, is significant. First among these are "country, liberty."

In relation to the Taliban, this may be seen as placing their recent history and its representation in a fairly direct relation to the extremity of their actions. I hesitate to put it more strongly, both because "Mourning and Melancholia" is quite tentative and full of disclaimers as regards empirical or clinical proof, and because the "complex" of melancholia is a difficult one to characterize. In one of those fascinating moments of departure from the seeming-objectivity of clinical language, Freud resorts to a physical metaphor relating to the body, and it is one he has used in an earlier version of the paper:[36] that of an open wound.

> The complex of melancholia behaves like an open wound, drawing to itself cathectic energies—which in the transference neuroses we have called "anticathexes"—from all directions, and emptying the ego until it is totally impoverished.[37]

The paragraph after this in Freud's text is a brief speculation on the possible somatic content of the complex. Taken with another feature of melancholia that is of particular relevance, the way in which both the object and the ego are implicated, this is a very full set of affects. The body, the mind, and external relations are all involved in similar ways.[38]

Brought together, all this offers a way of understanding the readiness of the Afghans, like the Palestinians, to carry out suicide raids in the name of an idea. The underlying condition is one characterised by Freud as "a mental constellation of revolt," and we recognize that Bhaba's assessment of Fanon, cited above, is an unconscious quotation from Freud.[39] The objection may be raised, that the suicide raiders seem to be in a state of mind that is very far from melancholic.

But melancholia can evince a tendency to turn into mania; and indeed, Freud concludes that "the content of mania is no different from that of melancholia."[40] The boy soldiers of Afghanistan, like the father of the three girls in Shah's film, appear to be prime examples, having lost their family, their country, their masculinity, their femininity—in my terms, their sexed identities. Common to mourning and melancholia, according to Freud, is the need to let go of the lost object, which requires at the same time the withdrawal of attachments to that object. The melancholic, however, displays a tremendous loss of self-regard, "an impoverishment of the ego on a grand scale," which can manifest

in a tendency to suicide.[41] This leads in diverse ways to the following important observation in which Freud makes clear the link between object and ego:

> The analysis of melancholia now shows that the ego can kill itself only if, owing to the return of the object-cathexis, it can treat itself as an object— if it is able to direct against itself the hostility which relates to an object and which represents the ego's original reaction to objects in the external world.[42]

The destruction of the Buddhas is a dramatic symbol of this capacity for self-harm. Any culture that can destroy its own artefacts in such a manner is displaying serious symptoms. There are particular ironies in attacking one's culture in the name of defending it against the cultural imperialism of the West. The act of destroying the Buddhas is on a strange and terrible continuum with the acts of the suicide raiders who flew into the World Trade Center and the Pentagon. Their ambivalent attraction towards Western culture has been remarked upon in the press coverage as if this were somehow proof of their bad faith. But this cultural transference is comprehensible as evidence both of the self-objectification and of the loss of their country that are elements of melancholia.

How comparable is this, I wonder, with the wholesale demolition of English towns after the Second World War? The widespread desire to create a new-built environment was at the cost of the most readily visible signs of the material culture, its old urban structures, over which the war was fought. Of course this is not the same as the Taliban's destruction of the Buddhas. Of course Western women are not imprisoned or directly controlled as contemporary Afghan women still continue to be since cessation of formal conflict. But Western women have been, at varying times in our history; and the repetitious mutual threat between masculine and feminine as clearly attached to sexed bodies remains an irruptive and discouraging historical phenomenon. We all continue to be harmed by essentializing theories of what is natural to men or women.

This is the parallel with the destruction of the Buddhas. For the melancholic masculinist culture harms itself through treating part of itself as an object. Women. This is not a strategy for survival, for life. Why "choose" the strategy of melancholia over parousia? It is not an empowered capacity to act meaningfully. Its tendency is to suicide. Bhaba asks whether there can be culture without melancholy. Of course there can be culture without melancholia at its structural core. Or heart.

POSTSCRIPT. REVOKING *THE OATH OF THE HORATII*

Louis David's painting *The Oath of the Horatii* of 1785 is a staple of art-historical education. It illustrates a moment in a story from Titus Livius, previously the subject of Corneille's tragedy of 1640, when the three Horace brothers swear to fight in the name of Rome three enemy soldiers to decide the fate of their two opposing armies. Two of the brothers fall at the first bout and the three ene-

mies are wounded. The third brother pretends to flee, but separately kills each of the three opponents, thus assuring victory. It is a supposedly heroic story, but it is shot through with treachery.

It also plays out across a woman. To the right of the picture, a woman languishes. She is the sister of the victorious Horace, engaged to marry one of the defeated men. She expresses her anger and grief over his death, and is murdered by her brother. His crime is forgiven for services rendered to the fatherland. Family values are clearly subordinated to those of war in the story. While in literature, Corneille's tragedy sets such abstracted notions of patriotism against the human values of the defeated and of the sister, Camille, the notion that women are expendable when the nation is at stake remains clearly embedded in the stories of Europe. The Taliban's abstracted religiosity replays this Roman scenario. The West must ensure it does not do the same by depicting the opponent as less than human, as totally other, and building this into reconstruction programmes that leave out art, and by failing to take its own art socially. We are all the poorer for the loss of the Buddhas. Buddhism, and the art of Buddhism, may not be full of women. But it is not founded on their death.

Notes to chapter 7

1. "Keeping it moving," response to Butler *Psychic Life of Power.* 153
2. This is one application where Lacan's often ludicrous insistence that a Subject is one or the other may well apply. See Julie Mitchell and Jacqueline Rose (eds.), *Feminine Sexuality* and *Jacques Lacan and the Ecole Freudienne* (trans. J. Rose), London: MacMillan, 1982.
3. London/NY, Routledge, 1993.
4. For example, see 81ff. et passim. Brennan connects her theory with the strand of philosophical thinking that traces back to the Pre-Socratics, while cautioning against too rigid a separation (as in Heidegger or Irigaray) between Greek thought before and after Plato. What has occurred, rather, is a hardening of certain of the ideas of the "punctual self."
5. Reconnecting individuals with the cosmos unfortunately "survives on miserable arguments," as she says, as in New Age "cosmic consciousness," where the connecting force is always assumed to be good, but historically has some much more weighty advocates, such as Spinoza. See Brennan, chapter 3.
6. This rest of this chapter is closely based on my essay "On the Destruction of Cultural Features, Masculinist Nationalism and Melancholia," in Jacquie Swift and John Swift (eds.) *Soundings and Reflections,* (Volume IV, the final volume of the series *Disciplines, Fields, Change in Art Education*), ARTicle Press, 2002: 9–26.
7. According, for example, to Saira Noorani, an Afghan surgeon, at the time of writing exiled and unemployed in Pakistan, in Jason Burke "The gender war. The Afghan women who saw freedom ebb away" *The Observer,* Sunday, September 30, 2001. Suzanne Goldberg, however, points out that "What the Taliban did was to adopt the most unyielding of Pashtun customs, then try to impose [. . .] on an entire society [. . .]. Now, almost unnoticed, the Taliban have begun to indicate that they are more tolerant than they will admit outright." "Veiled Threats," *The Guardian,* December 21, 1999. Her comparative optimism about the liberalizing effect of the realities of government have proved unfounded.

8. See *Differential Aesthetics*, co-edited by myself and Nicola Foster (Ashgate 2000) for a fuller explanation of this position.
9. Mohsen Makhmalbaf, director. The film won the Ecumenical Jury Prize, Cannes 2001 (awarded before September 11) and went on general release November 2001.
10. See Aida Edemariam, "The Film Bush Asked to See" *The Guardian*, Friday, October 26, 2001.
11. "Compelling Charm. Some Reflections on Goethe's Move to Weimar" 57–66 in Davies, Swift and Swift *Disciplines, Fields, Change. Vol. 3 Art therapy, Psychology and Sociology*, Birmingham, ARTicle Press, 2001, hereafter "DFC v 3 *Art therapy....*"
12. Ibid. 64.
13. But history, as Umberto Eco put it, is a two-edged sword, and we must argue in this case in the present. "The roots of conflict. Is Western culture better than any other?" *La Repubblica* and *The Guardian*, 13 Sept 2001. Eco argues through a series of ironic comparisons of historical evidence on either side of the current conflict in favor of pluralism and an "alternative" anthropology in which Islamic fundamentalists and others research Christian fundamentalism and other Western beliefs and customs. He argues that what is important is not superiority but pluralism and toleration.
14. "Vandalism" is an appropriate term here, deriving as it does from the Germanic invaders of Europe and North Africa of the fourth and fifth centuries (see OED). Afghanistan, like so many countries, is a recent creation as a nation, its instability a result of cutting across more fluid identifications and allegiances. The kind of act perpetrated by the Taliban is inscribed in the history of Europe. I am not saying that it is somehow "Islamic."
15. Intrigue over oil is implicated in much of the conflict with the Arab world, and this is a significant part of why the West has recently been so actively interventionist in the Middle East.
16. There is a question about how far Afghanistan is a nation in the modern sense of the nation state. The same is true of many of the national boundaries that have been imposed since WWII, in Western Europe, Asia, and Africa. The "Nation" is for many a far less stable entity than British and American people experience through the "island" mentality they tend to share, despite obvious differences of scale. See, e.g., David Brown, "Between a rock and a hard place," *The Guardian*, Wednesday, September 19, 2001.
17. "Behind the burka. We should make the Northern Alliance sign a contract on human rights—especially women's rights." Polly Toynbee, *The Guardian*, Friday, September 28, 2001. An honorable exception to the absence of male journalists' interest in Afghan women is Jason Burke's "The gender war. The Afghan women who saw freedom ebb away." Jason Burke. *The Observer*, Sunday, September 30, 2001, cited above.
18. The *burqa* is a garment that covers women from head to toe; the heavy gauze patch across the eyes makes it hard to see and completely blocks peripheral vision. Since enforced veiling, a growing number of women have been hit by vehicles because the burqa leaves them unable to walk fast or see where they are going. Recently in Kabul, a Taliban tank rolled right over a veiled woman. Fortunately, she fell between the tracks. Instead of being crushed to death, she was not seriously hurt, but was severely traumatized. ©1998 On The Issues. Summer 1998, vol. 7, no. 3 / Web page: 7-2-98.
19. *Unholy War*, broadcast on Channel 4 TV, 11 November 2001.
20. See for example Jo Stanley "Handling the Hidden Injuries of Class, Race and Gender," Zahid Dar "Dance of Shiva" in DFC v 3 *Art therapy....*

21. See Patricia Huntington, *Ecstatic Subjects, Utopia, and Recognition. Kristeva, Heidegger, Irigaray*, Albany, SUNY Press, 1998: especially xxii and chapter 3. These ideas were much clarified through her work. Like her, I am translating between specialist discourses, and in so doing, I may move her arguments into areas about which she might have reservations.

22. See for example Kate Broom in *Reflective Practice and Reversals in Art Therapy* DFC v 3 *Art therapy* . . . : 23–40. Broom demonstrates how varying approaches can not only enable or dis-enable the same individual, but can generate new meanings between client and therapist. Significantly, such meanings did not pre-exist the therapeutic encounter. They can also be lost in subsequent encounters.

23. See especially Cornell's *The Imaginary Domain*, Routledge 1995; Brennan's *History after Lacan*, Routledge, 1993; and for an analysis of, and collection of essays by, aestheticians, Florence and Foster *Differential Aesthetics*, Ashgate Press, 2001.

24. See James Donald (ed.) *Psychoanalysis and Cultural Theory. Thresholds*, London, Macmillan, 1991: 89–103.

25. The OED, for example, gives eight quite lengthy definitions, including "with reference to a nation, prevailing character [. . .]." After "native intellectual power of an exalted type," it adds that "this sense [. . .] appears to have been developed in the c18," contrasting "native endowment" with "aptitudes acquired by study." I point out this permeability between aesthetics and ideas of the nation to stress the consistency in Western culture of arrogation of political power and the power to assign meaning to certain groups alluded to above.

26. See Nancy Hartsock's 1987 essay, reprinted in 1990, "Rethinking Modernism: Minority vs. Majority Themes" in Abdul R. JanMohamed and David Lloyd (eds.) *The Nature and Context of Minority Discourse*, Oxford, Oxford University Press: 26ff.

27. This pun will be familiar to readers of Lacan and his followers. It associates the Name of the Father (*nom* in French) with prohibition/refusal/impossibility (*non*, or "no," is a perfect homophone with *nom*).

28. Bhaba 1991: 102, emphasis in the original.

29. Ibid, 99, 102. A provocative exploration of the African statue in a European art context—wrested from its dialogic relation with its society—is Chris Marker and Alain Resnais' film *Les statues meurent aussi* (France 1953). The film was banned when it came out. Thanks to Mary Anson, my former student, who first showed me the film some years ago.

30. Ibid.

31. The best exploration of this I have seen is *Mother Ireland*, an independent film produced in the 1980s by Derry Film and Video Workshop.

32. I would align this essay more with Gillian Rose's extraordinary work *Mourning Becomes the Law* (1996), than with Leo Bersani's *Culture of Redemption*, both of which I admire; but I disagree with the latter.

33. Malcolm Bowie, "Freud and the European Unconscious," in *Psychoanalysis and the Future of Theory*, Oxford UK/Cambridge USA, Blackwell, 117–141, 1993: 139.

34. Sigmund Freud, "Mourning and Melancholia" 1917 (1915), *SE* XIV: 243–258.

35. Ibid.

36. In the Standard Edition there is a note directing the reader to the "rather abstruse" Section IV of Draft G of 1895 (Freud 1950a), and to the editor's note on page 229.

37. Ibid. 253.

38. Freud's passing reference to the transference is also interesting because of the transferential ways the Americans and the Afghans related in their public rhetoric.

39. Bhaba: 248. I "discovered" Bhaba's essay after drafting the basic ideas in this chapter, and it does indeed reference the Freud later; who knows how far my essay began as an unconscious recollection of it. Be that as it may, I would question in sexed terms Bhaba's notion of the subaltern discourse as a "melancholia in revolt."

40. "Mourning and Melancholia": 254.

41. Ibid. 246.

42. Ibid. 252.

index

Derrida, 27n40, 81, 88, 93n46, 95–96, 99, 102, 116–117, 119–120
Descartes, René, xi
Deutscher, Penelope, 1, 3, 4
Dickens, 31
"differencing the canon," 6
differential, 22
differential universal, 1, 6, 18
digital art, 80
Dionysus, 13, 46, 65, 104
Dispatches, 171
dissymmetry, 22
"Doctor Lawyer Indian Chief: *'Primativism'* in Twentieth Century Art, at the Museum of Modern Art in 1984," x
Dollimore, Jonathan, 65, 66
Donne, John, xiii, 165
Dorment, Richard, 86, 93n58
"double dissymmetry," 96
Double Life, 51
Double Mirror, 146, 146 fig. 44
Double Negative, 142, 144
Downey, Robert Jr., 85
Dryad, 47 fig. 4, 48, 49
Duchamp, 133, 136
Duncan, Isodora, 155

Eakins, Thomas, 154
Éclipse, 116
economics, 20, 22, 170
Eco, Umberto, 169, 178n13
Edelson, Mary Beth, 87
eggs, 11, 12, 15, 54
ego, 77, 101, 176
Ego and the Id, The, 77
"ego's era," 167
Egyptian Book of the Dead, 46
eidetic intuition, 33
Eisenman, Stephen, 98, 111, 125n16
Electra, 86
electricity, 91n12
Elegies to the Spanish Civil War, xiii
Elektra, 86
Éléments et mémoire de paysage, 120, 165 fig. 56
Eleusinian Mysteries, 46
Eliot, George, 12, 106, 151
Ellington, Duke, 155
Emin, Tracy, 10
Engels, Friedrich, 24
Enlightened Women, 27n40
Enlightenment, 68, 168
Éperons: Les styles de Nietzsche, 116
Epicurus, 33
Epstein, 133

Erewhon, 98
ethics, 1, 3, 5, 61, 64, 119, 131
"ethics of discussion," 3
Ethics of Sexual Difference, An, 5
ethnography, 99, 114, 132
ethnology, 100
Eugénie, Empress, 69
Eumenides, 152
European Renaissance, 24
"evolutionary psychology," 170
exhibition(s), 6, 43, 46, 53, 56n5, 57n22, 114, 120–121, 123, 146
From Blast to Pop, 11
Centenary Exhibition, 8
Constructive Art, 153
"Eccentric Abstraction," 16
of Himid, 51
La tache aveugle (Blind Spot), 113
L'invitation au voyage. French Painting from Gauguin to Matisse from the Hermitage, 44
of Manet, 75
Manet/Velásquez. The Spanish Manner in the 19th Century, 69
Matisse-Picasso show, 48, 49
Paris, City of Culture, 17
Salon des Refusés, 74
existential philosophy, 61

family paradigm, 3
family values, 174, 177
Fanon, 155, 173, 175
Fantin-Latour, 87
Faure, 85
Faust, 89
feminism, 3, 11, 25n18, 33, 40, 55, 61, 91n7, 98
deconstruction, 99
Manet and, 66, 67
modern, 24
psychoanalytic, 61
"second wave," 99
Utopian, 98
Fer, Briony, 156
Figures, 156
Figures in a Landscape: Cornwall and the Sculpture of Barbara Hepworth, 26n32
Fille, 133
Fillette, 156
Finland, 130
Fisher, Jean, 54
Fishing, 84
Five Revolutionary Seconds, 85
Flanagan, Barry, 164n60
flatness, 69

reiterative universalism, 4, 34
Relating Narratives, 31
relativism, x–xii, xv
religion, 55, 84–85, 88, 100–107, 111, 113, 167–169, 176–177
Remacle, André, 127n58
Renaissance, 39
Republic, 14
"resexualization," 95
Return of the Real, The, 98
Reynolds, Dee, 126n54
Richards, M.C., 87
Richardson, Mary, 93n55
Richter, 7
Riley, Bridget, 114, 116, 146, 148
Rimbaud, 89, 110
Ringaround Rosie, 133
Roberts, 25n15
Rodin, 142
Rokeby Venus, The, 84, 93n55
Romanian artists, 5
Rose, Gillian, 43
Rose, Jacqueline, 1
Ross, Andrew, 99, 125n24
Rothko, Mark, 25n15
Rubens, 84
Rubin, William, x
Ruskin, John, x
Russell, Bertrand, 33
Russell, Lina, 93n51
Russian Formalists, 38

Said, Edward, 97, 147, 155
Salon des Refusés, 74
Satyr and Nymph, 45
Saussure, 37
Schlegel, 55
Screen, 116
"screen-effect," 82
sculpture, 7, 9, 12, 18, 106, 129–161
Sculpture in the Age of Doubt, x
Sculpture with color (Deep blue and red), 148
Sedgewick, Eve, 107
Self Portrait In A Single Breasted Suit With Hare, 84
self-portraiture, 7, 79, 80, 80–81
Semele, 46
September 11, 167, 176
Serra, 136, 142
Serres, Michel, 43, 54
Several, 159
sexual asymmetry, 101
sexual difference, 5, 8
Shah, Saira, 171, 175
Shakespeare, 97, 114

Shapiro, Gary, 12, 13, 14
Shaw, Jennifer, 53
Shelf Life, 151
Sherman, Cindy, 80
Shiff, Richard, 63
Shift, 142
Silent Takeover, The, 20
Sir John Soam Museum, 123–124
Slater, Philip, 86
Slut, 87
Smithson, 142
social choice, 171–172
social power, 35
Socrates, 14, 15
Soliloquies I, 84
Soliloquy I, 86 fig. 15, 86
Soliloquy series, 86
Soliloquy V, 86
Solomon-Godeau, Abigail, 125n16
Some Living American Women Artist/Last Supper, 87
Song of Ceylon, A, 102
Song of Soul, 108
sorrow, xiii
South Africa, 170
Soyez amoureuses, vous serez heureuses, 112
Soyez Mystérieuses, 127n58
Space in the Forest, 123, 123 fig. 27
"spaces between," 17
Spain/Spanish, 69, 70
spatiality, 122, 134
Spectres of Marx, 119
Spender, Humphrey, 57n23
Spinoza, 33, 40n12, 120
[Spiral] Jetty, 142
Spivak, Gayatri, 155
Stations of the Cross, 110
Stedelijk Museum, Amsterdam, 52
Steichen, Edward, 133
Stella, Frank, 108, 109, 113
Stephens, Chris, 9
St Ives School/painters, 10, 52
Stokes, 25n16
Straight Mind, The, 29
Strauss, Richard, 86
structuralism, 29
Study for Lightness, 120
subjectivism, 63
Sullivan, Françoise, 155
Sumerian Inanna, 106
super-powers, 20, 21
Surrealism, 16, 23, 153, 156, 164n58, 164n59
Suspended Ball, 153
Symbolism, 15, 23, 112, 115, 144, 163n56
Symposium, 55

Books from Allworth Press

Allworth Press is an imprint of Allworth Communications, Inc. Selected titles are listed below.

Writing About Visual Art
by David Carrier (paperback, 6 × 9, 224 pages, $19.95)

Uncontrollable Beauty: Toward a New Aesthetics
edited by Bill Beckley with David Shapiro (paperback, 6 × 9, 448 pages, $24.95)

Beauty and the Contemporary Sublime
by Jeremy Gilbert-Rolfe (paperback with flaps, 6 × 9, 208 pages, $18.95)

Sculpture in the Age of Doubt
by Thomas McEvilley (paperback with flaps, 6¼ × 9¼, 448 pages, $24.95)

Sticky Sublime
edited by Bill Beckley (hardcover, 6¾ × 9⅞, 272 pages, $24.95)

Out of the Box: The Reinvention of Art, 1965-1975
by Carter Ratcliff (paperback with flaps, 6 × 9, 312 pages, $19.95)

The End of the Art World
by Robert C. Morgan (paperback with flaps, 6 × 9, 256 pages, $18.95)

Redeeming Art: Critical Reveries
by Donald Kuspit (paperback with flaps, 6 × 9, 352 pages, $24.95)

The Dialectic of Decadence
by Donald Kuspit (paperback with flaps, 6 × 9, 128 pages, $18.95)

The Chronicles of Now
by Anthony Haden-Guest (paperback with flaps, 6 × 9, 224 pages, $19.95)

Lectures on Art
by John Ruskin, Introduction by Bill Beckley (paperback, 6 × 9, 264 pages, $18.95)

Please write to request our free catalog. To order by credit card, call 1-800-491-2808 or send a check or money order to Allworth Press, 10 East 23rd Street, Suite 510, New York, NY 10010. Include $5 for shipping and handling for the first book ordered and $1 for each additional book. Ten dollars plus $1 for each additional book if ordering from Canada. New York State residents must add sales tax.

To see our complete catalog on the World Wide Web, or to order online, you can find us at **www.allworth.com.**